T0138460

# Baroque Science

# Baroque Science

OFER GAL

RAZ CHEN-MORRIS

The University of Chicago Press

CHICAGO AND LONDON

OFER GAL is associate professor of the history and philosophy of science at the University of Sydney. RAZ CHEN-MORRIS is a lecturer in the Science, Technology, and Society Program at Bar-Ilan University.

The University of Chicago Press, Chicago 60637
The University of Chicago Press, Ltd., London
© 2013 by The University of Chicago
All rights reserved. Published 2013.
Printed in the United States of America

22 21 20 19 18 17 16 15 14 13    1 2 3 4 5

ISBN-13: 978-0-226-92398-7 (cloth)
ISBN-13: 978-0-226-92399-4 (e-book)
ISBN-10: 0-226-92398-3 (cloth)
ISBN-10: 0-226-92399-1 (e-book)

Library of Congress Cataloging-in-Publication Data

Gal, Ofer.
Baroque science / Ofer Gal, Raz Chen-Morris.
pages cm
Includes bibliographical references and index.
ISBN 978-0-226-92398-7 (cloth : alk. paper) — ISBN 978-0-226-92399-4
(e-book) 1. Science—History—17th century. 2. Mathematics—History—
17th century. 3. Optics—History—17th century. 4. Discoveries in science—
History—17th century. 5. Science—Philosophy—History—17th century.
I. Chen-Morris, Raz. II. Title.
Q127.E85G35 2013
509.4′09033—dc23
2012043141

להורינו

# Contents

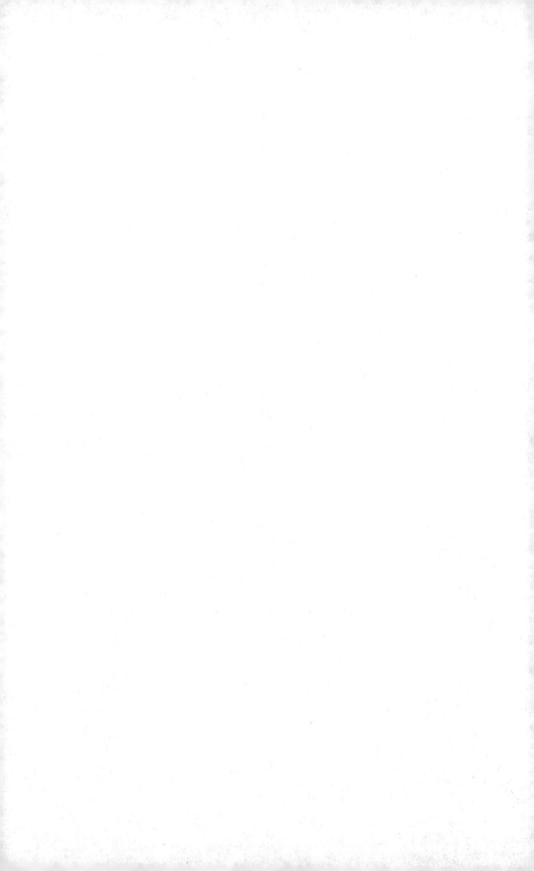

# Figures

# *Acknowledgments*

THIS BOOK is a culmination of an intellectual companionship that began almost a quarter century ago, in the early years of the Cohn Institute for the History and Philosophy of Science and Ideas at Tel Aviv University. If it shows scholarly determination and verve, these must be ascribed to our education in the uniquely vibrant and stimulating environment of those heady days. The joy reflected in this writing must be attributed to the deep friendship that developed not only between ourselves but also between our loving and supportive families—our wives Joanna Chen and Yi Zheng; and our children Hagar, Jasmine, Emily, and Daniel.

Even in its current form, this book is the product of a very long process, and having been written by two people over four continents and eight years, it owes to more institutions, meetings, workshops, publication venues, and people than we will manage to mention below. We are thankful to all.

Our research was generously supported by two Australian Research Council grants—DP0664046: *The Imperfection of the Universe*, and DP0772706: *The Origins of Scientific Experimental Practices*. It was made possible by a Senior Fellowship at the Dibner Institute in 2003; a Membership at the Institute of Advanced Studies in 2007; a Guest Scholarship at the Center for Literary and Cultural Research, Berlin, in 2009; a Rosenblum short-term fellowship at the Folger Shakespeare Library, Washington, in 2009; and a research fellowship at the Minerva Humanities Center, Tel Aviv University, in 2010-2011.

Short versions of some of the chapters were published as: "Nature's Drawing," *Synthèse* 185.3, 2012: 429-66; "Baroque Optics and the Disappearance of the Observer," *Journal of the History of Ideas* 71.2, 2010: 191-217; "The Use and Non-use of Mathematics," *History of Science* 44.1, 2006: 49-68; "Mirrors,

Enigmas, and Lenses: Visual Knowledge from the Middle Ages to the New Science," *Zmanim* 93, 2006: 4–15 (in Hebrew); "Metaphysical Images and Mathematical Practices," *History of Science* 43.4, 2005: 391–414; "From Divine Order to Human Approximation: Mathematics in Baroque Science," in Gal and Chen-Morris, *Science in the Age of Baroque* (Dordrecht: Springer Verlag, 2012); "The Controversy over the Comets: What Was It Really About?" in Victor Boantza and Marcelo Dascal (eds.), *Controversies in the Scientific Revolution* (Amsterdam: John Benjamins, 2011), 33–52; "Empiricism Without the Senses: How the Instrument Replaced the Eye," in O. Gal and C. Wolfe (eds.), *The Body as Object and Instrument of Knowledge* (Dordrecht: Springer Verlag, 2010), 121–48.

We owe special thanks to the members of the History of Science Group at the Institute for Advanced Studies in 2007, and in particular Sven Dupré, Jonathan Israel, Roy Laird, Tony Malet, and Heinrich von Staaden. We owe much to the excellent Sydney Early Modern Science Group, and especially Alan Chalmers, John Gascoigne, John Schuster, and Charles Wolfe for criticism and advice, as well as to our friends and colleagues at the Unit for History and Philosophy of Science in Sydney and the Science, Technology and Society Graduate Program at Bar Ilan University and the Baroque research group at the Minerva Humanities Center at Tel Aviv University.

We are deeply grateful to the participants of our 2008 *Baroque Science* workshop in Sydney, who helped us crystallize what it was exactly that we meant by this term: Victor Boantza, Nick Dew, Paula Findlen, J. B. Shank, and Koen Vermeir. John Schuster deserves a special mention here as well.

We are very thankful to our graduate students during the period—Megan Baumhammer, Israel Belfer, Shiri Cohen, Yossi Eliav, Sr. Mary Sarah Galbraith, David Gilad, Yael Justus-Segal, Claire Kennedy, Kiran Krishna, Ian Lawson, Alan Salter, and Ian Wills—for taking us seriously and questioning us relentlessly. To our research assistant Jennifer Tomlinson, who dabbled as an invaluable editor, we owe special gratitude.

We also thank our friends and scholarly comrades Gadi Algazi, Dani Dor, Michal Gal, Snait Gissis, Helen Irving, Lia Nirgad, Ohad Parnes, Eileen Reeves, Sam Schweber, Dorit Tanay, and Hanan Yoran for their affectionate encouragement and brilliant conversation over these years, and we owe special thanks to Hal Cook, Rivka Feldhay, Stephen Gaukroger, Anthony Grafton, and Dror Wahrman for their crucial intellectual and institutional support.

Finally, we thank the two anonymous referees for their enlightening comments, and especially Karen Darling and Michael Koplow, our dedicated and most supportive editors at the University of Chicago Press.

# INTRODUCTION

———— ✳ ————

## IN THE EYE OF THE PAINTER

A PAIR OF PAINTINGS by Johannes Vermeer from the late 1660s present *The Geographer* (fig. I.1) and *The Astronomer* (fig. I.2), apparently the same model, clearly in the same room.[1] Physically immersed in the materiality of heavy furniture and clothing, they are reflective and absorbed, their passions measured and controlled. They are surrounded by their objects and instruments of knowledge, which is clearly mathematical: diagrams are lying on the desk and hanging from the wall, compasses are in use, an astrolabe ready to hand. It is also clearly a worldly, empirical knowledge, coded in maps and charts, with only a few books to be seen, shelved away on top of the closet. There are no optical instruments in view, but they are suggested by the real actors: the painter, master of the camera obscura, and the model, rumored to be the great microscopist Anthony van Leeuwenhoek.

Vermeer captures the fundamental mores of the New Science just coming of age, and quietly celebrates its achievements. Yet a certain tension is pronounced in the brooding, distant gaze of the figures, both clearly distracted from their work. Compared, the two paintings give the brooding a clear focus. It is in the curious inversion of the distance and immediacy of knowledge: the intimate acquaintance with the celestial globe, reflected in the gentle touch of the astronomer's hand, comes at the price of an alienation from the terrestrial globe, which is resting, white and faceless, behind the geographer's turned back.[2]

These tensions and inversions at the heart of the New Science are the subject matter of this book.

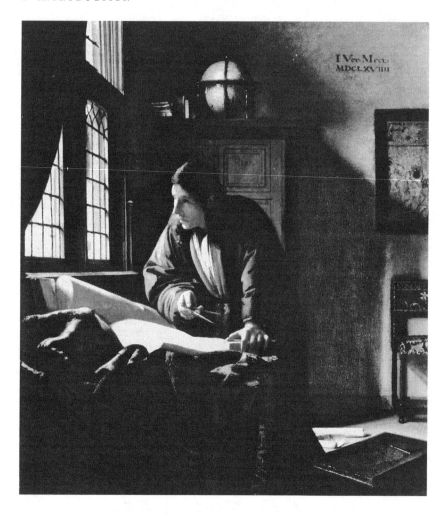

FIGURE I.I Johannes Vermeer's *Geographer*, 1669. Städelsches Kunstinstitut, Frankfurt, Germany/Bildarchiv Foto Marburg/The Bridgeman Art Library.

## THE PRICE OF NEW KNOWLEDGE

Vermeer was not the only or the first artist to express such anxious brooding over the new practices of early modern knowledge, their success, and its price. It can be found already fifty years earlier, in Jan Brueghel and Peter-Paul Rubens' *Allegory of Sight* (fig. I.3).[3] Venus, the epitome of visual knowledge and carnal beauty, is surrounded by artificial instruments of ob-

FIGURE 1.2 Vermeer's *Astronomer*, 1668. The Louvre, Paris, France/Giraudon/The Bridgeman Art Library.

servation, mathematical devices, and artificial representations of natural, historical, religious, and mythological scenes. Like Vermeer's figures, she is pensive and indecisive, and like them, it is the inversion between observed and observer, natural and artificial, immediate and mediated that gives reason to her wonderings. Even the appearance of the outside world seen through a huge window, depicted in rigid one-point perspective, is more

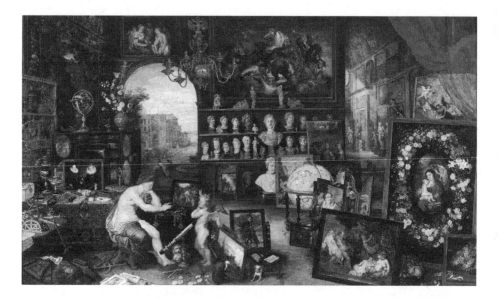

FIGURE I.3 Peter-Paul Rubens and Jan Bruegel's *Allegory of Sight*. Prado, Madrid, Spain/The Bridgeman Art Library.

like another painting than external reality. A ray of light beaming through a small opening in the upper right hand side, suggesting a camera obscura, supplements the artificial light of an ornate chandelier. An observant monkey accentuates the irrationality and melancholy of Venus' yearning for enlightenment. Bespectacled, it cannot view true Nature, only its artificial representation—the painted landscape—mediated by lenses.

Painters' intense and well-informed engagement with the claims and aspirations of the new savants, as well as with their new skills, instruments, and capacities, was not limited to the immediately shared concerns in the senses in general and vision in particular. Mario Bettini's 1647 *Anamorphosis of Cardinal Colonna's Eye* (fig. I.4) demonstrates how it was not only the empirical prowess of the New Science that came under close scrutiny, simultaneously critical and admiring, but also its other emblematic achievement: the submission of all phenomena to mathematical order. In Bettini's drawing mathematics is hardly a failsafe route to true order. In his hands, it can produce *both* correct and distorted representation. Indeed, one may ask which is which: the easily recognizable one is laid on a curved surface. The flat, "natural" surface presents the distorted, anamorphic representation.

Bettini's is neither an outsider's view nor a flippant remark: the drawing

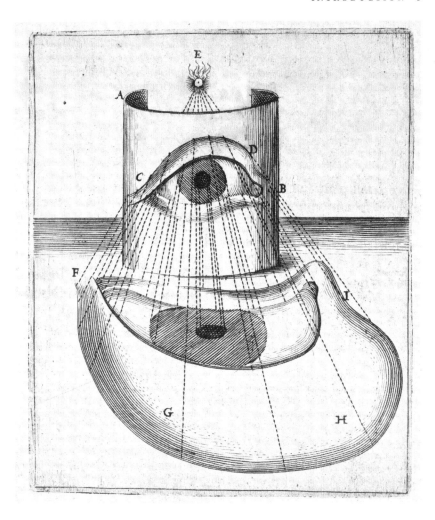

FIGURE 1.4   Mario Bettini's *Cardinal Colonna's Eye*. *Apiaria* 1, part 5, 8. Linda Hall Library of Science, Engineering & Technology.

is nested in his book of mathematical instruction whose title suggests a thorough fusion of practical and theoretical, rigorous and playful, "scientific" and "artistic": *Apiaria universae philosophiae mathematicae in quibus paradoxa et nova pleraque machinamenta exhibentur* (The beehive of universal mathematical philosophy, in which paradoxes and many and new siege engines are exhibited). Nor do Rubens, Brueghel, and Vermeer appear estranged from the instruments and practices they depict. The brooding of their protagonists

is a comment by an involved participant, not an observer. The scientific in-
struments they represent are an integral part of the painted interior, inter-
mingled with the painter's tools, embedded in the contemplated scenery. The
meditation of the central figures concerns observation and visual knowl-
edge in general; the camera obscura, monkey's spectacles, and telescope are
assembled together, as well as the drawings, the globe, and the armillary
sphere. Even the mathematical tools are undifferentiated: the painter's staff
and compass lie side by side with the astrolabe and the quadrant.

### THE OPPOSITION

It should hardly be surprising to find practitioners in one cultural field
reflecting on the pretenses and achievements of another, especially when
the intellectual themes and tools are so closely related, as in the case of
seventeenth-century science and art. Yet it has very rarely been suggested
that the deep tensions and confusions inhered in the work represented by
these paintings and painters have any bearing on understanding the rise
and spectacular success of the New Science they comment on.[4]

The reason for this neglect is the opposition enforced by a long and active
tradition. On the one hand stands the "baroque style" ascribed to seventeenth-
century art, more easily to Rubens, but recently as much to Vermeer:

> Forceful and occasionally forced paradox; violent contrast; reliance on sensual
> detail, particularly color and touch, to indicate moral condition and religious
> theme; deliberate distortion of regular structures to produce the asymmetric
> effect of baroque art; and unity of thought more dependent on imagery than
> on logic.[5]

On the other stands the content of these paintings: *The Formation of the
Modern Scientific Attitude,* with its

> rigorous standards in observing and experimenting. By insisting that it deals
> only with material entities in nature, it excludes spirits and occult powers from
> its province. It distinguishes firmly between theories confirmed by multiple
> evidence, tentative hypotheses and unsupported speculations. It presents . . . a
> picture of nature . . . in which all available facts are given their logical, orderly
> places.[6]

The juxtaposition is striking. The traditional perception of these two
primary cultural movements of the period neatly arranges them in exactly
symmetrical opposition. Of course, with the decline of the grand narratives

of the *Scientific Revolution* the concept of "scientific attitude" has lost its explanatory appeal, but the overtones of provocation that our title still carries demonstrate that the opposition has not lost its air of self-evidence: early modern science appears to have developed either in oblivion or in direct opposition to the high culture of its time: seventeenth-century art is supposedly "sensual," "distorted," and "paradoxical"; the budding science of the seventeenth century is "rigorous," "orderly," and "logical."

## THE POWER OF PARADOX

The search for the emergence of proper "scientific attitude" is no longer regarded as anything more than a way to "read the future into the past with a sense of elation",[7] but the opposition of the emerging practices of early modern science to the distortion and sensuality of its contemporary art has survived. This is perhaps because empirical rigor, mathematical orderliness, and passion-free logical inquiry were not introduced by eager historians; they pervade the polemic manifestos, methodological prefaces, and philosophical musings of seventeenth-century savants themselves, often as self-serving rhetorical tropes, but also as true intellectual aspirations, and sometimes with great pride in their realization.

Yet even "actors' categories" should be taken in context. The significance of these categories and their relations to the practices in which they were allegedly embedded are far from straightforward. When one considers, as we shall do below, Galileo's proclamations of accuracy in his polemic *Assayer* with a mind to the particular challenge he recognizes; when one reads Descartes' promises of certainty in the *Discourse on Method* in light of the disturbing insights of the *Optics* that the *Discourse* prefaces; or when one analyzes Newton's famous "General Scholium" in relation to his discarded "Copernican Scholium," these categories no longer appear to comprise a self-standing, coherent, and confident philosophy or "method" that drives the new means and ways of producing knowledge. Rather, they reveal themselves as tense struggles with the same dilemmas and anxieties that the works of Brueghel and Rubens, Bettini and Vermeer grapple with.

This book is about these dilemmas, anxieties, and tensions. They evolved, we are going to show, from the very core of the emerging new practices of experimental, mathematical natural philosophy, and had a crucial role in shaping them. In particular, we are going to direct our attention at three interrelated paradoxes, which the paintings above help illustrate:

The empiricism of the New Science was not merely a philosophical posi-

tion; it comprised observation techniques and capacities the ambition and accuracy of which were hardly imaginable before. Their hallmarks were the microscope and telescope, which produced the marvelous spectacles of the very far and the very small. These optical instruments were now expected to answer fundamental questions and resolve cosmological riddles by direct observation into the foundations of nature. But this empirical prowess came at an unexpected price and with unexpected results. The new instruments did not offer direct observation at all; rather than extending and improving the senses, they were aimed at replacing them altogether. Moreover, the champions of instrumental empiricism justified the mediation of instruments by rejecting the immediacy of the senses themselves. To rely on the authority of instruments was to admit that the human eye is nothing but an instrument, and a weak one at that. The human sense organ, always regarded as the intellect's window to the world, has become, instead, a part of this world, a source of obscure and unreliable data, demanding uncertain deciphering. Paradoxically, accurate scientific observation and the naturalized understanding of the senses detached the intellect from its objects and meant that, fundamentally, we are always wrong.

No less paradoxical was the other grand achievement of The New Science: the submission of all phenomena to a small set of exact mathematical laws. Indeed, mathematical procedures borrowed from the mixed sciences and applied to natural philosophy allowed a new ordering of the most diverse phenomena. Mathematized natural philosophy turned local motion—the paradigm of change—into the carrier of order and assigned certainty to causal relations and explanatory power to mathematical structures, all with great success. But this success necessitated the gradual abandonment of the original hope that mathematics—the science of simple, perfect structures—will help deciphering God's perfect design for the world. Rather than reading "the language of mathematics" in which "the grand book" of nature was written,[8] the new mathematical investigation of nature relied on obscure, artificial procedures, and in place of divine harmonies it revealed an assemblage of isolated, contingent laws and constants.

Finally, even the idea of "facts" and "their logical, orderly places" turned out to be deeply paradoxical. Fundamentally mediated and brazenly man-made, the knowledge provided by the New Science, with all its marvelous success, could no longer lay claim to direct acquaintance with the objects of nature. In their stead, the mind produced its own objects: through instruments, experiments, and mathematical manipulations it brought about stars and sunspots; infinitesimal magnitudes and imaginary curves; the spring of air and the isochrony of spring. Objective knowledge appeared to rely on

the mind's creative, "poetic," engagement, or in other words—on the imagination; the faculty of images. But to revert to the mind's images in lieu of real objects was a very dangerous habit: it stirred the passions, leading to confusion, melancholy, and madness. The theories of the passions sprouting from mid-seventeenth century on are an attempt to resolve this dilemma with a paradoxical reversal of the order of knowledge: the assurance that reason, detached from material nature and dependent on the imagination, does not lead us astray, had to be entrusted with the orderly functioning of the passions, which direct the human body through the vicissitudes of nature and are sanctioned by its survival. Requiring "a science of the passions" to control their reason, the new savants embodied these contradictions in their very person.

This cluster of paradoxes is what our title designates. Enforcing order in the face of threatening chaos, blurring the boundaries of the natural and the artificial, and mobilizing passions in the service of objective knowledge—so is our contention—the New Science is a Baroque phenomenon.[9]

## BAROQUE[10]

*Historians of art have lately been using, for some part of the [sixteenth and seventeenth centuries] the adjective "Baroque"; but this is a word borrowed from the technicalities of formal logic as a term of contempt for a certain kind of bad taste prevalent in the seventeenth century, and its adoption as a descriptive epithet for the natural science of Galileo, Descartes, and Newton would be "bien Baroque."*
Collingwood, *The Idea of Nature*

It is, of course, this traditional use of "Baroque" that gives our claim its force. "Baroque" is not a neutral designation of a cultural period. Neither are its counterparts, "Renaissance" and "Enlightenment," but in diametric opposition to them it dwells, as Herder wrote, "im Dunkeln."[11] Having been coined in hindsight and in derision (not unlike "Middle Ages"), "Baroque" carries "bad taste" connotations that even the classical analyses of Wölfflin, Benjamin, Panofsky, and Maravall did little to amend—again, in diametric opposition to the self-congratulatory resonance of "The Scientific Attitude."

Our use of "Baroque," however, is different from the "adjective" whose application to science seems to Collingwood perverse enough to deserve a pan. It is not only that we have no interest in passing judgment on taste, but that we will not engage in formal analogies between fully accomplished cultural artifacts on which such judgment can be passed in the first place. These analogies produced, within the German critical tradition, some inter-

esting application of the notion of "Baroque Science," such as Henry Siger-
ist's reading of Harvey:

> One can apply to [Harvey] exactly what Wölfflin says about the artist, namely
> that he does not see the eye but the human gaze; that not the body in its
> boundaries binds him, but the unbounded motion of the body and its parts;
> that he does not see the muscle, but the muscle's contraction and its effects. In
> this sense Harvey is the first physician in whom the Baroque worldview em-
> bodied itself.[12]

But we do *not* use "Baroque" to designate style or *Weltanschauung*. For us
"Baroque" refers to the very particular set of tensions, anxieties, and para-
doxes sketched above and explored below. This is admittedly a somewhat
idiosyncratic use of the term but it is by no means arbitrary.

This use of "Baroque" to designate loci of cultural discontent allows the
phrase "Baroque Science" to serve as a reminder of the simple but always-
neglected fact that the works of Kepler and Galileo, Descartes and Huygens,
Hooke and Newton, are cultural products of the very same times and places
as those of Rubens and Shakespeare, Rembrandt and Milton, Vermeer and
Dryden. The phrase should bring to attention the fact that though some
of these works came to be regarded as harbingers of modern science and
others as works of art, their makers shared backgrounds and milieus, drew
on similar resources, and confronted similar challenges. The coupling of
"Baroque" and "Science" thus has a liberating effect: it allows looking at
both on their own terms, without the ahistorical burden of comparison and
adjudication of "taste" and "rigor."

In an important sense, however, Collingwood's quip may not be com-
pletely off-target. The phrase "Baroque Science" is not intended to shy away
from the troubled resonance of "Baroque" but to embrace it as a method-
ological preference. To the degree that "Baroque" designates acute atten-
tion to "paradox . . . contrast [and] distortion" then, ours is indeed "bien
Baroque"—a "Baroque history of science," to use J. B. Shank's phrase. It con-
centrates on questions over and above answers; on challenges more than
their resolutions; on the intellectual price paid for each successful develop-
ment. Hence our fascination with, for example, the strange Aristotelianism
adopted by Galileo in the *Assayer*, the bursts of skepticism in Kepler's *Optics*,
and the obstinacy of Hooke's debate with Johannes Hevelius.

This is by no means to equate "Baroque" with "crisis," or to suggest
that seventeenth-century culture was more prone to paradox than any
other culture or period. Our use of the term is very particular: it refers to
these specific tensions and paradoxes; these dilemmas, the anxieties they

created, and the curious inversions these forced. In this particularity "Baroque" retains its significance as a way to capture aspects common to the works of Rubens and Vermeer, Brueghel and Bettini, and others to whose work the term has been traditionally applied. But the coupling of "Baroque" and "Science" has the same liberating effect on interpreting the former as it had on understanding the emergence of the latter. The growing cultural presence of empirical, mathematical natural philosophy, understood as a fabric of challenges rather than a series of solutions, illuminates the motivations and resources invested into the "forceful and occasionally forced paradox; violent contrast; reliance on sensual detail; . . . deliberate distortion[, and] asymmetric effect." With the empiricism of the New Science in mind, for example, and when this empiricism is considered as an intellectual challenge rather than a wise and lucky discovery of a proper "scientific method," the Baroque obsession with details no longer appears as a self-indulgent extravagance. Rather, it is a related, sincere attempt to come to terms with the overwhelming variety of new objects that the seventeenth century impressed on savants and artists alike. Similarly, Baroque sensuality no longer appears as a decadent extroversion when one takes into account the unprecedented powers awarded to the senses by the new scientific instruments of vision. It becomes, rather, a genuine investigation of the possibilities of the artificial sense organs and the disturbing implications of this artificiality and the fundamental estrangement from reality it embeds. A counterpart, rather than anathema, of the mathematical New Science, Baroque distortion no longer suggests itself as illogical playfulness, but as a study of orderliness and the problematic means of producing it. Finally, with the achievements of the New Science and their intellectual price in mind, Baroque enthrallment with the passions is revealed not as a careless flight from reason but as a somber reflection on its limits. In short, "Baroque Science" takes the Baroque artist, like his contemporary savant, as seriously engaged in the intellectual challenges of his time.

The following, however, present an argument in the history of science rather than history of art, and the people and texts it considers are taken, mostly, from the heart of the canon of early modern natural philosophy. It is the development from Galileo to Descartes and from Kepler to Newton that we title "Baroque."

## THE ARGUMENT

Our argument comprises three parts. The first, "Observation," examines the rise of instrument-mediated empiricism and the new understanding of our

senses and our experience of the world that it implied and embedded. The second, "Mathematization," is a study of the promise, the challenges, and the paradoxical compromises required in turning mathematics into the primary tool of natural philosophy. This part is by nature more technical, and especially so chapters 5 and 6. These chapters are pivotal, as they lead our argument to the most celebrated achievement of mathematical natural philosophy: the inverse square law of universal gravitation. The faint of heart can, however, take our claims on authority and skip to the third part, "Passions," which contains only one chapter that also serves as a conclusion. It asks about the moral and ethical consequences of these reconfigurations of reason and the senses: what kind of person should the new savant be? What kind of life should he lead? What will warrant his claims to knowledge and virtue?

✳  **PART I**  ✳

*Observation*

———— ✳ ————

# Science's Disappearing Observer

## *Baroque Optics and the Enlightenment of Vision*

### INTRODUCTION

IN THE SEVENTEENTH CENTURY the human observer gradually disappears from optical treatises.

Traditional optics studied human vision. The standard of all medieval optical works, Alhacen's grand *Kitab al-Manazir* (c. 1030), declares vision as its subject matter in its very title, properly translated to Latin as *Aspectibus*. Vision is also the subject matter of John Pecham's *Perspectiva Communis* (c. 1280), and it still comprises the fifth chapter of Kepler's 1604 *Optics*. In the 1630s, however, René Descartes exiled vision from the *Treatise on Light* and *Dioptrics* to the *Treatise on Man*. Robert Hooke mentions the eye in the 1665 *Micrographia* only when discussing instruments, and vision is completely missing from Christian Huygens' 1678 *On Light*. When Isaac Newton reintroduces the eye in his *Optical Lectures* and *New Theory of Light and Color*, it is no longer as the *telos* of the optical process, but as a seat of natural phenomena. Indeed, the spectacularity of Newton's *New Theory* derives from the extravagant difference between the physical objects of optics (monochromatic rays) and the perceived object of vision (white light); a thorough reversal of simple and complex.

The divorce of optics from theory of vision is a paradoxical process. It does not reflect a disengagement of the human eye from its objects. Quite the contrary: the observer disappears from optics *because of* the evolving understanding of the eye as a natural, material optical instrument. It is the naturalization of the eye that begets the estrangement of the human ob-

server from nature. The naturalized eye no longer furnishes the observer with genuine re-presentations of visible objects. It is merely a screen, on which rests a blurry array of light stains, the effect of a purely causal process, devoid of any epistemological signification. It thus falls upon the intellect to decipher a purely natural phenomenon—a flat image—as the vague, reversed reflection of an object of no inherent relation to it.

The estrangement of the observer, its origins in the optical paradox, and its momentous ramifications are the subject matter of this chapter.

KEPLER

*Artificiosa Observationes*

The human observer starts slipping out of optics when Kepler turns his optical opus magnum, the *Ad Vitellionem paralipomena*[1] to artificial observations:

> On 1602 21/31 December at 6[h] in the morning, through a device described in Ch. 2 [camera obscura] and an instrument made for this purpose, a description of which is furnished below, the moon made an image of itself brightly upon the paper lying below, inverted in situation, just as it was in the heavens, gibbous . . . You should not think that what I would consider to be in the moon's ray was in the paper, for both the gibbous face and the spot in its middle were carried over to all parts of the paper whatever that was placed beneath it; rather, indeed, it was from moving the paper that the spot was first discovered.[2]

The observation, Kepler stresses, is not *his*. It is nobody's. The image of the moon is not the culmination of a cognitive process. It does not require an observer; a piece of paper is enough. In fact, even the paper is not necessary: it can be moved around without affecting the production of the image. This production is the main concern of *Ad Vitellionem*: being "The Optical Part of Astronomy," it is about the making of observations rather than their content. Earlier on in the book Kepler establishes the legitimacy and efficiency of his main instrument of *artificiosa observationes* (the term he uses in one of the subtitles of *Ad Vitellionem*), the camera obscura, by demonstrating that the image obtained through it is indeed that of the observed object.[3] He goes on to elucidate its underlying principle—namely the formation of an image on a screen behind a small aperture—by way of physical simulation:

> I set a book in a high place, which was to stand for a luminous body. Between this and the pavement a tablet with a polygonal hole was set up. Next, a thread

was sent down from one corner of the book through the hole to the pavement, falling upon the pavement in such a way as to graze the edges of the hole, the image of which I traced with chalk. In this way a figure was created upon the pavement similar to the hole. The same thing occurred when an additional thread was added from the second, third and fourth corner of the book, as well as from the infinite points of the edges. In this way, a narrow row of infinite figures of the whole outlined the large quadrangular figure of the book on the pavement.[4]

The threads from the book's corners pass through the edges of the polygonal hole, projecting images in the shape of the hole—a hole-shaped image for each corner of the book. The four images of the book's corners will be arranged on the floor in reversed order, and when this process is repeated from (ideally) every point of the book, a multitude of hole-shaped images will be projected on the floor, arranged in the (reversed) pattern of the book.

This is a neat solution to an age-old mystery, but the solution is not where the main novelty of Kepler's analysis rests. Neither the phenomenon of pinhole images, on which the camera obscura is based, nor its account in terms of intersecting rays is new to the optical tradition. Already in the *Problemata* pseudo-Aristotle asked, "Why does the sun penetrating through quadrilaterals form not rectilinear shapes but circles, as for instance when it passes through wicker-work?"[5] In the late thirteenth century John Pecham formulated the phenomenon thus: "Incident rays passing through angular apertures of moderate size appear rounded [when they fall] on facing bodies, and always become greater [in breadth] with greater distance [from the aperture]."[6] The notion that the phenomenon arises somehow from the intersection of the rays at the aperture was also available to the optical tradition at least since Levi ben Gershon (Gersonides) in the beginning of the fourteenth century.[7] Kepler cites both "Rabbi Levi" and Pecham (under the wrong name Pisanus), and for good reasons. Levi (as well as Francesco Maurolyco[8] and others) uses the assumption that the roundness of the image is a reflection of the roundness of the sun in the way Kepler intends to use his account of the phenomenon: as a justification for the use of the pinhole for solar observations. But this is exactly where Kepler's indebtedness also ends.

For the perspectivists, the pinhole image is not just a reliable projection of its source. It is unique *re-presentation* of the sun. The circular image is not *caused* by the sun and by light; it is the true form of the sun or the perfect dissemination proper of light, as Pecham explains:

The spherical shape is associated with light and is in harmony with all the bodies of the world as being to the highest degree conservative of nature, all parts of which join together most perfectly within itself. This is why a raindrop assumes roundness. Therefore, light is naturally moved toward this shape and gradually assumes it when propagated some distance.[9]

Understood this way, the circularity of the image does not simply testify to a property of its source; it is a sign of the image's indubitable authenticity. This essential relation between source and image completely disappears from Kepler's account, together with the exactness of representation it ensures. There is nothing unique to the circularity of the pinhole image: a rectangular body will produce a rectangular image, as the experiment with the book shows. Neither does the pinhole image *represent* light: it is light, as we shall see below, that is simulated by the threads pulled through the hole, but the image projected on the pavement can be of any object, not necessarily luminous—a book. The trustworthiness of the projection, for Kepler, does not rest on its perfect loyalty to the object projected but on understanding the physical process of projection. Indeed, Kepler discovers, one cannot hope for such loyalty: The book pattern on the floor is created by a "narrow row" of partially overlapping "figures," so not only is the image reversed, its boundaries are fuzzy. Moreover, these stains are a reflection of the *aperture*. For Maurolyco, who may appear to suggest a similar account, the image cast through the aperture is composed of many images *of the luminous body*.[10] These are merged together as the distance from the screen to the aperture grows, and the images of the source grow accordingly. Kepler is well aware of this option. Besides the image that "consists of shapes that are potentially infinite, similar to the window, mutually overlapping," he also posits "infinite, individual inverted images of the luminous surface," passing through "the individual (and thus infinite) points of any window." Yet for him this only means further complexity: "The shape of a ray on the wall is a mixture of the inverted shape of the luminous surface and the upright shape of the window."[11] Kepler's "figures" bear no inherent resemblance to the light source. The complete, smooth, upright perception of the book on the pavement is a construct.

### The Challenge of Astronomy

However, Kepler's interest is in the legitimation of the instrument, not its demise. The challenge he takes on in the *Ad Vitellionem* is "to preserve as-

tronomy's dignity and to subdue the hostile fortress of doubt,"[12] and in this he addresses a very genuine worry. Towards the end of the sixteenth century the legitimacy of astronomy's claim to knowledge was assaulted by the likes of Zabarella, Carbone, Ursus, and Frischlin:

> God the Creator placed [the heavenly] bodies so far away from our senses that we are unable to produce principles of demonstration for them (as we can in the sciences of other things) or to discover what is natural and familiar, by means of which we may afterwards set out the causes of particular appearances.[13]

The notion that the heavens are too far to be observed goes back to Aristotle, for whom this distance means that "the evidence [concerning celestial bodies] is furnished but scantily by sensation."[14] It troubled even the most committed astronomical reformers; Kepler's mentor Michael Maestlin, a staunch Copernican, still felt compelled to point out that "no one is able to ascend to the aethereal region, where he would see everything in person."[15] Any claims to "principles" or "causes" in the heavenly realm lay beyond the boundaries of astronomical knowledge. Even Tycho Brahe, whose determination of the heavenly place of the *Stella Nova* of 1573 and the comet of 1577 was of such obvious and far-reaching cosmological significance, had to concede that. In his debate with Rothman over the question of the heavenly matter, Brahe acknowledged that in the final account, as a physical problem, the matter of the heavens was inscrutable (*imperscrutabilis*).[16]

This physical realm, however, was exactly where Kepler intended to take astronomy. "Physicists, prick up your ears!" he would declare in the introduction to his *Astronomia Nova* (not published until 1609, but already being composed), "for here is raised a deliberation involving an inroad to be made into your province."[17] The eye is particularly deficient in providing the evidence required for this grand new venture:

> the eyes are attached to the head, so, through the head, they are attached to the body; through the body, to the ship or the house, or to the entire region and its perceptible horizon.

Hopelessly embodied and situated, "the sense of vision is in error about the movable." It is thus unable to adjudicate between "Copernicus, whom I follow," Ptolemy, and Tycho, let alone support the ambitious claims of his *physica coelestis*. Since (reiterating Maestlin) we do not have "someone . . . to carry us across to the moon or to another of the wandering stars"[18] (which would help little, Kepler points out), Kepler requires a new agent to bridge the epistemological rift and carry images from the far away.

### Light and the Transformation of Optics

Kepler's agent is light:

> I firmly established by irrefutable experiments, that . . . from the Sun, and from
> the colors illuminated by the Sun, species exactly alike are flowing, diminished
> by the flow itself, until for whatever reason, they fall on an opaque medium,
> where they paint their source: and vision is produced, when the opaque screen
> of the eye is painted this way . . . and it is confused when the pictures of the dif-
> ferent colors are confused, and distinct when they are not confused.[19]

> For there are certain passions of light, or of rays descending from the illumi-
> nating bodies, *qua* light, not *qua* inhering in the transparent air, the modes of
> which are emission and extension, and their contrary, reflection and refrac-
> tion or condensation. Therefore, nothing prohibits a certain action to be of the
> same light . . . illuminating and altering the screens [of the eye] through which
> colors, that is to say light, are not only poured upon but are also imprinted and
> the contraries are destroyed.[20]

It is light that generates images, bouncing off "an opaque medium" and
falling on an "opaque screen." If it happens to be "the opaque screen of the
eye"—the retina—"vision is produced," but there is nothing unique to the
eye: any screen will do.

With light as the sole agent of all optical phenomena, there is no funda-
mental epistemological difficulty with observing the distant celestial phe-
nomena: the mathematical nature of light and the conviction that the rays
do not decay but only disperse (propositions 6 and 7 of *Ad Vitellionem*) turns
distance into nothing but an element in the geometrical analysis of obser-
vation. And with light, there is no epistemological difficulty with *artificiosa
observationes*. The image on the pavement is reversed and fuzzy, but so is the
one on the retina. The instrument is trustworthy not because it does not in-
terfere with the visual flow, but because it is no worse than the eye.

Kepler turned optics into a mathematical-physical study of the produc-
tion of images by light. Light optics dissolved the dichotomy between in-
strument and eye, mediated and direct observation, and set the stage for a
new type of observation, to which we will return in chapter 3. In general,
the assumption that light is mathematical *in essentia* was a powerful intel-
lectual instrument for Kepler in fields other than optics, and in chapters 4
and 6 we will discuss the role it played in the mathematization of natural
philosophy. The ramifications of turning optics into "*physica*" tend to be ob-
scured by his obvious indebtedness to the perspectivist tradition[21] acknowl-

edged by titling his optical treatise after Witelo—but Kepler's transformation of optics was fundamental.[22]

The subject matter of traditional optics was human vision. Its basic assumption, as we will discuss in the next chapter, was that vision is a direct acquaintance of the visual faculty with visible objects, and optics is the study of the agents whose function is to communicate these objects to the eye.[23] This communication—the optical process—has always been self-evidently teleological. It was aimed at providing adequate images of visible objects for the intellect: "a species produced by a visible object has the essential property of manifesting the object of which it is the likeness" says Pecham.[24] Kepler was well aware of this: "Aristotle defines light," he writes, "not . . . in its nature, but to the extent that it is characteristic of the process of vision."[25] The assumption of visual teleology survived throughout the Renaissance. Summarizing scholastic optics for his audience of painters and art patrons, it is the one aspect the great theoretician of artificial perspective, Leon Battista Alberti (1406-72), chooses to stress:

> philosophers . . say that surfaces are measured by certain rays, ministers of vision as it is (*quasi visendi ministris*), which they therefore call visual rays, since by their agency the images of things are impressed upon the senses.[26]

This metaphysical assumption had clear practical ramifications: "Alberti's picture," Svetlana Alpers points out, "begins not with the world seen, but with a viewer who is actively looking out at objects."[27] The *physical* nature of the "ministers of vision" was debated since antiquity: *simulacra* or forms, visual rays or *species*, but their teleology and authenticity were never in doubt. Grosseteste, for instance, founds them on the premise that it is an essential property of the visible object itself, its agency or "virtue," which "multiplies" itself until it made itself present to the eye:

> A natural agent continuously multiplies its power from itself to the recipient, whether it acts on sense or on matter. This power is sometimes called species, sometimes a likeness, and it is the same thing whatever it may be called.[28]

Following Grosseteste's teaching, Roger Bacon underscores the essential relation that assures the trustworthiness of the multiplied agents to the visible object: "species is similar in essence and definition to the agent and the things generating it."[29] The authenticity of *species* was a fundamental assumption not only of optics but of medieval Aristotelianism as a whole; optics legitimated natural philosophy by accounting for the fundamental knowability of His Creation.[30] Visual rays guaranteed the veracity of vision,

and the geometrical analysis of their propagation was always subsidiary to the assumption of their intentionality and their consequent indubitability. So was the analysis of the eye, as Pecham stresses: "vision takes place by the arrangement of the species on [the surface of] the glacial humour *exactly* as [the parts] of the object [are arranged] outside" (italics added). This is so, precisely because "*unless* this were so, the eye would not see the object distinctly."[31] Optics, he assumes, is a theory of visual perception, and any such theory that failed to account for the adequacy of the seen image is ipso facto false.[32]

Kepler does away with this line of reasoning. The optical process, he declares, is strictly the effect of light: "genuine vision occurs when the folding door or pupil of the eye is exposed most closely to the arriving ray of light."[33] Gone are all intentional agents, and with them the privileged import of the eye. Passively receiving "illumination" like any instrument, the eye is not merely comparable to "a closed chamber": the cornea is truly nothing but a lens; the retina nothing but a screen, essentially the same as the paper or the pavement; the pupil is just another aperture, "for the pupil takes the place of the window."[34] As Francis Bacon would put it only a year later:

> Are not the organs of the senses of one kind with the organs of reflection, the eye with a glass, the ear with a cave or strait, determined and bounded? Neither are these only similitudes, as men of narrow observation may conceive them to be, but the same footsteps of nature, treading or printing upon several subjects or matters.[35]

### Light in Traditional Optics

Light did have a place in traditional optics. "A real and inherent quality in any self-luminous or illuminated object," in A. Mark Smith's words,[36] it was one example of the emanation of *species*. "Visual rays, lights, colors, and forms," are listed indiscriminately by Witelo in the preface to his *Perspectiva*. They all suffer the same "projection, infraction, and refraction . . . in transparent bodies and mirrors" and can be dealt with employing the same "geometrical elements, nowhere to be found in Euclid," which he is proud of.[37] Moreover, from Ptolemy and through Alhacen, light was a fertile ground for empirical research of emanation.[38] As the most accessible type of *species*, it was observed and experimented on, and the results generalized to other, less accessible types. For Neo-Platonists in particular, from Plotinus through Grosseteste, light was the very paradigm of emanation.[39] Light is of course a necessary condition of vision, and Aristotelians and Platonists attempted to

explain its role in enabling the medium to carry those "ministers of vision." But light was never identified with these *"ministri visendi."* As Bacon emphasizes, opticians should turn to light only as an example of multiplication of species that is more evident to our human perception than any other multiplication.[40] Until Kepler, light is *not* the "agency" by which "the images of things are impressed upon the senses."

Most historians of optics have failed to notice the essential difference between light and visual rays in the perspectivist tradition. Carl Boyer, in his classical *The Rainbow*, continuously conflates the two.[41] For A. C. Crombie, otherwise so attentive to the nuances of styles of reasoning, light and *species* are simply synonymous: "Bacon, Witelo, and Pecham," he writes, "following Alhacen and Avicenna, had recognize the function of the lens as an organ focusing *light or 'visible species'* entering the eye."[42] Similarly so for Lindberg, who wraps in one "the nature of light or species and the mode of its generation and multiplication."[43] Those scholars, like Stephen Straker[44] and Antoni Malet, who noted that "in *Ad Vitellionem* . . . Kepler substituted his own novel ontology of light for the medieval notion of species,"[45] did not elaborate on the ramifications of this novelty. The term "visual rays" is nowhere to be found in Kepler's *Optics*, and "species" is smoothly redefined: "Species of things," Kepler writes in its preface, are simply "light and shadow." Yet Lindberg denies the difference between light and species in Kepler's work altogether: "I disagree vehemently," he writes, "that Kepler continued to employ the archaic terminology of species while divesting it of its traditional content."[46]

Historians' disregard of the fundamental difference between the causality of Kepler's optics and the teleology of the perspectivist tradition is importantly offset by Smith. "Alhacen and his medieval Latin followers," he argued recently, "were far more concerned with making sense of sight than with understanding light." But even Smith does not relate this difference to Kepler's change of the role of light in optics (or to his interest in artificial observations). According to Alhacen, Smith claims, "we see things by means of the luminous color they radiate to the eye."[47] This is true, however, only for *luminous objects*, namely, when the "forms" carried from the object to the eye are properly of the light of the object itself: "sight does not occur unless something of the visible object comes from the object." This "something" cannot be light, unless the visible object itself is luminous. It has to be an entity that is both indubitably authentic to the object and immediately transparent to the intellect; a "form." Even the perception of light itself requires this intellectual propagation. "The eye does not perceive the light

and color in the visible object unless something comes to the eye from the light and color in the object," writes Alhacen; he stresses that "the forms of light and color in the visible object reach the eye . . . that which comes from the visible object to the eye . . . is merely that form." Light is not the agent of vision in Alhacen's optics; not even of the vision of light.[48]

### The Consequences

One can hardly overstate the significance of Kepler's reformulation of optics. Produced by light, images are mere causal effects; stains of light that happened to bounce off an object and fall on a screen; no forms or visual rays are involved. With their abolition, the intentionality and teleology of vision are lost, and with them the import of optics as the epistemological anchor for all other sciences.

Kepler's optics is as much epistemologically oriented as traditional optics. However, instead of guaranteeing the veridicality of our visual knowledge in general, it aims at supporting the empirical underpinning of his new astronomy, and of long-distance instrumental observation in particular. More crucially, it fulfills this immediate task at the expense of the general epistemological assuredness provided by traditional optics. Kepler's justification of the astronomical use of the camera obscura is thus diametrically opposed to that of Gersonides and Maurolyco. For them the instrument was trustworthy because it did not interrupt the seamless flow of forms through the eye to the intellect; for Kepler, because there is no such flow. Since light is the producer of all images, the similarity of form between the sun and its projection—or the book and the "figure . . . on the pavement"—no longer means that the process connecting them has any inherent epistemic value. It is a strictly causal process, and its veracity—in which Kepler *is* keenly interested—does not arise from a particularly privileged relation between source and image. "*All* celestial observation takes place through the mediation of light and shadow."[49] We can trust images, whether on the pavement or on the retina, whether far away or nearby, because they are outcomes of a purely natural, causal process that we can investigate through experimenting and theorizing. This means that we can trust observations of stars as much as those of books, and we can trust instrumental, artificial observations as much as we trust our eyes.

Making mediation essential to all observation, we will show in the next chapter, Kepler rebels against the basic dichotomy of traditional optics between perception "face to face" and "looking through a glass darkly." It also justifies the thorough instrumentalization of scientific observation, to

which we will return in chapter 3. Yet this way of establishing empirical trust on mediation comes at a steep epistemological price: if the instrument is not prone to error more than the eye, it is immediately implied that the eye is as vulnerable to error as the instrument. If "the passion of vision follows the action of illumination," then the picture on the retina, like the one on paper or pavement, is *not* an accurate reflection of the object. It is a fuzzy "row of infinite figures," the shape of each of which is caused by the accidental shape of the aperture, "for the pupil takes the place of the window." For Pecham and the tradition he represents, "the arrangement of the species [is] *exactly* as the objects [are arranged] outside" (see above). But Kepler is unwilling to accept this assumption. Quite the opposite: "for it has been demonstrated most clearly, *from the very structure of vision*, that it frequently happens, that an error befalls the sense of vision."[50]

Visual errors are of course nothing new, but Kepler's is a new concept of error. In the Aristotelian paradigm, errors are created by the intervention of the human imagination; the visual data are indubitable. With the new optics, the doubt is directed at the very images perceived. "The deficiency impinges on the sense of vision";[51] the fuzziness is a feature of the optical phenomenon itself, and errors follow "from the very structure of vision." The "illumination" of optics and the naturalization of vision warded off the epistemological challenge to astronomy only to have a deeper, more fundamental doubt emerge.

Kepler is no skeptic. The purpose of his optics is to "subdue the hostile fortress of doubt," not to reinforce it, and much of *Ad Vitellionem* is dedicated to accounting for the reliability of the retinal image. Indeed, the book experiment applied to the eye demonstrates that the pattern on the screen *does* correspond to the projected object. The real doubt does not arise from the possibility of error but from the need for such demonstration, and is all the more devastating for that.[52]

The crucial ramification of Kepler's optics is that all the eye can provide are these retinal images. Instead of self-authenticating re-presentations of objects,[53] the visual process furnishes the intellect with effects that have no inherent relation to their cause; natural objects of one kind (stains of light) that the intellect has to decipher as marks for objects of a different kind. How the intellect meets the challenge is a complete mystery, Kepler admits:

> How this image or picture is joined together with the visual spirits that reside in the retina and in the nerve, and whether it is arraigned within by the spirits into the caverns of the cerebrum to the tribunal of the soul or of the visual fac-

ulty; whether the visual faculty, like a magistrate, given by the soul, descending from the headquarters of the cerebrum outside to the visual nerve itself and the retina, as to lower courts, might go forth to meet this image—this, I say, I leave to the natural philosophers to argue about.[54]

This is what we have called above the optical paradox: the naturalization of the eye estranges the observer, and a deeper understanding of optics turns vision into a mystery. The paradox cannot be resolved by optical theory, and Kepler leaves the resolution "to the natural philosophers" and out of *Ad Vitellionem*. Years later, he attempts a metaphysical resolution, through the trust in the mathematical infrastructure divinely endowed in both nature and human intellect. "Geometry," Kepler would promise in his *Harmonices Mundi*, "is coeternal with God, and by shining forth in the Divine Mind supplied patterns to God."[55] Accordingly, contra Aristotle (and in proto-Kantian fashion), Kepler assigns geometrical structures to the mind, preceding and determining sensory perception: "The recognition of quantities, which is innate in the mind, dictates what the nature of the eye must be; and therefore, the eye has been made as it is because the mind is as it is, and not the other way around."[56] Kepler was clearly aware of the untoward consequences of his novelties.

## ANXIETIES, SOLUTIONS, AND COMPROMISES

### Practitioners

Kepler's novelty does not lie in the use of mirrors and lenses as a locus of investigation and manipulation of human vision. In his *Magia naturalis* of 1589 Giambattista della Porta suggested just that:

> For what could be invented more ingeniously, then that certain experiments should follow the imaginary conceits of the mind, and the truth of Mathematical Demonstrations should be made good by Ocular experiments? What could seem more wonderful, then that by reciprocal strokes of reflexion, Images should appear outwardly, hanging in the air, and yet neither the visible object nor the Glass seen? That they may seem not to be the repercussions of the Glasses, but Spirits of vain Phantasms?

Della Porta discusses many arrangements of lenses and mirrors, plain and concave, but he finds that "nothing can be more pleasant for great men, and Scholars and ingenious persons to behold" than the camera obscura:

You must shut all the Chamber windows ... Onely make one hole ... as great as your little finger, over against this, let there be white walls of paper, or white clothes, so shall you see all that is done without in the Sun ... If you put a small centicular glass to the hole, you shall presently see all things clearer.[57]

Kepler knew these words well,[58] and della Porta himself, of course, was not original in producing "this kind of spectacle" with the camera obscura. What makes these words particularly interesting is that della Porta also goes so far as to suggest the instrument as a model for the eye:

> it may appear to philosophers and those that study opticks how vision is made; and the question of intromission is taken away, that was anciently so discussed; nor can there be any better way to demonstrate both, than this. The image [*idolum*] is let in by the pupil, as by the hole of a window, and that part of the Sphere, that is set in the middle of the eye, stands in stead of a Crystal Table.[59]

Coming so seemingly close to Kepler, della Porta's speculations serve to highlight how fundamental the break that Kepler's new optics made from the traditional understanding of vision, an understanding della Porta never challenges. "I know ingenious people would be much delighted in it," writes della Porta, and promises to follow the camera obscura model "in our Opticks." He fulfills his promise in his *De refractione* of 1593, but this more professional and theoretical discussion makes it particularly clear that the exciting idea that the eye can be studied like an optical instrument does not shake his belief in the essential teleology of the visual process:

> The form of visible things has its nature in the material thing itself, but taken up by light, immediately releases itself from matter and radiates [*emicare*] following a certain spiritual reason, the more it approaches the eye from the object the more it accommodates itself from a wider base to the pupil and the eye, the way liquid bodies force themselves into places. From there [the form] projects [*portendit*] the figure from itself to the eye according to the pyramidal lines of the rays and its apex strikes the crystalline [sphere]. This, we claim, is the way the smooth flow of images [*illapsum simulachrorum*] happens.[60]

Interestingly and originally, della Porta assigns to light the agency of delivering "the form of visual things," but it is by no means the causal agency that becomes the core of Kepler's innovation. The primary assumption of traditional optics—that vision is a self-authenticating process of communication between object and reason through the eye—remains intact. That light takes visual rays' role of ensuring that the eye receives a genuine "form" of the object makes della Porta's loyalty to this traditional presump-

tion all the more conspicuous: the image is not naturally produced on the retina; it is a "simulachrum" (or *"idolum"* in *Magia naturalis*) of the "visible thing" endowed with the task and capacity of properly informing reason about the object. Unfettered, the eye and the image cooperate so "the simu-lachra enter the crystalline [humor], and like a truthful poetess resides in the eye to discharge her duties."[61]

"I have oft made sport with the most fair women with these glasses," della Porta declares, but never relinquishes the traditional postulate that unmediated vision and undisturbed eye provide images that are ipso facto veridical. The power of his instruments does not stem from simulating the natural visual process but from distorting it, and this distortion can occur only by interfering with the "smooth flow of simulacra" to the eye. The weak eye can also be helped by instruments: "I shall add also those Spec-tacles, whereby poor blinde people can at great distance, perfectly see all things," della Porta writes, but never suggests that the "forms" (as *simulacra* or *idola*) themselves can be created or altered, nor that the eye itself can be fooled. It is "imaginary conceits *of the mind*" that the instruments produce; the eyes of the "fair women" receive exactly the "forms" that della Porta's lenses and mirrors deliver; it is their feeble mind that can be tricked to judge them "hanging in the air."[62]

For Kepler, "error in vision must be sought in the formation and func-tions of the eye itself." The "conceits" are essential, as they arise from a "de-ception of the sense of vision."[63] The image on the retina is a natural effect: an aggregate of partially overlapping pupil-shaped stains of light. It is not a true re-presentation of "the visible object." Our very visual conception of the object—three-dimensional, smooth-contoured, upright—is a construct; a product of the "conceits of the mind." For della Porta the very idea of the *formation* of image is completely foreign. The "idolum" or "simulachrum" is not formed by light on a screen, but "taken up" (*suspectam*) by light from the visible object and laid in the crystalline humor. Perhaps most telling is that in spite of his analysis of the camera obscura in terms of hole, lens, and screen of "white walls of paper, or white clothes," and despite the sugges-tion that "the Sphere, that is set in the middle of the eye, stands in stead of a Crystal Table," he still assumes that the images end up "residing" in the crystalline sphere, rather than being refracted to the screen behind, as he assumes they do when passing through the "Crystal Table" of the camera obscura.

Kepler's understanding of vision and the relation it constitutes to the world is thus very different from that of optical magicians like della Porta. The notion that the visual given is fuzzy and distorted while the "proper"

image is a construct relates Kepler to a different cultural milieu. Embracing fuzziness as the *reality* of visual experience is what makes Dutch painting of the seventeenth-century "realist." This realism (or better still—naturalism)[64] is not an attempt to get the objects as they are, but vision as it is; an attempt to capture the naked, optical phenomenon that is the retinal image before it is processed by the higher faculties. This is the relation between northern art and Keplerian optics noticed by Alpers:

> Modern students of northern art have been moved to speak of artists who are "fully aware of the differences between artificial perspective and natural vision" and to compliment them for "using their eyes with fewer preconceptions than their predecessors." With Kepler's assistance I think we can better suggest that the issue is not "record of facts" vs. "look" of things.[65]

What one could grasp with "Kepler's assistance"—what one had to come to terms with if the implications of his teachings were admitted in their fullness—was that only "preconceptions" or "artificial perspective" transform retinal images into the appearance of coherent reality. The painter's tools in creating this apparent coherence—Alberti-style perspective is perhaps the primary one at the service of early modern artists (see fig. 4.4)—is artificial in imposing ideal mathematical structure on visual reality which is inherently diffused; a series of partially overlapping stains of light. Keplerian optics does not imply, even in the eyes of those concerned with the illusory power of such techniques,[66] that the use of these tools is disingenuous or a mere stylistic whim. It does imply, however, that their success does not stem from capturing independent reality or perfect vision, but from recapitulating the operation of the "visual spirits," which turn inverted and fuzzy retinal images into well-delineated objects of perception.

The distorted, anamorphic, perspective of Baroque ("Northern") artists reflects an acknowledgment of this disturbing insight and an attempt to rebel against the artificiality of the intellect and return to the reality of the eye. "Using their eyes," explains Alpers, artists from van Eyck to Vermeer produced paintings with

> many small details versus few large ones; light reflected off objects versus objects modified by light and shadow; the surface of objects, their colors and textures ... rather than their placement in a legible space; an unframed image versus one that is clearly framed; one with no clearly situated viewer compared to one with such a viewer.[67]

Vermeer's camera obscura-like works bear the signs of this loyalty to the pure optical image exactly in appearing *wrong* in either perspective (for

instance, the relative size of the figures in *Officer and Laughing Girl*), lighting (like the spots of light and the blurred outlines of the *View of Delft*), or both (as in the *Milkmaid*).[68] "Vermeer seems to have been delighted by the optical effects of the lens and tried to recreate them on the canvas" writes David Hockney. "Foreground objects and figures are sometimes very large, some things are painted in soft focus, or out of focus altogether," distortions that Vermeer "would not have seen with the naked eye."[69] But, unlike della Porta, Vermeer's delight comes not from the distortion, but from the ability to re-create the pre-ordered, pre-cognitive visual reality. The realism of the Baroque seizes Kepler's "narrow row of infinite figures" just before being "joined together with the visual spirits," and recaptures it as it is on "the opaque screen of the eye":

> Vision thus occurs through a picture of the visible object at the white of the retina and the concave wall; and those things that are on the right outside, are depicted at the left side of the wall, the left at the right, the top at the bottom, the bottom at the top.[70]

The camera obscura is a mere instrument for della Porta, at most analogically comparable to the eye. For Vermeer, it is a way to re-create the image that light paints on "the white of the retina." For Kepler, the eye and the camera obscura are one and the same.

## Pictures and Images

Being expressed in the work of artists strongly suggests that the epistemological ramifications of light optics, even if not fully articulated or attributed, have not gone unnoticed: the naturalization of the eye meant separation between image creation and visual perception; optics was no longer a theory of vision. Kepler himself, as noted above, in spite of avowing to "leave to the natural philosophers to argue about" the consequences of this separation, found them unnerving enough to try to stave off at least its most difficult implication, namely, that *all* visual experience is a fabrication of the human mind, and ipso facto distorted. He does so by evoking an old definition of the essentially distorted "image":

> The opticians thus call it "an image" when an object is seen, with its own colors and parts, but not in its own place, not showing the proper quantities, and its parts holding wrong proportions. In short, the image is the vision of a certain object linked to an error of the faculties concurrent with vision. The image itself, therefore, is hardly anything and it would have been better called an

imaginary fabrication. It is something made up from the species of real color and light and [from] intentional quantities.[71]

Traditionally, the concept of "image" fulfilled exactly the role Kepler seems to require of it: it designated vision that is distorted because it is mediated. This is how the term is defined by Pecham, who asks "What then is an image?" and answers

> that it is merely the appearance of an object outside its place. For example, sometimes the eye judges one thing to be two . . . because the object appears not only in its true place but also outside it . . . it is the object that is really seen in a mirror, although it is misapprehended in position and sometimes in number.[72]

But the concept of distortion-by-mediation that Pecham takes for granted and refers to by the term "image" cannot solve Kepler's worry. For Pecham the mediation that causes the distortion is clear: it is introduced by the mirror, which deludes the eye into judging the object outside its real place. Kepler, however, had already established that all human vision involves instrument-like mediation. The distorting mediation that concerns him is the "error of the faculties concurrent with vision." Vision is essentially mediated, so it is not the presence of the mirror or any other mediating instrument that distorts the image. It is rather the "visual spirits" or "visual faculty" residing in the eye. The concept of a wholly undistorted optical entity that Kepler searches for and to which he would like to contrast the erroneous "image" is the purely physical entity preceding all intervention of the faculties: "Whereas up to now an image has been [considered] a rational entity, now figures of objects truly existing on paper, or other screens, are called pictures."[73]

Being "rational" is not a reassurance for the image's veridicality—quite the opposite. The image (*imago*) is a "rational entity" because it is "an imaginary *fabrication*" of the mind. The picture (*pictura*) is a genuine physical effect. It can be on the retina "or other screens"—what is important is not that it is unmediated by instruments but that it is free of any intellection. This distinction, Kepler hopes, should resolve the skeptical worry that his optics gives rise to, that all vision is in and of itself distorted.[74]

The ontological distinction, however, cannot alleviate the epistemological worry; the physical existence of an unmediated, undistorted physical image does not provide for unmediated, undistorted vision. Kepler's analysis entails that all visual experience is constructed. We have no access to the un-fabricated retinal images any more than to the un-mediated objects

or to the "pictures" on screens other than the retina. The book and pinhole demonstration may lure us into imagining that we can observe both image and original, or at least both image and picture, but this is never the case. The mind, according to Kepler's own account, is furnished always with an already-constructed image, the book image as completed by our own "sense perception" or "visual spirit" from a multitude of light stains on the retina. Once committing himself to the reduction of optics to a theory of image production by light, Kepler cannot avert the tyranny of mediation and its disturbing epistemological ramifications.

### Scheiner and the Jesuit Compromise

For some of the most accomplished and up-to-date practitioners of the *scientia media*, like the Jesuit mathematician Christoph Scheiner, these ramifications were too daunting. In his *Oculus*, published some fifteen years after the *Ad Vitellionem*, he tries to avoid them by shunning the physicalization of the optical process and preserving its Aristotelian teleology:

> In order to see, the eye of the animal fulfils the duty it was ordained by God, grasping the presence of visible things [*rerum videndarum*]. The things are made present to the eye not by rays emitted from the eye to them, but [by rays] admitted into the eye from the objects.[75]

Scheiner's eye has retained—or returned to—its traditional role: the *terminus ad quem* of the optical process; discharging a divine task; "acquiring the presence of the visible things." Its relation to "the things" has also returned to be immediate and self-authenticating; the things themselves "are made present" to the eye. Declining the physicalization of vision goes hand in hand with rejecting the mathematization of light, which Scheiner stresses by reaffirming the strict disciplinary separation dictated by the Aristotelian tradition:

> Physics and optics alike dwell on *visibilia* and the organ of vision; yet in a different mode. For geometry, as the Philosopher said,[76] investigates lines, but not to the extent that they are physical; perspective, on the other hand, [investigates] mathematical lines, but not to the extent that they are [mathematical].[77] Truly, thus, both investigate the same things in different ways.[78]

Scheiner is employing here a typical Jesuit strategy: marking strict boundaries so as to be able to stride very close to them.[79] In such a way he hopes to maintain the empirical achievements of the new optics, especially con-

cerning the physiology of the eye, without committing himself to its fun-
damental novelty and the epistemological predicament it implies. He thus
admits that the retina is the visually sensitive part of the eye and that the
crystalline humor functions as a lens, while interpreting these findings in
the traditional terms of visual rays and species. The title of the first chapter
of his third book "in which it is explained, how the visual ray stimulates the
retinal membrane and the reason for the structure of the eye"[80] is particu-
larly telling:

> In order to avoid confusion with things seen from a distance, and so that the
> pictures of the visible things be experienced orderly and distinctly, it is re-
> quired of the vitreous humour to expand, by this adjustment it collects the rays
> refracted in the crystalline [humour], so that the figure from the crystalline will
> be painted distinctly on the retina.[81]

Scheiner's picture, like Kepler's and against the perspectivist tradition,
is "painted on the retina," and the crystalline humor refracts, rather than
absorbs the image. This admission already compromises the veridicality
of vision: the picture is a refracted, two-dimensional representation of the
object. But Scheiner toils to make this his last concession to the new optics.
Vision in the *Oculus* is still created by "visual rays" that come from "visible
things" and whose "*beneficio*" is to assure clear and distinct visual percep-
tion. Light is nowhere to be found—it is "*species*" that are refracted through
the crystalline humor. And it is also *species* that Scheiner skillfully manip-
ulates in developing and expanding Kepler's experimental apparatus and
procedures, employing lenses and screens to simulate humor and retina.
Most important of all, Scheiner's pictures are well ordered:

> At the terminal point within [the eye] the borders of the remote thing are ar-
> ranged, so the right appears at the right side of the eye, the left at the left, the
> above—above; thus the locus of vision falls in the same place where the visual
> ray conveys the thing into the eye.[82]

This final triumph of Jesuit epistemic tactics does not come easily. Scheiner
wants to retain Kepler's analysis of the crystalline humor as a lens. But this
implies the diffraction of the rays, resulting in the inversion of the image on
the retina. So in order that in the retinal image the right will "appear at the
right side of the eye, the left at the lefts," he has to assume that the image is
already inverted when passing through the humor. For this to be achieved,
the visual rays have to cross paths before entering the eye through the pupil,
a strange feat indeed. Yet lured by Kepler's achievements and troubled by

their naturalistic and skeptic implications, Scheiner is willing to claim just that. The whole second part of the first book of *Oculus* is dedicated to demonstrating this pre-visual crossing of rays empirically, both from observation and with carefully constructed experiments.

One could not have expected a Jesuit scholar to overlook, let alone accept the solipsistic implications of, Keplerian optics. The attempt to preserve the unity of mind and object of Aristotelian epistemology while incorporating the new science was at the heart of the Jesuit project around the turn of the seventeenth century.[83] Scheiner manages to save the teleology of vision while preserving Kepler's empirical and geometrical infrastructure: the rays are refracted, the images are inverted, but the eye is still fully successful in fulfilling the function it was "assigned by God." Yet avoiding Kepler's boldest move—the conversion of optics from visual rays to light—had a price as well. Scheiner could not benefit from those of Kepler's achievements that depended on the mathematical-physical nature Kepler ascribed to light, such as the law of the decline of light with the square of distance, which we will discuss at length in chapter 6.

At the end of analysis, Scheiner remains completely committed to the one-to-one correspondence between object and perceived image that was both the great achievement and the clear boundary of Arabic optics, carried on by the *perspectiva* tradition:

> All rays by which some visible point is carried [*derivatur*] into the organ of vision are called visual rays; but some are less important and secondary, or mediated and diffracted: but one [is] principal, primary, and immediate, that is formal. Insofar as the organ of vision itself senses the form of color, it is this [ray] that enters [this organ] and [is] sensed.[84]

## DESCARTES

### *The Colors of the Rainbow*

Some Keplerian successes did defy the Jesuit compromise. One optical phenomenon that the new light optics was much better equipped to decipher— but at the price of a full commitment to turning optics from vision to light— was the rainbow.

The aerial colors of the rainbow presented a difficult challenge to Aristotelian theories of vision and of light because color, according to Aristotle, is a quality of visible, bounded bodies: "whatever is visible is color and color is what lies upon what is in its own nature visible." Color cannot be a prop-

erty of the medium because the transparent, like air or water, is "not visible in itself, but rather owing its visibility to the color of something else." To the degree that a transparent body *is* colored, the "color [is] either at the external limit, or itself that limit"; color makes sense to Aristotle only on surfaces or "boundaries" of solid bodies. The rainbow, therefore, can neither be a property of the transparent air, nor can it be a property of light, because light is not a body and has no boundaries: it is "the activity of what is transparent inasmuch as it has in it the potential of becoming transparent."[85]

Some Renaissance commentators attempted to circumvent these difficulties by basing their accounts on the complementary relations that Aristotle posits between light and color: light is "the color of the transparent" whereas "color [is] the limit of transparency in determinately bounded body." The various colors, in this scheme, are mixtures, in different ratios (Aristotle uses the Pythagorean musical consonants as an analogy) of darkness and light in potentially transparent bodies (like air and water) or of the equivalent black and white in opaque bodies. Since light is not a substance but the actualization of transparency and darkness is simply its "privation," the "plurality of colors besides the White and Black" seems to be understood by Aristotle simply as degrees of illumination.[86] Hence, since Aristotle explains that "halo, rainbow, mock suns, and rods . . . are all reflections,"[87] the different rainbow colors can be understood as effects of different reflections creating differences in levels of illumination: red being the strongest, violet—weakest and closest to darkness. This was a route taken by Themo in the fourteenth century and Piccolomini in the sixteenth.[88]

Neither traditional optics, however, nor Aristotelian natural philosophy provides much support for these attempts. On the one hand, the Aristotelian concepts of light and medium do not allow for causal relations between the two; as put simply by Scheiner's fellow Jesuit Horatio Grassi (who Galileo debates in *The Assayer*, discussed in chapter 3) in 1619, the year of Scheiner's *Oculus*, "the air cannot be illuminated."[89] Moreover, neither light nor color exists independently; they require a substance to be transparent and colored: "the transparent, according to the degree to which it subsists in *bodies* . . . causes them to partake of color."[90] On the other hand, in spite of the language of degrees and musical consonants, there is nothing in these considerations that may relate them to the strict geometry of mathematical optics. The notion of 'more or less' illumination makes little sense in terms of mathematical optics or the related empirical knowledge (even that concerning the angles in which the various colors appear), because it is not light that is reflected (or refracted) in this optics, but *sight*. Aristotle's analysis of

the rainbow in the *Meteorologica* is completely dictated by this assumption, and the resulting account is far from smooth. The epistemological burden placed on optics as a theory of vision forces Aristotle into uncomfortable compromises when the object of sight is, as it is in the case of the rainbow, literally insubstantial and formless:

> We must accept from the theory of optics the fact that *sight* is reflected from air and any object with a smooth surface just as it is from water; also that in some mirrors the forms of things are reflected, in others only their colors. Of the latter kind are those mirrors which are so small as to be indivisible for sense. It is impossible that the figure of a thing should be reflected in them, for if it is, the mirror will be sensibly divisible, since divisibility is involved in the notion of figure. But since something must be reflected in them and it cannot be figure, it remains that color alone should be reflected.[91]

As we argued above, the difference between light and sight in traditional optics did not receive proper attention by historians, and this is particularly true in the context of theories of the rainbow. It is easy to read "light" into Grosseteste when he writes about *"lineae et superficies radiosae, sive proiecta sint illa radiosa ex sole,"*[92] but Grosseteste is in fact completely consistent in referring only to "sun rays" (*radii solis*), remaining loyal to the division of optical labor assumed in the *Meteorologica*:

> *Sight* is reflected from all smooth surfaces, such as air and water among others ... But things are best reflected from water, and even in process of formation it is a better mirror than air, for each of the particles, the union of which constitutes a raindrop, is necessarily a better mirror than mist.... A mirror of this kind renders the color of an object only, but not its shape. Hence it follows that when it is on the point of raining and the air in the clouds is in process of forming into raindrops but the rain is not yet actually there, if the sun is opposite, or any other object bright enough to make the cloud a mirror and cause the *sight* to be reflected *to* the object then the reflection must render the color of the object without its shape. Since each of the mirrors is so small as to be invisible and what we see is the continuous magnitude made up of them all, the reflection necessarily gives us a continuous magnitude made up of one colour; each of the mirrors contributing the same colour to the whole.[93]

The color is "of the object"—it is a property of the sun as a body, not as a source of light; "color cannot be seen otherwise than in light,"[94] but it is not created by it. Scholastic commentators like Nicole Oresme noted the awkwardness of this treatment, which gives form and color dimensions, making form "too large" to squeeze into the raindrop and color just small enough. For all these commentators, however, the relations between light as math-

ematically analyzable radiation and light as the enabler of vision—the transparency of the medium—remained completely mysterious: "*lumen* is ... the quality of the diaphanous medium through which illumination is made."[95] So they had little idea of how to make use of the insight that the rainbow colors relate to sunlight on the one hand and to reflection or refraction on the other. When Grosseteste, for example, attempts an account of color that would give him more flexibility than Aristotle's, he comes up with "color is light admixed with transparency."[96] This is a strange notion, from the Aristotelian perspective, given that light itself is the actualization of transparency. Yet this bold move only stresses the rupture between mathematical optics and the physical hypotheses about color and light. In this respect Grosseteste can offer little beyond Aristotle, and although he comes close to using "*lumen*" and "*radii solis*" as synonyms,[97] he has no suggestion on how to apply the sophisticated mathematical tools developed for visual rays to the relations between light and color. The different colors, he submits, are generated by the relative purity of the medium and the "clarity and obscurity" and "multitude and paucity" of light,[98] Aristotelian expressions that can hardly be related to mathematical optics despite their quasi-quantitative resonance.

The development of new optical instruments and practices from the late Middle Ages through the Renaissance, the subject matter of the next chapter, did not resolve any of these difficulties. As late as 1619 Grassi still stresses, in his defense of traditional visual epistemology against Galileo's assault, that "the radiation of luminous bodies is *a sensation of the eye* and not illuminated air"[99] (see chapter 3). The epistemological responsibility of optics as a theory of vision kept the boundaries between the theories of light and of sight intact.

### *Descartes' Keplerian Solution*

Kepler noticed early that the treatment of light as a physical flow suggested a way to solve the mystery of the rainbow. "Thus frequently I have reflected," he wrote to Maestlin,[100]

> whether the proportion of the angles of refraction constitutes the terms in which it is said that a color is green, blue, etc. So, if refraction is direct, [that is] the angle is zero, it creates yellow, or rather this is what is most splendid in yellow, light itself. ... Thus by the reason of the divisions of the right angle colors are constituted.[101]

This is the type of consideration that made Descartes declare Kepler his "premier maître en optique"[102] and adopt optics as his model for the mathe-

matical physics he was aspiring to. Descartes, in conscious contrast to the tradition represented by Scheiner and Grassi, takes the mathematization of nature as the hallmark of his epistemological project,[103] and the Keplerian account of the colors of the rainbow as modifications of light provides him with a paradigm of the way in which mathematical analysis can provide causal understanding of a physical phenomenon:[104]

> Taking into consideration that this arc can appear not only in the sky but also in the air near us whenever there are drops of water in it that are illuminated by the sun . . . it was easy for me to judge that it came merely from the way in which rays of light act against those drops, and from there toward our eyes.[105]

Kepler's light optics allows Descartes to stipulate a straightforward cause for the colors—the refraction of the sun's rays by drops of water. More important still, it makes sense of the idea of mathematical physics—a mathematical science of causes. We noted above that the notion that the different colors of the rainbow correspond to differences in refraction was not new, but as Boyer and Eastwood stress, one should not read into expressions like "multitude and paucity" an appeal for a quantitative approach. Similarly, one should also be careful not to conflate the transfused "*lumen*" with the geometrical "light rays."[106] The aspirations of Descartes' Keplerian account of the rainbow are novel. It is an attempt to apply mathematical optics to light while demanding that the mathematical analysis will be embedded in and provide a causal explanation of a physical phenomenon—colors.

Descartes' hypothesis has little to do with the "more or less illumination" of traditional optics. The various colors, in his account, are direct effects of the very angles of refraction, independent of the medium. This is a *physical* hypothesis, albeit formulated mathematically, so the exact details—which angle creates which color—can be filled in experimentally. Simulating a raindrop with the traditional instrument of empirical optics, the water globe, employed in this role at least since Alhacen, Descartes finds that when the angle *DEM* between the globe, the eye, and the center of the sun is 42°, the color observed is brilliant red, and so, to a lesser degree, when the complimentary angle *KEM* is more or less 52° (fig. 1.1). "If these points are viewed all together, without our noting anything about their position except the angle at which they are seen, they must appear as a continuous band of red."[107]

Descartes, following Kepler, turns optics into a branch of natural philosophy, while maintaining its mathematical language and methods. He thus sets himself the task of accounting for physical details such as the fact that

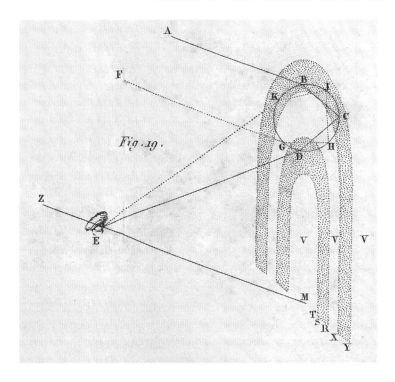

FIGURE 1.1 "I discovered . . . when the sun came from the part of the sky marked AFZ, my eye being at point E, when I placed this globe at . . . BCD, its part D appeared to me completely red and incomparably more brilliant than the rest . . . whether [I moved or it moved, so long as] the line DE . . . made an angle of approximately 42 degrees with the line EM . . . D always appeared equally red." (Descartes, *Discourse 8 of Meteors*, in *The World*, 85.) Reproduced with permission of the Rare Books and Special Collections Library, The University of Sydney.

the colors of the rainbow are organized in a "continuous band" and why certain angles create certain colors:

> why, when there are many other rays which, after two refractions and one or two reflections, can tend toward the eye when the globe is in different position, it is nevertheless only those of which I have spoken that cause certain colours to appear.[108]

Descartes ventures to answer these questions experimentally. In spite of his new project, his early experiments are still rooted in traditional optics; not only in the use of the water globe, but more fundamentally, in privileg-

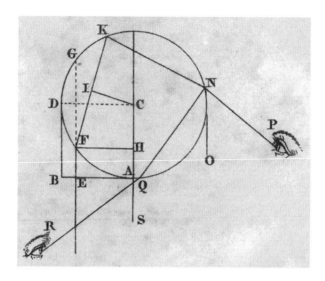

FIGURE 1.2 "Let AFD be a drop of water ... consider one of these rays in detail: EF ... instead of passing directly through G, is deflected toward K, is reflected from K toward N, from where it goes toward the eye P ... or it is reflected once more from N to Q, and from there is turned toward the eye R." (Descartes, *Discourse 8 of Meteors*, in *The World*, 92.) Reproduced with permission of the Rare Books and Special Collections Library, The University of Sydney.

ing the human eye as *the* significant station of the optical process: the rays "act ... toward the eye" and the angles are taken from the eye (fig. 1.2). Once the mathematical questions receive their causal-physical import, however, the eye loses its import: the angles of the rainbow do not refer to the eye—the rays fall on different screens and the same colors appear from different viewpoints. Disappearing together with the eye is the water globe; no longer attempting to mimic raindrop and eye, Descartes constructs a physical-experimental model of abstract refraction and abstract projection (fig. 1.3):

> Remembering that a prism or a triangle of crystal causes similar colors to be seen, I considered one of them such as MNP which has two completely flat surfaces, MN and MP, inclined to one another at an angle of around 300 or 400 ... and when I covered one of these two surfaces with a dark body, in which there was a rather narrow opening DE, I observed that the rays, passing through this opening and from there making for the cloth or paper FGH, paint all the colors of the rainbow on it.[109]

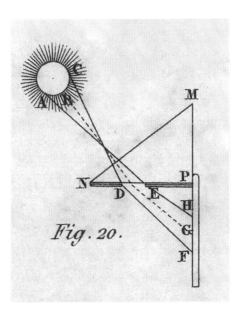

FIGURE 1.3 "I observed that the ray, passing through this opening and from there making for the cloth or paper FGH, paint all the colors of the rainbow on it." (Descartes, *Discourse 8 of Meteors*, in *The World*, 87–88.) Reproduced with permission of the Rare Books and Special Collections Library, The University of Sydney.

The water globe and the raindrop have become particular cases of refracting surfaces, generally represented by the prism; the retina—of a screen, represented by "cloth or paper." The colors of the rainbow are thus produced strictly by refraction of light rays. The eye is completely incidental to the phenomenon; the retina, as it has become for Kepler, is just another screen: "nor does the angle under which [the colors] appear need to be of any particular size, for this can be changed without any change in them."[110] "Appear" is divorced from "caused."

Casting the eye out, Descartes completes Kepler's reapplication of traditional optics—the mathematical investigation of lines of sight—to the behavior of light. His optics is now a bona fide experimental-mathematical natural philosophy, which he can turn to investigating the very nature of colors. But if colors are not optical phenomena in the traditional sense; if they are neither a modification of the visual rays "on the way to the eye" nor the partial reflections of objects' forms, what can they be? How are colors produced, and what do we sense in them? This is the prime causal-physical

question of the new theory, and Descartes answers it in mechanical terms; the motion of the particles of light. The homogeneous particles of light are moving rectilinearly with uniform velocity. Refraction, as well as reflection from opaque bodies, imparts on the particles rotary motion, and the velocity of this rotation depends on the place of the particle in the ray; its distance from the refracting surface. The rotation *is* the color: this explains why the same colors are created by the same angles of refraction and are always in the same order. The details of the mechanistic speculation are of little importance in comparison with the epistemological consequence of the mechanization of colors, which Descartes is quick to point out:

> I cannot accept the distinction that Philosophers make between true colours and others which are only false or apparent. For because the entire true nature of colours consists only in their appearance, it seems to me to be a contradiction to say both that they are false and that they appear.[III]

If colors are modifications of light rather than properties of the object, they cannot be held to the distinction between true and apparent: their truth *is* their appearances. It is only in reference to an intelligent observer that colors, images, and other optical phenomena can be either true or false. Otherwise, they are simply causal effects. Yet if optics no longer studies epistemic processes but merely the transportation of light and its effects, it has no place for such an observer.

### Keplerian Optics and Its Travails

The success of Descartes' theory of the rainbow is predicated on casting the human observer out of optics. Oblivious to the distinction between true and false, optics is thus stripped of its role as an epistemological anchor. Estranging objects and their visual representation it becomes, instead, a source of epistemological anxiety. This is the anxiety that Kepler attempted, with the aid of irony, to sidestep. Descartes addresses it head on:

> We must take care not to assume—as philosophers commonly do—that in order to have sensory perception the soul must contemplate certain images transmitted by the objects to the brain; or at any rate we must conceive the nature of these images in an entirely different manner from that of the philosophers. For since their conception of the images is confined to the requirement that they should resemble the objects they represent, the philosophers cannot possibly show us how the images can be formed by the objects, or how they can be received by the external sense organs and transmitted by the nerves to the brain.

Their sole reason for positing such images was that they saw how easily a picture can stimulate our mind to conceive the objects depicted in it, and so it seemed to them that, in the same way, the mind must be stimulated, by little pictures formed in our head, to conceive the objects that affect our senses.[112]

Descartes' argument is a direct affront to the Aristotelian-perspectivist tradition epitomized by Pecham and resuscitated by Scheiner. The main assumption of Aristotelian naturalism, that the senses carry their own criteria of veridicality, Descartes is claiming, is at best naïve.[113] The "philosophers" take for granted that our senses truly re-*present* the objects, that they furnish the intellect with *resemblances*. But in assuming that they have nothing to rely on but the viciously circular belief that "*unless* this were so, the eye would not see the object distinctly," as Pecham had it, or that the "function" of the eye is "to avoid confusion," as in Scheiner's rendition. In truth, sensory perception does not provide images at all—at least not if by "images" we understand representations that "should resemble the objects they represent."

The dissimilarity between objects and their representation to the intellectual faculties, we saw, was a necessary implication of Kepler's optics, an implication Kepler had to acknowledge, but was reticent to explore. Descartes was not deterred. Retinal images bear no resemblance to the original object: Kepler's optics demonstrated that there is no book image on the screen, only a fuzzy collection of light stains. Furthermore, as we have recourse only to these retinal images, we are "uncertain . . . that the light which we see as if in the Sun exists outside us, in the Sun." Thus, when "pain and color . . . are judged to be certain things existing outside our mind, it is absolutely impossible to understand in any way what things they are."[114]

Descartes carefully works his way through the skeptical implications that Kepler attempted to avoid. Having embraced the idea that one cannot trust the senses to provide likenesses of the objects, he attempts, already in his early *Regulae*, to develop a concept of sensual representation without resemblance. He does it with the help of an ancient metaphor:

> Sense perception occurs in the same way that wax takes an impression from a seal. It should not be thought that I have a mere analogy in mind here: we must think of the external shape of the sentient body as being really changed by the object in exactly the same way that the shape of the surface of the wax is altered by the seal. . . . Thus, in the eye, the first opaque membrane receives the shape impressed upon it by multi-coloured light.[115]

The "mere analogy" that Descartes has "in mind" here is clearly the one Aristotle presented in *De Anima*:

> By a "sense" is meant what has the power of receiving into itself the sensible
> forms of things without the matter. This must be conceived of as taking place in
> the way in which a piece of wax takes on the impress of a signet-ring without
> the iron or gold.[116]

Descartes, however, is turning the famous metaphor on its head. Aristotle
does not use the seal-and-wax analogy simply to "explain sense-perception
through Touch,"[117] as he writes in *On Sense and Sensibilia*. It is to explain
how it can be that "the sense is affected by what is coloured or flavoured
or sounding, but it is indifferent what in each case the substance is."[118] In
other words, the wax metaphor allows Aristotle to make sense of the notion
that what we sense is not just *true* of the object, but *inseparable* from it, even
though the object itself remains remote, which is particularly pertinent, of
course, in the case of vision: "On a smooth surface the air possesses unity;
hence it is that it in turn sets the sight in motion, just as if the impression on
the wax were transmitted as far as the wax extends."[119] Indeed, it is the same
metaphor by which Aristotle dismisses the Platonist separation of matter
and form: "it is as meaningless as to ask whether the wax and the shape
given to it by the stamp are one."[120]

### Indirect Representation

For Aristotle, then, the wax metaphor stresses the direct contact of the
object, through the medium, with the sense organ, and reinforces the te-
leology, immediacy, and veridicality of sense perception. For Descartes the
metaphor conveys the exact opposite: what touches the "opaque mem-
brane" is *not* the properties of the visible, corporeal body but "the multi-
colored light." The same is true concerning all the senses; they provide no
direct re-presentation of the sensed objects. The unity of the senses, which
for Aristotle meant that remote objects of vision are represented as reliably
as the immediate objects of touch, means for Descartes that the images pro-
vided by vision do not resemble their objects any more than the sensations
of smell or taste.[121]

Descartes expresses the opaqueness of the relations between sense per-
ceptions and their objects by envisioning a grammar of line segments and
their arrangements that represent the various sensible qualities to their re-
spective sentient organs.[122] The quasi-geometrical reference to lines and
their arrangement directed Descartes' commentators to the mathematical
aspects of the *Regulae* endeavor. Yet it is the estrangement between the quali-

ties of objects and their sensual representations that is the most radical aspect of his theory of vision and what the analogy to mathematical representation is meant to convey. What Descartes stresses in this notion of grammar is that there is no inherent correspondence between the "objects of the sense" and the objects they are purported to represent; that the relation between those different types of objects is neither transparent nor self-authenticating; that sensations need to be *deciphered*. A few years after the *Regulae*, in his *Le Monde*, Descartes underscores the nontransparency of sense representation, the need to decipher and infer objects from sensations, by replacing the wax metaphor with a linguistic analogy:

> Now if words, which signify something only through human convention, are sufficient to make us think of things to which they bear no resemblance, why could not Nature also have established some sign which would make us a sensation of light, even if that sign had in it nothing that resembled this sensation? ... It is our mind that represents to us the idea of light each time the action that signifies it touches our eyes.[123]

The wax metaphor implied that the relation between objects and sensation was causal and mediated rather than essential; the geometrical analogy stressed that perceptions do not resemble objects; the words metaphor makes the relation between objects and things completely contingent: it is no more essential a bond than the "human convention" that relates words to things. Again, Descartes picks an Aristotelian trope only to subvert its meaning. "Spoken words," writes Aristotle in *De Interpretatione*,

> are the symbols of mental experience, and written words are the symbols of spoken words. Just as all men have not the same writing, so all men have not the same speech sounds, but the mental experience, which these directly symbolize, are the same for all, as also are those things of which our experiences are the images.[124]

Aristotle specifically limits the contingency of linguistic representation to sounds and written characters: since it is the objects themselves that are represented in the human mind, their mental images can only be what they actually are, hence are identical for all humans. Sensual re-presentation, in the Aristotelian tradition, is a series of re-productions of properties of the thing itself: in the medium, in the sense organ, in the mind, in language. This process of representation is contingent *only*, if at all, at the stage of naming mental images with words—the same objects may be designated by different words. Descartes reverses the analysis: the "action that signifies"

is the motion of light which is reflected from the visible thing, through the medium, to the retina, creating on it an image whose relation to the thing— its status as a sign—is as contingent as that of words to concepts. Returning to words in his *Dioptrics*, Descartes stresses again that it is exactly this contingency and the separation "between the object and its image" that his geometrical and linguistic analogies purport to convey:

> We should, however, recall that our mind can be stimulated by many things other than images—by signs and words, for example, which in no way resemble the things they signify. And if, in order to depart as little as possible from accepted views, we prefer to maintain that the objects that we perceive by our senses really send images of themselves to the inside of our brain, we must at least observe that in no case does an image have to resemble the object it represents in all respects, for otherwise there would be no distinction between the object and its image. It is enough that the object resembles the image in a few respects.[125]

These are the full epistemological consequences of Kepler's optics, and Descartes resolutely elaborates them. The process by which images are created belongs to light, not to the eyes or to the objects. It owes no inherent allegiance to either; both are just accidental points that light happens to bounce off. This is not a random or capricious process: the same image on the retina may be assumed to be the outcome of the same process, and therefore represent the same object, just as we can expect a word to always signify the same object. But this precarious uniformity is the only anchor for our trust in our perceptions, and in itself it is nothing more than the regularity of cause and effect: from the epistemological foundation of all science, vision had become dependent on science as the guarantor of its limited reliability.[126]

### Descartes' Doubt

Light optics offered a successful model for mathematical natural philosophy and convincing grounding for the new instrument-based empiricism, but at the cost of forfeiting the trustworthy foundation of all knowledge—simple, unmediated vision. This excruciating dilemma is the origin of Descartes most famous legacy—the "hyperbolic" doubt.

There are few concepts and arguments studied more voluminously than Descartes' doubt, so there is little point in attempting a thorough survey of its various interpretations, but the significance of this insight requires

a quick comment on the current approaches. In contemporary scholarship one can discern three competing lines of interpretation that bear directly on our analysis.[127] A long and active philosophical tradition finds the anxiety that we may be completely wrong at the very core of "the modern condition," and credits—or blames—Descartes. In Bernard Williams' influential elaboration,[128] this doubt is the result of a failed "quest for certainty." Setting the bar for proper knowledge at no lower than mathematical certainty, so goes this reading, Descartes comes to worry if we can know anything at all, which is altogether different from the ancient skeptical warning that we are often mistaken. In Richard Rorty's powerful and controversial version, both the quest and its failure stemmed from a concept of the mind that Descartes invented: unlike the ancient seat of wisdom or the medieval arena of sin and redemption, his—ours—is an enclosed internal space, in which entities of a unique kind "represent" in a nontransparent way a world made of entities of a completely different kind. It is this concept of the human mind, claimed Rorty, with the "veil of ideas" mediating between it and the world, that created the question of how we know anything at all, and the philosophical discipline to answer it: modern epistemology.[129]

A competing interpretation of Descartes' "hyperbolic doubt" arose from the work of Richard Popkin on the history of skepticism.[130] In this reading, it was the rediscovery of ancient skeptical texts and the subsequent revival of Pyrrhonism to which Descartes owed his own skepticism. There is some debate among the adherents to this approach how much novelty there is in the extremity of Descartes' doubt,[131] but all are opposed to the very strong stress on the revolutionary modernity of Descartes characterizing the traditional interpretation.

More recently, attention has shifted to the relation between Descartes' skepticism and his science. Margaret Wilson interpreted the worry about the failure of the senses to represent reality as a straightforward implication of the mechanistic philosophy underlying his science: since "real and physical" qualities include just "extension, figure, and motion," and since "the sensory ideas formed in our mind," being devoid of these qualities, "are completely 'unlike' the material things," the latter ipso facto do not resemble the former, and "human beings . . . are systematically and constantly deceived in ordinary sense experience."[132]

In contrast, Daniel Garber and Stephen Gaukroger present Descartes' skepticism as an introductory move towards his new science: by presenting the poverty of the immediate sense perception empiricism on which Aristotelian science was based, Descartes is clearing the way to his new "method,"

which, far from being a priori and foundationalist, is hypothetico-deductive in character.[133] In general, Gaukroger's definitive interpretation of the early development of Cartesian thought has rejected the traditional view that Descartes' science was founded on his philosophy. According to him, Descartes' metaphysical positions, whether mechanistic or theological, are legitimatory reflections on a science whose intellectual motivations are largely independent, and for this reason they are flexible and changing. Harold Cook, arguing for the long-neglected practical ambitions of Descartes' mature work, is not willing to grant even the skepticism about empirical knowledge. He points out that Descartes himself stresses that the "hyperbolic doubt" of *Mediations* 1–2 is not his last word. In Meditation 6, the last of the *Meditations*, as well as in his "Replies to Objections" and various letters, Descartes presents the doubt as part of an argument that "showed (versus Montaigne and other skeptics) how one could have confidence in the knowledge about the world that came to the mind through the senses."[134]

Descartes' doubt, however, is expressed in its full power not in his philosophical writings like the *Meditations* or the *Regulae*, but at the heart of his properly "scientific" texts, and it does not *lead* to the New Science; it is its consequence. The doubt is a reflection on the painful compromise that light optics forced Descartes into, as Smith's strong words properly capture:

> Kepler's account of retinal imaging represented not a continuation, but a repudiation of the medieval optical tradition. At issue was the relationship between objective cause, in the form of light and color, and subjective effect, in the form of perceptual impressions. Medieval optics was explicitly designed to bind the two as tightly as possible by means of intentional representations. Keplerian optics was implicitly designed to sever this bond by interposing the opaque wall of the retina between the perceiving subject and the perceived object. Out of the resulting disjunction arose not only the modern science of physical optics but also the mind-body dualism of Descartes and his philosophical successors.[135]

Smith does not pay full attention to the role of light and causality in Kepler's endeavor or to his epistemological motivations for physicalizing optics, but he is exactly right concerning the import of Keplerian science in Descartes' philosophy. This insight provides clear answers on the points of contention between the different interpretations of Descartes' skepticism. The Cartesian doubt, it clarifies, is an expression of a very novel anxiety, even if it is sometimes elaborated in traditional terms. The anxiety originates from an analysis of perception that would have been completely foreign to the ancients and their medieval disciples. It is indeed intimately related to Des-

cartes' science, as Gaukroger, Garber, and Cook argue, but it is a wholly genuine anxiety, not a rhetorical or argumentative move. It is not directed against the old science, but stems immediately and disturbingly from the very success of the New Science.

This anxiety is perhaps nowhere more vividly expressed than in the famous illustration from the *Dioptrique* (fig. 1.4). It is a depiction of a real experiment, conducted also by Scheiner and Schott: observing the world as it projected on the retina of the eye of an ox.[136] But it is as much an emblem of the success of the new optics and the disconcerting ramifications of this success, in all their paradoxical entanglement. The observer has disappeared from optics, but not the eye. Detached from the viewer, it is now reabsorbed into the mechanistic account and the empirical inquiry. But it is no longer the end of the visual process, merely an arbitrary point of reference, an unprivileged station in the natural process; "the eye of a newly deceased man, or, for want of this, of an ox or some other large animal" tells as much about its operations as a living human eye could. This is already a clear rejection of Aristotle's position that the eye must be a part of the visual process in order to be an eye:

> Sight is the substance of the eye ... the eye being merely the matter of seeing; when seeing is removed the eye is no longer an eye, except in name—no more than the eye of a statue or a painted figure.[137]

Descartes detaches eye from sight, and his observations drive the skeptical wedge deeper. Cutting "through the membranes," being careful not to let any of the humors spill out, Descartes covers the dead eye with "some white body, thin enough to let daylight pass through it, as for example with a piece of paper or with an eggshell." The eye is positioned with its front toward an illuminated space and its back, covered with the white screen, toward the inside of a dark room, and one can notice the images of the illuminated objects appear on the white cover. Descartes concludes most emphatically that "the images which we cause to appear on a white cloth in a dark chamber are formed there in the same way and for the same reasons as on the back of the eye." The experiment concludes with "admiration and pleasure," but its implications are disconcerting. The eye is no longer a window, it is a screen; it is no longer *through* it that we observe, but *at* it.[138]

There is thus something very correct in the most traditional interpretation of Descartes' skepticism, especially in Rorty's version, with all its historiographic inaccuracies and the mistaken ascription of philosophical foundationalism to Descartes. The "hyperbolic doubt" is not *about* vision; it

FIGURE 1.4 Watching the retina. Descartes' observations of an ox eye (*Dioptrique*). Reproduced with permission of the Rare Books and Special Collections Library, The University of Sydney.

is visual skepticism. Descartes does not rediscover what was indeed noted since antiquity, that our vision is not to be trusted. He invents the eye of the mind, modeled on but completely independent from the eye of the flesh. It is an invention that reverses the epistemological role of vision: from being the vouchsafe of our knowledge and a paradigm of direct acquaintance, it becomes a metaphor for mediation. It is a paradoxical insight: understanding how we see taught Descartes that we do not know.

## CONCLUSION

The naturalization of vision led to the estrangement of nature. Confidence in images from the very far away cast fundamental doubt on our sense of the immediate. Scientific observation entailed the disappearance of the observer. This is the optical paradox that Kepler's "enlightenment" of optics created and that Descartes' skepticism articulated as the fundamental epistemological conundrum of the Baroque.

———— ✳ ————

# Per aenigmate

## Mirrors and Lenses as Cognitive Tools in Medieval and Renaissance Europe

### INTRODUCTION

THE OPTICAL PARADOX had a momentous cultural effect because it touched deep epistemological and theological convictions, well beyond natural philosophy and astronomy. The ideal of direct vision made sense of the aspiration to true and complete knowledge, not only of nature but also of its Creator. With Kepler's optics—and as we will show in the next chapter, with Galileo's telescope—one had to contend that there was little meaning to the dream of unmediated vision. Vision was in its very essence a causal process of mediation, carried out more reliably by artificial instruments than by the natural eye, which itself was nothing but a lens and a screen. Baroque visual culture, with the optical paradox at its core, was no less than a new way of being in this world and negotiating its objects; it is therefore necessary to consider in greater detail the medieval and Renaissance assumptions about direct and mediated vision that served as backdrop for Kepler and Galileo's thoughts.

### SPECTACLES

Clearly, observing through instruments was not a new fad at the beginning of the seventeenth century. Lenses and camera obscura, mirrors and spectacles had been in wide circulation throughout Western Europe for several centuries.[1] Devices similar to Galileo's telescope were first introduced in the Netherlands, and there's evidence that similar devices were already in use

by Pope Leo X to observe the hunt, his favorite entertainment.[2] Lenses had been developed and improved all through the later Middle Ages: spectacles were known from 1280, and lenses to magnify and to assist weak sight are mentioned in Roger Bacon's *Opus Majus* of 1266. Since that dramatic moment when an anonymous craftsman managed to connect two lenses side by side so that they could be held or mounted on the tip of one's nose, spectacles won great popularity. Artistic evidence, commercial documents and literary testimonies present princes, poets, monks and scholars gladly utilizing the new contraption to assist them in pursuing their studies in the autumn of their lives.

These lenses were associated with the world of learning and reading, yet in no way did they constitute an integral part of acquiring empirical knowledge. As the following paintings exemplify, optical devices were significantly alien to the processes of relating to the world through the senses.

The first painting (fig. 2.1), dated 1352, is a fresco by Tommaso da Modena (1325–79). It depicts a Dominican friar who clearly wears spectacles made of a pair of lenses mounted on his nose while he is deeply engaged in reading a book. A fresco on the other wall of the same room in San Nicolò in Treviso presents another Dominican friar using a magnifying lens trying to read an ancient folio. The identity of these two friars is well known, they are respectively Hugh of St. Cher (Hugues de Provence, 1200–1263) and the Cardinal Nicholas of Rouen. Hugh, one of Thomas Aquinas's mentors, was a leading personality in the Dominican order in the thirteenth century and was known for composing the first concordance to the Bible and writing a comprehensive commentary on the Scriptures. He is depicted as the careful and attentive reader he wanted to be remembered as: reading the Bible, a person who "meditates therein day and night" (Joshua 1:8) even after his eyesight has dimmed. The pair of glasses aid his reading and noting the minute details that differentiate between the distinct parts of the Scripture.

A second example of an artistic depiction of spectacles is Jan van Eyck's famous *Madonna and the Canon* from 1436 (fig. 2.2). At the center is seated the Virgin holding her divine baby, at her right is the kneeling canon Joris van der Paele with St. George by his side. Facing St. George is St. Donatian, the patron of the cathedral in Bruges. Van Eyck employs a complicated play of reflections, lights, and gazes to present the human aspiration to directly contemplate God as a mediated act of mirroring and imaging.[3] Between the canon's fingers, a pair of spectacles is noted. He had just used these to read his prayer book, and now has taken them off so as to raise his eyes and stare at the divine scene revealed to him. If in the first painting from Treviso the

FIGURE 2.1 Tommaso da Modena's fresco *Hugues de Provence* [bespectacled] *at his Desk*, 1342. San Nicolo, Treviso, Italy/The Bridgeman Art Library.

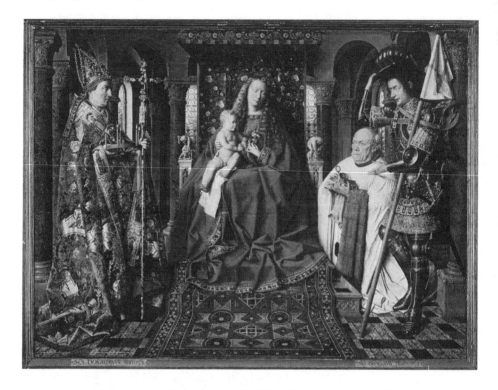

FIGURE 2.2 Jan van Eyck, *Madonna and Child with Canon Joris van der Paele*, 1436. Groeningemuseum, Bruges, Belgium/The Bridgeman Art Library.

spectacles were used as a tool for meticulous and rigor scholastic exegesis, for van Eyck the spectacles are but another element in the game of illuminations and refractions that fashion the revelation of holiness. The sacred vision appears through a play of reflections (the Virgin's red robe is reflected in St. George's armor) a game of gazes (the canon does not stare directly at the Virgin and her son, but at his patron saint, who is watching the Virgin) and the bright illuminations reflected back from the rich draperies, jewels, and windows.

A century later, Raphael makes explicit this contemplation on light, mediation, and the knowledge of the divine in his 1518 portrait of Pope Leo X in the company of two cardinals (fig. 2.3). The pope sits on his throne surrounded by his advisors, staring into an invisible point in space, his hand holding a magnifying glass while resting on the Bible, open to the Gospel of St. John: "And the light shineth in darkness; and the darkness comprehended it not." Raphael combines his religious and epistemological musings

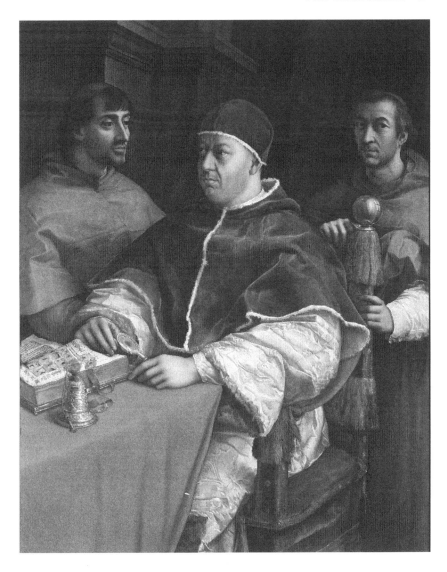

FIGURE 2.3 Raphael, *Portraits of Leo X, Cardinal Luigi de' Rossi, and Giulio de Medici,* 1518. Galleria degli Uffizi, Florence, Italy/The Bridgeman Art Library.

with a political commentary on the inimical ambience in the papal court, where the pope cannot trust his advisors just as he cannot trust his own eyes. Even the power of the magnifying glass is limited; the room is dark, and the only hope is in the divine promise to bring light. Raphael posits the artificial aid to observing the world and deciphering the text (represented

by the magnifying glass) against human counsel, searching for prudence but hopelessly entangled in the webs of mundane power (represented by the pope's advisors). While the lens does assist the pope in reading the divine promise, if in a limited way, his advisors exhibit human shortsightedness and doubt in human judgment.[4]

Traditional concepts of vision endowed special significance to the triple connection that these paintings reflect on, between spectacles, the act of reading and human longing for revelation and knowledge. Something of the fundamental transformation in these concepts that we are following in these chapters is captured by one gesture shared by the canon and the pope: the removal of the spectacles. In an important sense, the disappearance of this gesture *is* the revolution that brings the new economy of vision into existence. Following Kepler and Galileo, one is no longer supposed to take the lenses off the tip of one's nose in order to observe the truth hidden within, or behind, visual appearances. On the contrary, in the Baroque culture of vision, only the artificial mediation of an optical lens provides reliable knowledge. The eye itself is understood to be an integral part this process of mediation.

## THROUGH A GLASS, DARKLY

For Tommaso, van Eyck, and Raphael, the removal of the artificial mediator is crucial—optically, symbolically, and religiously. They were all acutely aware of St. Paul's declamation in the first epistle to the Corinthians (13:12), that

> For now we see through a glass, darkly [*per speculum in aenigmate*]; but then face to face: now I know in part; but then shall I know even as also I am known.[5]

Humans observe the world but cannot see the truth; more accurately, they see it as if a mirror intercedes between them and the divine. The corporeal world we see mirrors the acts of the Creator, yet it is *only* mirror images we perceive: partial, distorted, and ambiguous. Our ability to decipher these images is inherently limited. The glass divider does not disclose the hidden significance of things in the world; it only alludes to it, presenting the human contemplator with riddles. The challenge facing Man after the Fall is to reinstate a direct line of sight to the divine, allowing for the intimate and unmediated knowledge of the Creator he lost with his sin. The loss, however, does not imply that until "then," until salvation, we are condemned to complete ignorance. In his epistle to the Romans (1:20) Paul consoles the

believers that a way to grasp the true meaning embedded in the corporeal world is open to us:

> For the invisible things of him from the creation of the world are clearly seen, being understood by the things that are made, even his eternal power and Godhead.

"The things that are made" are symbols of God's "invisible things" and signs of his "eternal power"; deciphering these signs is a way out of our fallen state of ignorance and a way back to God. A moral and intellectual effort is demanded of those who take this way: they have to clean the glassy substance of their eyes and to shine the mirror of their soul before they notice that those lights they sense are but signs that could lead them in their quest after the hidden truth. The difficulties of the way are very concrete. The eye and our sense of sight, explains Paul, were deformed at the moment of the Fall. They cannot perceive and contemplate the Godhead, only the clues and allusions He left enclosed within the visible world.

St. Paul has no doubt that "things that are made" are "clearly seen," but this corporeal vision is not to be confused with knowing "the invisible things of him." For the real, divine truth, the senses provide only an opaque, distorted view, *in aenigmate*, for which Paul's immediate metaphor is that of the mediation of an artificial optical tool—the mirror. In order to see the truth "face to face," observation should turn from registering appearances to interpretation of the visible realm for signs of "the invisible things of him."

The corporeal world has been metamorphosed into a text, as nicely put by Alan of Lille, the twelfth-century poet:

> every creature of this earth is alike a picture or a book; it is a mirror of ourselves; it is a faithful mark of our life and our death, of our condition, and our fate.[6]

Paul's observer seeks the way in which nature exhibits scriptural truth, transforming nature, in his way, into a book to be allegorically interpreted. For Augustine, the need to *read* the observed world defined the difference between human, mediated knowledge of nature and the Angelic direct knowledge of the Godhead:

> You have extended like a skin the firmament of your book [*Liber*], your harmonious discourses, over us by the ministry of mortals. . . . Let the angels, your supercelestial people, praise your name. They have no need to look upon this firmament, to know through reading your word. For they always see your face, and read there without syllables of time your eternal will. . . . They are always reading the changelessness of your counsel.[7]

## SIGNS AND SYMBOLS

In order to observe the world as it really *is* one has to learn to read, and doggedly decipher and interpret what the eye sees. For John Scottus Eriugena, "there is no visible and corporeal thing that does not signify a corporeal and intelligible thing."[8] For Kepler "the chain linking the corporeal and the spiritual world"[9] was light; his great optical novelty was turning light into the natural, causal agent of vision. In the mediaeval Neo-Platonic scheme, christened by pseudo-Dionysius, light is assigned a symbolic role, communicating between the visible world and the spiritual and invisible realms:

> Light because It is an Originating Beam and an Overflowing Radiance, illuminating with its fullness every Mind above the world, around it, or within it, and renewing all its spiritual powers, embracing them all by Its transcendent elevation. . . . The presence of the spiritual Light joins and unites together those that are being illuminated, and perfects them and converts them toward that which truly Is—yea, converts them from their manifold false opinions and unites their different perception, or rather fancy, into one true, pure and coherent knowledge, and fills them with one unifying light.[10]

This communion of High and the Low through the "Overflowing Radiance" of light, sourceless, boundless, and "embracing . . . all," provided the theoretical framework for medieval monastic practices of mystical contemplation. Concentrating on a world of splendor and colorful flickering lights, the contemplative soul turned away from the mundane and corporeal world towards the supreme theological insight. In meditating over the treasures of the cathedral of St. Denis, and especially the "wonderful cross of St. Eloy" and "that incomparable ornament commonly called 'the Crest,'" the Abbot Suger of St. Denis was reminded of the words from Ezekiel 28:13: "Every precious stone was thy covering." Suger was moved to contemplate the allegorical properties of "the many colored gems" and described his experience:

> [The] worthy meditation has induced me to reflect, transferring that which is material to that which is immaterial, on the diversity of the sacred virtues: then it seems to me that I see myself dwelling, as it were, in some strange region of the universe which neither exists entirely in the slime of the earth nor entirely in the purity of Heaven; and that, by the grace of God, I can be transported to that higher world in an anagogical manner.[11]

This progression from the contemplation of the multicolored brilliance of the gems towards their hidden significance promised a reform of human

sight—from gazing at the creation to the promised Pauline knowledge of "face to face." Within this promise, however, lurks a theological danger—if the world appears as an enigma, and one can contemplate its hidden truth only through mediation, as through a mirror, then the knowledge one attains in this way is always uncertain. Nothing can substantiate the observer's interpretation of the different visible signs, so the claims to truth revealed in the contemplation of the signs cannot guarantee the essential separation between the High and the Low and prevent dangerous confusion.[12]

Throughout the eleventh and twelfth centuries many of the early scholastics, such as St. Anselm of Canterbury and Hugh of St. Victor, discussed intensively the way to ward off this danger by providing the mind with an exact itinerary to its destination, hoping to control its ways and secure eternal rest in contemplating the presence of the Lord. In order to trace this path of confident interpretation, the appropriate divisions and classifications of the Scripture were required. This need opened the way for the Aristotelian corpus to enter the intellectual world of early scholasticism, as the commentators and theologians found in them a solid answer to their interpretative anxieties.[13]

## THE ARISTOTELIAN ORDER

The Aristotelian system was particularly efficient in preventing the dreaded confusion. It emphasized correct classification and the allocation of a specific and unique place for each substance in the world, and simultaneously assigned to each and every place in the world its own unique substance. This classificatory act was founded on the sophisticated tools of the Aristotelian logic and its ideals of common sense. The assertions and divisions of the Aristotelian system did not only include the definitions of the various objects and substances that populate the natural world and their classifications into genus and species. It also classified and demarcated the different tools of thought humans do and should apply in coming to understand the natural world. Each and every scientific discipline had its own unique intellectual means, mental devices, and modes of knowing specifically appropriate to it. The Aristotelian philosopher of nature had to keep the different mental categories separated and be wary of conflating and mixing them, because in a mental mingling distinct things would appear as if subsumed under the same category. Aristotle was scrupulous about preventing confusions of sensory experiences and categories of thought (the visual faculty cannot hear and the auditory faculty does not see), and Aristotelian philos-

ophy, as we will discuss in the next chapter, admonished especially the mingling of mathematical explanations and natural phenomena. The mathematical realm consisted of well-defined and unchanging entities, whereas natural objects are always changing, subject to generation and corruption.

Beyond the obvious theological difficulties arising from adopting a pagan system of knowledge into Christian thought, Aristotelian scholars found themselves confronting one specific problem concerning observation. The problem was inherent to Aristotelian analysis of perception and the status it assigned the human eye as a vehicle for the acquisition of knowledge.

According to Aristotle, the faculty of vision and the act of observation were fundamental to any act of knowledge. As discussed in chapter 1, vision was the anchor of Aristotelian epistemology; our ability to grasp our environment visually signified the suitability of the human mind and senses to their task of knowing. This notion is evocatively expressed in the very first sentence the *Metaphysics*:

> All men by nature desire to know. An indication of this is the delight we take
> in our senses; for even apart from their usefulness they are loved for them-
> selves; and above all others the sense of sight . . . . The reason is that this, most
> of all the senses, makes us know and brings to light many differences between
> things.[14]

The eye itself is most suitable to cognize the different colors of the different natural bodies in its visual field and cannot err in this act of sensation (Aristotle mentions that besides color the eye cognizes something else but he does not specify what this is; one can interpolate that Aristotle thinks of the image of the visual object). The eye is impeccable in regard to its definition as the organ that senses visible qualities such as colors. It cannot misjudge when it senses a specific color, nor can it mistake that a specific body is in view. Vision, in Aristotelian thought, is self-veridical: it does not require any external criteria of correctness, but defines what true knowledge is.

This unquestioning trust in our visual competence burdened the Aristotelian system with a number of inconsistencies. One of Aristotle's methodological cornerstones, and a primary reason for his appeal to the early scholastics, was the emphasis on clear distinction and exact classifications of natural objects and their appropriate places. The eye, on the other hand, communicates to the observer distant objects with which the observer has no immediate contact, and thereby appears to transgress the demarcating lines between the observer and the observed, transcending its own place. The visual power seems to go out into the visible world and grasp even ex-

tremely distant objects such as the celestial bodies. Furthermore, many optical phenomena, such as images in mirrors and the colors of the rainbow, always appeared to call for mathematical explanations, apparently trespassing the crucial metaphysical-methodological boundary between mathematics and the realm of physical phenomena.

The transgression of the visual faculty was too crucial to ignore, and Aristotle attempted to shield it off by stressing that the eye does not relate to distant objects through some occult power but through the mediation of a transparent medium, such as air. Transparent media—air, water etc.—imbue the space between the eye and the object, creating a cohesive continuum through which the distant object actually *touches* the membranes of the eye. It thus acts as a go-between to the visible object and the sense organ and guarantees that the knowledge the visual faculty acquires is indeed true of the object. A similar problem, however, was presented by light: like the visual faculty, it appears to be in more than one place at once. The apparently infinite speed of light—the fact that the room seems to be illuminated instantaneously once a candle has been lit or shutter been opened—cannot find a satisfactory explanation in the Aristotelian scheme. Neither instantaneous speed nor occupying multiple locations simultaneously is allowed in the fullness of Aristotelian world, where each thing has its one and only unique place.

Aristotle answers this challenge by giving light a unique ontological status. It is not a separate physical entity moving from one place to another immediately, but a quality of the transparent media. There are no "rays" flowing from the burning candle, spreading its light to the remote corners of the room. Rather, the air around the flame is activated and turns pellucid, and this transformation is what one calls light.[15] Yet this was a difficult idea, and was already challenged in antiquity. Mathematicians from Euclid onwards were assuming the existence of real rays of light, after which they modeled the putative visual rays, connecting object and eye. In *De anima* Aristotle explicitly denies the existence of visual rays, but as we saw in chapter 1, he was forced to fall back on them when explaining the formation of the rainbow in his *Meteorology*.

Aristotelian theory enabled scholars to comprehend vision as a natural process based on the makeup of objects, media, eye and mind, with no recourse to obscure or occult powers. For monotheistic thinkers in general and Christian theologians in particular it provided assurance that we do indeed perceive the world as it is, thanks to the capacities we were given by Him. It allowed religious contemplation, as an extension of observation,

to be perceived as a continuous and gradual progress, without the danger-ous need for mystical leaps to revelation. Aristotelian analysis of light, how-ever, contradicted basic maxims of Christian theology. From the Scripture's description of the appearance of Jesus as true light, through the Church fathers and Neo-Platonic theological treatises, light fulfilled an important role of relating Man and Divine, as a vehicle for religious ascension towards encountering the Godhead "face to face."

Aristotle's theory of light, however, deflated all exclamations like Eriu-gena's "Originating Beam and an Overflowing Radiance." If light is not a substance but only a state, then idioms and metaphors of radiation, emana-tion, and flowing made little sense and had no physical meaning.

In confronting this complex web of philosophical and theological que-ries scholastic philosophy mustered different strategies of interpretation. Thirteenth-century Dominican scholars, for instance, adopted the Aristote-lian stance and preferred to emphasize its intrinsic intellectual power over the theological difficulties it implied. Thomas Aquinas, for example, denied light a separate existence as a substantial form and reinterpreted those ap-pearances of the word "light" in the New Testament and in Augustine as a metaphor and allegory. In the "*solutio*" of his commentary on Distinction Thirteen of Petrus Lombardus' *Sentences*, Thomas explains that *lux* is not a substance but a sensible quality per se, which has no existence indepen-dent from its place in the sensual process (as Kepler remarked about Aris-totle). The Aristotelian analysis of light as a quality also assists Aquinas in his metaphorical reinterpretation of the spiritual dimension of light. Spiri-tually, *lux* comes to signify the quality that produces an intellectual manifes-tation to the mind, just as worldly, sensible light is a quality that produces illumination among corporeal, sensible objects. Therefore, when St. John the Evangelist and St. Augustine speak of *lux*, they should be understood, according to Aquinas, as speaking in this spiritual sense and not as if light is some Divine substance. Light should not be interpreted as a physical entity even in considering biblical verses or Augustinian speculations. When *lux* is discussed, it refers to a spiritual manifestation and to an integral quality of intellectual enlightenment.

After suggesting the way of interpreting *lux* in a religious and spiritual context, Aquinas turns to natural light and attempts to accommodate ray analysis into his Aristotelian ontology. In order to achieve this he distin-guishes between four instances of light:

- *Lux,* which is the quality by which any luminous body illuminates an-other, as in the case of the sun;

- *Lumen* is that which the illuminated transparent body (*i.e.*, the medium) receives;
- *Radius* is the illumination according to a direct line from a luminous body.

Aquinas carefully preserves the Aristotelian dictum that rays are only fictionally applied to the analysis of vision. Thus, where a ray is drawn from the visible object to the luminous body one can assume the existence of a transparent illuminated medium, but there are no rays within that medium.

- *Splendor* is the reflection of *lumen* (conceived as a ray) by any clean and polished body.

With these distinctions Aquinas solves the infringement of mathematics into natural philosophy's ground. Geometrical ray analysis is reduced to no more than a heuristic procedure with a definite dictionary for its translation into the real physical state of affairs, and each time one of the perspectivists uses the term "ray," Aquinas can translate it into the Aristotelian paradigm without harming the coherence of either geometrical optics or Aristotelian physics.

In general, Aquinas disregarded the theory of perspective. He never mentions the basic optical law of reflection, or the phenomena of refraction, and only incidentally speaks of species and their activity.[16] Albertus Magnus' attack on the claims of medieval perspective was even more vigorous. The only way to utilize geometrical analysis in optics, he insisted, is by adopting Aristotelian principles, and it is possible and necessary to formulate an Aristotelian perspective. In *his* commentary on the *Sentences*, Albertus asserts that whatever there is in the perspectivists' text concerning nature cannot be accepted when it contradicts the authors of natural philosophy (*i.e.*, Aristotelian natural philosophy). The question of whether *lux* is a body is not within the competence of the authors of perspective, as Anaritius (Abū'l-ʿAbbās al-Faḍl ibn Ḥātim al-Nairīzī, turn of the tenth century) says in his *Commentary of Euclid's Geometry*. Hence, the "Author of *Perspective* acted unwisely in interposing this discussion."[17] Moreover, says Albert, we do not lack books on perspective by other philosophers, such as Aristotle, who posit principles of natural science different from the perspectivists' texts. At the end of his discussion of mirrors Albert summarizes the relationship between geometrical explanation and physical meaning:

> However, all these [questions of mirror images] are to be treated according to perspective, because these and their causes are impossible to be known with-

out geometry; and therefore what these assertions are, they are assertions according to ideal explanation, and not because they are [really] so intended. But it establishes out of all these, that vision needs a medium, that is, an actually transparent [body], through which such radiations could be produced, and that colors are not seen unless in such a medium.[18]

Like Aquinas, Albert differentiates between the "ideal explanation" that geometrical analysis of specific phenomena (such as the formation of images in mirrors) can provide and the physical truth behind them. He restates the Aristotelian case concerning the ontological status of light and rejects any claim of the perspectivists to contribute to natural philosophy with their mathematical tools.

## SCHOLASTIC LIGHT METAPHYSICS

The Dominican mode of integrating the Aristotelian notions of light with Christian theology was not, however, the only way to confront those difficulties. The Franciscan order that evolved in the thirteenth century in parallel to the Dominican could not simply accept the Aristotelian categories and logical hierarchy. Essential to the Franciscan conception of religious life was St. Francis' experience and his call for the believers to follow and imitate the life of Jesus and his apostles (*imitatio Christi*), from which it followed that humans have the potential to ascend already during their lifetime and reach a total immersion in the figure of the Son. Such an ecstatic mystical union with the Godhead, with its climactic *stigmata* experienced by St. Francis himself on Mount Alvernia in 1224, could not be accommodated into the Aristotelian framework. During the thirteenth century certain English theologians and natural philosophers who were either members or sympathizers of the Franciscan order embarked on formulating a new theory of religious contemplation that would overcome the Aristotelian obstacles and offer a new answer to the Pauline challenge of observing the created world not as enigmatic reflection, but "face to face."[19]

Robert Grosseteste (1175?–1253), who as the Bishop of Lincoln facilitated the introduction of the Franciscan order to Oxford, incorporated in his short treatise "On Light" (to which we will return in chapter 6) new optical principles he learned from the Muslims, especially al-Kindi (ninth century).[20] These philosopher-mathematicians integrated geometrical analysis and Neo-Platonic notions of emanation into a physical theory of vision, and Grosseteste incorporated this combination into an original commentary on

the first verses of Genesis that was meant to serve as a guide for mystical meditation. The reader's mind follows the flow of the primal point of light, which for Grosseteste captures "the form of corporeality," and learns how through a pulsating process of pouring out and reflecting back, the celestial light is molded to create the sublunar realm. At the end of this mental imaging the reader's intellect reaches the limits of human rational comprehension and is ready to contemplate what is beyond its discursive ability.

In his effort to establish earthly vision that would allow one to gaze at the divine, Grosseteste transgressed and obliterated more than one of the Aristotelian dichotomies and demarcations so dear to his Dominican contemporaries. In particular, "On Light" gave geometrical optics the status that Albert and Thomas specifically denied, not only through the mystical prowess Grosseteste assigned to the contemplation of light, but through careful considerations of Aristotelian metaphysics:

> The extension of matter in three dimensions is a necessary concomitant of corporeity, and this despite the fact that both corporeity and matter are in themselves simple substances lacking all dimension. But a form that is in itself simple and without dimension could not introduce dimension in every direction into matter, which is likewise simple and without dimension, except by multiplying itself and diffusing itself instantaneously in every direction and thus extending matter in its own diffusion. For the form cannot desert matter, because it is inseparable from it, and matter itself cannot be deprived of form.... It is light which possesses of its very nature the function of multiplying itself and diffusing itself instantaneously in all directions ... Corporeity, therefore, is either light itself or the agent which performs the aforementioned operation and introduces dimensions into matter in virtue of its participation in light.[21]

Light, in its formal-mathematical characteristics, is the very foundation of corporeal nature, determines Grosseteste, so the study of mathematical qualities—geometrical optics—is fundamental to natural philosophy. With this assurance of its solid foundations and the philosophical import, Grosseteste's younger Franciscan brother, Roger Bacon (1214?–94) turned to Muslim optical theories to adopt and develop one crucial idea: that each point in the visual field radiates its image in all directions. Bacon, however, assigns this image much more than its purely visual characteristics, such as the point's color. It comprises the point's *species*—its material and formal aspects; every single body radiates all about itself not only its visible accidents but also its true essence.[22] Following the lead of geometrical optics one can therefore observe the natural world *directly*; not as an enigma but as a clear

manifestation of divine truth. For Bacon that meant that geometry can serve as a mighty tool in explicating the spiritual meaning of the Scripture. In order to decipher such mysteries as Noah's Ark, the Temple of Solomon, and Ezekiel or Aaron's vestments, one has to be "well acquainted with the books of the Elements of Euclid and Theodosius and Milleius and of the other geometricians." Deciphering these geometrical secrets will transform human sense of sight and will reveal the truth hidden in the deepest mysteries the Scriptures present:

> Oh, how the ineffable beauty of the divine wisdom would shine and infinite benefit would overflow, if these matters relating to geometry, which are contained in Scriptures, should be placed before our eyes in their physical forms! For thus the evil of the world would be destroyed by a deluge of grace.[23]

In geometry lies the key for true, "face to face" vision. Understanding the geometrical principles underlying biblical mysteries will allow the human contemplator to gaze through their allegorical or spiritual appearance at their fully materialized form:

> And with Ezekiel in the spirit of exultation we should sensibly behold what he perceived only spiritually, so that at length after the restoration of the New Jerusalem we should enter a larger house decorated with fuller glory. Surely the mere vision perceptible to our senses would be beautiful, but more beautiful since we should see in our presence the form of our truth, but most beautiful since aroused by the visible instruments we should rejoice in contemplating the spiritual and literal meaning of Scripture ... which the bodies themselves sensible to our eyes exhibit. Therefore I count nothing more fitting for a man diligent in the study of God's wisdom than the exhibition of geometrical forms of this kind before his eyes.[24]

Bacon's radical program crossed over the Pauline threshold. Scientific knowledge, especially in its geometrical form, can redeem humanity, according to Bacon, and restore it to the state it was in before the Fall. A fully geometric sense of sight would combine the veracity that Aristotle assures the eye in all matters sensible with the certitude that geometry guarantees to reason. This new mode of visual perception would be able to detect and prevent the intellect's faulty judgment, and to engrave a most accurate picture of the created world as it really is, and thence lead the mind into a direct contemplation of the Godhead.

Bacon's scheme was an obvious threat to the ecclesiastical establishment and its role as the necessary and sole mediator between the flock of believers and divine grace; it further undermined its authority as the sole interpreter

of the Scriptures and of God's presence in Creation. Less than a decade after Bacon published his major work, John Pecham, a Franciscan monk who served as the Archbishop of Canterbury, took it upon himself to restructure the new optics and neutralize its radical theological implications. Pecham aimed to classify and demarcate the different branches of optics. He reinstated the disciplinary borders between the mathematical and physical elements involved in optical explanations, and between those parts dealing in direct vision and those concerned with reflected and refracted rays.

This differentiation between the subjects of optics was commonly accepted since Euclid in the third century BC. For Pecham, however, it meant more than a disciplinary distinction. The difference between the visual rays flowing directly from the object to the eye and those that are reflected off the mirror or refracted when penetrating through a surface (such as water) had, in Pecham's analysis, an immediate significance in regard to the quality of knowledge acquired through these rays. Not that Pecham suspected that the reflected image is false or distorted, since the image in a mirror does represent the object. Because the reflection or refraction disrupts the straight flow of species from the object to the eye, this representation contains added, unnecessary information that causes confused perception. Pecham's basic assumption is that "straightness is naturally associated with the propagation of light (as well as with any other action of nature), it arranges and orders nature, for every action is strong in proportion to its straightness."[25] What is true of light is true of the species flowing from objects: in the mirror the species hits the reflecting surface and only then does it rebound and arrive at the eye. Although it "maintains its essence and thereby reveals the object," the tortuous path the species is forced into means that it is not only "in another position" but also lacks any material-physical reality: "it is evident that nothing is impressed" in that wrong position.[26]

## MEDIATION

The conclusions from Pecham's analysis are clear: any disruption to the proper flow of species from object to eye, especially the refraction and reflection of the optical instrument, distorts and obscures vision. Developing the same Muslim optics employed by Bacon, Pecham is thus able to fend off their conflation of mathematics and natural philosophy, with the threat of mystical enthusiasm it connoted. Straight propagation of light and species, in this interpretation, does not really need geometrical analysis. It is simply linear, suffers no variations, and requires no elaborate diagrams—it

is the subject of philosophy. Mediated, disrupted vision, on the other hand, reflected and refracted flow, calls for diagrammatic representation and complex mathematical account—it is the subject matter of geometry.

Reinstating and fortifying the clear distinction between direct and mediated vision and between the roles of mathematics and of causal natural philosophy, Pecham neutralizes the threats of Bacon's radical program and retrieves Aristotelian order into his system of knowledge. Only an unmediated encounter yields true knowledge: eye to eye and "face to face." There is no place for the arrogance of geometrical certainty in humans' strivings to know God's creative power. Geometry is limited to the study of repetitions, imitations, and distraction of God's creation. God created the eye in order to see, so on viewing nature straight on it provides good, reliable knowledge, but no geometrical certitude can or should be aspired to. Bacon's ambition, to use geometrical optics and artificial visual instruments to force nature into disclosing the divine message treasured in its recesses, is but vain hope. Mirrors and lenses cannot deliver new knowledge about the world; they only reiterate what the eye has already seen directly and more clearly.

Pecham was not a solitary voice in his thorough critique of Bacon's optico-theology, and during the turn of the fourteenth century prominent scholastic philosophers and theologians attacked different aspects of Bacon's ideas. The attraction of his promise of True Knowledge did not fade, however, and continued to inspire theological innovations, especially among Franciscans in England and Italy. This intellectual interest in vision and its promises was further shored up by the emergence of the new instrument of sight that aroused Bacon's enthusiasm, the spectacles, which rapidly became a loyal companion of weary-sighted scholars all over Europe. The undeniable efficacy of spectacles enforced a new perspective on the relations between vision, the eye, and the mediating instrument. Spectacles provided a concrete example of the fact that reflected rays, passing through lenses, do not have to be a cause of error or of superfluous, confusing information. They corrected or supplemented specific weaknesses of human sight and magnified the small script in ancient scrolls. They provided accurate images, indeed more than those gained by direct vision, and the information they added was valuable and unavailable to the unaided eye.

Ipso facto, the use of spectacles highlighted the inherent flaws in the human sense of sight and the limitations of the human eyes, and severely questioned the Aristotelian postulate that the eye is self-authenticating. Not only was human vision defective, it could be corrected by artificial means;

the fundamental preference of vision "face to face" had to contest against the new fascination with reflected and refracted images. In the last quarter of the fourteenth century, for instance, John Wyclif (1324–84) mobilized Bacon's optics to understand the divine presence in the Eucharist.[27] Jesus is present in the world, according to Wyclif, in several different modes. He is in heaven at the right of God the Father, but He is in the whole of the universe *in potentia,* and thus He can reveal His own presence to the eyes of the believers. This presence, Wyclif contends, can also be realized in three distinct ways. Jesus can appear directly to His blessed disciples while His species are multiplied throughout the heavens, or He can be present through the true believers' pronunciation of His holy name; and finally, He is present for the entire congregation in the bread and wine at the Eucharist. This spiritual presence in the holy bread, explains Wyclif, is similar to the presence of an image in a mirror, and he proceeds to analyze it exactly as if it were an image reflected from a parabolic mirror or refracted through a magnifying glass. Wyclif proclaims that this mediated vision is the only mode of knowing God open to the sinful humanity after the Fall, but does not take this to mean that we are doomed. Rather, it represents a very real way to see and sense the presence of God—just as one can truly observe external physical reality in the reflected image.

Wyclif's optical theology adds another dimension to van Eyck's *Madonna and the Canon.* The canon removes his spectacles in the presence of the Holy Mother, but neither the view through lenses, nor the multitude of reflections and illuminations populating the scene is worthless. The pair of spectacles in the canon's hand may not assist in looking "face to face" at the divine, and he indeed averts his gaze from the virgin to the saint, but what he *is* able to see, mediated and reflected, is not worthless. Just as the spectacles enable the canon to read God's name in his book of prayers, so the reflections of the Virgin and her holy Son in the armor of St. George and the flickering lights reflected off their figures throughout the whole of the painted space enable the believer, kneeling in front of the holy icon, to sense the image of God as a true visual experience.

While theology was embracing reflections and mirror images into the realm of religious experience, it was also undermining the status of the eye and natural vision. In the second half of the fourteenth century the French philosopher and mathematician Nicole Oresme (d. 1382) published his treatise *De causis mirabilium;*[28] a full-fledged assault on tales of encountering devils and ghosts, stories about supernatural events and all such superstitions.[29] Oresme's main contention was that all these stories can be ex-

plained rationally as sensory delusions. In the chapter dealing with visual illusions Oresme argues this concerning the sense of sight in particular; following Aristotelian psychology and contemporary theories of optics, he claims, the whole visual process is uncertain and prone to error, as each and every stage of the process—whether the medium, the eye itself, the imagination, or memory—is liable to distort visual data. One cannot trust the senses, and vision is no exception; tradition should be the principal arbiter in all contentious claims to knowledge. Oresme's conservative skepticism was not conducive to the Franciscan aspirations of visual experience of the Godhead, but it also offered little support to the Dominican-Aristotelian confidence in direct vision, and his critique of the visual faculty highlighted the role of artificial aids to the faulty human sight, like the spectacles and the magnifying glass.

### TRANSCENDING THE POWER OF REASON

This theologically driven suspicion of the human visual faculty and the conviction of the benevolent role of optical instruments and their ability to assist it is the ideational context in which Raphael's Leo X, unable to trust either his eyes or his councilors, is condemned to use a magnifying glass to read the divine promise, "and the light shines in the darkness." It is also the philosophical context of the work of Nicolas of Cusa (1401–64), philosopher and man of the church, who in one of his later small treatises suggested an experiment with a beryl stone as a sort of a lens:

> Beryl stones are bright, white, and clear. They have both concave and convex forms, and looking through them one apprehends that which was previously invisible. If an intellectual beryl (*intellectualis berillus*) that had both a maximum and a minimum form were fitted to our intellectual eyes, then through the medium of this beryl (*per eius medium*) the indivisible principle [*principium*] of all things would be attained.[30]

The beryl lens allows seeing "that which was previously invisible"—not simply because it was too small, but because it was truly a secret: "the indivisible principle [or beginning] of all things." Nicholas of Cusa suggests that with this the mediation of the stone-lens the mind can attain a vivid image of the invisible unification of opposites (*oppositorum coincidentia*); with the aid of the beryl the reader can glimpse into the unknowable:

> Whoever will have read what I have written in my various books will see that I have often dwelt in the unity of opposites and that I am frequently striving

towards an intellectual vision (*intellectualem visionem*), which transcends the power of reason (*rationis vigorem*). Hence in order to provide as clear a concept as possible for reading, I will put forward a mirror and a riddle (*speculum et aenigma subiciam*), by which the frail intellect would aid and guide itself at the outer limits of the knowable . . . And although short, this little book provides sufficient practical instruction as to the manner in which it is possible from riddles [*ex aenigmate*] to arrive at the loftiest vision.[31]

The *speculum et aenigma* are obviously a direct allusion to St. Paul's dictum, but for Nicholas of Cusa they no longer represent a sign of Man's fallen state. The enigma, or "riddle," is an essential vehicle for salvation; it provides a bridge for the intellect to perceive what is beyond the power of reason and measurement to apprehend.

Nicholas of Cusa's enchantment with gems, mirrors, and lenses in general, and the beryl with its "maximum and minimum" in particular, is anchored in a heavily Neo-Platonic metaphysics of similitudes, representations, and reflections, in which perceptual relations, and especially visibility, are assigned a fundamental role. These relations are hierarchical: from the First Beginning, the "Intellect," emanates a flow of light communicating its own intelligence, creating entities in a descending scale of likeness to itself. The human mind, in its ascent toward God, traces and measures the different levels of this hierarchy of similitude: "Hence, man finds within himself, as in a measuring scale (*ratione mensurante*), all created things."[32]

With likeness assigned a creative potency, Man's creativity makes him resemble God. Through his measurements and the application of mathematics (artificial forms) man actively and creatively participates in the hierarchy of similitude:

> For just as God is the creator of real entities and natural forms, so is Man of rational entities and artificial forms, which are nothing but the likenesses [*similitudines*] of his intellect, just as the creations of God are the likenesses of the divine intellect. Thus Man has an intellect that, in creation, is a likeness of the divine intellect. Hence Man creates likenesses of the likenesses of the divine intellect, just as the external artificial figures are likenesses of the internal natural forms. Therefore Man measures his own intellect in terms of the powers [*per potentiam*] of his works and thereby measures the divine intellect, just as truth is measured in terms of [its] image. And this is the science of enigmas [*aenigmatica scientia*].[33]

The notion of man as measure of creation is entwined throughout this short treatise. It follows naturally from Nicholas of Cusa's metaphysics of similitudes, but it also serves to distinguish his epistemology from that of

his Neo-Platonic predecessors, in making *measuring* the true intellectual tool that can communicate between visible reality and divine meaning. Like Bacon, Nicholas of Cusa takes visible reality as a book that expresses divine intention:

> For *sensibilia* are the books of the senses; in these books the intention of the Divine Intellect is described in perceptible figures (*sensibilibus figuris*), and the intention is the manifestation of God the Creator Himself.[34]

Yet the mode of reading has changed. In order to decipher the divine meaning embedded in the visible world, Nicholas of Cusa's human mind has to measure and compare. This act of setting things one against the other, matching and weighing them relatively, will lead the intellect to appreciate the juxtaposition of contraries embedded in the material and visible world. Every human investigation of nature must be mathematically conceived, as Nicholas of Cusa asserted in an earlier tract, *De docta ignorantia*:

> All investigations judge by proportional comparison of the certain to the uncertain, therefore every inquiry is comparative and uses the means of comparison ... Therefore, every inquiry proceeds by means of a proportional comparison, whether an easy or a difficult one ... However, since proportion indicates an agreement in some one respect and, at the same time, indicates an otherness, it cannot be understood independently of number. Accordingly, number encompasses all things proportionally compared.[35]

The fundamental role Nicholas of Cusa assigns to measurement leads him to elaborate in *De Beryllo* on the nature of numbers and their relationship to the corporeal world, to sensation and experience. In sensing the world, he explains, Man measures it, and in measuring it, Man prepares it for the act of true knowledge. This preparation is not a passive abstraction of geometrical shapes from perceptible things, but an active and creative process of reading quantities and geometrical figures *into* nature:

> Mathematical entities and numbers [*mathematicalia et numeri*], which proceed from our mind and exist as we conceive them, are not substances or principles [*principia*] of perceptible things, but only of rational entities of which we are the authors [*conditores*].[36]

And Nicholas of Cusa sums this line of thought up by adopting Protagoras' celebrated dictum:

> Protagoras, then, rightly stated that man is the measure of things. Because man knows—by reference to the nature, that is, by sensing—he knows sensed things to exist for the sake of such sensory knowledge, he measures the sensed things

in order to be able to apprehend, through his senses, the glory of the divine intellect.[37]

The conviction that the intellect has a creative role in knowledge is carefully maintained by Nicholas of Cusa in his thoughts about mathematics. His "mathematical entity" of choice is the geometrical diagram, which serves, like the beryl, as a vehicle to "acquire knowledge about the principle of opposites and about their differences."[38] The diagram is a paradigm of a practical enigma, whose playful manipulation exposes the point of the unification of opposites, and Nicholas of Cusa explores various kinds of diagrams in his writings. In *De Beryllo*, for example, he presents a geometrical line *ab*, which is "of the likeness of Truth" (*similitudinis veritatis*). The line is folded at some point *c*, and the movement of the folded line, creating different angles, "captures the motion by which God calls forth nonbeing into being."[39] The angular line is an enigma to be contemplated through a mathematical manipulation:

> Hence, when the author-intellect [*intellectus conditor*] moves *cb*, he unfolds [*explicat*] exemplars that he has within himself in a likeness to themselves, just as when a mathematician folds [*plicat*] a line into a triangle, he unfolds this triangle, which he has within himself in the mind, with an enfolding motion [*motu complicationis*].[40]

The enigmatic diagram (and for Nicholas of Cusa all geometrical diagrams can serve as *aenigmata*) allows human contemplation to bypass its own limitations and *to see* what is beyond sensory experience and commonsense conceptualization, because

> Our intellect cannot conceive of the essence of things, because it cannot conceive the simple and creates a concept in the imagination, which receives ... likenesses from the *sensibilia*. Yet the intellect does see the indivisible beyond the imagination and its [imaginary] concept.[41]

The diagram, the beryl, and the lens; all serve as means to look beyond mundane experience and grasp the elusive beginning of the world:

> Now, if you apply eyeglasses [*applicas oculare*] and see equally according to the maximum and minimum ... you will be able to make a truer speculation regarding the divine mode.[42]

Beyond their mundane and benevolent role in assisting the weak eye of the flesh in reading faded manuscripts, artificial instruments, especially lenses, became also an analogy and an aid to the imagination in its strive to observe what is beyond human sight. Savanarola, in his *Sermon on the Art of Dying* of 1496, argues that in order to comprehend something one

must form a phantasm in the imagination, and these phantasms are "the eyeglasses of the intellect." Just as eyeglasses mediate visible objects, so the imagination mediates true knowledge; and just as one needs clear lenses for observation, so one needs a well-ordered imagination. As opaque lenses distort visual data, so the imagination governed by human passions can distort the truth. In order to control the imagination one has to form strong images that attract the imagination and move the human soul towards the Godhead:

> The strength of the fantasy moves man even against reason... If lustful things
> come into your fantasy, you will immediately be moved to evil. If you wish to do
> good and shun evil, make a strong *fantasia* of death. These are the eyeglasses I
> am telling you about.[43]

In the sixteenth century the notion that the imagination operates like a lens had become a commonplace, beautifully captured by Giovanni Battista Naldini (1537–91) in his work for the studiolo of Francesco de Medici. At the center of the *Allegory of Dreams* (fig. 2.4), appears Aurora holding a large convex circular object, which a careful examination reveals as a huge lens.[44] The feminine figure of Aurora embodies those moments at dawn, when according to classical tradition one can envision dreams of truth. These dreams, which allow a glimpse into the mysteries of the world, however, are not clear. The fog surrounding the slumbering mind obstructs the dreamer from deciphering the riddles and grasping the message concealed in the vision, and she is in danger of gliding over the visionary wings into the abyss of madness. The dreamer is prone to losing her ability to differentiate between imaginary apparitions, springing from desires and passions, and the divine message, concealed in the dream's symbolic language. The lens as an artificial means, a human-made object, replaces the incompetent natural eye as the tool to achieve this super-sensory perception of truth through the clouds of fantasy. In order to comprehend the inner content formed in the imagination, one has to filter them through artificial instruments shaped by the imagination. This paradoxical method further distances one's inner fantasies from external, physical reality. The lens, instead of reducing the fantastical mental image to a concrete sensible appearance, accentuates the nonexistent nature of these apparitions and specters.

## CONCLUSION

Mediating between fantasy and truth, the lens had become a means to a wholly different type of knowledge from what Aristotelians hoped to achieve

FIGURE 2.4 Giovanni Battista Naldini, *Allegory of Dreams*, c. 1570 (oil on slate). Palazzo Vecchio (Palazzo della Signoria), Florence, Italy/The Bridgeman Art Library.

by direct observation of natural phenomena. Instead of reliable perception of nature, it suggested a path to a direct encounter with the divine. Fascination with mirrors and lenses reversed the Pauline dictum: only through the enigmatic mirror, by submerging oneself in its reflections and apparitions, could one find oneself "face to face" with one's creator.

Keplerian optics, then, was steeped in theological thought as deeply as in the mathematical mixed science, and it wreaked as much havoc in the Neo-Platonist aspirations of the former as in the Aristotelian epistemology of the latter. Light, with all the complex metaphysical functions it carried for Kepler, was producing images in a straightforward natural, causal way. Little sense could be made of the dream of "direct vision": vision *was* a process of mediation, produced by light reflected off objects and refracted by the cornea. The artificial instrument was not analogous to imagination or a means to contemplate the divine: it was essential for worldly observation of natural objects. The eye itself was nothing but an inferior natural version of the optical instrument. The advent of the telescope gave these paradoxical developments another twist.

——— ✳ ———

# The Specter of the Telescope

## Radical Instrumentalism from Galileo to Hooke

### INTRODUCTION: INSTRUMENTS AND COSMOLOGY

INSTRUMENTS embedded sophisticated mathematical knowledge and fine artisanal skill. They could undoubtedly aid faulty vision, but they were still suspect. Their enthusiastic embrace by theological innovators like Roger Bacon and Nicholas of Cusa could only heighten this suspicion. For those interested in the study of nature as it is and as far as optical theory was concerned, instruments mediated, therefore distorted. That the eye seemed to mediate as well did not alleviate the suspicion. Rather, it gave rise to a skepticism that further sharpened the distrust and that Francis Bacon famously articulated with a barb at the saying favored by Nicholas of Cusa:

> it is a false assertion that the sense of man is the measure of things. On the contrary, all perceptions as well of the sense as of the mind are according to the measure of the individual and not according to the measure of the universe. And the human understanding is like a false mirror, which, receiving rays irregularly, distorts and discolors the nature of things by mingling its own nature with it.[1]

Bacon's account of his "idol" demonstrates that the *speculum* was still a symbol of distortion for him, and that mediated perception was ipso facto unreliable. By the turn of the seventeenth century, however, scientific practices were making obsolete the idea that mediation is a source of error; Kepler's new optics decreed that *all* vision is necessarily mediated, and astronomical observation was becoming increasingly reliant on sophisticated optical devices.

Into this moment of tense reflection about vision Galileo introduced his telescope, with monumental consequences:

Men who ... grew up with the telescope and were taught what it revealed formed a different fundamental conception of the cosmos from that of their predecessors. The Aristotelian duality between the sublunary and superlunary regions had been the commonsense notion for a long time: the only permanence was found in the heavens, and all bodies above the moon, with the exception of the sun, looked alike. They were all stars; some were fixed, and some wandered. But after the telescope had been directed to the heavens ... the planets were shown to have many things in common with the earth, while ... the fixed stars now appeared much farther away than had ever been dreamed before.[2]

Galileo's observations of the maculate moon and the satellites of Jupiter in 1609, the phases of Venus in 1610, and the spotted sun in 1612 were indeed devastating blows to the "Aristotelian duality between the sublunary and superlunary regions." For practitioners of astronomy, however, they were only spectacular reiterations of the controversial claims that the new astronomy had been making for some time. The enormous distance of the fixed stars was entailed by the Copernican hypothesis, already seventy years in print and almost a hundred in circulation. No Copernican himself, Tycho Brahe had drawn on his instruments to argue for the even more outrageous claim that the heavens are changing. With the unprecedented accuracy that these artificial devices allowed, he could claim with authority, decades before the telescope, that the *Stella Nova* of 1572 and of the comet of 1577 were above the moon, placing ephemeral objects in the heavenly realm, where supposedly only "permanence was found."

When Galileo comes to defend his instrument, therefore, both the exhilarating prospects and the disturbing ramifications of instrumental observation, including lens instruments such as the camera obscura, have already been explored. The far-reaching physical and cosmological ramifications of the new astronomy, we argued in chapter 1, moved Kepler to search for epistemological groundings in optics. By turning optics over to light, Kepler reassigned the inferiority of the instrument to the eye. By assuming the mathematical nature of light, he formulated a new justification to trust both. For Kepler mathematics was not only the proper means to study idealized lines of sight. It could replace direct acquaintance as the vouchsafe of true *observational* knowledge because light, the new optical agent, was mathematical *in essentia*. In the *Assayer* of 1623 Galileo adopted a similar mathematical ontology for similar epistemological purposes:

Philosophy is written in this grand book—I mean the universe ... in the language of mathematics.[3]

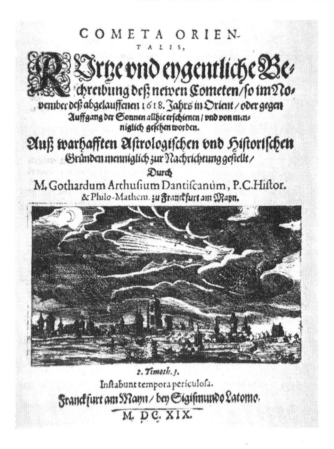

FIGURE 3.1 One of the many popular accounts of the comets of 1618: Arthusius'
*Cometa Orientalis.*

## THE CONTROVERSY OVER THE COMETS

The occasion of the writing of *The Assayer* was a new set of observations
reasserting the prowess of the new visual methods and returning their cos-
mological ramifications to the center of attention. During the fall of 1618
three comets appeared in the European sky in short succession (fig. 3.1).
The third and most impressive of them, in late November, was carefully ob-
served by astronomers all over Europe. A few months later the Jesuit mathe-
matician Horatio Grassi published, anonymously, his *De Tribus Cometis Anni
1618 Disputatio Astronomica.* Limiting himself to the traditional role of as-
tronomy, namely "the single role of the mathematician," Grassi promised

"not to exceed the boundaries of our knowledge" and declared that "if I explain the position, motion, and magnitude of those fires, I shall be satisfied that I have fulfilled my purpose." The "position and motion" he assigned to "those fires," however, were far from traditional, that is, if two generations after Tycho and three after Copernicus, one should still take "tradition" to refer to Ptolemy and Aristotle: "our comet," Grassi declares, "was not sublunar but clearly celestial."[4]

Tycho, we mentioned, had already arrived at this conclusion concerning the comet of 1577, but the idea that comets were superlunary did not lose its revolutionary cosmological significance: the sharp dichotomy between the realms under and above the moon, which the heavenly position of comets undermined, was not an arcane scholarly conviction; it was well entrenched in religion and common sense.[5] The "disputation" in Grassi's title suggests that he expected contentious reactions, and he indeed found himself under fierce assault, but it did not come from the guardians of tradition. Instead, it came from the person Grassi made a point to hail with the very first lines of the treatise by writing "only comets have remained aloof from these lynx eyes."[6] It was the eyes of the Lincean Galileo Galilei that Grassi was referring to, and it was Galileo, of all people, who had risen to defend traditional cosmology from the new observations.

That it *was* Galileo did not become immediately clear, because Grassi's anonymous *Disputatio* set off a masquerade. Galileo's initial answer, the *Discourse on the Comets*, was dictated, in Tuscan, through his disciple and fellow academician Mario Guiducci.[7] Grassi, however, was not fooled. He mocked "Galileo [for] order[ing] the matter to be discussed through intermediaries and interpreters" and joined the play of "secrets of mind"[8] by replying with the *Astronomical and Philosophical Balance*, apparently composed in collaboration with other members of the Collegio Romano, under the anagram Lothario Sarsi of Siguenza. For the celebrated climax of the debate Galileo (who never observed the comets with his own eyes) unmasked and answered 'Sarsi's' Latin *Balance* (*Libra*) with his own—again Tuscan—*Assayer* (*Saggiatore*), simultaneously denying that he was behind Guiducci *and* complaining about Sarsi's lack of manners in exposing him.[9]

### The Arguments

The claims Galileo vehemently contests are carefully measured factual conclusions—Grassi tries hard not to "exceed the boundaries of our knowledge"—and remain within the realm of empirical modesty. He is compelled

to station the comet in the celestial realm, he explains, by his parallax cal-
culations—the comparison of the angles of sight from different positions:

> If the comet was observed from different places and compared with the stars
> of the firmament, and if it preserved the same distance from them, it must be
> regarded as either in the firmament or certainly not far removed from it. But if
> it underwent parallax, it must be placed below the firmament in proportion to
> the amount of the difference of aspect.[10]

These calculations gained further support through the intricate network
of Jesuit scholars and institutions deployed all over Europe. When observers
in "Milan and in Parma . . . from Innsbruck in Germany and from France
and Belgium" report the same position for the comet, and when finally two
particularly accurate observations from Rome and Cologne completely co-
alesce in time and place, Grassi feels assured. Well aware of the far-reaching
implications of placing the comet in the heavens, however, he buttresses
the argument from the (lack of) parallax with three further arguments, all
of them anti-Aristotelian in detail, but Aristotelian in their general outlook
and assumptions.[11] The first is directed against the Aristotelian claim that
comets are fiery exhalations, a claim that Galileo will be making extensive
use of: comets are simply much too large, Grassi calculates, to be fueled by
exhalations from the earth. For Grassi this argument also implies that the
light of the comet is not its own "but that of the sun; and the solar rays,
either refracted or reflected, proceeded farther on and formed the tail"; "as
Kepler would have it," he adds, displaying his acquaintance with the state
of the optical art. Obviously, though he places the comet "in the firmament
or certainly not far removed from it," Grassi assumes that it is more akin to
planets than to the fixed stars. The second argument is that whereas "fiery
irruptions have no regular and definite motion . . . The motion of our comet
was always constant and not unlike the motion of the planets." The comet's
motion "always follow[s] a middle and splendid pathway," allowing the as-
tronomer to recognize it as part of the planetary realm.[12]

It is Grassi's final argument that arouses Galileo's ire, and it is this wrath
that points to the real issue of the debate. On the face of it, however, the
argument appears fairly innocuous:

> It has been discovered by long experience and proved by optical reason that all
> things observed with this instrument [the telescope] seem larger than they ap-
> pear to the naked eye; yet according to the law that the enlargement appears
> less and less the farther away [the observed things] are removed from the eye,
> it results that fixed stars, the most remote of all from us, receive no perceptible

magnification from the telescope. Therefore, since the comet appeared to be enlarged very little it . . . is more remote from us than the moon, since when [the moon] has been observed through the telescope it appears much larger.[13]

Because Galileo retains the masquerade of names and titles through his argumentation, it takes some prodding to reveal that this is the argument he aims to refute. Even in the *Discourse*, dictated to Guiducci and before being entrapped in the Jesuit disputation mode, Galileo adopts positions that have little merit other than as refutations of Grassi's arguments. He ignores altogether Grassi's quasi-quantitative claim about the size of the comet as well as the reference to Kepler. This takes him out of the dangerous zone of planetary theories and the already-contentious issue of Copernicanism it entails, and it makes easy prey of Grassi's other auxiliary point, that "the motion of our comet was always constant and not unlike the motion of the planets." This claim demanded some strenuous extrapolation of the comet's trajectory, and after all, even the constancy of planetary motion is also a product of much theorizing:

> As to the clarity, the observations and statements of these very people have shown the motion not to be regular because of being continually decelerated in such a way that the comet of 1577 was 20 times as fast at the beginning as at the end, and the recent one was about twice as fast.[14]

Grassi's primary argument from astronomical observations—the lack of parallax—receives a different treatment altogether. Galileo does not attempt to undermine the accuracy of the observations or their interpretation. Instead, he assaults the physical assumptions that allow them:

> A comet is not one of the wandering stars which become visible in a manner similar to that of some planet.[15]

"Parallax operates reliably," Galileo explains, "in real and permanent things whose essence is not affected by anyone's vision; these do not change place when the eye is moved. But parallax does not function in mere appearances," and comets are among those

> reflections of light [*luce*] images, and wandering simulacra which are so dependent for their existence upon the vision of the observer that not only do they change position when he does, but . . . would vanish entirely if his vision were taken away.[16]

The suggestion that comets are mere appearances also takes care of Grassi's point about the needed fuel, but Galileo never really commits to their physical makeup. The most he is willing to claim is that "there is noth-

ing among real visible objects which so much resembles a comet as do some of these optical images," but this suspicion is enough for him to declare the parallax calculation "nil":[17]

> If parallax has no cogency in determining the distances of all these refractions or reflections, images, appearances, and illusions because they change place as the observer moves (and change not only their place but their identities), I shall not believe that parallax has really any place in comets until it is first proved that comets are not reflections of light, but are unique, fixed, real, and permanent.[18]

Galileo stresses, as Descartes will a couple of decades later (see chapter 1), that some appearances, like the colors of the rainbow, are just that—appearances in essence: "every eye sees a different rainbow, a different halo, or a particular set of mock suns; those which are seen from different places are not derived from the same rays . . . but from diverse ones."[19] Comets may belong to the same category; Galileo is not committed to any physical theory of their makeup. He is undoubtedly aware that his claim that comets are sublunary, "originat[ing] in the elemental sphere," will make his reader assume that he is reverting to Aristotle's theory, according to which they are created when condensed hot and dry exhalations are set on fire by the motions of the sky. But Galileo is adamant that this is impossible: the sky has a smooth lower surface, so it cannot move the air underneath. Moreover, Galileo insists that motion per se cannot cause heat. On the contrary: experience shows that it cools down warm things. Only friction and compression of solid bodies cause heat, whereas

> I do not believe that mere agitation made in water or in air or in any other tenuous and yielding body could excite heat and fire. . . . moreover . . . friction does not produce heat in all sorts of solid bodies, but only in those of which one or both are consumed or pulverized . . . when they are struck together.[20]

With *The Assayer* the controversy comes to its virtual end. Grassi still attempts to reply (as Lothario), but apart from complete dismay at Galileo's ingratitude has little new to offer. The surprise by which Grassi and the Jesuits are taken by Galileo's positions and arguments is very telling, especially considering the common interpretation of *The Assayer*.

## *The Assayer*

Very little of this immediate context and none of the complex of visual practices and beliefs we presented above are mentioned when *The Assayer*

is usually discussed. This is important to note because *The Assayer* occupies a place of honor in the scientific epic, best captured in Stillman Drake's words: "the philosophy of Galileo as set forth in the *Assayer* is best characterized by saying that he presented an open system of scientific inquiry in opposition to the closed system of the schools."[21] More recent readings of *The Assayer* have moved beyond the general acclamation of the "admirable clarity and conciseness" that Cassirer found in the long tract,[22] but kept the traditional understanding of its main thrust. One line of interpretation finds in *The Assayer* a demonstration of Galileo's mathematical Platonism.[23] The other reads it as part of Galileo's struggle to free Copernicanism from the dictates of scriptural interpretation.[24] Both interpretations concentrate on its two famous paragraphs:

> Philosophy is written in this grand book—I mean the universe ... in the language of mathematics.[25]

And

> I do not believe that for exciting in us tastes, odors and sounds there are required in external bodies anything but sizes, shapes, numbers, and slow or fast movements; and I think that if ears, tongues, and noses were taken away, shapes and numbers and motions would remain, but not odors or tastes or sounds. These, I believe, are nothing but names, apart from the living animal just as tickling and titillation are nothing but names when armpits and the skin around the nose are upset.[26]

Neither interpretation pays much attention to the controversy over the comets or to the positions Galileo and his adversaries take in this debate. In his *Galileo's Intellectual Revolution,* William Shea presents a rare exception, but even he takes Galileo's surprising positions as sophisticated rhetorical moves in the service of his Copernicanism.[27] In general, *The Assayer* is still customarily referred to as it was by Ernest Cassirer: "the polemic against the Aristotelian and scholastic physics."[28]

By 1623 Galileo was definitely of the Copernican persuasion[29] and had already formulated a public defense of its supposed discrepancies with Scripture. He had undoubtedly challenged "Aristotelian and scholastic physics," and as we shall show in the following chapter, there may even be some merit in calling him a Platonist, if by that one implies a commitment to the reality of mathematics. Yet very little of this is relevant to *The Assayer*. First, because the only mention of scriptural interpretation by either side of the controversy is a casual reference by Grassi to the advantage of Tycho's over Copernicus'

system in that respect.[30] Nowhere in *The Assayer* does Galileo present or refer to anything like his famous arguments about scriptural interpretation from the "Letter to the Grand Duchess."[31] Second, because Galileo explicitly asserts that it is not "an appropriate place to call into comparison with Tycho such men as Ptolemy and Copernicus."[32] Third, and most importantly, because Galileo's famous paragraphs are part of a wholly empirical argument—an attempt (by Galileo!) to discredit the value of parallax observations.

### *The Price: Back to Aristotelianism*

The use of parallax in astronomy was the most established technique of mathematical empiricism, employed already by Aristarchus and brought to new levels of accuracy by Tycho and his mighty instruments. Parallax calculations allowed Tycho to make, some forty years before Grassi, those claims that produced the "different fundamental conception of the cosmos."

It is important to stress that the vehement opposition between the telescope and parallax techniques was anything but obvious. To Kepler, a decade earlier, it was actually obvious that they would complement each other extremely well, in particular regarding the question of the distance of comets. He made this point with some excitement in his generally enthusiastic endorsement of the telescope in his *Conversation with Galileo's Sidereal Messenger* of 1610:

> If a comet appears, it will be possible to make highly accurate observations of its parallax (like the moon's) by comparison with those quite minute and very numerous stars which are visible only through your instrument. From the parallax measurements we may draw more definite conclusions than we have ever had before about the height of comets.[33]

If Galileo's intention in the controversy on the comets was "a polemic against the Aristotelian and scholastic physics," then Tycho should have been his close ally and parallax observations his cherished weapon. This is exactly how Kepler saw it: the telescope, he raved,

> couples itself with Brahe's observational method in a most appropriate marriage, so that Brahe has good reason to rejoice at your method of observation, and you must base your method on Brahe's.[34]

Yet early on in the controversy Galileo has Guiducci claiming on his behalf,[35]

> In order to have the comet appear as without parallax to all observers, and still originate in the elemental sphere, it would suffice for vapours . . . to be diffused

on high and to be capable of reflecting the sun's light through distances and spaces equal to . . . those from which the comet is perceived.[36]

This is as removed from "opposition to the closed system of the schools" as one can imagine. Not only does Galileo reject parallax; and not only does he do it with a proto-Aristotelian concept of the comets and vapors; he does so in defending "the Aristotelian duality" between heavens and the "elemental sphere." The positions Galileo takes in the controversy concerning its explicit subject matter—the nature and position of comets—are extremely conservative, not to say reactionary, and far more "Aristotelian" than those of his "opposition. . . . of the schools"—the Jesuits.

These positions are particularly surprising because of the special import that *The Assayer* holds in the historiography of science, which requires another short digression into existing interpretations of the arguments it comprises. Those who have noticed how reactionary Galileo's position is[37] tend to ascribe it to the importance he assigns to defending the original Copernican system against the Tychonic compromise.[38] If comets are planet-like, Tycho's system is indeed better adapted to accounting for their trajectory; it easily explains why they show no retrograde motion while in opposition to the sun, as the Copernican analysis will predict. But as Shea notes, this interpretation means that Galileo "was so intent on refuting Tycho that he failed to notice that he was pleading for a world where there would be no room for the heliocentric theory";[39] an inexplicable oversight over many years and the composition of two separate texts. Moreover, Kepler, no less a Copernican, had little difficulty in holding to a superlunar position for the comets, realizing exactly the significance of this discovery to the demolition of the old worldview and the substantiating of the new. There were voices claiming that planetary analysis of comets means that "the Copernican hypothesis would collapse," but even those were fully aware that this is so on the condition that "other way of saving the appearances could not be found."[40] Given the reward at hand—an overthrow of Aristotelian cosmology—one would have expected Galileo to be enthusiastically searching for such a way rather than clinging to questionable Aristotelian objections. Finally, interpreting Galileo as defending Copernican heliocentrism from the Tychonic compromise relies on a clear division between two aspects of the texts he produced in the controversy. On the one hand there was the debate about the position of the comets, where Galileo maintains "a decadent Aristotelianism"; on the other, the debate about method, in which his position is supposedly a paradigm of "progress."[41] There is, however, nothing to sup-

port this division. Not only are the "decadence" and "progress" of the *Assayer* entirely intertwined, Galileo's claims about the comets are wholly subservient to his attempt to refute Grassi's argument.

Galileo, it needs stressing, does not have a strong position of his own as to what comets really are, and his trust in the Aristotelian theory is tentative and qualified at best. Relying on this theory to cast doubt on Grassi's parallax calculations means replacing mathematical-empirical technique with the qualitative and analogical mode of explanation, Aristotelian in essence if not fully Aristotelian in details. Together with the curious concept of friction causing cooling, this goes against the grain of his career-long commitments in both method and substance. It is also not the case that Galileo harbored some deep aversion to parallax considerations, or that he was always so committed to Aristotelian meteorology or convinced in the errors of Tycho's way. In a series of public lectures following the supernova of 1604 he took a clear Tychonic position and used the lack of parallax to argue that the new star was superlunar.[42] The steepest price, however, is in the very rejection of Tycho and the Jesuits' breakthrough claim that comets are "not sublunar but clearly celestial." In declining to accept their demonstrations for the changes in the heavens and in employing the notion of "elemental sphere" in his own account, Galileo reembraces the sharp distinction between the sub- and superlunar realms.

### *The Rival: Mild Instrumentalism*

Galileo pays a heavy intellectual price for the positions he takes in the controversy, and for reasons he never makes completely explicit. *The Assayer* clearly cannot be read as a simple confrontation of the new against the old, the mathematical against the verbal, or the empirical against the scholastic. This does not mean that it should no longer be thought of as a manifesto of the epistemology of the New Science, but that the empiricism it argues for and the positions that it recognizes as rivals are completely different from what has been assumed, and that these intellectual motivations are significant enough for Galileo to suspend his anti-Aristotelianism.

These intellectual motivations reveal themselves in that famous sentence about the mathematical language of nature. Galileo's plea for replacing the language of authority with the language of mathematics is not directed against some ancient authority—of Aristotle, of religion, or of habit and common sense. It is, rather, a direct assault on a particular type of empiricism, encapsulated in Grassi's knockdown parallax argument:

If at the same time from other regions the same star was also observed very near to the comet, no stronger and clearer argument could be hoped for by which it might be demonstrated that the comet had very little or no parallax, since this could be observed without any instrument and by *observation with the unaided eye*.[43]

What for Galileo is the core of the debate, what defines for him the Jesuit-Tychonic position on parallax is captured in this last clause. This is what his rhetoric of mathematics, which has always fascinated historians and philosophers of science, is aimed to demolish and replace. The debate *is not* about dogmatism vs. empiricism and definitely not about whether instruments should be employed; it is not a case of "an open system of scientific inquiry in opposition to the closed system of the schools." It is a debate between two versions of empiricism, between what one may call Renaissance and Baroque concepts of directness and mediation, a debate about the relative import of eye and instrument.

For Grassi and the Jesuits, the final arbitrator and the measure of all observations is the "unaided eye." Grassi is not at all opposed to the use of the telescope. In fact, he opens his *Disputatio* with eulogy for the achievements of "the lynx eyes":

> Now no part of the sky escapes our glance, nor is the beauty of the moon so great as it was for us formally. We have been able to distinguish the circular motions of Venus and Mercury, and who does not blush to see the sun occasionally disfigured? We have laid bare the stratagems of Mars in approaching the earth and we have exposed the attendants of Jupiter and Saturn, hitherto hidden away to no purpose.[44]

Commonsensically, Grassi perceives the telescope as a legitimate, indeed marvelous, extension of the eye, strengthening its weaknesses and repairing its errors. As Antoni Malet has recently shown,[45] this was the common way of conceptualizing this novelty among its most sophisticated users and theorizers, and Kepler among them. And indeed, interpreting Galileo as debating for this legitimacy, Grassi bitterly protests (under the name of Sarsi and on behalf of his Jesuit colleagues) what he perceives to be his portrayal as a scientific reactionary. Nothing is farther from the truth, the author of *Libra* complains; he is a champion of progress and a staunch defender of Galileo and his instruments:

> There were not lacking those who ... asserted that ... the telescope carries spectres to the eyes and deludes the mind with various images; therefore it does not display genuinely and without deception even those things which we

observe close at hand, much less those which are far removed from us, except it will show them bewitched and deformed. We ... publicly confuted the ignorance of those for whom this instrument was of no significance ... we hoped that by protecting from invidious calumnies this telescope ... we might therefore deserve well of [Galileo] rather than ill.[46]

There is no particular reason for Grassi to reject the telescope. Traditional mathematical optics provides him with a clear and trustworthy account of the principles of the instrument's operation:

Objects are enlarged by the telescope because these objects are carried from it to the eye under a greater angle than they are observed without this instrument ... according to optics, whatever things are observed under a larger angle seem larger.[47]

This analysis also provides him with an explanation, again in terms taken directly from traditional eye-centered, Euclidean-based optics, why the fixed stars, and presumably comets, should elude magnification:

Be the visible objective whatever it may, the more it is removed from the eye the smaller and smaller the angle at which it is seen ... thus, the angle of incidence of the images at the telescope scarcely vary after the objects have reached a very great distance, for then it is just as if all the rays fell perpendicularly on the lens.[48]

Note how 'modern' Grassi is, how well entrenched in the most contemporary cosmology: Copernican or Tychonian, Grassi's world offers "very large distance" for the fixed stars. Yet Kepler's optics and its abolition of the dichotomy between eye and instrument, if he is aware of either, have left him completely unaffected. The "visible object," for him, is seen *by the eye*. The telescope is of a different status altogether; it is a part of the medium *through* which vision occurs, and subject to the same mathematical analysis. It helps like any instrument might—hence the title *Libra*—but it does not change the principal onus of evidence and argument. This lies, always, with what "could be observed without any instrument and by observation with the unaided eye."

## THE SUPREMACY OF THE INSTRUMENT

### Grassi's Challenge

Grassi, we saw, was taken aback by the vehemence of Galileo's replies, and understood them as a defense of telescopic observation. But his baffled de-

fense of his credentials in this respect was misplaced. Galileo had even less patience for his hearty support than for his mild criticism: "Sig. Sarsi, give up trying to exalt this instrument with these admirable new properties of yours unless you wish to throw it into utter disrepute."[49] His sarcasm aside, what is clear is that Galileo was not disturbed by Grassi's empirical claims but by his analysis and arguments, and disturbed enough that he felt compelled to reject both Grassi's support and his conclusions, even at the price discussed above. Galileo would not allow that one can conclude about the distance of the comets from the failure of the telescope to magnify them, because he will not admit to this failure; the telescope magnifies regardless of distance:

> If a surface of a ball seen through the telescope at a distance of half a mile increases a thousand times, then so will the moon's disc increase a thousand times and no less; so will that of Jupiter and finally that of a fixed star.[50]

Galileo has no qualms about Grassi's geometrical analysis of magnification "for objects seen naturally." In that case, "the diminution of the angle is made in a continually greater ratio the more the object is removed."[51] But Galileo has little respect for the way objects are "seen naturally." What Grassi completely fails to comprehend is that the issue for Galileo is no longer the epistemological legitimacy of the telescope. From Galileo's point of view, the instrument does not extend the sense organ, but replaces it altogether, and in the process, it is the naked eye that loses its legitimacy as a source of knowledge:

> The naked eye distinguishes none of these shapes [of the heavenly bodies] without the telescope.[52]

Galileo does not reject Grassi's cosmological conclusions because he nurtures some deep-held belief in the sublunary nature of comets. Rather, he finds himself placing the comets in the "elemental sphere" because he is adamant to reject the implications of Grassi's two main arguments to the contrary. The first argument Galileo cannot accept is that fixed stars, like comets, are not magnified by the telescope, which implies that the telescope does not magnify *all* objects. The other is that absence of parallax is *the* unassailable testimony for the great distance of comets, which implies the supremacy of what "could be observed without any instrument and by observation with the unaided eye."

Galileo, it should be stressed, does not defend the telescope or apologize for its failure to magnify very distant objects. There is no such failure, he in-

sists: comets and fixed stars do not appear magnified *to the eye* because of a distortion produced *by the eye* and repaired by the telescope:

> the telescope "robs the stars of irradiation" ... [namely] it operates upon the stars in such a way [as to circumvent] the irradiation which disturbs the naked eye and impedes precise perception.[53]

The eye introduces a spurious splendor around stars and comets, which makes them appear larger. This is not real magnification, of course: the body of the celestial objects remains invisible to the naked eye. Because the telescope removes this "irradiation," the eye fails to notice that it has also magnified and made visible the celestial bodies themselves. This is not an *apologia* for the instrument. It is, rather, a charge against the eye, which errs twice: once in introducing the false irradiation and once in failing to notice the correction and magnification. Grassi's claim that fixed stars and comets "suffered scarcely any enlargement"[54] meant that they were not perceived as larger *by the eye*. But the eye, in Galileo's new radical instrumentalism, is no longer the main point of reference for visual phenomena, and definitely not the final adjudicator of their trustworthiness. The communication with Grassi unravels because, for Galileo, the mediation of the instrument is neither another source of error and distortion nor merely a remedy for the weaknesses of the eye.

## Mediation Again

Kepler's optics dictated that all vision is mediated, hence the instrument is no worse than the eye. Galileo, unperturbed by Kepler's careful optical and epistemological deliberations, is significantly more radical in his stand for the instrument: *the eye* mediates and distorts; the instrument provides the standard of trustworthy perception against which the eye should be judged. In a sense, Galileo reintroduces the distinction between artificial and natural vision that Kepler labored to abolish, reversing the epistemological hierarchy. The two ways of observation, he is arguing, provide data of entirely different value, not to be conflated or compared, and Grassi is fundamentally wrong to submit the telescope to the same analysis as ocular vision:

> Your error lies in comparing the star taken together with its irradiation when seen with the naked eye to the body of the star alone when seen with the telescope and distinguished from the irradiated regions.[55]

If Kepler was keen to hold the skeptical ramifications of his optics at bay, Galileo is unhesitant: his endorsement of the instrument comes at the

expense and with the assistance of explicit distrust in the eye. The human sense organ is not merely weak but a positive source of various deceptions, which he makes a point to enumerate:

> There is another illumination here, made by refraction in the moist surface of the eye, and by this, the real object appears to us to be surrounded by a luminous circle . . . there is a third vivid splendor here, almost as bright as that of the original light itself; this is produced by reflection of the primary rays in the moisture at the edges of the eyelids, and it extends over the convexity of the pupil . . . this radiant crown [is] a sensation of the eye . . . it does not depend upon the illumination of the surrounding area.[56]

Like Kepler, Galileo thrusts the eye into the outside world. From a veridical conduit of knowledge it becomes part of a causal process of material nature, producing phenomena to be studied and explained physically. And while the eye mediates, adding spurious and distorting brilliance, the telescope is not only a reliable source, but the standard against which to judge the observation made through the eye and the means by which to remove the errors it introduces:

> Fancy to yourself some definite size for [a] wig, and in the center of this imagine a very tiny luminous body. The shape of this will be lost, being crowned by excessively long hair . . . the telescope, by enlarging the star but not the wig, makes the tiny disc which originally was imperceptible . . . so that its shape may be well distinguished.[57]

One can only speculate if and to what degree Galileo was deliberate in choosing the "wig"—this paradigm of artificiality—to denote the eye-added splendor. But his inversion of natural and artificial, direct and mediated, is definitely deliberate, and Galileo provides it with a well-considered justification.

## *The Eye of the Mind*

The famous phrase about "the language of mathematics," in which "philosophy is written in this grand book . . . the universe," is the core of Galileo's support of the inversion of roles and standing of the eye and the instrument. The eye had always been, and for Grassi and his collaborators still was, the divinely assigned instrument of visual knowledge. This is nicely and simply put by Grassi's Jesuit colleague Christoph Scheiner in his *Oculus*, published four years before the controversy: "in order to see, the eye of the

animal fulfils the duty it was ordained by God, grasping the presence of visible things."[58] With Galileo, the eye loses this independent "duty" and becomes part of the "things." It introduces error because it is immersed in the confusing nature to be observed and its passions and affects are causally bound physical phenomena.

The telescope, on the other hand, is not bound to the physical world. It is mathematical *in essence*, fully captured by the mathematical laws governing the shape and reciprocal placing of its lenses; "the convex lens unites the rays, the concave glass expands them and forms an inverted cone."[59] The asymptotic diminution of the angle of vision to the eye, with which Grassi accounted for the apparent lack of magnification, is thus of no significance. Magnification is strictly a mathematical relation, and the telescope always magnifies, whether the eye is capable of perceiving it or not. In a pedantic mood, Galileo even insists that changing the mutual position of the lenses results in having a completely different instrument:

> [Sarsi] says that a telescope which is now long and now short may be called the same instrument though differently applied . . . Our case is just the reverse, for the use of the telescope is always the same . . . while the instrument itself is diversified by its alteration in one essential respect, which is the interval between its lenses.[60]

This pedantry is not merely a rhetorical maneuver. As Sven Dupré[61] has recently shown, contrary to what has been long assumed, Galileo did develop a mathematical understanding of the telescope. This was based on contemporary optics, which owed as much to new lens- and mirror-grinding techniques as to traditional perspective theory; it was not informed by Kepler's innovations, but it provided Galileo with the confidence to insist on the mathematical nature of his instrument. Being thoroughly mathematical, the telescope was not an extension of the eye but of reason. As beautifully put by his fellow Lyncean Faber, Galileo succeeded

> with marvellous skill [to] fit spectacles to an aging world that with mind still sound but eyes dimmed and body weakened it might see through two glasses.[62]

Galileo and Faber were not alone in the dream of an instrument of mind, superior to the eye and answering directly to the laws of reason. Just a few years earlier Kepler was contemplating similar ideas:

> Certainly, the mind itself, if it never had the use of an eye at all, would demand an eye for itself for the comprehension of things outside it, and would lay down

laws of its structure which were drawn from itself (if in fact it were pure and sound and without hindrance, that is, if it were only what it is).[63]

In Kepler's terms, Galileo could have said that the telescope is the sense organ that reason *would have* had. For this reason he finds it is very important to stress that in contrast to its Dutch predecessor, his telescope was "discovered by way of reason." The original contraption was accidentally discovered by a "simple maker of ordinary spectacles" (he does not honor Hans Lipperhey by name) who "in casually handling pieces of glass of various sorts happened to look through two at once, one convex and the other concave, and placed at different distances from the eye." His instrument, on the other hand, followed a "reasoning" that he cursorily recounts, allegedly to "render less incredulous those people who, like Sarsi, may wish to diminish whatever praise there is in it that belongs to me."[64] One can easily identify with Grassi's astonishment at the ingratitude of the one he dubbed "the Lynx," but it is less important for Galileo to gather supporters than it is to clarify that his instrument is no pair of spectacles (and he, of course, no "simple maker"). It does not assist the eye; it is an extension of reason, an embodied mathematical entity, and it can allow reason an unmediated approach to reality because *reality* is mathematical: this is the import of the famous sentence about the mathematical language of nature.[65]

As it did for Nicholas of Cusa, "the mathematical book of nature" serves Galileo as a justification for the mathematical study of nature, and the similarities and differences between their uses of the idiom are telling. Like Nicholas of Cusa, Galileo's justification purposefully conflates ontology and epistemology, reconstructing reality so it would fit the way he purports to know it. Like Nicholas of Cusa, Galileo finds in mathematics the creative power of reason: it is through mathematics that reason creates the telescope, which allows "reading" through appearances.[66] But here is also the limit of the resemblance between the Baroque natural philosopher and the Renaissance Neo-Platonist. Unlike the beryl stone, Galileo's instrument is decidedly an artifact, with no occult powers of its own, and observation through it does not lead *beyond* things but *at* them. Galileo offers neither a route to gaze at the divine, nor a justification for mathematical reasoning, but an argument for radical instrumental empiricism: nature is written in a language legible *only* through the instrument. The mathematical structure of reality underscores, and explains how it is, that the telescope does not mediate—it reveals the real makeup of nature; shapes, figures, quantities—directly to reason. *The senses* mediate, creating appearances that are not proper representations of the "external bodies":

I do not believe that for exciting in us tastes, odors and sounds there are re-
quired in external bodies anything but sizes, shapes, numbers, and slow or
fast movements; and I think that if ears, tongues, and noses were taken away,
shapes and numbers and motions would remain, but not odors or tastes or
sounds. These, I believe, are nothing but names, apart from the living animal,
just as tickling and titillation are nothing but names when armpits and the skin
around the nose are upset.[67]

"Sizes, shapes, numbers, and slow or fast movements"; nature comprises
elements that the instrument makes apparent, but that the senses mask with
"tastes, odors and sound . . . tickling and titillation." What is true for noses
and armpits is just as true for the eye:

I believe that vision, the sense which is eminent above all others, is related to
light [*luce*], but in that ratio of excellence which exists between the finite and
the infinite, the temporal and the instantaneous, the quantity and the indivis-
ible; between darkness and light.[68]

### THE CONTROVERSY CONTINUES

#### *The Thriving of the Jesuit-Tychonic Tradition: Riccioli*

Grassi's bafflement at finding himself on the opposite side from Galileo
is hardly surprising. He was completely justified in perceiving himself as
being at the forefront of the new practices of *Astronomia et Philosophia*: he
performed complex experiments and meticulously gathered empirical data,
he used sophisticated geometrical analysis and theorized along the latest
available hypotheses. Nevertheless, his and Galileo's projects were essen-
tially different. For Grassi and his fellow Jesuits, the new science was to
come with minimal interference to existing authorities, and most definitely
with no challenge to religious ones.[69] Understood as an aid to the eye, the
telescope served them very well. As Albert Van Helden noted, "The telescope
was a blessing to conservative astronomers, because it established an area of
research within astronomy in which one's religious and astronomical con-
victions did not particularly matter."[70]

The real radical implications of Galileo's manner of using and interpret-
ing the telescope were epistemological, and "religious and astronomical"
only by consequence. For the Jesuits those aspects were intricately inter-
woven, but what made the confrontation inevitable is that for the Lynceans
and Galileo the overthrow of old authority in the name of their own was
an integral part of the new challenge and opportunities. Like Kepler cry-

ing "physicists, prick up your ears,"[71] they were explicit and brazen in their assault on disciplinary boundaries and structures of epistemological authority:

> As to the system of Ptolemy, neither Tycho ... nor even Copernicus, could clearly refute it, inasmuch as a most important argument taken from the movement of Mars and Venus stood always in their way ... Yet I have demonstrated this to be true ... by means of a fine telescope.[72]

The dismantling of the Ptolemaic system, Galileo declares, is not an unexpected outcome of the new instrumental prowess, but part of its raison d'être and its claim to fame over and above the comparatively reticent "Tycho and even Copernicus."

Galileo's radicalism, on the other hand, was not necessitated by the use of the telescope in particular or by the new astronomy in general. The Jesuit-Tychonic approach represented by Grassi was as conducive to progressive inquiry, and his arguments are still to be found decades after the controversy. A particular fine example of this tradition is the opus magnum of Jesuit astronomy, Jovani Baptista Riccioli's *Almagestum Novum* of 1652.

Riccioli's title captures the epistemological option that one finds in the Jesuit posture towards the new science: new tools and techniques in the service of age-old pursuits and under the guidance of age-old criteria.[73] The *Almagestum Novum* can be read as an argument in two long volumes in favor of Tycho's system. Like Scheiner's dressing of the foundations of traditional optics with all the insights and procedures of Kepler's new optics he could afford (see chapter 1), Riccioli supports the Tychonian version of geocentrism with the most sophisticated and up-to-date empirical, instrument-assisted observations, interpreted through theoretical apparatus in which novel ideas are carefully administered within a traditional conceptual framework.

In his demonstration of the prowess of Tycho's techniques and his defense of the system affixed to it, Riccioli dedicates significant space and attention to the question of comets and particularly their position. Parallax observations are his clinching argument in favor of placing comets in the superlunar realm; they are the "Achilles or Atlas of astronomers."[74] In regards to Grassi's arguments from the telescope, however, Riccioli's attitude is more reserved and complex. Though his final conclusion would be that the comets *are* superlunar, he accepts Galileo's arguments why this *cannot* be inferred from the application of the telescope. Though he accepts Galileo's arguments concerning the telescope, he renders them in scholastic, syllogis-

tic exposition and, again in a manner analogous to Scheiner's treatment of
Kepler's analysis, neutralizes their epistemological implications by turning
them to the eye as the point of reference and final epistemic arbitrator.

Grassi presented two arguments from the telescope. To the first, the lack
of magnification, Galileo answered by acknowledging that the eye does not
perceive a magnification of the fixed stars and denying all Grassi's conclu-
sions: that the stars are not magnified; that the telescope's alleged failure to
magnify them is a consequence of their distance; and that one can infer by
analogy that the comets are similarly distant. Riccioli fully understands and
seems to accept Galileo's account of the apparent lack of magnification: the
cause of that is the disappearance of the spurious radiance surrounding the
fixed stars when observed by the naked eye:

> The truer cause that [Galileo and Guiducci] give is that the stars, as well as com-
> ets and flames that the naked eye perceives at a long distance, appear to us with
> a crown and surrounded by certain adjoining rays, which are not truly within
> the object or proper to it, but are an affectation of our dilated pupils and the fal-
> lacies [*fallacia*] of our vision.[75]

Riccioli reads the 30-year-old controversy as if it were a 300-year-old *dis-
putatio*. Galileo, in his rendition, "negates the causal proposition assumed
[*positam*] in the major proposition of the syllogism" provided by Grassi: all
things not magnified are far away; the comets are not magnified; hence the
comets are far away. Galileo, according to Riccioli's interpretation, rejects
the premise that the cause of the lack of magnification is the distance of the
fixed stars, but accepts that they are not magnified. This interpretation cap-
tures the structure of Galileo's argument and makes it a valid refutation of
the inference from the distance of the fixed stars to that of the comets, but
it effectively suppresses its radical core. Riccioli entirely overlooks Galileo's
vehement refusal to allow either that the telescope is limited in its applica-
tion or that "magnification" is a predicate of the image, prior to and inde-
pendently of being perceived by the eye. For Galileo, *the eye* failed to per-
ceive the magnified representation of the distant object because *the eye*—the
"affectation of our dilated pupils and the fallacies of our vision" as Riccioli
properly paraphrases—introduced false radiance that the telescope filtered
away, providing a magnified image the real object. For Riccioli, "the tele-
scope indeed strengthens and protects the eye, not allowing *their* oppressive
radiance into the pupil." The "fallacy," in his analysis, is caused *outside* the
eye, which is properly fulfilling its divinely ordained duty. The Jesuits had
little difficulty in integrating telescope and eye: in his *Rosa Ursina*, twenty

years earlier, Scheiner himself went as far as to write about "the affinity (*affi-nitas*) and [mutual] dependency (*necessitudo*) of the eye with the tube and the tube with the eye."[76] The instrument, for Grassi, Scheiner, and Riccioli, is highly beneficial; it "protects the eye," but it has no claim to an independent epistemological status, definitely not one superior to the divinely endowed sense organ.

Riccioli, then, admits the details of Galileo's arguments concerning the apparent lack of magnification, but neutralizes their radical implications. This is also the thrust of his treatment of Grassi's other telescopic evidence to the distance of comets, namely the fact that they are best seen with the instrument fully contracted. The nearer the observed object, Grassi points out, the more one needs to extend (*producere*) the telescope. The comets, one has to conclude by simple analogy, must be among the farthest objects observed by the telescope, definitely farther than the moon, which does require extension. Riccioli's analysis is symptomatic:

> the real cause of the difference is that the nearer object cannot be seen through the telescope without confusion of many *visual rays* and [cannot be] properly received [*ac bene terminatum*] unless the tube is very elongated.[77]

Riccioli agrees with Galileo: the need to contract the telescope when observing comets is no argument for their distance. However, his reasons are inverted: the manipulation of the telescope is to aid the eye in its reception of *visual rays*—those perspectivist entities communicating objects to the mind. This is again the same strategy that Scheiner adopted in dealing with Kepler's optics some forty years earlier: attempting to grant the empirical advances while ignoring the most fundamental epistemological ramifications. Visual rays made sense only in reference to the human eye, so reinstating them, for Riccioli as it had been for Scheiner, was an attempt to return to the sense organ as *the* point of reference. This is the visual epistemology privileging the eye that Kepler carefully demolished and Galileo blatantly rejected.

Sophisticated telescopic astronomy could thrive without the fantasy of the instrument as a materialized mathematics allowing direct approach to nature's constituents. For Riccioli, changing the length of the telescope was merely a practical manipulation of a tool. There is no mention in his long discussion of the fact that this is done in order to change the distance between the lenses, and there is definitely no hint of the mathematical relation embedded in this distance, which for Galileo was the very essence of the instrument.

Riccioli would use parallax considerations to rule in favor of Tycho, but his telescopic considerations conclude in *aporia*; the comparison between observation of the moon and the comets *"nondum constat."*

### *Radical and Mild Instrumentalism: Hooke vs. Hevelius*

Central to the "instrumental Tychonism" tradition shared by Grassi and Riccioli was the attempt to find a place for the new instrumental capacities within the old visual epistemology. Galileo's radical instrumentalism was a direct challenge to this compromise, and Robert Hooke's 1674 *Animadversions on the . . .* Machina Coelestis *of . . . Johannes Hevelius* is a particularly eloquent representative of the polemic tradition that Galileo inaugurated.

Hooke's text, brought to print as an issue of his Cutlerian Lectures,[78] is, as his title declares, a critical review of the first volume of Hevelius' grand *Machina Coelestis*, published in Gdansk a year earlier. Hooke clearly and explicitly identifies Hevelius as an heir to the tradition established by Tycho, directing both his approbation and critique at the "instruments of . . . *Hevelius* and *Tycho*."[79] As such, the *Machina Coelestis* represented an important challenge for Hooke and radical instrumentalism. Like Grassi and Riccioli before him, Hevelius complemented his Tychonic techniques and instruments with exquisite observational skills, and his commitment to the telescope was even more pronounced and triumphant than theirs.[80] He designed, built, improved, and used scores of them for different purposes, from the domestic one he depicts himself using in fig. 3.2 to the 140-foot instrument depicted in his *Machina Coelestis*, which was practically unusable; an object of marvel, celebrating instrumental prowess.[81] He undoubtedly conceived himself, like Grassi, not only as a consummate practitioner but as his generation's leading advocate of their cause.

Hooke is happy to acknowledge Hevelius as an "honourable, learned, and deservedly famous astronomer." His critique does not concern his rival's skills or his commitment to the telescope. Like Galileo's but devoid of the rhetorical flare, it is clearly directed at the epistemological standing and relative status Hevelius assigns to eye and instrument. With all his great instruments, Hooke complains, Hevelius is still basically suspicious of the alleged mediation of lenses,

as if he had some dread of making use of Glasses in any of his sights. Whether it were, that he supposed Glasses to have some hidden, un-intelligible, and mysterious way of representing the Object, or whether from their fragility, or

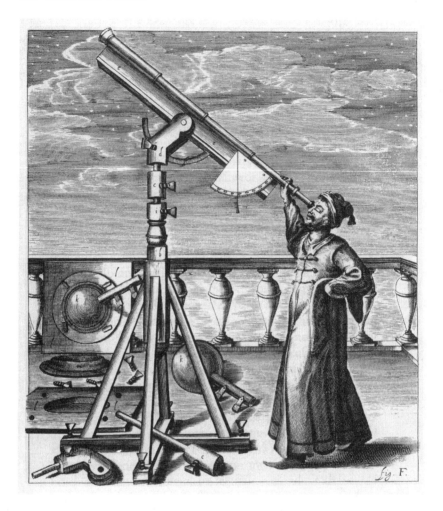

FIGURE 3.2  Hevelius and one of his telescopes (*Selenographia*, 1647). Reproduced with permission of the Rare Books and Special Collections Library, The University of Sydney.

from uncertain refraction ... or whether from some other mysterious cause ... I cannot tell.[82]

Hooke's complaint concerns Hevelius' preference not to use telescopic sights (*dioptrae telescopicae*) with his instruments. With Hevelius' credentials, the use of the telescope itself was obviously not in question, but nei-

ther was it in the controversy over the comets. Galileo did not deny that Grassi and the Jesuits successfully incorporated the instrument; he had no more pretext than Hooke for such a claim. He was advocating an inversion of the relative standing of the naked eye and the instrument, and Hooke's disappointment, expressed in the milder style of the Royal Society, is that Hevelius has yet to adopt this inversion:

> There is therefore one thing in *Hevelius* his instruments, that though they be never so large, never so accurately divided, of never so choice and convenient material, and never so tractable for use, with one of about two or three foot radius of mettal [*sic*] with *Tycho*'s Sights and Diagonal Divisions, which is occasioned by the limited power of distinguishing by the naked eye.[83]

With two more generations of instrument design and construction behind him, Hooke feels entitled to bolster Galileo's metaphysical arguments for the principle superiority of the instrument over the naked eye with a practical one: unless instruments completely replace the eye, the accuracy of observation will always be finally determined by the eye's "limited power of distinguishing":

> If the eye cannot distinguish a smaller object then [*sic*] appears within the angle of half a minute, 'tis not possible to make any observation more accurate, be the instrument never so large.[84]

Hooke proceeds to explore "the limited power of the naked eye" in a series of experiments and concludes that "those therefore that desire or need Instruments to make Observations to Seconds must take another course then [*sic*] any that I know yet described."[85] Jed Buchwald has recently argued that Hooke was wrong: Hevelius was capable of making naked eye observations of a higher resolution than allowed by Hooke, perhaps better than telescopic sights enabled at the time.[86] Flamsteed and Halley indeed came to acknowledge as much.[87] Our point here, however, is not the relative power of Hooke and Hevelius' arguments but the terms of the debate, which Buchwald's captures nicely as being between "the judging eye [and] the sighted telescope."[88] This is also how Hevelius perceived "that issue of the sights,"[89] as he calls it derisively, even though he could not help feeling that Hooke and Flamsteed (before he was persuaded) were primarily questioning his integrity and skills. He understood better than Grassi that the debate was between senses and instruments—by his time, it was no longer a question of the "instrumentorum certitude,"[90] but of how much authority the naked eye would still be allowed to claim. In this regard, Hevelius had not forsaken the

Tychonic-Jesuit foundation. Unlike his predecessors, he was aware of the rivalry he was in, and could now explicitly support his position. "The matter rests primarily" he argued, on the fact that his rivals "could not plainly perceive any observation by their telescopic sights, unless they would first examine and rectify" these sights, which perforce would mean recourse to naked eye instruments such as his "sextant, octant or scaled quadrant."[91]

The dream that Hevelius, with all his trust and pride in his instruments, would not share with Hooke, is the one in which those instruments all but take over, marginalizing eye and observer. Hooke had already sketched this fantasy a decade earlier, in his 1665 *Micrographia*, in the complex of instruments described in the "preface" and drawn in Hooke's *Schem. 1* (fig. 3.3). The power of Hooke's instruments stems from their interdependence; they derive their authority from each other. The microscope is lit by a water globe (*fig. 5*—a successor to the traditional optical empirical instrument which was used by Descartes in his rainbow experiments) and serviced by the lens grinder (*fig. 3*). The water microscope (*fig. 4*) is there to solve its aberration problems and the refractometer (*fig. 2*) to gauge the fluids introduced into it. The barometer (*fig. 1*), "an Instrument . . . contriv'd to shew all the minute variations in the pressure of the Air"[92] ascertains the qualities of the medium and experiments constitute these relations and establish their parameters. Hooke's instruments embody Kepler's optics: they manipulate light. They have no recourse to visual rays or *species*, because they do not defer to the human observer. Hevelius also has "great instruments, that is quadrants, sextants and octants, and especially the azimuthal quadrants,"[93] but they all relate observer to object; they can be calibrated against each other, but they are meaningless without the human eye. In contrast, in Hooke's "Scheme" there is no eye. His instruments are not meant as aides to a weak human organ, they are meant to replace it. Conceived specifically in order to bypass the "limited power" of the human sense, Hooke's instruments are "artificial Organs."[94]

Hooke's rhetoric is not particularly novel. The expression "artificial eye" dates back to Kepler, and the Jesuits were happy with "the eye is a natural telescope; the telescope is an artificial eye."[95] Yet Hooke's instruments do far more than cover for the "infirmities"[96] of the senses and they are important even beyond the "benefit for humane life, and the Advancement of *Real Knowledge*"[97] that Thomas Sprat celebrates on behalf of the Royal Society. Beyond the Baconian and empiricist commonplaces dictated by the *Micrographia*'s designation as the "handsome book" that the Royal Society would present to the newly restored monarch lies instrumentalism as radical as

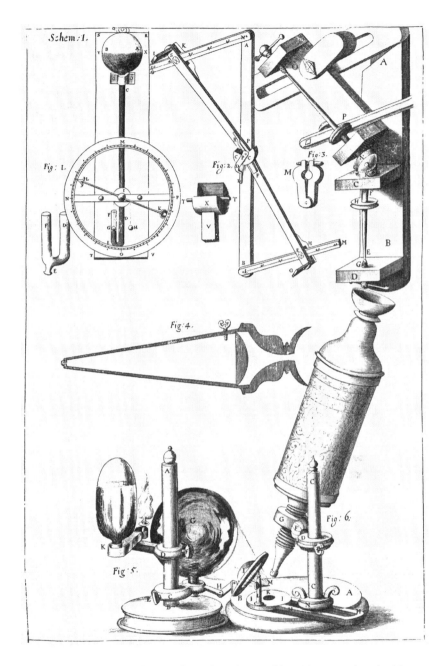

FIGURE 3.3 Hooke's Scheme 1 from the *Micrographia*, 1665. Reproduced with permission of the Rare Books and Special Collections Library, The University of Sydney.

Galileo's. "Artificial instruments," in Hooke's world, have a quasi-religious significance:

> By the addition of such *artificial Instruments* and *methods*, there may be, in some manner, a reparation made for the mischiefs, and imperfection, mankind has drawn upon it self, by negligence, and intemperance, and a wilful and superstitious deserting the Prescripts and Rules of Nature, whereby every man, both from a deriv'd corruption, innate and born with him, and from his breeding and converse with men, is very subject to slip into all sorts of errors.[98]

Hooke may have overstated his case, but he was completely sincere. It was appropriate to discuss instruments in terms of fall and redemption, "the only way which now remains for us to recover some degree of those former perfections,"[99] because they represent the one divine advantage that humans enjoy over beasts:

> It is the great prerogative of Mankind above other Creatures, that we are not only able to *behold* the works of Nature, or barely to *sustein* our lives by them, but we have also the power of *considering, comparing, altering, assisting, and improving* them to various uses. And as this is the peculiar priviledge of humane Nature in general, so is it capable of being so far advanced by the helps of Art, and Experience, as to make some Men excel others in their Observations, and Deductions, almost as much as they do Beasts.[100]

In terms of "observations" and the capacity to "behold the works of nature," Mankind is essentially inferior to "Beasts":

> As for the actions of our *Senses*, we cannot but observe them to be in many particulars much outdone by those of other Creatures, and when at best, to be far short of the perfection they seem capable of.[101]

Our senses carry no promise of veracity. They are but a part of our material nature, unfavorably compared to those of other "Creatures." The "helps of Art" are therefore indispensible for our acquisition of knowledge. As they were for Galileo, "*artificial instruments*" are extensions of *reason*, "the great prerogative of Mankind above other Creatures," not aids to the natural organs. They are not answerable to the unmediated senses but sanctioned by reason's capacity to capture the essentially mathematical structure of nature:

> It seems not improbable, but that by these helps of subtilty [*sic*.] of Bodies, the structure of their parts, the various texture of their matter, the instruments and manner of their inward motions, and all other possible appearances of things, may come to be more fully discovered.[102]

This artificial, reason-produced, and mathematically-secured whole of the *Micrographia* allows Hooke in the *Animadversions* to put another clear distinction between his use of observation instruments and Hevelius': radical instrumentalism thoroughly detaches observation from the particular observer. As Winkler and Van Helden demonstrated, Hevelius' authority as an observer and interpreter of his observation rests with him, personally. He is the one operating his telescope in the *Selenophia* (fig. 3.2) and his sextant in the *Machina Coelestis* (with Elizabetha, his wife), and the drawings are in his own hand; Hevelius takes full responsibility for all aspects of observation, record, and reproduction:

> How could the reader be sure that what was on the page was really what Hevelius observed? The visual information passed from Hevelius' eye through his brain to his hand, and by his own drawing and engraving directly to the page without the interposition of any agent. Hevelius stressed this seamless process, from observation to the printing of the engravings, in order to certify his illustrations: *his* pictures actually represented what he saw.[103]

Hooke's observation practices and instruments, in contrast, have nothing personal in them:

> To prevent the inconvenience of looking up or in any other uneasie posture by the help of reflex Metal one may always look Horizontally, that is, perpendicularly to the plain of the Wall of Mural Quadrant. And to prevent the trouble and labour of moving or lifting the Tube by the help of a long yard poysed upon Centers on a Frame before the said Instrument, both the Tube & Arm for the sight, and the Seat on which the Observator sits, may be counterpoised, so that by turning a windle, he may easily raise himself with the Tube to any posture desired . . . By this means (in one Nights Observation) the Declinations of some hundreds of Stars may be taken to a Second by one single Observator, having only one or two Assistants to write down the Observations as fast as made. And at the same time the right Ascension of every one of them may be taken by the help of a very accurate Compound-circular Pendulum Clock, which I shall elsewhere describe.[104]

The adjustable chair is no trifle. Like the pendulum clock, the telescopic sight, the micrometer, the grid, and the universal joint (fig. 3.4), fixing the seat and standardizing the posture are means for making observation independent of any specific "observator." Hooke's instrumental complex is not designed to assist a human observer, definitely not any individual. It mechanizes and depersonalizes observation, turning it into a causal process in which the observer is a replaceable part rather than the terminus.

FIGURE 3.4 Hooke's pendulum-controlled quadrant (*Lectiones Cutlerianae*, 1679). Reproduced with permission of the Rare Books and Special Collections Library, The University of Sydney.

CONCLUSION: WHAT IS THERE TO SEE?

The naturalization and depersonalization of naked eye observation is the complement of the mathematization of the instrument and its objects. Like Galileo, Hooke legitimized radical instrumentalism with the notion of the instrument as a mathematical extension of reason that enables the observer to read "the language of mathematics" by which "Philosophy is written in this grand book . . . the universe."[105] The microscope could be more easily associated with elements of nature than the telescope, and in the *Micrographia* Hooke takes both metaphors quite literally: "We must first endevour to make *letters*, and draw *single* strokes true, before we venture to write whole *Sentences*," he writes, and commences his observations, "as in geometry,"[106] with a physical "point": "the point of a Needle." He follows with an observation of a line: "the edge a Razor," then surface: "fine lawn," and so on in rising geometrical complexity, "bodies of the most simple nature first, and so gradually proceed to those of a more compounded one."[107]

Hooke's valiant attempt to practice what he and Galileo have been preaching brings to the fore the tensions inhering in radical instrumentalism and in the attempt to justify it by feigning a common mathematical essence for reason, instrument, and nature. The "physical point" that Hooke chooses as "the most natural way of beginning,"[108] as well as his first lines, surfaces, and solids are not, in fact, part of nature. They are, as he is well aware and reflective about, products of art. To a degree, this is the reason why they are disappointing through the microscope (fig. 3.5); why

> the top of a Needle (though as to the sense very sharp) appears a broad, blunt, and very irregular end; not resembling Cone, as is imagin'd, but onely a piece of a tapering body, with a great part of the top remov'd, or deficient.[109]

After all, artifacts are "design'd for no higher use, then what we were able to view with our naked eye," so there should be no surprise that when "A Razor [is] viewed by the Microscope, . . . we may observe its very Edge to be of all kind of shapes, except what it should be." Hooke also offers the obligatory nod towards "the Omnipotency and Infinite perfections of the great Creatour [*sic*],"[110] but all these considerations only go to stress that with respect to the alleged mathematical order to be revealed by the instrument, the difference between art and nature is only matter of degree:

> the *Microscope* can afford us hundreds of Instances of Points many thousand times sharper [than the needle's]: such as those of the *hairs*, and *bristles*, and *claws* of multitudes of *Insects*; the *thorns*, or *crooks* . . . of many of which, though the Points are so sharp as not to be visible, though view'd with a *Microscope*

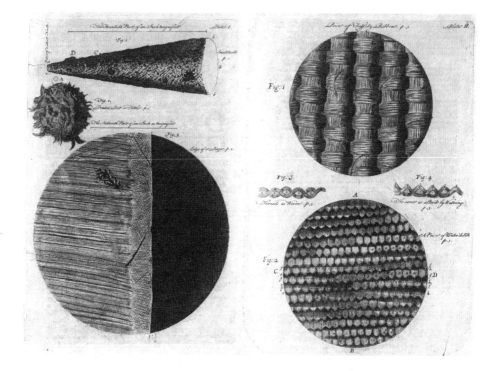

FIGURE 3.5 Hooke's needle point, razor edge, and silk taffetas (*Micrographia*). Reproduced with permission of the Rare Books and Special Collections Library, The University of Sydney.

(which magnifies the Object, in bulk, above a million of times) yet I doubt not, but were we able *practically* to make *Microscopes* according to the *theory* of them, we might find hills, and dales, and pores, and a sufficient bredth [*sic*], or expansion, to give all those parts elbow-room, even in the blunt top of the very Point of any of these so very sharp bodies. For certainly the *quantity* or extension of any body may be *Divisible in infinitum*, though perhaps not the *matter*.[111]

Artificial magnification reveals the "deformity" of all "*Artificial* things,"[112] but it does not reveal any "form," definitely not a mathematical one, in natural things. This could be admired:

in natural forms there are some so small, and so curious, and their design'd business so far remov'd beyond the reach of our sight, that the more we magnify the object, the more excellencies and mysteries do appear; And the more we discover the imperfections of our senses.[113]

But what is admired is not the promised mathematical structure of nature but its inexhaustible variety; its "excellencies and mysteries." The "rudeness and bungling of *Art*" are revealed only by more sophisticated art, "if examin'd with an organ more acute then that by which they were made." Indeed, "the more we see of their *shape,* the less appearance will there be of their *beauty:* whereas in the works of *Nature,* the deepest Discoveries shew us the greatest Excellencies." This beauty is "An evident Argument, that he that was the Author of all these things, was no other then *Omnipotent.*" However, not because the instrument reads the "mathematical language" by which He wrote "in this great book . . . nature." Rather, the microscope reveals that He is

> able to include as great a variety of parts and contrivances in the yet smallest Discernable Point, as in those vaster bodies (which comparatively are called also Points) such as the *Earth, Sun,* or *Planets.*[114]

The attempt to support radical instrumentalism with the concept of "the language of mathematics" had become self-defeating. By the 1670s Hooke was already not alone in finding grandeur in the variety and mystery, rather than order, discovered through the new optical instruments. Nicholas Malebranche, for example, has already committed to the arguments and line of reasoning that Galileo and Kepler sketched on behalf of radical instrumentation. Malebranche was particularly impressed by the separation of the eye from reason and its demotion into the causal realm of nature. The consequence, he reasons, is that not only "our eyes generally deceive us in everything they represent to us," but that in fact "it is not the eye but the soul that sees." Indeed, in order to decipher the "disturbances of the brain's fibers produced by the light reflected by objects and the perceptions we have of them," the soul would require "knowledge of the construction of its eyes and the brain" and "so great a knowledge of optics." Since one cannot assume it to possess such a knowledge, let alone use it "at the very instant that we open our eyes and look around," Malebranche has to conclude that "God alone gives us perceptions of objects." If natural vision is a mediated, causal process, there is no point in militating against the mediation of the instrument, and Malebranche allows artificial magnification to take a central role in his arguments for the greater glory of the Creator: "With magnifying glasses, we can easily see animals much smaller than an almost invisible grain of sand."[115]

Yet fifty years earlier, Grassi, a Jesuit and devoted to His Word no less than to the New Science, either did not have at his disposal or would not

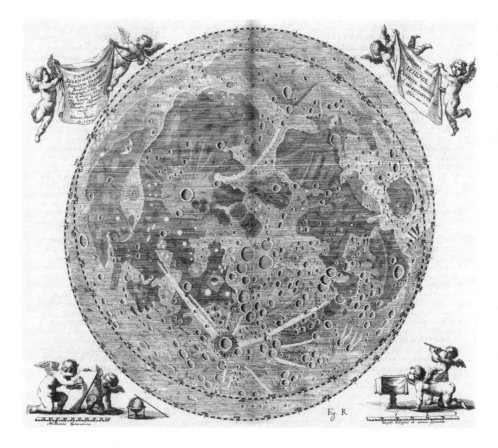

FIGURE 3.6 Moon map from Hevelius' *Selenographia*. Reproduced with permission of the Rare Books and Special Collections Library, The University of Sydney.

use such a concept of glory. For him, the variety introduced by the telescope revealed that nature was less perfect, hence less beautiful than we assumed:

> No longer, like earlier generations, are we bleary-eyed from continual watching of the stars since we know that they are very far removed, and now not part of the sky escapes our glance, nor is the beauty of the moon so great as it was for us formerly. We have been able to distinguish the circular motions of Venus and Mercury, and who does not blush as we see the sun occasionally disfigured?[116]

Galileo, anxious to defend the mathematical rapport by which he legitimized the inversion of epistemological standings, finds himself defending

FIGURE 3.7 The planets according to Galileo's *Assayer* (*Opere* 6:361). Reproduced with permission of the Rare Books and Special Collections Library, The University of Sydney.

the simplicity of its revelation. Instead of Hooke's "Telescopes or Microscopes producing new Worlds and Terra-Incognita's to our view,"[117] Galileo's "telescope 'robs the stars of irradiation.'"[118] Gone are the marvels and wonders of the *Sidereus Nuncius*; the beautiful moon has to be left, at least temporarily, to Hevelius and the Tychonic tradition (fig. 3.6). Radical instrumentalism requires the bare bones representation of the heavens as "triangles, circles and other geometrical figures" (fig. 3.7).

# ∗ PART II ∗

*Mathematization*

———— ✳ ————

# Nature's Drawing

## *Problems and Resolutions in the Mathematization of Motion*

### INTRODUCTION

FOR GALILEO, mathematics was a justification for the new practices of instrumental observation. For Kepler, it was a justification for causal arguments about the heavens. Their mathematics was to be descriptive and explanatory. Nature, as it presented itself through the new instruments, had to comply. The dramatic challenges and marvelous accomplishments of the new empirical and mathematical practices determined the theoretical and metaphysical aspects of the "mathematization of nature."

One might have expected the application of mathematics to theory to have been a much more straightforward process. The motivations for the mathematization of natural philosophy seem clear: enjoying the clarity and certainty of mathematics; the resources can be easily identified: the mathematical "middle sciences" of the schools and the revival of Archimedean mathematics; and the rivals and challengers long recognized: the Aristotelian dismissal of the explanatory power of mathematics. Still, the mathematization of nature was not a progressive process of successful submission of the varied phenomena to a handful of simple, universal mathematical laws. What was hoped that mathematics would achieve; what had been perceived as the main obstacles and their solutions; and the ways in which the new mathematical natural philosophy was justified—all changed dramatically through the seventeenth century.

TRACES

> And I have not satisfied my soul with speculations of abstract Geometry, namely with pictures, "of what there is and what is not" to which the most famous geometers of today devote almost their entire time. Instead, following the traces [*vestigia*] of the Creator with sweat and heavy breath, I have investigated geometry through the actual [*expressa*] bodies of the world themselves.[1]

These are the words with which Kepler expresses his ideal of mathematical investigation of nature. Below are the words with which Galileo introduces *his* great achievement in the mathematical "new science," the analysis of accelerated motion:

> And first of all it seems desirable to find and explain a definition best fitting natural phenomena. For anyone may invent an arbitrary type of motion and discuss its properties; thus, for instance some have imagined helices and conchoids as described by certain motions which are not met with in nature, and have very commendably established the properties which these curves possess in virtue of their definitions; but we have decided to consider the phenomena of bodies falling with an acceleration such as actually occurs in nature and to make this definition of accelerated motion exhibit the essential features of observed accelerated motions.[2]

The similarity of their phrasing is telling. Both Galileo and Kepler had their mathematical skills and repertoires well rooted in the mixed sciences—Galileo's in mechanics, Kepler's in astronomy and optics (sharing an interest in music).[3] Yet it is commonly alleged that their trust in the extension of mathematics to natural philosophy originated from different sources: Kepler's from Neo-Platonism, and Galileo's from the success of its practical applications. Here, however, they apply the same contrast and aver the same choice. Between "abstract geometry" produced by "motions which are not met with in nature" on the one hand, and geometry that "exhibits ... observed ... motions" or "expresses the body of the world" on the other, both choose to follow real "traces."[4] Galileo and Kepler, we saw, shared an idea of mathematics as a guarantor of the new ways of seeing. Here they seem to share the demand that mathematics itself be *seen*.

The obscure concepts of geometrical "traces" and of a mathematical definition "fitting natural phenomena" suggest that it is not epistemology that worries the two court mathematicians here, but ontology. Neither of them questions the power of mathematics to provide the knowledge they seek; it is the objects that mathematics can be true about that they both feel forced

to establish. Mathematics is not easily applied to "natural phenomena"; it coheres much more easily with "an arbitrary type of motion." What, therefore, does real motion need to be if it is to be captured by mathematics, and what can be the mathematical entities that apply to real "observed . . . motions"?

These ontological dilemmas and the ways in which they were confronted were not free-wheeling philosophical musings. The traditions from which Galileo and Kepler borrowed their mathematical tools determined their proper use with a set of metaphysical presuppositions: the understanding of what mathematics is, and what the objects to which it is applicable are, established the proper questions, the permissible answers, and the distribution of intellectual labor between practices and practitioners of mathematical knowledge. Kepler and Galileo's metaphysical toil embed their efforts to accommodate and modify these tools so they could serve their own mathematical project, which was far more ambitious than tradition allowed. Freed from the difficulties Kepler and Galileo perceived themselves as confronting, their successors found their solutions of little use as they further reshaped the mathematical means and ends of Baroque natural philosophy.

## KEPLER

### Physica

It may seem surprising that Kepler found it necessary to justify his use of geometry with such an ornate idea as "traces." As discussed in the previous chapters,[5] his trust in mathematics as a key to unlocking the mysteries of the cosmos was anchored in Neo-Platonic religiosity, which should have demanded little else:

> geometry . . . is coeternal with God, and by shining forth in the Divine Mind supplied patterns to God . . . for the furnishing of the world, so that it should become best and most beautiful and above all most like to the Creator. Indeed all spirits, souls, and minds are images of God the Creator. . . . Then since they have embraced a certain pattern of creation in their functions, they also observe the same laws along with the Creator in their operations, having derived them from geometry.[6]

Yet from very early on Kepler is clear that he wants more from the mathematical study of nature than could be provided by either the Neo-Platonism of his time or the long mathematical traditions of the mixed sciences. The

physicalization of optics, with its dramatic effects that we expounded in the first chapter, was a means rather than the primary end of this endeavor. The speculations he was sending to his erstwhile teacher Michael Maestlin even before his *Mysterium Cosmographicum* of 1596 (and which the latter was finding of minimal value) were already aiming at a full-blown, causal science of the heavens:

> The moving soul [is] . . . in the sun . . . But what makes the remote [planets] slower is due to another cause. We comprehend this from our experience with light. For light and motion are connected by origin [i.e., the sun] as well as by action and probably light itself is the vehicle of motion. Therefore, in a small orb, and so also in a small circle [of light] near the sun, there is as great [a quantity of moving force or light] as in the greater and more distant [orbit]. The light in the larger [orbit] is certainly more rarefied, whereas in the narrower it is denser and stronger. And this power again is in a proportion of circles, or of distances.[7]

This is the dream of *physica coelestis*, which Kepler believed he realized in his *Astronomia Nova* of 1609. It was novel, he later bragged (in the 1621 second edition of the *Mysterium*), and indeed superior to his first attempt in the *Mysterium*, in managing to find mathematical relations that are maintained purely physically:

> Proportions between the motions have been preserved . . . not by some understanding created jointly with the Mover, but by . . . the completely uniform perennial rotation of the sun [and] the weights and magnetic directing of the forces of the moving bodies themselves, which are immutable and perennial properties.[8]

### Order in Motion

Kepler's challenge is capturing motion mathematically. It is not the ancient task of reducing "anomalies" to uniformities that should be as close to rest as possible. Rather, "rotation" and "weights"—physical causes and motions—were to *cause* mathematical "proportions." This is the insight that makes music and astronomy share not only their mathematical method but also their physical underpinning:

> In general in everything in which quantity, and harmonies in accordance with it, can be sought, their presence is most evident in motion rather than without motion. For although in any given straight line there are its half, third, quarter, fifth, sixth, and their multiples yet they are lurking among other parts which are incommensurable with the whole.[9]

Static lines comprise only the possibility of significant mathematical proportions; they contain all relations, and most of those are "incommensurable." Kepler adjoins this metaphysical reasoning on the primacy of motion with an epistemological corollary:

> The mind, without imagining certain *motion*, does not discern harmonic proportions from the confused infinite [proportions] surrounding them within a given quantity.[10]

The divine origin of the mathematical order of nature and the warranty it provides for geometrical knowledge do not entail that the mathematical "pattern" be at rest. Quite the contrary: without motion there are no "harmonic proportions" at all, hence nothing to know. Moreover, geometrical lines themselves should be understood as motions:

> A chord is understood here not, like in Geometry, as subtending an arc of a circle, but as any length capable of emitting a sound; and because sound is produced by motion, in abstract a chord should be understood as a length of some motion, and so should every length conceived by the mind.[11]

Mathematics—order—is *in* motion. This is what makes Kepler's new astronomy, as was his optics, a real mathematical *physica*, distinguished from the *scientia media* in which he was educated: motion, forces and actions of nature, are not only reduced to static mathematical structures; they are expected to *produce* mathematical curves, "traces" for the mathematician to follow.

## Light and Pure Motion

Of course, not all moving bodies trace perfect geometrical curves—Kepler was very alert to the imperfections of the material world. However, he also had a model of pure motion, thoroughly mathematizable: light. Light, as we discussed in chapter 1 and will return to in chapter 6, is *essentially* mathematical: "Light falls under geometrical laws . . . as a geometrical body" is Proposition 1 of the *Optics*.[12] It can be thoroughly mathematical because it is incorporeal: "Light has no matter, weight or resistance" (Prop. 3) and "To light there belong only two dimensions" (Prop. 10). Embedded in the material world, a physical and causal agent, it is still a proper object of *physica*. As Kepler put it in the letter to Maestlin, light is a "vehicle of motion." This combination of properties enabled Kepler to apply the mathematical techniques of traditional optics to light and turn it into the model of mathematical science that Descartes was to adopt. The letter to Maestlin suggests

that from early on he intended it to serve a similar role in turning traditional mathematical astronomy into the *physica coelestis* of the *Astronomia Nova.*

It is a complex meditating role that light fulfills for Kepler in the establishment of a mathematical philosophy of nature. Intellectually, light mediates mathematics and motion: it suggests that notions from mathematical optics could be applied to physics. Physically, it mediates between the sun and the planets, as the hypothetical *virtus motrix* by which the sun moves the planets about itself, or at least the carrier of this force. Ontologically, light mediates between the ideal and the corporeal: as *the* mathematical entity, it is the divine vehicle of order in the world. Epistemologically, it mediates between external reality and the knowing human mind: light is the agent by which nature directly affects the human sense of sight, producing images on the retina for reason to decipher.

The concept of mathematical traces stems from this search for mediation in light and the flexible relations between its different aspects, some of which Kepler remains committed to, whereas some are provisional; intellectual scaffolding he dismantles as he proceeds. In the *Astronomia Nova*, for example, Kepler comes to reject the idea that it may be light that carries the sun's rotation to the planets (see chapter 6). He adopts Gilbert's magnetism and decides that the light may serve only as an analogy for the *virtus motrix.* The need for light to justify the application of mathematics to motion already disappears throughout the *Optics.* At the beginning of chapter 1, clearly for theological reasons, light is still "the chain linking the corporeal and the spiritual world" and "the instrument of the creator for giving form and growth to everything."[13] Yet only a few pages later, it is no longer light that is equated with mathematical order, but its very motion:

> Prop. 8: *A ray of light is no part of the light itself flowing forth.* . . . A ray is nothing but the motion itself of light. Exactly as in physical motion, where its motion is a straight line, while the physical movable thing is a body; likewise in light, the motion itself is a straight line, while the movable thing is a kind of surface. And just like in the former instance the straight line of the motion does not belong to the body, so in the latter the straight line of the motion does not belong to the surface.[14]

The "straight line" is no longer a property of light itself, this supposedly "geometrical body," but of the ray. Kepler may appear to be returning to traditional mathematical optics, whose subject matter was rays, but his ray is not the line of sight of old: it is "the motion itself of light." Motion, again, is the carrier of mathematical order; the mediation of light is no longer required.

Kepler has taught himself how to understand and justify the application of mathematics directly to motion: the mathematical object is pure motion. The ray, "motion itself," has a particular mathematical form—a straight line, in the case of light. "The movable body" or "the physical movable thing" instantiates this pure, mathematical motion: "the straight line of the motion does not belong to the body"; the body, one might say, "belongs" to it. In his last major study of *physica coelestis*, the *Harmonies of the World* of 1619, Kepler gives the mathematical role of the ray an almost poetic expression: "there is no ray," he stresses, "but there was, or almost was."[15]

The light ray is a trace; it "was, or almost was." It was left by the real motion of light, so it is not mere representation—it is an appropriate object of physical inquiry. However, it is not a material object, so it is also an appropriate object of mathematics. Moreover, with Kepler's new visual epistemology, traces are the real objects of knowledge:

> Inasmuch as all the external senses are brought about by reception and impression, they are clearly passive, since the species of the external things is imprinted on that which senses: and that passion is called sensation. Now inside the brain there is something, whatever it would be, called common sense, on which the species from the affected instrument of vision is imprinted, that is [the species is] drawn by the light from the visible thing.[16]

In his 1604 *Optics* (*Ad Vitellionem*) Kepler divested species (together with visual rays and all similar entities) of their epistemological privileges. "Species," he explained in the "Proemium," "is nothing but light and shadow."[17] Here, in the *Dioptrics* of 1611, species are further downgraded: they become the means of communication between the "instrument of vision" and the "common sense." The epistemological point that occupied Descartes is underscored: "*Ut pictura, ita visio*";[18] vision is nothing but nature's drawing, through the action of light, directly on our retina. Knowledge is the interpretation of these traces.

Light allowed Kepler the ontological jump between "the corporeal and the spiritual," between imperfect "physical movable" and the perfect "straight line." However, of all the roles that Kepler assigns to light, the mediation of knowledge is the one he remains most committed to. Knowledge, for Kepler, is very literally a process of illumination: light is the active agent, "imprint[ing]" on the "passive . . . instrument of vision" and "drawing" (*picti*) nature in the brain. Indeed, the cones of light are "little brushes" (*penicilli*);[19] Kepler works the association of illumination with drawing to its fullness.

Kepler's justification for his mathematical *physica* is thus a natural exten-

sion of his epistemology: all knowledge is the following of traces; the mathematician, however, is "following the traces of the Creator." These are, however, traces of motions, and motions are the sine qua non of human ability to perceive the mathematical substrate of the world. In order to conceive geometrical lines, the human mind must indeed evince "by contemplation what the hand evinces by drawing a line." The mind's perception of geometrical order is equivalent to the drawing hand because this order is embedded in motion. The hand, for its part, is drawing real mathematical curves: chords, triangles, circles.[20]

## GALILEO

### *Seeing Mathematics*

"Traces"—the relations between drawing hand, geometrical line, and physical motion—enable Galileo to come to terms with the difficult idea of the indiscernible motion of the earth and to explain to his readers how to conceptualize changing frames of reference.

Galileo presents the problem in his *Dialogue Concerning the Two Chief World Systems* by having Simplicio ridicule of the Copernican notion of the earth's diurnal motion as "a bald denial of manifest sense." He then allows Sagredo to answer with a fable to explain away why "this motion in common ... remains as if nonexistent to everything that participates in it." Sagredo invites Simplicio to imagine a point of a pen attached to a ship on its way from Venice to Alexandretta, "leaving visible marks of its whole trip." He then asks "what trace—what mark—what line would it have left?", and Simplicio duly answers that disregarding the scarcely sensible fluctuations of the vessel the line traced by the pen would be "part of a perfect arc." Sagredo continues by inviting Simplicio to further imagine "an artist ... drawing with that pen ... all the way to Alexandretta." This artist

> would have been able to derive from the pen's motion a whole narrative of many figures, completely traced and sketched ... Yet the actual, real, essential movement marked by the pen point would have been only a line: long, indeed, but very simple.

Of this line, however, "no trace would remain" since the pen shared that motion with the paper and "with everything else in the ship." The only visible trace left on the paper would be the small motions "communicated by the artist's fingers to the pen but not to the paper."[21]

The traces left by the imaginary pen allow Galileo to study motion independently of the moving object, but he is very careful to keep apart those left by nature and those for which the painter is responsible. Nature, with her grand motions, draws simple curves; the human hand, oblivious to the natural motion within which it is steeped, applies "small motions back and forth, to right and left," to sketch "thousands of directions, with landscapes, buildings, animals, and other things." In the same vein humans sense minute and insignificant motions of stones falling off towers and of birds flying over in the sky, yet completely miss the all-encompassing motion of the earth. Motion is Nature's tool in drawing straight lines and curves, and tracing Nature's draftsmanship is the crux of Galileo's endeavor to pursue the "definition best fitting natural phenomena." The pen is Galileo's version of Kepler's "little brushes"; it leaves traces that allow *seeing* mathematics.

### Natural and Arbitrary Curves

Mechanics presented Galileo with the same challenge that physicalizing astronomy presented Kepler: the application of mathematics to motion. Traditional mechanics seems to have offered a model for this application, but Galileo could not be satisfied with it any more than Kepler was with traditional astronomy and optics. The ontological status that the mixed sciences tradition ascribed to mathematics was not one that Galileo could accept: "indivisible points, or lines," stressed Nicole Oresme, "are nonexistent." Indeed, "it is necessary to feign them mathematically (*mathematice fingere*) for the measures of things and for the understanding of their ratios," but "of course, the line of intensity of which we have just spoken is not actually extended . . . but is only so extended in the imagination." Witelo, a century earlier, expressed the same conviction: "Every line along which light . . . reaches . . . is a natural sensible line . . . within which a mathematical line is to be assumed imaginarily."[22]

In the Archimedean tradition those mathematical entities could even be perceived as moving, as long as the imaginary status of this motion was firmly kept: "the same common origin for the generations of all lines, as the mathematicians duly assert, is a point by its imaginary flow or motion giving birth to lines," explains Regiomontanus.[23]

Yet imaginary lines and motions and artificially produced "arbitrary" curves are exactly what Galileo vows not to waste time on. His investigation, we saw in the citation from the *Two New Sciences*, would be of those "met in nature." This may read as a simple appeal to empirical accountability, in

line with common Renaissance realist rhetoric echoed, e.g., in Leon Battista Alberti's recommendation that

> one should avoid the habit of those who aspire to extol in the art of painting after their own ingenuity with no natural forms present in front of their mind or eyes.[24]

Galileo is indeed very familiar with this rhetoric, which served him to celebrate his *Sidereus Nuncius* illustrations as genuine representations of trustworthy observations:

> There are between the practice of natural philosophy and the study of it precisely those differences that we find between drawing from life and copying the works of others ... there are those who never do take up drawing from Nature, but always persist on copying drawing and paintings, such that they fail not only to become perfect painters, but are also unable to distinguish great art from bad, and good representations from poor ones.[25]

Plain engagement with Nature is preferable on both epistemological and aesthetic grounds, but the same basic techniques—of mathematics in the *Discorsi* and of drawing in the *Sidereus*—can be used to create exact representations of Nature or capricious copies of other representations.

So the search "to find and explain a definition best fitting natural phenomena" is not merely a reiteration of empiricist credo—it is also a comment about the place of "definitions," of mathematics, within "natural phenomena." This demand that the empirical itself be mathematical, which we discussed in chapter 3, can be discerned already in the *Sidereus*; it is *drawing—disegno*, in Renaissance Italian jargon—rather than painting—*pingendi*—that Galileo is lauding in the statement above.[26] Side by side in his spectacular visual representations of the moon, Galileo gives primacy to lines and angles over colors and textures, as he will do in the *Assayer*, some thirteen years later:

> I do not believe that for exciting in us tastes, odors and sounds there are required in external bodies anything but sizes, shapes, numbers, and slow or fast movements.[27]

As it was for Kepler, motion upholds the mathematical structure of nature while mathematics (for Kepler—embodied in light) secures our very ability to see it. In the *Assayer*, mathematics guaranteed seeing through the telescope. In the *Discorsi*, motion allows us to perceive the mathematical elements of nature: it is the lines drawn by motion, rather than the colors and

complex shapes of bodies with which Nature reveals its secrets, because motion precedes objects and can be studied independently of them.

### Historiographic Interlude

Recent Galileo scholarship makes the seeming reversal of roles between mathematical and empirical appear less surprising. One important achievement of this corpus was to reformulate the grand themes concerning the emergence of Galilean mechanics in clear and well-defined terms. Thus, instead of New Science vs. Church establishment, we have the differing intellectual agendas of, e.g., Dominicans and Jesuits;[28] instead of metaphysical persuasion vs. experimental evidence, we have the complex of artisanal and practical-mechanical traditions from which evolve new ways of matching theoretical and practical forms of knowledge;[29] instead of Neo-Platonism vs. internal mathematical development we have Aristotelian mixed sciences[30] and mechanical Archimedean modeling.[31]

The crucial significance of this achievement is in historicizing the very epistemological and ontological categories of traditional Galileo historiography. Evidence and metaphysics; experience and theory; even novelty and tradition, we have learned, were themselves reshaped as result of the struggles involved in the emergence of the new scientific practices. In particular, works like William Shea's, Ron Naylor's, and Jürgen Renn, Peter Damerow, and Simone Rieger's,[32] make clear that neither "mathematization" nor "nature" can be taken as supra-historical or self-explanatory; that the metaphysical and the technical aspects of Galileo's work were too fluid and mutually dependent for either to be considered as the "real" engine behind the mechanical philosophy of nature that we take to be his legacy; and that both the mechanical phenomena and the mathematical apparatus were reshaped in the process of its evolution.

In this new historiographic context the paragraph from Galileo's *Two New Sciences* we began with regains the crucial importance that Alexandre Koyré once assigned to it,[33] but for different reasons. As Koyré pointed out, Galileo does not look for a mathematical description for a phenomenon he has mastered, but the reverse; he is seeking a "definition" of a motion that would fit a mathematical expression he had already determined. For Koyré, this order of inquiry, in which the mathematical precedes the phenomenal, served as evidence for Galileo's mathematical Platonism. Recently, however, Renn et al. have demonstrated that this interpretation is much too simplistic. Masterfully unraveling Galileo's complex of empirical research, mechan-

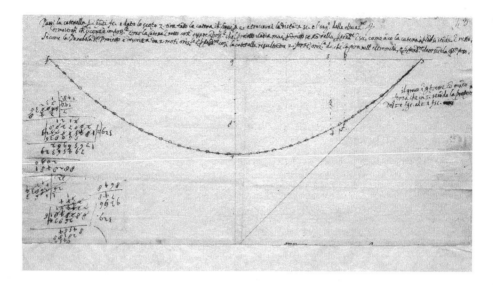

FIGURE 4.1  Galileo's attempt to fit a chain line onto a parabola. MS. Gal. 72, folio 43r. Su concessione del *Ministero per i Beni e le Attività Culturali/Biblioteca Nazionale Centrale di Firenze.*

ical speculations and mathematical presuppositions, they have shown that Koyré was right that Galileo asks for a definition of uniform acceleration when he already knows the law of free fall, but wrong in assuming that this knowledge was arrived at by abstract considerations. In fact, Galileo starts (with Guidobaldo del Monte) by letting real-life cannon balls roll over an inclined roof, drawing full-scale ballistic curves. Observing that the curve appears symmetrical but not circular, Guidobaldo and Galileo guess that it is a parabola. Considerations of pendulums and inclined planes give rise to the notion of "neutral" motion: motion that is neither natural nor violent and therefore neither accelerates nor decelerates—its velocity is constant. From the parabolic trajectory and the assumption of constant velocity of the horizontal component—namely distance proportional to time—follows the square proportion between distance and time for the vertical component, or constant acceleration. This, argue Renn et al., is the origin of the law of free fall. These fortuitous guesses and hypotheses turn the parabola into Galileo's curve of choice, into which he attempts to accommodate other drawings of nature, some successfully, as with the celebrated rolling inked balls, and some in vain, such as the chain line of fig. 4.1.[34]

## *Natural and Artificial Curves*

If Kepler's "mathematical traces" are an extension of his light epistemology, Galileo's are literal and practical: the parabola is genuinely a trace, drawn by the rolling ball or hanging chain. One can study nature mathematically by analyzing the curve and infer the physical characteristics of the motion from the mathematical trace it has left, or reverse the process and harness nature to draw the curve for further use:

> Salviati: there are many ways of tracing these curves; I will mention merely the two which are the quickest of all. One of these is really remarkable; because by it I can trace thirty or forty parabolic curves with no less neatness and precision and in a shorter time than another man can, by the aid of a compass, neatly draw four or six circles of different sizes upon paper. I take a perfectly round brass ball about the size of a walnut and project it along the surface of a metallic mirror held in a nearly upright position, so that the ball in its motion will press slightly upon the mirror and trace out a fine sharp parabolic line; this parabola will grow longer and narrower as the angle of elevation increases. The above experiment furnishes clear and tangible evidence that the path of a projectile is a parabola; a fact first observed by our friend and demonstrated by him in his book on motion . . . it is advisable to slightly heat and moisten the ball by rolling in the hand in order that its trace upon the mirror may be more distinct.
>
> The other method of drawing the desired curve upon the face of the prism is the following: Drive two nails into a wall at a convenient height and at the same level; make the distance between these nails twice the width of the rectangle upon which it is desired to trace the semiparabola. Over these two nails hang a light chain of such a length that the depth of its sag is equal to the length of the prism. This chain will assume the form of a parabola, so that if this form be marked by points on the wall we shall have described a complete parabola which can be divided into two equal parts by drawing a vertical line through a point midway between the two nails.[35]

Note that Galileo has no use here for the customary distinction between real motion in a medium and idealized motions in a void. The paragraph on "observed accelerated motions" assumed that *all* curves are "described by certain motions." In that context, Galileo wanted to distinguish between motions that are artificial and those "met in nature." Here, even this distinction is not made. Galileo has no interest in ideal curves; all curves are products of motion, and all motions leave traces that can be studied mathematically. It is up to the mathematician to decide which to investigate as

it is up to the painter to decide if he is "drawing from life" or "copying the works of others." The latter option is not without value; even though "anyone may invent an arbitrary type of motion," the "properties" of the "imagined helices and conchoids" can still be "very commendably established." Just as the techniques of drawing are the same for "drawing from life and copying the works of others," so the relations between motions and mathematical curves are the same for artificial and natural motions. Natural motions deserve more attention than artificial ones; what "actually occurs in nature" is the proper subject matter for the philosopher. Still, both types of motions constitute the same mathematical objects—they draw curves to be studied. Mathematics is the study of real "phenomena," not their idealized representation.[36]

### Vacua *and Indivisibles*

For Galileo, as it was for Kepler, the "mathematization of the world view" was neither an abstract metaphysical commitment nor a straightforward application of old mathematical methods. A full-fledged mathematical natural philosophy required changes to the fundamental dichotomies of traditional mathematics: between artificial and natural and between abstract and concrete, and there was no place for Galileo to find justification for such changes. Moreover, in the two paragraphs from the *Two New Sciences* Galileo is clearly positioning himself against the three traditional approaches to mathematics and its relation to nature. He evidently rejects the Aristotelian distrust of mathematics' capacity to capture nature's motions and changes. He also rejects the criteria for rigor of traditional Greek mathematics, represented by both Euclid and Apollonius, which only recognized curves constructed by static ruler and compass. Most surprisingly, Galileo distances himself from the revived Archimedean tradition of constructing complex curves, "imagined helices and conchoids." The concept of curves drawn by nature's own motions answers a very immediate intellectual need: to provide an ontological and epistemological foundation for the new mathematical study of nature, a foundation that no tradition could provide.

Put differently, though most of their mathematical wherewithal was not novel, what Kepler and Galileo aspired to achieve by its application to the study of nature was fundamentally different from their predecessors, and their justification for this application was accordingly novel. When Galileo wants to mark his intention to provide such a justification he allows Simplicio to narrate the common arguments about the limits of mathematics

in various places throughout the *Discorsi* and the *Dialogo*. When he wants
to further stress that it is the relations between abstract considerations and
real phenomena that he is investigating, he even has Sagredo hesitating
"whether, as a matter of fact, nature actually behaves according to such a
law."[37] Such is the case after his discussion of the *Rota Aristotelis*, which Sim-
plicio concludes with the disclaimer:

> The arguments and demonstrations you have advanced are mathematical, ab-
> stract and far removed from concrete matter; and I do not believe that when ap-
> plied to the physical and natural world these laws will hold.[38]

Galileo is happy to let Simplicio call his arguments "abstract and far re-
moved from concrete matter" exactly because he can trust his readers to
realize that they are anything but. Both Galileo's reasons for turning to the
pseudo-Aristotelian paradox and his proposed solution are material and
concrete: both have to do with the structure of matter.[39] Discussing the
paradox allows Galileo to present his way of handling the boundaries of
mathematical and physical thought, because the *Rota Aristotelis* was always
perceived as reflecting the difficult relations between *continuum physicum*
and *continuum mathematicum*: how it is that two concentric circles of dif-
ferent diameters, rigidly attached, rolling together around a common center
and along a tangent to one of the circles, cover the same distance, whereas,
rolled separately, each will cover a distance equal to its circumference?[40]
    The question leading Galileo to discuss the paradox concerns the forces
that constituted the solidity of bodies. Empirical considerations reveal that
the *horror vaccui* that we are familiar with from experience, and whose *forza*
Galileo teaches his readers to measure experimentally, does not suffice to
account for the coherence of solid matter. Rods and cables can be extended
well beyond the "eighteen cubits," which is the famous limit on the height of
a column of water that the "resistance of the vacuum" alone can hold before
the column breaks under its own weight.[41] Galileo is reluctant to account
for this additional "resistance to breaking" by hypothesizing some mate-
rial "glue" between their particles, primarily because the same questions
can be raised about the coherence of *this* hypothetical material entity.[42] In-
stead, Galileo explores the possibility of an intra-particle *horror vaccui*. Ac-
cumulated, these "extremely minute vacua that affect the smallest particles"
should suffice to provide any required force: "any resistance, so long as it is
not infinite, may be overcome by a multitude of minute forces."[43] The solu-
tion to the *Rota Aristotelis* serves a double role: first, it demonstrates that the
"multitude" can always be large enough, because "within a finite extent it

is possible to discover an infinite number of vacua." Second, it supports the hypothesis by showing that assuming these vacua solves an important paradox of motion.

Galileo begins by inviting his audience to consider two rolling polygons. In this case the paradox does not arise: if they roll around the vortices of the larger polygon, the sides and vortices of the smaller one are carried forwards in arcs (IO; PY in fig. 4.2); if around the smaller, those of the larger will similarly recede in arcs (Bb in fig. 4.3). The distance traveled by each point will thus be the same, whether it rests on the larger or smaller polygon. If the circles of the *Rota Aristotelis* are considered as "polygon[s] of infinite number of sides," the paradox is supposedly resolved:

> the infinite number of indivisible sides of the greater circle with their infinite number of indivisible retrogressions, made during the infinite number of instantaneous delays of the infinite number of vertices of the smaller circle together with the infinite number of progressions, equal to the infinite number of sides in the smaller circle, all these . . . add up to a line equal to that described by the smaller circle.[44]

### Embedded Mathematics

This is a problematic solution in more than one respect. Galileo obviously does not have the tools to deal with infinities, and his moves between indivisibles and mathematical points are strained. Moreover, whereas the paradox is symmetrical—the same argument applies whether the larger circle carries the smaller or *vice versa*—the solution seems much better fit for the case of the smaller carrying the larger. Experience is more in line with a larger wheel carrying a smaller one, as in a coach wheel and its nave, and this is indeed the way Galileo first introduces the paradox (fig. 4.2). Yet the solution is presented and explained with the smaller carrying the larger (fig. 4.3). Worst, perhaps, is the need to rely on *horror vaccui* as a physical cause. The notion that the effect—the motion into a space—happens because of a counterfactual—nature's dread lest a vacuum be created—is obviously against the maxim that "the cause must precede the effect," and Galileo is forced to concede the embarrassment. He allows Simplicio the very rare pleasure of providing "an adequate solution to [Sagredo's] difficulty" with the "excellent and reliable maxim of [Aristotle], namely . . . since nature abhors a vacuum, she prevents that from which vacuum follows as a necessary consequence."[45]

Galileo is willing to embrace all these difficulties because the primary motivation of this analysis is to educate his readers in his new way of

FIGURE 4.2 Galileo's introduction of the paradox of the *Rota Aristotelis*. *Two New Sciences* [68] 21. (Image from Galileo's *Discursus*, 20.) Reproduced with permission of the Rare Books and Special Collections Library, The University of Sydney.

FIGURE 4.3 Galileo's solution to the paradox of the *Rota Aristotelis*. *Two New Sciences* [94] 50. (Image from Galileo's *Discursus*, 45.) Reproduced with permission of the Rare Books and Special Collections Library, The University of Sydney.

solving problems of natural philosophy with the aid of mathematics—and *vice versa*. This is not the limited leeway allowed by Aristotle for the mixed sciences, nor is it the grand Platonic image of mathematical order underlying a less-than-perfect "concrete matter." It is not even the Archimedean allowance to create artificial approximation using 'mechanical curves'. Galileo refuses to limit mathematics to the ideal. Mathematics can deal, with all its accuracy, without resorting to abstraction or approximation, with all the complexities of the corporeal. The difference between success and failure in mathematization is merely a difference in our knowledge of all the details involved; "errors," he insisted already in the *Two Chief World Systems*, "lie not in abstractness or concreteness, not in geometry or physics, but in a calculator who does not know how to make a true accounting."[46]

Galileo's mathematics is embedded in nature. This is why the physical question of cohesion can be solved mathematically while the mathematical paradox is solved physically. The paradox is solved once the *Rota* begins to move and its infinitesimally small "particles" find their place within the "extremely minute vacua." The *Rota Aristotelis* had always been a Zeno-style demonstration of the limitations of the application of mathematics to motion.[47] Galileo reverses this commonplace: motion is geometrical in essence.

### BEFORE KEPLER

Motion leaves traces, straight or curved lines, that are always available to mathematical inquiry, because motion is mathematical in essence. Order, geometrical structure, is created by motion. This is what mathematical natural philosophy comes to signify for Kepler and Galileo.

#### *Alberti's Veil*

The fusion of mathematics and motion flew in the face of the most entrenched concepts of order and change. The idea of that the visible can be captured mathematically, however, was not new. The conviction that *drawing* should be assigned this task may be traced back to the development of linear perspective in the first decades of the fifteenth century. This geometrically based technique provided painters with a way to create a two-dimensional illusion of a lifelike scene. For Leon Battista Alberti, the foremost theoretician of this novel technique, its success did *not* lie in imitating particulars, but in capturing true beauty.[48] When considering the parts of the body he wishes to represent, Alberti argues in his *De pictura*, the painter

"should be attentive not only to the similitude of the things, but primarily to their true beauty."[49] This beauty resides in geometry—in the harmonious proportions of forms: "from the composition of surfaces arises that elegant harmony and grace in bodies, which is called beauty."[50]

Yet Alberti's mathematical forms of true beauty are not Galileo's traces. First, because his harmonious proportions do not reside *in* nature. Exactly because of their mathematical foundations, perspectival techniques are means for excavating the hidden remnants of beauty recondite in physical bodies rather than the fullness and variance of nature. Alberti's mathematics indeed does not refer directly to an ideal realm. He acknowledges that professional mathematicians "measure the shapes and forms of things in the mind alone, and divorced entirely from matter," and explicitly limits himself to visible points, lines, and surfaces that "concern the painter who strives to represent only the things that are seen."[51] Yet in representing the beauty of "the things that are seen," the painter has to collect and reconstruct the mathematical structures from different beautiful bodies:

> From the beautiful bodies all the esteemed parts are to be selected. Accordingly, no small effort is demanded in order to grasp, and indeed to have and experience by industry and discipline beauty . . . because all the beautiful qualities are not discovered from one place but are scattered or dispersed.[52]

Mathematical proportions "are not discovered from one place." Unlike Galileo, Alberti does not expect to find mathematical order in each body, in each phenomenon, in each hanging chain or rolling ball. Moreover, Alberti's beautiful forms are not *traces*. The geometrical proportions in which beauty resides are necessarily static. Natural motion, which for Kepler and Galileo *created* mathematical proportions, obstructs the tranquility Alberti requires of beautiful forms. This is exactly the raison d'être of mathematical perspective: to provide an anchor of stability in a world of shifting images, without which art cannot aspire to reveal and present beauty. Knowing "how impossible it is to imitate something that does not continually present the same aspect," Alberti thus instructs the painter to insert "an intersection" between the eye and the object to be painted:

> A veil loosely woven of fine threads, dyed whatever color you please, divided up by thicker threads into as many parallel square sections as you like, and stretched on a frame.[53]

The veil ensures that "the object seen will continually keep the same appearance." The scenes Alberti teaches his readers to paint are anyhow

FIGURE 4.4 Dürer's interpretation of Alberti's grid from his *Unterweysung der Messung*, 1525/The Bridgeman Art Library.

static—usually ideal scenes, statues, and paintings in the context of this citation, so the veil is a measure to remove the very last source of change—the movement of the painter's eye as it travels from object to easel. This corporeal grid stabilizes the whole visual pyramid, "for once you have fixed the position of the outlines, you can immediately find the apex of the pyramid." It is a materialization of a geometric relation between object and observer; a frozen "intersection" of lines (see fig. 4.4).[54] Mathematics, for Alberti, is static and removed from natural change—this is the source of its usefulness for the painter.

### Leonardo's Deluge

Alberti's *De pictura* and *De statua* make up a program that promises "mastering and understanding"[55] of the ways to excavate and project beauty in mathematical harmonies. This is the program Leonardo turned to later in the century to guide his study into the secrets of nature—linear perspective was to provide him with a geometrical means to uncover Nature's hidden structure and beautiful order.

   Leonardo is more ambitious than Alberti. His scientific research is not limited to static beauty. Like Galileo, he aims at capturing Nature's dynamics and powers and harnessing them in the service of the artist-engineer. Yet this ambition is frustrated exactly by the mathematical approach embedded in linear perspective, since the assumptions about the powers and limits of mathematics do not enable him to capture the infinite power of transformation he observes in Nature. Geometrical drawing *could* depict an instant of

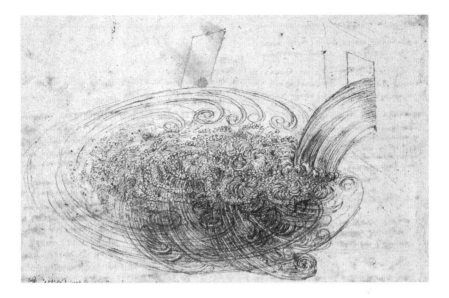

FIGURE 4.5  Leonardo's *Water Studies*, c. 1513. The Royal Collection © 2011 Her Majesty Queen Elizabeth II.

order within nature, but such order is ephemeral, immediately transforming into different, unstable structures (see fig. 4.5).

When Leonardo observes nature with the "industry and discipline" commended by Alberti, he does not find only static, orderly beauty, but a progression from order to chaotic destruction. This process is particularly manifest in his hydraulic investigations. Leonardo begins his inquiry with a basic classification of the different spirals that the motions of water assume: "four varieties, namely convex spiral, planar spiral, concave spiral and the fourth is the columnar spiral,"[56] and adds four drawings exhibiting these variations. When different streams of water conflate in a real motion, however, this simple classification breaks down; Leonardo then observes:

> Running water has within itself an infinite number of movements which are greater or less than its principal course. This is proved by [watching] the things supported within two streams of water, which are equal to the water in weight. . . . [The revealed motions of such things are] sometimes swift, sometimes slow, and turning sometimes to the right and sometimes to the left, at one instant upwards and at another downwards, turning over and turning back upon itself, now in one direction and now in another, obeying all the forces that

have power to move it, and in the struggles carried on by these moving forces always as the booty of the victor.[57]

The motions are orderly to begin with; one finds the same vortices in spiralling water and curling hair,[58] but when different motions clash in the natural world the tranquillity of order collapses. The powers of nature destroy and re-create transient orders, and the painter can hope to capture Alberti's "same appearance" only for a fleeting moment. These unstable sceneries are what Leonardo depicts in his drawings of the deluge (fig. 4.6) coupled with his analytical description of the horrible and magnificent powers of nature. In these drawings one observes the vortices of water filled with matter swirl and fall over a dwarfed town below, and disorientation governs the event as all distinctions between solid, liquid and the void evaporate. Another drawing represents the same theme in a wholly different medium: a writhing mass of swirls and tight curls over tiny human figures and horses thrown asunder, presided over by a wind god.

Although devastation and chaos govern these scenes, the careful geometrical delineation has not completely disappeared. In an analytical and dispassionate mode, Leonardo describes the quantitative relationships that participate in the deluge:

> And let the mountains, as they are scoured bare, reveal the profound fissures made by the great earthquakes. . . . Round these again are formed the beginnings of waves which increase the more in circumference as they acquire more this movement; and this movement rises less high in proportion as they acquire a broader base and thus they are less conspicuous as they die away. . . . And if the heavy masses of ruin of large mountains or grand buildings fall into the vast pools of water, a great quantity of water will rebound in the air and its course will be in a contrary direction to that of the object which struck the water; that is to say: the angle of reflection will be equal to the angle of incidence.[59]

Geometry is not completely worthless in face of this horrific occurrence; the upheaval is made up of "proportion" and "equal . . . angle[s]." Yet a complete picture of true physical motion necessarily escapes geometry's grasp even in basic mechanics:

> The science of weights is led into error by its practice, and in many instances practice is not in harmony with this science nor is it possible to bring it into harmony: and this is caused by the poles of the balances . . . which poles according to the ancient philosophers were placed by nature as poles of a mathematical line and in some cases in mathematical points, and these points and lines are devoid of substance whereas practice makes them possessed of substance . . .[60]

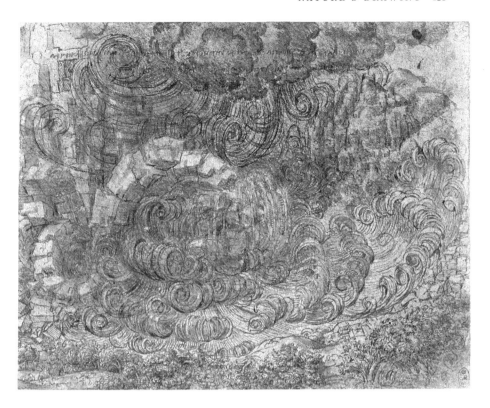

FIGURE 4.6 Leonardo's *Deluge*. The Royal Collection © 2011 Her Majesty Queen Elizabeth II.

In another notebook Leonardo stresses:

> There is an infinite difference between the mechanical point and the mathematical point, because the mechanical is visible and consequently has continuous magnitude and everything continuous is infinitely divisible. The mathematical point, on the other hand, is invisible and without magnitude and where there is no magnitude there is no division.[61]

This gap between geometrical forms and the real physical world led Leonardo to such disappointment with Albertian linear perspective that he almost abandoned it. Leonardo examined several problems, such as angular problems of apparent size;[62] lateral recession; the fact that "the eye does not know the edge of any body"; and binocular vision. In depicting the elusive appearance of leaves on trees, for example, he notes that each leaf is affected by four tonal factors, "that is to say, shadow, brightness, luminous

highlight, and transparency." Their specific combination transforms each leaf's apparent color at any one time. Furthermore, the apparent leaf is subject to more variables: "Remember, O painter, that the varieties of light and shade in the same species of tree will be relative to the rarity and density of the branching." All these minute changes are blurred at a distance and thus the sense of vision finds it "difficult to recognize the parts, in that they make a confused mixture, which partakes more of that which predominates." "You imitator of nature, be careful to attend to the variety of configurations of things," Leonardo admonishes, but nature's infinite variety of forms, not to mention all the various optical transformations, frustrate any attempt to capture it in its details or to salvage an inherent mathematical order.[63]

The painting itself—the human product—Leonardo was still convinced, possesses a geometrical structure, but it was not this structure that warranted its correspondence to the physical world. This was not to say that there is no geometrical order to nature itself: the reason that geometry could capture only a very partial aspect of nature's order was that this order was *creative*. Leonardo demonstrates this geometrical creativity in the *Codice Atlantico* with a series of transformations of given mathematical ratios. The constant proportions of encircled, shaded, and unshaded areas produce 180 different shapes throughout the folio (fig. 4.7). *On the transformation of one body into another without diminution or increase of substance* was to be the name of the book Leonardo planned.

It is not nature's creativity that distinguishes Leonardo's mathematical ventures from Galileo's—Galileo's nature is also creative. It is in constant motion and continually produces new forms; like the human painter, it draws. However, for Galileo, both nature and painter draw mathematically; motion and its mathematical traces are common to nature and artifice. Like the good painter, Nature's motions are consistent and their mathematical "traces" can be followed, copied, and studied. For Leonardo, the very regularity of geometrical figures generated transformation and change, and this creativity was destructive at worst, whimsical and random at best. In Galileo's work, motion creates geometrical order. In Leonardo's, geometrical structures beget self-destructing change.

### Tartaglia's Trajectories

The attempts to capture physical motions by means of drawing during the generations immediately following Leonardo accentuated his dilemmas rather than resolving them. The tensions between experience, physical ex-

455

FIGURE 4.7 Leonardo's transformation of curves, *Codex Atlanticus*, 455r. Biblioteca Ambrosiana, Milan, Italy/The Bridgeman Art Library.

planation, artistic drawing, and geometrical analysis strongly affects Niccolò Tartaglia's striving for a *Nova Scientia* of motion, creating an untenable discrepancy between his "official" diagrams and his Aristotelian analysis of projectile motion on the one hand, and his explicit empirical accounts and frontispiece drawing on the other (fig. 4.8).

Tartaglia's aspirations are novel, but his difficulties are old. He intends to create a science of motion with immediate practical applications and promises the Duke of Urbino that his analysis of the motion of projectiles will allow accurate calculations of ballistic trajectories. These aspirations confront him with the ancient Aristotelian query of violent motion: why should a heavy body continue to move once departing its initial cause of motion rather than fall immediately down? Tartaglia approaches the question with theoretical assumptions that are unrelentingly Aristotelian:

> I also found, by reasons evident to the intellect, that it is impossible for a heavy body to move with natural motion and violent motion mixed together.[64]

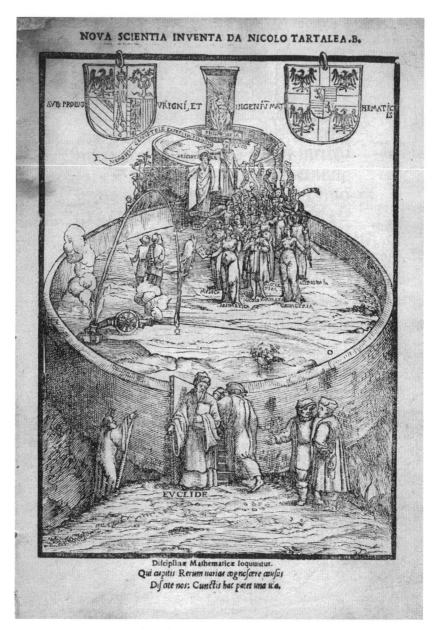

FIGURE 4.8 The frontispiece of Tartaglia's *Nova Scientia*. Note the curved trajectories of the cannon and the mortar. Reproduced with permission of the Rare Books and Special Collections Library, The University of Sydney.

Tartaglia's diagrams attempt to remain true to the assumption of dichotomy between natural and violent motions. Acknowledging that a projectile does not change its course all at once, the diagrams still record a careful attempt to delineate the two species of motion by a circular arc (fig. 4.9):

> Every violent trajectory or motion of uniformly heavy bodies outside the perpendicular of the horizon will always be partly straight and partly curved, and the curved part will form part of the circumference of a circle[65]

But Tartaglia is well aware that this is not the way in which real cannon balls behave, and he immediately adds:

> Truly no violent trajectory or motion of uniformly heavy body outside the perpendicular of the horizon can have any part that is perfectly straight, because of the weight residing in that body, which continually acts on it and draws it towards the center of the world.[66]

Aristotelian doctrine agrees neither with experience nor with commonsense analysis: cannon balls do not fall perpendicularly, and there is no reason why they should abruptly change their trajectory at any particular point. This implies that the trajectory should be curved throughout, and this realization is clearly represented in the drawing on the *Nova Scientia*'s title page. Still, Tartaglia's diagrams, unlike his frontispiece, follow Aristotle. For Tartaglia the mathematical diagram was to correspond to reason, represented by a rational theory, but that meant that it was unable to reflect the complexity of real motion.[67]

### Maestlin and Cesi

Painting could capture the variety and complexity of nature, but not order; its mathematical structure was artificial. Mathematical diagrams did present reasoned order, but not true motion and change. One solution to the conundrum was offered by Kepler's mentor Maestlin in *De Astronomiae Principalibus* (1582). Astronomy, he explains—following the mixed sciences tradition—is a *mathematical* science, and it can be so, because it "catalogs, measures and investigates the causes of the heavenly bodies' *apparent* motions." However, Maestlin himself had to acknowledge some discontent with this limiting solution to the problem of mathematizing motion. Although the heavenly bodies, by virtue of their corporeality, should be "the object or matter of physics," astronomy has to forgo any physical causal

te,a e d.dal tranſito, ouer moto naturale,d b, & dal ponto,a,al p onto
d,ſia protratta la linea,a d c,hor dico che il ponto,d,è il piu lontan eſ=
fetto dal ponto,a,che far poſſa il detto corpo,b,ſopra la linea, a d c, os
uer ſopra quel piano doue è ſita la detta linea, a d c, coſi conditiona=

tamente eleuato,Perche ſe la detta poſſanza,a,traeſſe il medemo cor=
po,b,piu elleuatamente ſopra a l'orizonte,quel faria il ſuo effetto di
moto naturale ſopra la medema linea,a d c. come appar in la linea o=
uer tranſitoia f g in ponto,g,ilqual effetto,g,dico che ſaria piu propin

FIGURE 4.9 Tartaglia's tripartite trajectory from *Nova Scientia*. Reproduced with permission of the Rare Books and Special Collections Library, The University of Sydney.

explanations: "Indeed, apparent motions are *not* demonstrated physically, but are demonstrated according to mathematical reasons."[68]

The other horn of the dilemma—that "pictures showed too much" but could not capture "what was essential and regular about things"[69]—was also known since antiquity. Writers of the period were well versed in Pliny the Elder's complaint that

> [some] Greek writers ... adopted a most attractive method [in botany] ... which has done little more than prove the remarkable difficulties, which attended it. It was their plan to delineate the various plants in colors, and then to add in writing a description of their properties. Pictures, however, are very apt to mislead ... it is not enough for each plant to be painted at one period only of its life, since it alters its appearance with the fourfold changes of the year.[70]

As David Freedberg has noted, both the attraction and the disappointment haunted the efforts of Galileo's patron, Federico Cesi. Following Aldrovandi and Fuchs, Cesi and his fellows at the Academia dei Lincei were initially enchanted by the power of images to convey and represent knowledge. Careful drawings of selected specimens from the different kingdoms of nature were to create a new and precise foundation for a reformed natural history. However, this was a venture doomed "by the fundamental tension between the desire to picture everything and the desire for order."[71] Cesi was forced to abandon similitude and resemblance as his categorical principles and strive for alternative geometrical and textual modes of order exposition. These, like his grandiose *Apiarium*, ultimately failed.

## AFTER GALILEO

Kepler and Galileo justified the application of mathematics to motion and change by separating motion from the moving body. "Motion itself," endowed with an independent ontological status, could be *essentially* mathematical. Bodies were left to draw traces that could also be reproduced by the human hand and analyzed by the human mathematician. "Traces" allowed the mathematical knowledge of physical causes by ascribing to nature the efficacy of the human drawing hand. This breach of the boundary between natural and artificial was not an accident of Kepler and Galileo's solution. The aspiration to provide causal knowledge of nature by mathematical means dictated this trespass, because the traditional approaches to the mathematical study of nature pointed to that boundary as the locus of the obstacles facing the venture. It was exactly in between nature and art that mathematics had to find its epistemological role, and it was the strict

difference between the two sides that set the limits of this role. Alberti's veil was stationed between observed and reproduced object, and Leonardo despaired of it because of the difference between orderly human painting and infinitely varying nature. Maestlin allowed mathematics for apparent motion rather than real moving bodies, and the difference between Tartaglia's drawings and his diagrams was the difference between the tripartite trajectories dictated by the mathematical order of reasoned theory and the smooth curves traced by real motion. The new mathematical practices no longer respected this boundary, and "traces" provided the justification: natural and human motions; planet, projectile, and hand, left equivalent traces, embedding the same mathematical order, an order that could not be created and maintained but through motion.

## Descartes' Compass

For Kepler and Galileo, traces justified the application of mathematics to physical motions; for Descartes, traceable physical motion came to secure the validity of mathematical reasoning itself: "Tracing a curve—the ability to create or imagine a machine of independent regulated motions tracing a given curve—and conceiving a curve came together," as Matthew Jones recently put it.[72]

Mathematical certainty, for Descartes, resided in the ability to intuit the truth of every mathematical claim; to *see* that whatever the relation is claimed to be between any two mathematical elements cannot be otherwise: "the principal part of human industry is founded on nothing else," he stresses in the *Rules for the Direction of the Mind*, "but reducing these proportions so an equality between what is sought and whatever is known is clearly seen."[73] This is a mathematical version the famous criterion of clarity and distinctness, which confused and even angered commentators,[74] and which makes much better sense when considering the urge to "see the causes," which was Galileo and Kepler's legacy as well as the backdrop of traditional optical epistemology discussed in chapter 2. Descartes' Jesuit mentors, we saw in chapters 1 and 3, remained committed to the epistemology of visual encounter in the face of all changes to optics; unmediated vision remained their paradigm of reliable knowledge. Descartes, in contradistinction, enthusiastically adopted Kepler's optics; it became, we showed, his model for mathematical natural philosophy. He was also acutely aware of the epistemological compromise that the physicalization of optics entailed: vision was essentially mediated and could no longer be relied upon

to provide the assuredness of immediate encounter. Visual immediacy as an abstract ideal, however, remained Descartes' standard of knowledge: "when this [comparison] is clear and simple, no help of art is required to intuit the truth it provides, but the light of nature alone."[75] The eye of the mind is now assigned to provide, through mathematical intuition, the certainty that the eye of the flesh was shown to be incapable of.

Yet even mathematical deduction, Descartes was forced to admit, falls short of immediacy. The intellect can immediately grasp a mathematical relation, say A:B or B:C, but deduction is not such a moment of intuition; it is a process of comparing a series of relations, for instance C:D and D:E. As a process, it takes time and relies on memory, so the relation A:E that follows is not immediately intuited, even if each one of the steps was.[76] Even deduction involves mediation, and that of memory, the most fickle of faculties.

As he did in the analysis of vision, Descartes copes with the dilemma by acknowledging the mediation and embracing its epistemological ramifications. Keplerian optics turned image production into a causal process and thus deprived the intellect of the immediate visual re-presentation of objects. Descartes accepted that vision (and sensation in general) is contingent and opaque and sought to replace vision's role as an epistemological anchor with a causal, scientific, and contingent account of sensual representation. When his considerations of intuitive certainty reveal that deduction is a mediated process as well, he seeks another causal and contingent solution: a mechanical and artificial instrument connecting A to E, like the one depicted in fig. 4.10.

There is no great novelty in these "geometrical machines"; they were known since antiquity and could be found, *e.g.*, in Leonardo, Dürer, and van Schooten.[77] What is new is that for Descartes the mechanical means of drawing the curve are neither mere practical means for the artisan-artist, nor an admission by the mathematician that the curve is "merely" mechanical, hence not fully knowable. If we exclude complex curves from geometry because

> it is necessary to use a certain instrument to describe them, it is necessary to reject, for the same reason, circles and straight lines, seeing that they can only be described on paper with a compass and ruler, which we can also call instrument.[78]

To the contrary: it is the knowledge of the mechanical, causal principle ruling the motion of the instrument that lends credibility to the deductive process it embodies:

FIGURE 4.10 Descartes' relational compass from *Geometria* (20). Reproduced with permission of the Rare Books and Special Collections Library, The University of Sydney.

It is very clear that if (as we do) we understand by "geometry" that which is precise and exact, and by "mechanics" that which is not; and if we consider geometry the science that teaches us a general knowledge of the measures of all bodies, we must no more exclude complex lines from it than simple ones, provided that we can conceive them as being described by a continuous movement, or by several successive movements of which the latter are completely determined by those which precede: for by these means, we can always have an exact knowledge of their measure.[79]

The mathematician can fully understand the mechanical operation of the relational compass (fig. 4.10): the opening of the rulers YX and YZ pushes the straightedges BC, CD, DE etc., which slide along the rulers without changing the relations between themselves (B is the only rigid connection). So if YB:YC::YC:YD can be known intuitively, the subsequent mean proportionals, YB:YC::YE:YF, etc., can also be granted, together with all the consequent, complex relations between curves such as AD, AF, and AH: "producing curves through the motion of the compass allows the simultaneously grasped, clear and distinct intuition of the entire chain of relations," as Jones puts it.[80]

As was the case in the analysis of vision, the epistemological price of this

solution is steep. Instead of providing an epistemological justification and anchor of certainty for the causal and hypothetical claims of natural philosophy, mathematical reasoning itself is now expected to gain its credibility from our understanding of and trust in the causal principle underlying a material, artificial, moving device. As was the case with vision, Descartes is fully aware of the epistemological ramifications of his seemingly practical solutions and does not attempt to sidestep them. If geometrical deduction requires, or at least should be modeled after, the construction of mechanical artifices, mastering their operation and understanding their functioning principle, then it should be treated as a set of mechanical skills and intellectual habits. To acquire those, Descartes boldly suggests examining "the simplest and least exalted arts, and especially those in which order prevails—such as weaving and carpet-making, or the more feminine arts of embroidery."[81] Even if, at the end of such exercise, the manual-like exertion should be replaced by "the light of nature," this moment of natural enlightenment itself becomes, paradoxically, dependent on artificial means and human labor.[82]

## Huygens' Pendulum

The anxious reflection that accompanied the application of mathematics to motion disappeared within a generation, at least among the practitioners of the new mathematical natural philosophy.[83] Descartes' disciples such as Christiaan Huygens seem to have been oblivious to the epistemological conundrums and paradoxical implications that troubled their predecessors. For Huygens, the concept of abstract motion and the conflation of artificial and natural, mathematical drawing and physical motions, were simply tools of the trade that he applied without pausing to attempt a justification.

A fine example of Huygens' unfettered virtuosity with those new tools is his way of saving the Cartesian analysis of the sling and its centrifugal tendencies. Descartes' mechanics have a real difficulty in explaining what it is that keeps taut a revolving sling like the one in the famous diagram (fig. 4.11). According to Descartes' second law of nature the stone at $A$ has a tendency to continue along the tangent $AG$; the radial tendency along $EA$, $EBC$, and $EFG$—the cause of the tautness of the rotating sling—remains a mystery.

Huygens resolves the mystery by manipulating frames of reference. He imagines a sling revolving from $M$ towards $B$ (fig. 4.12), and the stone in the sling released at point $M$. An observer situated at the point where the stone was released appears from the center $A$ as rotating counterclockwise, but

FIGURE 4.11  Descartes' sling from *Principia Philosophiae*. Reproduced with permission of the Rare Books and Special Collections Library, The University of Sydney.

experiences herself as stationary and the original point of release *M* as moving away from her in clockwise direction. From the observer's perspective, the released stone, moving tangentially, rectilinearly, and uniformly along *MS*, appears to be accelerating along the curve *BRS*.[84] The explanation of the radial tendency is now contrived from meshing the real motions *MB* and *MS* with the purely mathematical construction *BRS*: *BRS* is tangent to the radial direction *AB*γ at point *B*, so the truly tangential centrifugal force is experienced as a radial tendency.[85] Real force with real effects—the radial tendency along *AB*γ—is created, in Huygens' analysis, from the relations between the naturally drawn line *BLNM* (equivalent to *LABF* in Descartes' illustration) and the mathematically drawn line *BRS*.

The boldness of Huygens' moves is hard to overstate. He respects none of the distinctions that were self-evident to practitioners from Oresme through Alberti to Maestlin and gave sense to their mathematical endeavors. Nor does he have any use for the distinction that Kepler and Galileo introduced to replace the traditional ones, the distinction between "arbitrary type of motion" that "anyone may invent" and motion that "actually occurs

FIGURE 4.12 Huygens' analysis of radial centrifugal force as the evolute of circular motion in *De vi centrifuga* (*Oeuvres* 16, 262). Reproduced with permission of the Rare Books and Special Collections Library, The University of Sydney.

in nature." Huygens ascribes causal efficacy—radial centrifugal force—to a purely mathematical relation—the angle between the evolute and the tangent. Moreover, he sees no difference between the real motions, that of the circle around *C* and that of the receding stone along *DB*, and the imaginary construction *BRS*.

Huygens presents yet a bolder example of conflating nature's and human drawing in his discovery that the cycloid—the line traced by a point on a rolling circle (*MKI* in fig. 4.13)—is the curve of isochronic oscillation—the curve on which the periods of the swings of a freely oscillating body will be equal to each other, whatever is the amplitude of each swing.[86] As Michael Mahoney describes the process in this case, "Huygens conflated a drawing of the pendulum and of the trajectory of its bob—that is, a sketch of the physical configuration—with a graph of its motion, that is, a mathematical configuration. His initial insight ... arose from treating the two configurations as one."[87] He begins with nature's traces: the line *TK* (fig. 4.13) represents the chord of a simple pendulum, and the curve *ZK* is a segment of the

FIGURE 4.13 Cycloids from Huygens' *Horologium oscilatorium* (11–12). Reproduced with permission of the Rare Books and Special Collections Library, The University of Sydney.

circular path it draws. Using a physical law—the square ratio between distance and velocity deducible from Galileo's law of free fall—he constructs the "parabola of velocities" *ADϘΣ*—a strictly mathematical curve. Employing a combination of physical laws of motion and mathematical theorems concerning relation of curves, Huygens then develops from *ADϘΣ* the inverse "parabola of times" *ΣΣGP*. A series of auxiliary constructions allow him to translate the mixed physical-mathematical query "Assuming that Zℵ is the curve of isochronic oscillation, what are its mathematical characters?" into a thoroughly mathematical analysis of these two parabolas from which the desired curve could then be constructed:

> I saw that, if we want a curve on which the times of descent are equal over any arcs terminated at Z, it must be of such a nature that, if one sets the ratio of the curve's normal ET to the ordinate EB equal to that of a given line GB to another EB, the [second] point E falls on a parabola with vertex Z. This I found to agree with the cycloid, by a known method of drawing the tangent.[88]

The isochronic curve turned out to be a cycloid; a paradigmatic "mechanical curve." On the one hand, it had to be produced by a moving body—a point on a rolling wheel (fig. 4.14, top); on the other, the mathematical properties of this motion had an immediate mechanical application. The cycloid,

[Fig. 2]

[Fig. 3]

FIGURE 4.14 Huygens analysis of isochronic pendulum (*Oeuvres* 16, 392). Reproduced with permission of the Rare Books and Special Collections Library, The University of Sydney.

Huygens had already proved, was its own evolute. That is, if *MKI* was a cycloid (fig. 4.14, bottom), so was the curve *MPI*, produced by the series of equal-length tangents *KNP*. Presented mechanically, as in Huygens' drawing, if *MKI* is a cycloid, so is the trajectory of a pendulum whose cord wraps itself around it. That meant that a clock's pendulum could be forced into an isochronous trajectory by constricting its oscillation with cycloidal "cheeks," an idea that Huygens is quick to implement.[89] For Huygens, the conflation of mathematical and mechanical and of natural and artificial are no longer an epistemological worry; they are a commercial opportunity.

### Hooke's Spring

The trust in mathematics to provide causal explanations was Kepler and Galileo's legacy, but the seamless way in which Huygens assimilated mathematical manipulations and mechanical considerations was well beyond their intentions. Yet whereas Huygens' virtuosity was unique, his willingness to conflate the material and the mathematical was not. Practitioners of mathematical natural philosophy in the generations after Descartes came to share the complete confidence he displayed in the power of mathematics to capture nature at its most complex, as well as the disregard to the distinction between real and artificial curves, between nature's traces and human constructions.[90] An excellent example of this approach is provided by Robert Hooke, who, five years after Huygens published his proof of the isochrony of cycloidal pendulum in the *Horologium Oscillatorium*, was using similar maneuvers for a similar purpose: to prove the isochrony of an oscillating spring.[91]

His mathematical skill was perhaps not as dazzling as Huygens', yet Hooke incorporates into his proof an even wider range of material and intellectual tools, and he moves amongst them smoothly. Consider fig. 4.15: within one page, Hooke moves from the realistic drawings of his experimental apparatus on the left, through the direct mathematical representations on the upper part of the diagrams on the right, through a set of physical claims about force and motion, to the purely mathematical constructions at the bottom part, and back to causal-mathematical claims about velocities. Like Huygens, Hooke starts with nature's own drawing: the horizontal line *AC* (*Fig. 4* in fig. 4.15) is simply a spring, stretched to points *B* and *C*. The vertical lines *BE* and *CD* are already abstractions; they "represent the power that is sufficient to bend or move the end of the spring" to these points.[92] According to the Law of the Spring that Hooke had just formulated,

FIGURE 4.15 Springs and diagrams of their workings from Robert Hooke's *Of Spring* (*De Potentia Restitutiva*). Reproduced with permission of the Rare Books and Special Collections Library, The University of Sydney.

The Power of any Spring is in the same proportion with the Tension thereof:
That is, if one Power stretch or bend it one space, two will bend it two, and
three will bend it three, and so forwards.[93]

The springs on the left of Hooke's drawing provide empirical support for
his law, but Hooke's law is much more than an empirical generalization.[94]
It is a consequence of a theory of matter that Hooke develops throughout
his career and that embeds the most fundamental idea that justified for Ke-
pler and Galileo the moving of mathematics from the realm of the mixed
sciences to that of natural philosophy. Namely, that order is created, rather
than demolished, by motion:

If we mix in the dish *several kinds* of sands, some of *bigger*, other of *less* and finer
bulks, we shall find that by the agitation the *fine sand* will *eject* and *throw out* of
it self all those *bigger* bulks . . . and those will be *gathered* together all into *one*
place . . . for particles that are all *similar*, will, like so many *equal musical strings
equally strecht*, vibrate together in a kind of *harmony* or *unison*.[95]

As Kepler had it, "everything in which quantity, and harmonies in accor-
dance with it, can be sought, their presence is most evident in motion." For
Hooke this comes to mean that the very structure of matter is produced by
motion. "The parts of all *bodies*, though never so *solid*, do yet *vibrate* [since]
*all* bodies have some degrees of *heat* in them";[96] matter is in constant mo-
tion, and it is this motion and its "harmonies" that create clusters of par-
ticles that become substances:

Let us suppose a dish of sand set upon some body that is very much *agitated*,
and shaken with some *quick* and *strong vibrating motion*, as . . . on a very stiff
*Drum*-head which is vehemently or very nimbly beaten with the Drumsticks. By
this means, the sand in the dish, which before lay like a *dull* and unactive body,
becomes a perfect fluid; and ye can no sooner make a *hole* in it with your fin-
ger, but it is immediately *filled up again*, and the upper surface of it *levell'd*. Nor
can you *bury* a *light body*, as a piece of Cork under it, but it presently *emerges* or
*swims* as 'twere of the top.[97]

Before coming to prove the isochrony of springs in *De Potentia Restitutiva*,
Hooke completes the analogy:

as we found that musical strings will be moved by Unisons and Eights, and
other harmonious chords . . . so do I suppose that the *particles of matter* will be
moved principally by such motions as are Unisons.[98]

With the aid of this theory of matter and its consequent dynamics, Hooke
sets to emulate Huygens. His Law of the Spring entails that the area of the

FIGURE 4.16  Galileo's diagrams of acceleration from *Two New Sciences* (*Discorsi*). Reproduced with permission of the Rare Books and Special Collections Library, The University of Sydney.

right-angled triangles *ABE* and *ACD* expresses the "aggregate of powers," and from the geometrical representation follow the physical properties of the force: the "aggregate" is "in duplicate proportion to the space bended or degree of flexure."[99] The similarity between Hooke's diagram and those used by Galileo to prove his law of free fall in the *Dialogo*[100] and the *Discorsi*[101] (fig. 4.16) is telling; Hooke is a loyal disciple of Galileo's causal-mechanical project. His confidence in the power of mathematics to provide causal accounts of motion is even more pronounced. He spends no space on justifications of the sort that Galileo attempts in his answers to Simplicio, and

while Galileo's analysis remains conspicuously kinematic, with lines and areas representing velocities and distances (and only an insecure gesture towards *"momenti"*),[102] Hooke's is brazenly dynamic: he has no compunctions about reading the properties on "power" directly off the mathematical constructions. Hooke's proof is completely dependent on the presentation of the "aggregate of powers" as two dimensional, producing acceleration not in percussion-like "moments," but continuously. This allows Hooke to use his "General Rule of Mechanicks," according to which "Velocities [are] always in a subduplicate proportion of the powers, that is, as the Root of the powers impressed."[103] Since he has already shown that this quantity—the square root of "the aggregate or sums of the power by which it [the spring] is moved"—is "proportionate to the degree of flexure," Hooke can conclude that the (final and average) velocity of any solid spring returning from stress is proportional to its distance from its resting point. Hence

> the Vibrations of a Spring, or a body moved by a Spring, equally and uniformly shall be of equal duration whether they be greater or less.[104]

Or in other words: the oscillation of a spring is isochronous; its duration is independent of its amplitude. So, like Huygens' cycloidal pendulum, springs can serve as time keepers; as regulators of clocks' escapements.

The isochrony of the spring is the most important conclusion of Hooke's analysis of matter and vibration in *De Potentia Restitutiva*, but he can do more: a study of the mathematical properties of his diagram provides approximations of the velocity of the oscillating spring at each point, and the time required for each segment of oscillation. The trapezes $DCBE$ (*Fig. 4* in fig. 4.15) represent the "powers" operating on the spring returning from its displacement to $C$ to its natural position at $A$. Thus, according to Hooke's "General Rule of Mechanicks," the velocities at points $B$ will be proportional to the square roots of the trapezes $DCBE$ or to $\sqrt{(AC - AB)(CD + BE)}$. The Law of the Spring dictates that $AC \propto CD$ and $AB \propto BE$, so the velocity is proportional to $\sqrt{(AC - AB)(AC + AB)}$ or $\sqrt{(AC^2 - AB^2)}$. Hooke draws the circle $ACF$ with $A$ as its center and $AC$ its radius. The ordinates $BG$ of this circle are equal to $\sqrt{(AC^2 - AB^2)}$ (by Pythagoras), thus they represent the velocities at points $B$. A further manipulation produces the "S-like Line of times" $CIIIF$. If $BG$ represents velocity, $CB$ distance, and $HI$ time, then $BG \times HI \propto CB$, or $BG : \sqrt{CB} :: \sqrt{CB} : HI$. Hooke then determines points $H$ and $I$ with the aid of $CHF$, which is a parabola whose ordinates $HB$ are proportional to $\sqrt{CB}$, giving him $BG : HB :: HB : HI$.[105] Like Huygens, Hooke "conflated a drawing of the . . . trajectory . . . with a graph of its motion,"[106] translating the motion of

the spring into an artificial curve, studying its mathematical properties, and then reinterpreting them as physical properties.

## Newton's Problems

Bold as their use of mathematics was, Hooke and Huygens no longer found it necessary to justify it. The fundamental assumptions that allowed Galileo and Kepler to submit the study of motions and their causes to mathematics—that motion begets order and mathematics is the study of its traces—were already seamlessly embedded in their work. Still, the efficacy of the virtuoso analysis of the spring and pendulum depended on ignoring the additional assumption in the original justification: the strict distinction between natural and artificial traces; between real and imaginary curves. For Galileo and Kepler this dichotomy ensured that they were indeed "following the traces of the Creator" and that their mathematics was not merely an art. Without the distinction, with artificial curves and genuine traces investigated indiscriminately, the beautiful fiction of nature's own drawing collapses: the subject matter of mathematical inquiry has to be provided by the human hand. This was exactly Newton's conclusion: "to describe straight lines and to describe circles are problems, but not problems in *geometry*," he explains in his preface to the first edition of the *Principia*. "*Geometry* is founded on mechanical practice."[107]

The very worry that Kepler and Galileo were careful to guard against becomes, for Newton, a fundamental epistemological insight; the one insight he finds necessary to discuss in the short author's preface introducing his opus magnum to his readers. Curves are not natural traces, they are practical "problems": "the description of straight lines and circles, which is the foundation of *geometry*, appertains to *mechanics*." The subject matter of mathematics is produced by art.

One immediate gain of Newton's remarkable about-face is in making moot the main traditional challenge to mathematical natural philosophy. Since it is a human practice that provides mathematics with its objects, the fundamental misfit between the perfect simplicity of mathematics and the complexity of nature gives way to a relative distinction between "degrees of exactness":

> since those who practice an art do not generally work with a high degree of exactness, the whole subject of *mechanics* is distinguished from *geometry* by the attribution of exactness to *geometry* and of anything less than exactness to *me-*

*chanics*. Yet the errors do not come from the art but from those who practice the art . . .[108]

Like Galileo, Newton does not find in the complexity of nature any essential difficulty for mathematical analysis: it is the limits of the philosopher, rather than of mathematics, that determine what can be analyzed. Unlike Galileo, Newton does not find these limits in theoretical knowledge. For Newton, as it was for Descartes, the achievement of mathematical order becomes a matter of good practice, and complexity becomes a practical challenge. Descartes was still hoping to keep a clear distinction between the "exactness" of practice and that of reason. Continuing his case for complex curves and the legitimacy of his compass, he argues that such curves cannot be rejected

> because the instruments that are used to trace them, being more complex than the ruler and the compass, are therefore not as exact, for were this the case, it would be necessary to exclude them from *mechanics*, where exactness of works made by hand is desired, rather than Geometry, where we seek only exactitude of reasoning, which can be as exact with reference to these lines as to simpler ones.[109]

For Newton, however, the "exactness" of mathematics, its perfection, is no longer detached from its practical origins. It is no longer, as it was for Kepler, a testimony for its being "coeternal with God." It is rather the idealized perfection of practice that provides the image of the divine: "Anyone who works with less exactness is a more imperfect mechanic, and if anyone could work with the greatest exactness, he would be the most perfect mechanic of all."

# From Divine Order to Human Approximation

*Mathematics in Baroque Science*

## KEPLER AND NEWTON

CLEARLY EXPRESSED on the first pages of Isaac Newton's *Principia*, it is extraordinary, and indeed very telling, that these ideas have been completely suppressed from Newton's legacy. It is not as a draughtsman that Newton and his disciples and admirers wanted him to be remembered, but as a grand priest, "unlock[ing] the hidden treasuries of Truth," as Halley wrote to open the *Principia*:

> Lo, for your gaze, the pattern of the skies!
> What balance of the mass, what reckonings
> Divine! Here ponder too the Laws which God
> Framing the universe, set not aside
> But made the fixed foundations of His work[1]

Halley's rhetoric may seem over the top, but he was far from alone in choice of words. "Nature and Nature's laws lay hid in night/God said, 'Let Newton be!' and all was light" was Pope's famous epitaph for Newton, and Voltaire echoed: "the catechism reveals God to children, but Newton has revealed him to the sages."[2] It is up to the reader to gauge the religious sentiment in these poetic efforts as either profound or ridiculous. Voltaire's suspension of his regular cynicism, however, attests that this demigod status was not assigned to Newton on theological grounds. Rather, the personal idolization of Newton reflected an understanding (and self-presentation, no doubt) of what his great achievement consisted of: to "Discern the changeless order of the world."[3]

This is a very different aspiration than that presented by Newton himself in his Preface to the Reader. "The laws which God ... made the fixed foundations of His work" do not require an "exactness" of "those who practice an art."[4] "Reckonings Divine" has little to do with a "Geometry founded on mechanical practice"; it is reminiscent, rather, of Kepler's "Geometry coeternal with God ... shining forth in the Divine Mind." Newton, so we learned from Halley, Voltaire et al., had realized Kepler's dream of "following the traces of the Creator,"[5] but the concept of human, practical mathematics that Newton stresses at the beginning of the *Principia* suggests that his aims and aspirations were different. Kepler was clear about the metaphysics and consequent epistemology directing his search: underlying all seemingly unruly phenomena was a simple, perfect, and harmonious structure, a small set of exact laws serving as the divine blueprint for the universe and available to human reason by means of the mathematics it shared with the divine mind.[6] This chapter will explore Kepler's metaphysics *cum* epistemology as they directed his mathematized *physica*, and argue that Newton's *Principia* reflects different commitments from Kepler's: to the modest and flexible concept of mathematical order expressed in the preface. Rather than "the fixed foundations of His work," Newton was aiming to submit the disorderly celestial motions to human-scale approximation, "founded on mechanical practice."

This is not to claim that Kepler's hopes and demands of mathematical natural philosophy were foreign to Newton, quite the opposite. His conversion from the search for "reckonings divine" to the approximation of "those who practice an art" happened shortly before he commenced the work on the *Principia*, following a short and intellectually explosive correspondence with Robert Hooke in the winter of 1679–80.[7] It was in the course of this correspondence (to which we will return in the next chapter) that Hooke presented to Newton the challenge that he would take on in the *Principia*: "compounding the celestiall motions of the planetts of a direct motion by the tangent & an attractive motion towards a central body."[8] The concession that "*Geometry* is founded on mechanical practice," we will show, was Newton's way of making sense of the implications of planetary trajectories that cannot be assumed to be geometrically meaningful "traces" but were rather physical "compounding" of forces and motions. But before he chose to adopt it, Newton put to Hooke a query that reflects a thorough commitment to the Keplerian principles of order and simplicity.

The query is embedded in the following illustration, sent to Hooke on December 13, 1679 (fig. 5.1).[9] Its resemblance to Kepler's diagram (fig. 5.2) is fundamental: both entail the assumption that simplicity of causes must

FIGURE 5.1  Newton's letter to Hooke, December 13, 1679. The stone falling through the earth from *A* along *FOG* etc. changes its apsides with every orbit. British Library Add. 37021, f.56 124. © The British Library Board, All Rights Reserved.

underlie the complexity of phenomena, and that the role of mathematics is deciphering this simplicity. Exactly seventy years separate these figures. Unlike Newton's private, hand-drawn figure, Kepler's is public and in print—it opens the 1609 *Astronomia Nova*. Kepler was aiming to convince the general astronomical public that the geostatic system, whether in its Ptolemaic or Tychonic version, was untenable. Newton was suggesting to Hooke that the idea that planetary motions are a "compound" was fundamentally flawed. Kepler's diagram is based on a careful calculation from the geostatic theory he thinks obsolete; Newton, on the other hand, feigns a quantitative theory he does not really have and fabricates a construction.[10]

Yet the structure of the argument these diagrams embody is essentially the same and very much in line with Halley and Voltaire's pronouncements. Both depict a hypothetical planetary orbit, a consequent of the theory under consideration, and both expect their audience to immediately perceive the orbit as obviously absurd, and eschew the theory that produced it. The orbit is obviously absurd because it is *chaotic*. Because, to quote Kepler, "these motions, continued farther, would become unintelligibly intricate, for the continuation is boundless, never returning to its previous path."[11] As Newton

FIGURE 5.2 Kepler's "Accurate depiction of the motions of the star Mars" from his *Astronomia Nova*. Reproduced with permission of the Rare Books and Special Collections Library, The University of Sydney.

would put it later (not before he ceased to take this as a self-evident refutation), Hooke's idea means that "there are as many orbits to a planet as it has revolutions." For Newton in 1679, as it was for Kepler in 1609, the argument ends here—an "unintelligibly intricate" orbit is prima facie unacceptable.

An absolute trust in simplicity and orderliness is entailed in these diagrams. It is such a strong assumption that it needs no explication: the reader—Hooke or the general readership—is expected to accept the impossibility of the theory by merely looking at the complexity of the orbit. It is so strong, that it seems to spill over from the level of causes to that of phenomena.[12] Even though it is only the orbit that is complex, Kepler and Newton reject the theory that predicts such an orbit. The complexity, they tacitly claim, is too much to allow a simple cause.

## KEPLER AND PERFECTION

For Kepler, the dream of "foundations" was very real. The aspiration to arrive, through mathematics, at the simple, divine infrastructure of our world

was a genuine commitment fundamental to his work. The trust in universal harmony and an effective belief in the power of mathematics to discover it were not, for Kepler, merely metaphysical, epistemological or religious positions, but together formed a working strategy.[13] It was a 'working metaphysics', assumed in the argument based on the *Astronomia Nova* diagram and embedded in his work throughout his career. In his *Mysterium Cosmographicum,* published thirteen years earlier, Kepler provides his most explicit expression of both: the universe, he tells his readers, is "complete, thoroughly ordered and most splendid."[14] It is simple, and its structure necessary. Kepler's mathematical inquiry is strictly structured by these assumptions. His question in the *Mysterium* is why there are exactly six planets, and his answer is that there are exactly five perfect solids. Thus, since the proportions between the planets' distances can be shown to correspond to the proportions between the solids (for Tycho has demonstrated that there cannot be any material solids in the heavens), then the number of planets has been explained—the mathematical directly accounts for the physical.

### The Mathematical and the Physical

Yet what kind of an explanation is this? Why should abstract mathematical proportions account for a material fact? Why should their aesthetic value be evidence for their truth? Guided by the metaphysics of order, Kepler suggests two complementary answers to this question. Either

> it is by some divine power, the understanding of the geometrical proportions governing their courses, that the stars are transported through the ethereal fields and air free of the restraints of the spheres,[15]

or

> God, like one of our own architects, approached the task on constructing the universe with order and pattern, as if it were not art which imitated Nature, but God himself had looked to the mode of building of Man who was to be.[16]

Either the planets themselves are using the "geometrical proportions governing their courses" to navigate the empty vastness of the heavens, or mathematics is God's own blueprint for the universe. The former option is a traditional idea that Kepler is still willing to entertain, if only for the sake of argument, in spite its antiquated resonance. While Kepler never completely relinquishes this possibility, it is an awkward assumption. It implies that the rationality of the structure can affect the material realm only if matter itself

(or some kinds of matter, like the celestial bodies) is also endowed with rationality, and, as we will discuss in the next chapter, Kepler largely retreats from it in the *Astronomia Nova*.

Kepler never renounces the other way of relating mathematical structures to physical phenomena. It is very telling that already in his earliest work Kepler uses a variation on the theme of "nature's drawing" to present the idea of mathematics as a divine infrastructure. Nevertheless, the playfulness of the challenge to the hierarchies of natural and artificial, human and divine should not be misleading: this quasi-theological assumption is fundamental to Kepler's thought throughout his career. It is this idea that allows him to "deduce the natural properties of the planets from immaterial things and mathematical figures," which, he is worried already in this early (1594) work, will "have the physicists against me . . . because I dare to investigate the origins of the circles from frankly imaginary cross sections."[17] As we saw in chapter 1, in the *Astronomia Nova* Kepler transforms the worry into a direct challenge: "Physicists, prick up your ears!" he declares in his introduction there, "for here is raised a deliberation involving an inroad to be made into your province."[18] However, the difference between the early and mature formulations is that of self-confidence, not substance: neither is Kepler's physicalism in *Astronomia Nova* new, nor are the mathematical convictions of the *Mysterium* a passing juvenile enthusiasm.[19] Assigning mathematics a physical role, we showed in the last chapter, was at the core of Kepler's project, but this physicalization of mathematics was not to come at the expanse of mathematics' promise to provide divine perfection. Quite the contrary: from Kepler's own perspective, the function of the physical explanation is to support the mathematical hypotheses. This is how he presents the relation between the causal-physical and purely mathematical lines of thought when explaining why he had given up on the hypothesis of the planets' "understanding of the geometrical proportions governing their courses." "So indeed I supposed," he writes in a note he adds to the 1621 second edition of the *Mysterium*,

> but later in my *Commentaries on Mars* [the *Astronomia Nova*] I showed that not even this understanding is needed in the mover. For although definite proportions have been prescribed for all the motions . . . by God the Creator, yet those proportions between the motions have been preserved . . . not by some understanding created jointly with the Mover, but by . . . the completely uniform perennial rotation of the sun [and] the weights and magnetic directing of the forces of the moving bodies themselves, which are immutable and perennial properties.[20]

Note what it is that Kepler thinks he has achieved in the *Astronomia Nova*. He did not present the mechanical-physical explanation to replace the mathematical one but to make it feasible. Mathematics is not, and never turns out to be, a description of the physical: the physical is always the way by which the mathematical is maintained. Kepler's belief in perfect proportions remains untouched from the *Mysterium* to the *Astronomia Nova*; only the mechanism by which these proportions are "preserved" is changed. Moreover, as the proportions are simple and harmonious, so is the mechanism preserving them: the rotation of the sun and the magnetism of the planets are "completely uniform [and] perennial." The mathematics—the analysis of the proportions between the solids and the consequent distances and periods—is left to safeguard the "complete, thoroughly ordered and most splendid universe."[21]

### Working Metaphysics

All this does not mean that Kepler is unaware of the difficulties in applying his grand mathematical scheme to the minute details of observation. In fact, the major part of the *Mysterium* is dedicated to this task. In particular, he wrestles to find a place for the eccentricities of the planetary orbits between the nesting polyhedra; the request for the latest values of the eccentricities was the pretext for his correspondence with Brahe, leading to their illustrious collaboration. The point, however, is exactly this: Kepler works to excuse the eccentricities by fitting them into the mathematical model constructed according to independent principles. For Kepler, the world has a universal, harmonic, perfect structure, which can be discovered by a priori, mathematical considerations, and into which one then has to fit the embarrassing particularities of the empirical.

Kepler is so impressed with these relations between the mathematical and the physical that in the second edition of the *Mysterium*, which he published decidedly unchanged (apart from added annotation) twenty-five years after the original version and twelve years after the *Astronomia Nova*, he found in it a proof for creation, hence the existence of God, which should have been good enough to convince the greatest pagan thinker of all:

> The reason why the Mathematicals are the cause of natural things (a theory which Aristotle carped at in so many places) is that God the Creator had the Mathematicals with him as archetypes from eternity in their simplest divine state of abstraction, even from quantities themselves, considered in their mate-

rial aspect. Aristotle denied the existence of a Creator, and decided that the
universe was eternal—not surprisingly, if he rejected archetypes, for I confess
that they would have possessed no force, if God himself had not regarded them
in the act of Creation ... in the end Aristotle was persuaded that splendid and
plainly necessary causes for this matter could be derived from the harmonies as
if from an archetype, I think he would accept with the fullest agreement that
the archetypes exist and, since they are ineffectual in themselves, God as the
architect of the universe.[22]

Still, the theological argument is only a fringe benefit. The primary way in
which "the principle of which I was then already so firmly persuaded has
repaid me with interest over these 25 years," Kepler announces, is strictly
scientific: "the causes of the eccentricities were eventually discovered from
this principle."[23] This assumption is an active guide to his work. Under-
lying perfection and simplicity are not mere rhetoric or general religious-
metaphysical belief: it is a working principle.

### NEWTON AND DISORDER

Kepler exemplifies what it is to genuinely pursue the "Laws which God/
Framing the universe, set not aside": he takes "this principle" as a crite-
rion of acceptability of particular hypotheses and employs it in "discover-
ing" physical "causes." The argument embedded in the drawing that New-
ton sent to Hooke reflects a similar commitment: a physical hypothesis has
to entail an underlying simple mathematical structure to be considered. Un-
like Kepler, however, Newton did not remain loyal to this commitment. By
the time he set out to write his opus magnum, less than five years after the
letter to Hooke, Newton no longer shared Kepler's twin beliefs in simple
harmonies and in the power of mathematics to discover them.

### *The Moving Aphelia*

The disappearance of "reckonings Divine" and "fixed foundations of His
work" between the correspondence with Hooke and the *Principia* is beau-
tifully reflected in Newton's transformation of the very argument and dia-
gram that he used to counter Hooke. Their final version is to be found in
propositions 43–45 of the first book of the *Principia*:[24]

> If a body, under the action of a centripetal force that is inversely as the square
> of the height, revolves in an ellipse having a focus in the center of forces, and
> any other extraneous force is added to or taken away from this centripetal

force, the motion of the apsides that will arise from that extraneous force can be found out . . . and conversely.[25]

Newton's drawing in the 1679 letter was meant to suggest to Hooke that his proposal "of compounding the celestiall motions of the planetts of a direct motion by the tangent & an attractive motion towards a central body"[26] implied the motion of the apsides. If the planet's trajectory was 'compounded,' Newton was arguing, there was no reason to assume that there was one permanent line between the closest and the farthest point of the orbit. In other words, the "compounding" did not produce a proper orbit at all, hence it was no real candidate as a theory of celestial mechanics. In the *Principia* Newton turns this argument on its head. Now, it is the ability to calculate this motion of the apsides that assures him of the power of his mathematics and the validity of those very physical assumptions he adopted from Hooke.

However, this new ability hinges on changing the very notion of an orbit and the way mathematics is used to construct it, and the change implies that the assumptions of perfection and simplicity underlying the original argument had been abandoned. This is borne out in the particulars of Newton's mathematics.

The crucial change transpires when Newton stops treating moving apsides as a sign that a trajectory is *not* an orbit. Instead, they become a property of *a particular kind* of orbit; a revolving orbit. This is the consequence of proposition 43, in which Newton teaches his readers "to find the force that makes a body capable of moving in any trajectory that is revolving about the center of forces in the same way as another body in the same trajectory at rest."[27] Given orbit VPK with center of force at C (fig. 5.3), Newton shows how to construct for each point P on this closed curve an identical curve through *up* at a constant angle PC*p*, equal to VC*u* (the diagram suggests the curve is a Keplerian ellipse, but nothing in the proof refers to or depends on this). Now, since VPK is an orbit around C, namely P is moving about C towards which it is drawn by centripetal force, it follows that area VCP is proportional to time. This is the very first theorem Newton proved in the *Principia*.[28] It is Kepler's law of areas, his so-called second law, generalized from an empirical approximation into a mathematical truth about all bodies revolving around a center of force.[29] Additionally, by the conditions of the propositions, angle VC*p* is proportional to angle VCP. Hence, the area described by C*p* will be proportional to area VCP, and therefore proportional to time.

The proof that C*p* is sweeping areas proportional to time is what turns "the figure *u*C*p*" into a sector of an orbit around C. This follows from

FIGURE 5.3 *Principia*, proposition 43. Reproduced with permission of the Rare Books and Special Collections Library, The University of Sydney.

Newton's second theorem, according to which "every body that . . . by a radius drawn to a point . . . describes areas around that point proportional to time, is urged by a centripetal force tending toward that same point."[30] In other words, not only does every body orbiting around a center of force abide by the area law, the complementary is also true: every body abiding by the area law around a given point is describing an orbit around that point as a center of force, so *up*K is an orbit:

> The body, being always at *p*, will move at a perimeter of the revolving figure *u*C*p*, and will describe its arc *up* in the same time in which another body P can describe the arc VP, similar and equal to *up*, in the figure VPK.[31]

Proposition 43 is pivotal not only because it allows Newton to claim control over the concept of a revolving orbit, but also because it formulates the difference between the stable and the revolving in terms of the difference of the laws of centripetal forces creating them. In the next proposition he calculates exactly what this difference is:

> The difference between the forces under the action of which two bodies are able to move equally—one in an orbit that is at rest and the other in an identical orbit that is revolving—is inversely as the cube of their common height.[32]

FIGURE 5.4 *Principia*, proposition 44. Reproduced with permission of the Rare Books and Special Collections Library, The University of Sydney.

The transformation of the unruly, hence impossible trajectory of the letter to Hooke into an orbit is thus an impressive show of skill and an important achievement; it is the culmination of Newton's treatment of "motion of bodies in orbits whose planes pass through the center of force,"[33] after which he moves on to deal with oscillation. When he reverts in the General Scholium to the patently false claim that "the aphelia of the planets are at rest"[34] (to which we will return below), it is not because he shies away from complex trajectories.

But what exactly has Newton achieved? C*p* obeys the areas law simply by virtue of C being a center of force, and "figure *u*C*p*" is a sector of an orbit by virtue of obeying the areas law. Yet the body at *p* does not travel along the dotted line. Newton makes it very clear in his illustration to Proposition 44 (fig. 5.4):[35] the body at *p* does not continue to *k* but to *m*. The curve *up* does not represent a real trajectory—it is only a copy of VPK around one known point *p* of the real trajectory. The real trajectory, like that in the drawing sent to Hooke, has no regular line of apsides. Moreover, VPK itself is not a real trajectory; there is no body that moves along this curve. Both trajectories—at rest and revolving—are mathematical fictions. The orbit itself, the real trajectory in which the body is traveling, does not possess any mathe-

matical status; it is not a recognizable curve and Newton does not presume to draw it. One may say that Newton returns the real trajectory to the status of mathematical and theoretical irrelevance that it had in traditional astronomy, before Kepler turned it into a study of real motions and their causes. Instead of curves that nature draws in the heaven—real continuous lines that the planets trace in their motion—Newton is studying points like V and $p$—presumably locations to be determined empirically, from observations—and fictive orbits constructed for calculation purposes. Still, the end of the calculation is a brilliant realization of Kepler's hope for *physica coelestis*: the mathematics provides causal account, relating real bodies by forces that impact their motions. However, the justification for this hope, the idea of simple mathematical infrastructure, has disappeared. Mathematics is not embedded in the behavior of the revolving body; it is only a sophisticated means to decipher it.

Propositions 43–45 put regularity into trajectories that follow no regular curve and have no stable line of apsides—they turn them into orbits. Yet it is *artificial* regularity; it is the work of art, the construction of fictive orbits. This regularity is the assurance that some features of these orbits can be determined by reason, but the determination comes by the application of *"Geometry* . . . founded on mechanical practice" rather than "Geometry co-eternal with God"; by human approximation rather than by the discovery of rational or simple foundations.

### *The Copernican Scholium*

This is neither the way Newton has been commonly interpreted nor the way he chose to present himself. Newton was so keen to trade his actual achievement for the quasi-religious accolades he collected that he obviated the magnificent achievement of propositions 43–45 with a patently false declaration: "The aphelia of the planets are at rest,"[36] he brazenly claims in the General Scholium concluding the *Principia*. Yet Newton never deluded himself about the implications "of compounding the celestiall motions of the planets," and he summarized these implications in a most revealing scholium which was conspicuously left out of the *Principia*:

> The whole space of the planetary heavens either rests . . . or moves uniformly
> in a straight line, and hence the communal centre of gravity . . . either rests or
> moves along with it. In both cases . . . the relative motions of the planets are
> the same, and their common centre of gravity rests in relation to the whole of

space, and so can certainly be taken for the still centre of the whole planetary system. Hence truly the Copernican system is proved a priori. For if the common centre of gravity is calculated for any position of the planets it either falls in the body of the Sun or will always be very close to it. By reason of this deviation of the Sun from the centre of gravity the centripetal force does not always tend to that immobile centre, and hence the planets neither move exactly in ellipse nor revolve twice in the same orbit. So that there are as many orbits to a planet as it has revolutions ... and the orbit of any one planet depends on the combined motion of all the planets, not to mention the action of all these on each other. But to consider simultaneously all these causes of motion and to define these motions by exact laws allowing of convenient calculation exceeds ... the force of the entire human intellect. Ignoring those minutiae, the simple orbit and the mean among all errors will be the ellipse.[37]

This is the so-called "Copernican Scholium," a crucial part of the final version of *De Motu Sphæricorum Corporum in Fluidis*—Newton's series of manuscripts leading to the *Principia*. The universe depicted in it is imperfect and far from simple; "the aphelia of the planets" in this scholium are, *in principle, not* "at rest." His original complaint to Hooke was correct, Newton is saying: if one accepts that the planetary trajectories are 'compounded' of forces and motions, one will have to concede that planetary trajectories do not constitute orderly orbits with a stable line of apsides. Yet if the wild trajectory was presented to Hooke as an absurdity, an argument against his hypothesis, in the Scholium it becomes a reality. That "there are as many orbits to a planet as it has revolutions," is no longer a challenge to a theoretical hypothesis but a conclusion of a mature theory. Kepler's confidence that "the forces of the moving bodies themselves" will assure that "proportions between the motions [would be] preserved" was unfounded, Newton concludes. Forces and motions create only chaotic trajectories: "the planets neither move exactly in ellipse nor revolve twice in the same orbit." There are, strictly speaking, no mathematically meaningful orbits at all. Pace Kepler and Galileo, nature does not draw mathematical curves; the "simple orbit" is a human construction, "the mean among all errors."

### Errors and Perturbation

It is tempting, and indeed common, to take Newton's rhetoric in the General Scholium at face value and accept Halley's and Voltaire's elegies as expressing Newton's real aspirations and achievements.

Read from this perspective, the Copernican Scholium may be understood

as an epistemological rather than metaphysical assertion: it is only the complexity of the phenomena that "exceeds the force of the entire human intellect," Newton may be claiming; planetary motions are governed by "exact laws," even if the limits of our intellect force us into "ignoring minutiae" when attempting to save the phenomena. The role of propositions 43–44, according to this reading, was not the mere reduction of complex planetary trajectories to wieldy mathematical fictions. Rather, it was to give a physical, dynamic account of the traditional "precession of apses": an explanation how a "Keplerian orbit in a focal ellipse is drawn out of that ideal curve through the disturbing force of solar gravity."[38]

The attraction of this interpretation rests on a common perception of Newton's achievement that never lost its appeal, despite scathing critique from the doyen of Newtonian research, D. T. Whiteside:

> It is, unfortunately, one of the most tenacious myths of Newtonian hagiography that this demi-god of our scientific past made his dynamical explanation of the moon's motion in all its irregularity the supreme proof of his monolithic principle of the universal inverse-square law of gravitation which governs all celestial and terrestrial movement, and this in a surpassingly rigorous geometrical manner which he made inimitably his own.[39]

According to the myth that Whiteside ridicules, Newton has succeeded in achieving exactly what he declared in the Copernican Scholium to be impossible: to "define" the most complex trajectory of all planets, that of the moon, by an "exact law"—the inverse square law of universal gravitation (henceforth ISL). Moreover, so it is said, in doing so Newton was able to prove the correctness of the inverse square law and its universality: beyond showing that the moon's orbit is an effect of a mutual attraction between the moon and the earth that was inversely proportional to their relative distance, Newton allegedly demonstrated that all deviations from the expected orbit were due to "perturbation" by an attraction from the sun that followed the ISL as well.

Newton, however, could not boast such a demonstration, although he worked at it relentlessly. In proposition 66 of the first book of the *Principia* he constructs a simplified geometrical model for the sun and two planets, assuming that they all mutually attract according to the ISL (fig. 5.5). Corollary 17 deals with the earth and the moon and demonstrates how to calculate the relative strength of the forces between the three objects from the periods of the moon around the earth and the earth around the sun. In proposition 25 of the third book Newton plugs into this geometrical formula the known periods and determines "the forces of the sun by which the

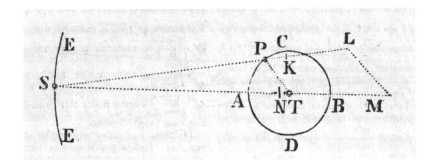

FIGURE 5.5 Newton's diagram for proposition 66 of the *Principia*. For the original theorem, P and S are orbiting T like two planets around the sun. From corollary 16 on, "*p* revolves about T very near it and T revolves about S at a great distance," like the earth and the moon around the sun. Reproduced with permission of the Rare Books and Special Collections Library, The University of Sydney.

motions of the moon are perturbed."[40] Yet as hard as he tries, Newton never succeeds in making the solar force he calculated account for more than half the rate of the precession of the lunar equinox.

Newton's attempts make up a series of increasingly bolder simplifications. He begins by assuming that only the sun's attraction in the direction of the vector-radius connecting the earth and the moon should be considered, and that the effect of the attraction in the transverse direction (where the sun's direction is perpendicular to the earth-moon radius) is negligible. He then further simplifies his model by placing the earth not in the focus of the moon's presumed elliptical orbit, but at its center. Were Newton's main objective to demonstrate the universality of the ISL, this would have been a self-defeating move because, as we will explain below, the force law for an elliptical orbit with the center of force at its center is very different from the ISL that follows from a Keplerian orbit around one of the foci. Yet he is not deterred. With this simplified model he is able to derive first approximations of the moon's longitudinal anomaly (its varying distance from the earth) and its motion through the ecliptic; the regression of the lunar nodes and the variation of the inclination of its plane (propositions 29–35). Still, the main prize, the precession of the line of apsides, keeps eluding him. He ends up adopting a version of Jeremiah Horrocks' kinematic model with a fluctuating eccentricity, a model that makes little dynamic sense but gives somewhat better approximations, but even this compromise does not provide satisfactory results. A little heady scholium in the first edition of the *Principia*, proclaiming that the difference between the precession pre-

dicted by these very difficult calculations and the one recorded in Flam-steed's tables "should be attributed to a fault in the tables,"[41] quietly disap-pears from the subsequent editions.

In his career-long strive to dismantle the "demi-god" image of Newton—"Nearer the gods no mortal may approach"[42]—and reinstate him as a mere human individual of his time (if supremely talented and skilled), it was im-portant for Whiteside to stress and demonstrate that Newton did *not* achieve this grand unification.[43] Of essence, however, is not the failure, even if it was so experienced by Newton himself, but the means by which he attempted to gain control over the precession of the lunar apsides. It would have been, of course, nice and convenient if all the forces at play could have been shown to follow one simple law, but in lieu of such uniformity, Newton does not hesitate to use his mathematics to provide approximate solutions. Mathe-matics, for Newton, is no longer a means to decipher the simplicity under-lying the complex phenomena, but a means to simplify, approximate, and subdue it. The assumption that gravity declines "exactly" as the square of the distance remains a physical hypothesis, not a metaphysical dictate. The inability to demonstrate the "monolithic principle of the universal inverse-square law of gravitation which governs all celestial and terrestrial move-ment" is thus a disappointment, but not a devastating refutation; some two generations later, Clairaut and Euler, tackling the moon's problem, were perfectly willing to entertain the idea that gravity may follow a more com-plex law, without worrying about tumbling the Newtonian edifice. Indeed, a careful look at proposition 66, the basis for Newton's efforts, reveals that it is not the uniformity of the mathematical force law that it sets out to estab-lish—the ISL is actually assumed for all three bodies—but the universality of the attraction:

> Let three bodies—whose forces decrease as the squares of the distances—attract one another, and let the accelerative attractions of any two towards the third be to each other inversely as the square of the distances, and let the two lesser ones revolve around the greatest. Then I say that if that greatest body is moved by these attractions, the inner body will describe around the innermost and greatest body [the sun], by radii drawn to it, areas more nearly proportional to the times and a figure more closely approaching the shape of an ellipse (whose focus is in the meeting point of the radii) than would be the case if that greatest body were not attracted by the smaller ones and were at rest, or if it were much less attracted or much more or much less perturbed [agitetur].[44]

The main point Newton is making in proposition 66, prior to all corollar-ies, is that the "greatest body is moved by these attractions." The physical

imagery pressed by the proposition is not that of an original orbit, an ideal curve drawn by one central body attracting another, which is then "perturbed" by the attraction of a third body. It is, rather, the scenery described in the Copernican Scholium: "the orbit of any one planet depends on the combined motion of all the planets, not to mention the action of all these on each other." All bodies attract each other simultaneously and the sun "is moved by these attractions" just like the moon. The ISL is a marginal point in proposition 66 and in the attempts to gain control over the vicissitudes of the moon's trajectory. It is mutual gravitation, a property of corporeal objects, which is universal, and all physical accounts of motion—celestial and terrestrial—must refer to it (though not all calculations—for the sake of those, as we saw, Newton allows himself purely kinematic models). Whether the force law governing these attractions for all bodies is the same is a matter of "much more ... or much less." Newton's celestial mechanics, unlike Kepler's, is not dependent on the uniformity and simplicity of the mathematical force law underlying the phenomena. Matter provides uniformity—not mathematics—and it is indeed the precarious and imperfect uniformity that can be expected of matter.

### Preparing and Using of the Inverse Square Law

The Copernican Scholium is an elaboration of the physical assumptions of proposition 66, and with its specter of "as many orbits to a planet as it has revolutions," makes perfect sense of the need to calculate "the motion of bodies in mobile orbits, and the motion of the apsides." It also has clear merit as a summary of Newton's mechanical cosmology, and Newton was keen to provide such a summary to himself and his audience: he wrote the "System of the World," comprising the third part of the final version (and the second part of the original two-part version of the *Principia*), twice, in two different modes and with different persuasive strategies in mind. However, this Scholium has been altogether omitted from the *Principia*, in which the rhetoric of perfection and accuracy is carefully maintained: "nature is simple" Newton reiterates at the beginning of the Third Book, it "does not indulge in the luxury of superfluous causes" and is "ever consonant with itself"; "gravity towards the sun ... decreases *exactly* as the squares of the distances"[45] he concludes on the last page.

The Baroque tension between practical acknowledgment of irreducible complexity and the insistent public avowal of discoverable, fundamental simplicity is a cultural phenomenon of utmost importance; a crucial aspect of the legacy of early modern science that its modern successor has never

acknowledged, let alone reflected on. However, our interest in this chapter is not in the discrepancy but in the epistemic practices proper. Embedded in those, in the actual physical-mathematical work invested in the *Principia*, is not a Keplerian dream of perfection but a conscious commitment to the metaphysics of disorder and the entailed epistemology of approximation expressed in the Preface to the Reader and the Copernican Scholium. It a metaphysics that dictates the search for "causes," in the plural, not a single unifying law, and in which "laws"—again in the plural—are to "*define* these motions" affected by them. The laws Newton seeks do not belong to the "fixed foundations of His work," but to "those who practice an art," and are designed for "allowing of convenient calculation."

This new working metaphysics was not a concession; it is not skepticism that Newton suggests in the Copernican Scholium. Like Kepler and Descartes' musings on the mediated nature of all vision, Newton's discussion of the consequences of the celestial ontology of forces elaborates on the success of the new endeavor. He does concede that "to consider simultaneously all these causes of motion and to define these motions by exact laws allowing of convenient calculation exceeds ... the force of the entire human intellect," but this declaration is not a lamentation of the limits of "the force of the entire human intellect." It is, rather, an introduction of what this intellect *is* capable of and should be expected to provide: "ignoring those minutiae, the simple orbit and the mean among all errors." It is within our powers—the powers of "practical mechanics" declared in the preface—to decide which lines to "draw" and which to "ignore." Unlike Descartes, Newton was never suspected of skepticism, and rightly so; our point is not that he is short of epistemological confidence but that he bases his confidence, in the Copernican Scholium, in the Preface to the Reader, and in his actual work, on the active capacity to mathematically approximate a "mean among all errors."

The ISL, in Newton's work, is both an outcome of and a means for such approximation. Newton, we will demonstrate in detail in the next chapter, did not need to "discover" the ISL—it was adopted by Hooke for gravity from Kepler's optics already in the 1660s[46]—but he establishes and uses it in wholly novel ways. None of these ways, however, suffice or aim at creating a "monolithic principle of the universal inverse-square law of gravitation which governs all celestial and terrestrial movement." Newton infers the ISL, in two different ways, both requiring significant simplifications of his dynamical model and the astronomical data. The first is by plugging Kepler's "harmonic law" into a geometrical proportion relating orbits and

periods to centripetal forces. This proportion, however, he proves only for circular, uniform motion. He then infers the ISL, independently, from Kepler's "first law"; for elliptical orbits whose center of force is at one of the foci.[47] This demonstration, however, includes also the difficult stipulation that a minor deviation of the sun from the focus—well below the empirical resolution—will make it completely wrong.

The former way has roots in Newton's work in the 1660s, and it is perfected in the same version of *De Motu* from which the Copernican Scholium is taken. Using a few fast-and-loose moves that Kepler would have hardly recognized as the "Mathematicals," which "God the Creator had with him as archetypes from eternity," Newton establishes a geometrical expression for the centripetal force holding a body revolving uniformly in a circular orbit: $f \propto AD^2/R$, where $R$ is the radius of revolution and $AD$ an infinitesimal arc.[48] He then adds five corollaries, all simple derivations from this expression. He assumes uniform motion, so $AD$ is proportional to the body's velocity. Thus, combining $AD \propto V$ with $f \propto AD^2/R$, it follows that:

Corol. 1. $f \propto V^2/R$.

Since the velocity of rotation is inversely proportional to the period of revolution, *i.e.*, $V \propto 1/T$, this is equivalent to:

Corol. 2. $f \propto R/T^2$.

Combining these two proportions, Newton can construct a force law—a ratio between force and distance—for *any* given ratio between the radius of the orbit and the period of revolution, and he demonstrates this capacity by providing three different ones:

Corol. 3. if $T^2 \propto R$, then $f$ is distance-independent,

Corol. 4. if $T^2 \propto R^2$, then $f \propto 1/R$; and

Corol. 5. if $T^2 \propto R^3$, then $f \propto 1/R^2$.

"The case of the fifth corollary holds for the celestial bodies ... astronomers are now agreed," he adds, almost as an afterthought.

Newton has no use for any of the justifications that Galileo, Kepler or Descartes felt required to provide for their mathematical-causal claims. He has no difficulty accepting that the physics follows the mathematics; that the actual law governing the force is simply what one finds by installing the empirical data into an abstract mathematical formula. The resultant law, as befitting a property of matter rather than a "mathematical" of the sort that Kepler was aspiring towards, is *contingent,* and Newton stresses this contingency by running through an assortment of possible force laws following imaginary data. The stress on contingency is important to him: the five corollaries of the *De Motu* are expanded to nine in proposition 4 of the

*Principia.* The case of where "the periodic times are as the $\frac{3}{2}$ powers of the radii" is just the sixth of them, and the language distinguishing this particular option in the consequent scholium is hardly more excited than in *De Motu*:

> The case of corol. 6 holds for the heavenly bodies (as our compatriots Wren, Hooke, and Halley have also found independently). Accordingly, I have decided that in what follows I shall deal more fully with questions relating to the centripetal forces that decrease as the squares of the distances from centers.[49]

Which force law to "deal more carefully with," Newton declares, is a matter of choice; he had "decided" on the ISL. This is not a mere turn of phrase: given that the proof is limited to "the centripetal forces of bodies that describe ... circles with uniform motion,"[50] its application to the elliptical orbits and changing velocities of the primary planets *is* a decision, and not a trivial one.

The point is *not* that Newton allows himself a convenient tolerance in "massaging" the empirical data into whatever mathematical apparatus is at his disposal. Quite the contrary. As he states in the Copernican Scholium, achieving "the mean among all errors" is the very task he undertakes in the *Principia,* and one that he carefully defines in the previous proposition and its corollaries:

> Proposition 3, Corollary 2: And if the areas are *very nearly (quam proxime)* proportional to the times, the remaining force will tend towards body T *very nearly.*
> Proposition 3, Corollary 3: And conversely, if the remaining force tends *very nearly* toward body T, the areas will be *very nearly* proportional to the times.[51]

Creating mathematical order in complex orbits by way of approximation is not a way of tolerating inaccuracies or an assertion of epistemological pessimism. It is, rather, a demand: the mathematics and the observations should fit *quam proxime.* Namely: if an exact force law gives an ideal orbit, an approximate one should give an orbit within the resolution of the empirical data. Newton does not feel obliged to legitimize his physical use of mathematics the way Kepler does, but the commitments he accepts as part of this epistemology of controlled complexity also exact an unavoidable price. The *quam proxime* requirement all but prohibits demonstrating the ISL from the empirical data and Kepler's "laws" directly, because very different laws can produce heavenly motions that are "very nearly" identical.

The problem presents itself most acutely in propositions 10 and 11, as Newton completes his instruction of how "to find centripetal forces" and

moves to "the motion of bodies in eccentric conic sections." Using the same proto-infinitesimal techniques of the *De Motu*, Newton proves in proposition 10 that for a body traveling in an elliptical orbit, "the law of the centripetal force tending towards the center of the ellipse" is as the (changing) distance of the body from the center of force. In the next proposition, number 11, he proves that if "the centripetal force [is] tending towards a *focus* of the ellipse," it will be inversely as the *square* of the distance.[52] In other words, if the sun is at the center of the planets' elliptical orbits, gravity *increases* with distance; if the sun is at the focus of these orbits, gravity *declines as the square of this distance.* Mars' is the most eccentric of planetary orbits, and still, as calculated by Kepler, it deviates so little from the circular, that the sun is *both* "very nearly" at the center *and* very nearly at the focus. Obviously, gravity cannot both increase with distance and decrease with its square.

Newton's demand that his approximation should fit *quam proxime* does not express a failure to apply simple mathematics to complex nature. Rather, it is a particular constraint that Newton puts on both mathematics and empirical data: the mathematical law should not provide an idealization of the natural motion, but a trajectory that approximates a knowable curve. For the ISL to be a demonstrated law of nature, it is not enough to deduce it from Kepler's (idealized) first or third laws—the force law needs to converge towards ISL as the orbits converge to Kepler's first law. The relation between the ISL and the ellipse fails this criterion. Yet there is no fact of the matter as to whether the orbit is an eccentric circle or ellipse. After all, "the planets neither move exactly in ellipse nor revolve twice in the same orbit," so Newton is free to prove the ISL from the circle, as he does in corollary 6 (corollary 5 of *De Motu*). "The simple orbit and the mean among all errors [is] the ellipse," but simplicity is only one of the considerations that Newton applies in choosing the mathematical order to apply to nature. Given the empirical data and the *quam proxime* requirement, the ellipse does not allow distinguishing between the various possible force laws, all possible, all contingent, that could create these rather than any other orbits. There is no overarching concept of underlying simplicity to compel Newton to accept one approximation over another.

So when writing "I have decided [to] deal more fully with . . . centripetal forces that decrease as the squares of the distances from centers," Newton refers to a very serious decision. It is a similar decision whether to trust Kepler's first law, lean on the proof of the ISL from the ellipse, and breach the *quam proxime* requirement, or lean on the proof of the ISL from Kepler's

third law, but assume the planetary motions are in circular orbits and uniform velocities—an obviously false assumption.

Newton chooses the latter. Although he is very expansive in demonstrating the capacity of his mathematics to handle orbits along various conic sections and complex curves, his work with the real planetary orbits always assumes motion "in the circumference of a circle." To do so within the *quam proxime* requirement, Newton develops a very complex theorem (proposition 7) which allows him "to find the law of centripetal force tending toward any given point" inside this circular orbit. Expanding it on the basis of the preceding propositions, George Smith transformed Newton's geometrical proportion into modern algebraic notation in which force is inversely as:

$$\left(\frac{SP}{a}\right)^5 + 3\left(1 - \varepsilon^2\right)\left(\frac{SP}{a}\right)^3 + 3\left(1 - \varepsilon^2\right)^2\left(\frac{SP}{a}\right) + \left(1 - \varepsilon^2\right)^3\left(\frac{SP}{a}\right)^{-1},$$

where $S$ (fig. 5.6) is the hypothetical position of the center of force (the sun in the solar system), $P$ the position of the moving body (the planet), $a$ the diameter of the orbit, and $\varepsilon$ its eccentricity (the distance of center of force— the sun—from the geometrical center to the orbit). As Smith acutely points out, "$SP$ to the power of 2 is nowhere to be found in this expression"[53] The expression as a whole converges towards $SP^2$ as it comes closer to the eccentric circle, which can be seen as an approximation of an ellipse with the center of force at a focus—it provides that gravitation will be "very nearly" proportional to $1/r^2$ if the planetary orbits are very nearly ellipses and the sun very nearly at their focus, but Newton has no commitment to the ISL as representing anything beyond the outcome of this complex convergence.

As we will show in the next chapter, the ISL as the law for the emanation of light was a feature of divine infrastructure for young Kepler—a reified "'mathematical," deduced directly and necessarily from light's essential geometrical structure. For Newton the ISL is a mere contingent fact about the properties of matter. It is "mathematical" in being an outcome of sophisticated mathematical manipulations and approximations. Its relative simplicity—the fact that the exponent is a simple integer—is but a provisional hypothesis, subject to further empirical inquiry and answering to the practical, human criterion of fitting the phenomena *quam proxime*.

## CONCLUSION

In his seminal paper "Newton and the Fudge Factor," Richard Westfall argued that "not the least part of the *Principia*'s persuasiveness was its delib-

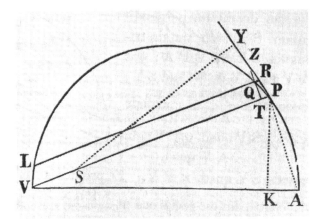

FIGURE 5.6  *Principia,* proposition 7. Reproduced with permission of the Rare Books and Special Collections Library, The University of Sydney.

erated pretense to a degree of precision quite beyond its legitimate claim." To create this lure of precision, Westfall showed in great detail, "Newton brazenly manipulated the figures" in determining the velocity of sound and the precession of the equinoxes, and in the all-important demonstration that "the attraction holding the moon in its orbit is quantitatively identical to the cause of heaviness at the surface of the earth."[54]

This latter issue—the famous "moon test"—is of particular interest to us; it was the way in which Newton related celestial attraction to terrestrial gravity by showing that the force holding the moon to its orbit around the earth is equal to the force of gravity on the face of the earth, multiplied by the moon's mass and divided by the square of its distance. "The law of universal gravitation," Westfall proclaimed, "rested squarely on the correlation of the measured acceleration of gravity at the surface of the earth with the centripetal acceleration of the moon."[55] The former measurement was achieved by Christiaan Huygens, who, following Mersenne's procedures, found the length of the pendulum beating seconds. Newton calculated the latter by estimating the distance the moon would fall towards the earth in one minute. To produce the level of precision he required, Westfall demonstrates, in this and the other examples, Newton was "doctoring the correlation."[56] As shown above, Newton allowed himself even more. "Gravity towards the sun . . . decreases exactly as the squares of the distances," he declares in the concluding lines of the General Scholium. This "is manifest

from the fact that the aphelia of the planets are at rest," he continues, even though his is fully aware that the aphelia are anything but at rest, that indeed "there are as many orbits to a planet as it has revolutions."[57]

Westfall is half bemused, half awed by Newton's audacity in "mending the numbers." The discussion above reveals, however, that the moves Westfall calls "more public relations than science" are fundamental to the way Newton perceives the role of mathematics in the application of order to nature. Westfall accepts the textbook view that "Newton had shown that a system of planets orbiting the sun in accordance with Kepler's three laws entails a centripetal attraction towards the sun that varies inversely with the square of the distance from the sun."[58] But Newton's "System of the World" itself is based on a "doctored" proof. This is so in its popular form, designed as the second book of the *Principia* but discarded by Newton for being too lenient in accommodating to the unschooled, and published only posthumously (in English translation) as *A Treatise of the System of the World*. It is as just as true in its final, formal version as book three. The claim that the force attracting the planets to the sun follows the ISL is proved by applying to Kepler's third law a proportion that was proved only for uniform, circular motion. Not surprisingly, Newton's primary example for his system is provided by the moons of Jupiter, which are the most orderly of the solar system.

When Newton writes that "gravity towards the sun ... decreases *exactly* as the squares of the distance as far out as the orbit of Saturn" he is addressing the public. Nowhere in the *Principia* is such a claim supported or applied. When he writes that this "is manifest from the fact the aphelia of the planets are at rest," he also knows this is overstated at best.[59] In the original *System of the World* he did not suppress "the very slow motion of [the planets'] apses,"[60] and the Copernican Scholium argues that such motion is, in principle, necessary. Yet this flexible and approximate use of mathematics is neither reckless nor a show of epistemological despair. It reflects exactly the way Newton perceived his science: the human enforcement of mathematical order on a messy nature.

"Nature and Nature's laws lay hid in night," wrote Pope; "God said, 'Let Newton be!' and all was light." What Pope had in mind was Kepler's Renaissance dream of divine order. Newton's achievement was largely indebted to relinquishing this dream in the name of the enforced order of the Baroque.

———— ✳ ————

# The Emergence of Baroque Mathematical Natural Philosophy

*An Archeology of the Inverse Square Law*

## HOOKE AND NEWTON

### *Priority*

WITH HIS FLEXIBLE USE of the inverse square law as a means to reduce inextricably complex phenomena into approximate, human-scale local order and with his pretense that the ISL is rather an element of the exact and simple "laws which God ... made the fixed foundations of His work," Newton establishes Baroque mathematical natural philosophy—a very different *physica* from what Kepler envisioned.

This difference in the conception of the epistemological role of mathematics and the ontological legitimation of this role is thus encapsulated in the vicissitudes of the ISL itself. The history of the ISL reflects the hopes of what mathematical *physica* could achieve and the tensions and compromises wrought by this venture, especially since it was Kepler himself who first formulated the ISL as a mathematical-physical "law of nature"; the law of the distribution of light. So it is worth stressing—again—that the ISL was *not* discovered by Newton, nor, indeed, by anyone else. As a matter of fact, Newton was not even the first to apply the ISL to gravity.[1] The earliest evidence for Newton proving, using, or discussing the ratio (and that only regarding the planets' centrifugal tendencies) is from his *annus mirabilis*—1666. In a manuscript titled "On Circular Motion,"[2] he develops the expression for centrifugal force that he will make use of in the *De Motu* and the *Principia* (see chapter 5), introduces the same astronomical corollaries, and arrives at the same contingent conclusion:

Finally since in the primary planets the cubes of their distances from the sun
are as the squares of the numbers of revolutions in a given time: the endeav-
ours of receding from the sun will be reciprocally as the squares of the dis-
tances from the sun.[3]

This, again, is from 1666, and Newton's conclusion is limited to "cona-
tus a sole recedendi." A year earlier, in his *Micrographia*, Robert Hooke was
assuming, with little fanfare, that terrestrial gravity declines with square of
the distance from the earth's surface:

> [I say *Cylinder*, not a piece of a *cone*, because, as I may elsewhere shew in the
> Explication of Gravity, that *triplicate* proportion of the shels [*sic*] of a Sphere,
> to their respective diameters, I suppose to be removed by the decrease of the
> power of Gravity].[4]

Hooke's parenthetical remark provides a justification for a calculation.
The curator of experiments for the Royal Society of London, he produced a
set of experiments to support his claim that the different layers of the atmo-
sphere have different densities. The experiments, to which we will return
below, are based on Evangelista Torricelli's example and consist, for the
most part, in measuring the compression and expansion of air that is being
pressed or stretched by the weight of mercury in the tubes on the left-hand
side of fig. 6.1. Hooke's experiments are mathematical-quantitative in es-
sence: he collects numerical results in tables, and uses the data to calcu-
late contingent mathematical facts about nature, such as the height of the
atmosphere. To produce this particular calculation, Hooke posits, "we will
suppose a *cylinder* indefinitely extended upwards."[5] The atmosphere, how-
ever, envelops the earth as a sphere, so, strictly speaking, the tube supports
a truncated cone of air rather than a cylinder. The argument Hooke outlines
in the square brackets justifies the move: the volume of a cone is in "*tripli-
cate* [cubic] proportion" to its height. The volume of a cylinder varies only
in simple ratio to its height. The difference between the cubic ratio and the
simple ratio is, however, "removed by the decrease of the power of Gravity."
That is, if gravity decreases with distance, it compensates for the difference
between the real and the assumed volume of air, and the atmospheric pres-
sure can be calculated, for convenience' sake, as if it were a cylinder of air
that the tube supports rather than a cone. Of course, for the calculation to
work it is not enough that gravity vary inversely as the distance—it must be
inversely proportional to the *square* of distance. Hooke assumes, off hand,
the inverse square ratio between gravity and distance.

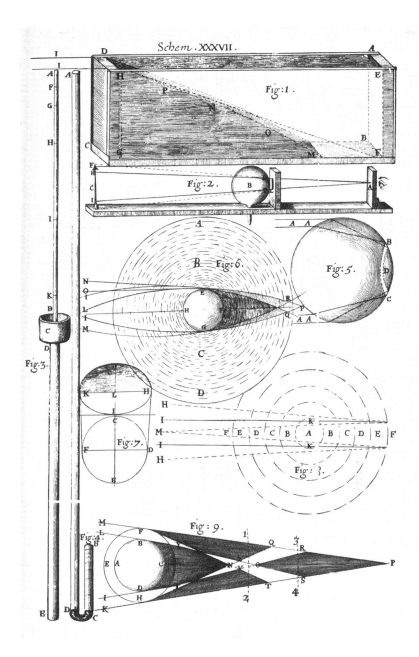

FIGURE 6.1 Scheme XXXVII of the *Micrographia* (adjacent to page 220). Reproduced with permission of the Rare Books and Special Collections Library, The University of Sydney.

*The Correspondence*

It would take Hooke fifteen years to put the ISL into use in *physica coelestis*, and it would come in an answer to Newton's query we discussed in the previous chapter. "The Attraction," he declares in a letter to Newton on January 6, 1680, referring to the solar draw that curves the inertial motion of celestial bodies into orbits, "always is in subduplicate proportion from the Center Reciprocal."[6]

It was Hooke who initiated this correspondence six weeks earlier and steered it to discuss a new mode of mathematized celestial mechanics. However, in his first letter, on November 24, 1679, he made no mention of the ISL or of the concept of a force law in general. "I shall take it as a great favour," he wrote,

> if you will let me know your thoughts of that [hypothesis of mine] of compounding the celestiall motions of the planetts of a direct motion by the tangent & an attractive motion towards a central body.[7]

Hooke is so succinct in this first introduction that he clearly expected Newton to have no difficulties recognizing and understand the essential concepts of 'that hypothesis of his': the planetary orbits are not reflections of primary order but an effect of constant change; outcomes of an attraction from the sun, which curves the planets' initial inertial rectilinear motion.

Hooke was seeking help with the mathematical aspects of the challenge, in which a force law would be featured, but Newton's answer reveals that the mechanical aspects of the hypothesis were far from self-evident. Trying to avoid Hooke's question concerning "the celestiall [annual] motions of the planetts" without being overly offensive, Newton replied on November 28 with "a fancy . . . about discovering the earth's diurnal motion." This involves dropping a heavy body from the top of a tower: because the body's "gravity will give it a new motion towards ye center of ye earth without diminishing the old one from west to east," it will fall to the east of the tower's foot "quite contrary to ye opinion of ye vulgar who think that if ye earth moved, heavy bodies in falling would be outrun by its parts & fall on the west side of ye perpendicular."[8] If allowed to continue through earth, Newton then adds, the stone will describe "in its fall a spiral line ADEC" (fig. 6.2).

The first part of Newton's "fancy" impresses Hooke, who promises to perform in reality what seems to be more of a thought experiment (and later claims to have done so successfully). Yet Hooke is also very happy to take Newton to task over the mistake introduced in the second, imaginary

FIGURE 6.2 Newton's diagram from his November 28, 1679, letter to Hooke. The stone at the top of the tower (A) falls to the east (D) of the bottom of the tower (B). If allowed to continue through the earth, it will spiral through E until reaching the center of the earth (C).

part. The intuitive assumption that the attraction to the center will produce a trajectory terminating at this center; that the falling stone will end up resting in the point it is falling toward, is of course a violation of the very Galilean and Cartesian innovations upon which the thought experiment was based, as Hooke pointed out on December 9:

> But as to the curve Line you seem to suppose it to Desend by . . . a kind of spirall which after sume few revolutions Leave it in the Center of the Earth my theory of circular motion makes me suppose it would be very differing and nothing att all akin to a spirall but rather a kind of Elleptueid.[9]

Newton, Hooke implies, did not fully comprehend the principle that the "new motion towards ye center of ye earth [does not] diminish . . . the old one from west to east," which Newton himself had cited. Motions in different directions do not cancel each other but combine in the moving body, and unless forced by some other cause, the tangential motion that the body retained as part of the rotating earth will not cease and will not allow the body to come to rest. Rather than "a kind of spirall which after a sume few revolutions Leave it in the Center," Hooke insists, the trajectory of the falling body, if allowed through the earth, will be "a kind of Elleptueid" orbit *around* the center—something like "the line *AFGHA* &c." (fig. 6.3).

FIGURE 6.3 Hooke's diagram from his December 9, 1679, letter to Newton. The stone falling through the "sliced" earth orbits center *C* in the ellipse *AFGHA*, unless it is impeded by a medium.

Hooke thus managed to reshape Newton's model and return the discussion to annual, orbiting motion. He also captured Newton's attention. Newton's next letter (of December 13) is the one with which we started our previous chapter. It demonstrates, as we discussed, that Newton has fully recognized the enormous significance and far-reaching ramifications of Hooke's hypothesis, and was careful in submitting to those. At the very least, he was determined to discover what Hooke's confidence was founded on; how did Hooke expect orderly orbits to emerge from independent motions and attractions? "If its gravity be supposed uniform, the body will not descend in a spiral to ye very center," he concedes, but he does not see any reason to accept Hooke's "Elleptueid" either. "Ye body will not describe an Ellipsoeid," he surmises, "but rather such a figure as *AFOGHIKL* &c." (see fig. 5.1).

There is little reason to believe that Newton's figure is based on any real calculations.[10] He is not providing a competing hypothesis, but a counter-argument: "compounding the celestiall motions," he points out, does not appear to fulfill the most basic premise of astronomy and celestial physics—that the planets move *in orbits*, that is, closed curves with a definite

line of apsides. In particular, Newton's sketch does not make use of a force law—it relies only on the notion of "innumerable and infinitely little motions ... continually generated by gravity in its passage." The curvature of the orbit, he explains, is determined by the balance between the "inclinations" of these "little motions"; the particular curve he suggests is caused "by reason of ye longer journey & slower motion" of the falling stone in the first quarter (AF) than in the second (Fg).[11] So it is difficult to decide what exactly the reference of "gravity be supposed uniform" is. Does Newton have in mind the model he is sharing with Hooke, of an object falling through the earth, in which case the amount of matter above and below it changes? If he is assuming gravity as a property of terrestrial (or all) matter, than these changes will affect the gravity in ways he may wish to bracket. Or does he refer to the celestial motions that Hooke would like this model to represent, and explain that it is the solar attraction that was "supposed uniform"? Perhaps Newton was consciously luring Hooke to suggest otherwise, namely, to divulge any other force law he had in mind and what kind of function he held for it in his scheme. Whatever the case, this remark did prompt Hooke to finally suggest the ISL, of which he has made no further use of since the 1665 *Micrographia*, as a crucial component of the solution. "Sir," he writes on January 6, 1680,

> Your calculation of the Curve by a body attracted by an æqual power at all Distances from the center ... is right ... But my supposition is that the Attraction always is in a duplicate proportion to the Distance from the Center Reciprocal, and ... that the Velocity will be in subduplicate proportion to the Attraction and consequently as Kepler Supposes Reciprocall to the Distance. And that with Such an attraction the auges will unite in the same part of the Circle and that the neerest point of accesse to the center will be opposite to the furthest Distant.[12]

This is the first attempt ever to apply the ISL to celestial mechanics. The application of the proper force law, Hooke assumes, together with a dynamic law—the square ratio between force and velocity—and an alleged empirical-astronomical law—the inverse square ratio between planetary distances and their velocity (which is a dated version of what Kepler turned into his area law)—will create enough balance to make "the auges [apsides] unite in the same part of the Circle." Hooke does not promise "the same point," only "the same part." This seems to have been enough of a hint for Newton, who did not bother to reply. Eleven days later, on January 17, 1680, Hooke wrote again, summarizing the challenge in one exacting sentence:

It now remains to know the proprietys of a curve Line (not circular nor con-
centricall) made by a centrall attractive power which makes the velocitys of
Descent from the tangent Line or equall straight motion at all Distances in a
Duplicate proportion to the Distances Reciprocally taken.[13]

### HOOKE

### *A System of the World*

The tremendous mathematical complexity of putting a force law into celes-
tial mechanics, which we explored in the previous chapter, explains why
Hooke had to finally submit to Newton's skills, humbly adding

> I doubt not but that by your excellent method you will easily find out what that
> Curve must be, and its proprietys, and suggest physicall Reason of this pro-
> portion.[14]

What is surprising, hence telling, is not Hooke's difficulty in realizing
the challenge he set for Newton, but his reluctance to put the ISL, which
he so easily assumed for terrestrial gravity, into use in his celestial mechan-
ics speculations. This is particularly surprising because a few years before
initiating the correspondence with Newton he gave himself an excellent
opportunity to do just that. In a two-page appendix to his 1674 Cutlerian
Lecture *An Attempt to Prove the Motion of the Earth* he promises a soon-to-be-
completed "System of the World . . . answering in all things to the common
Rules of Mechanics," in which a force law is one of the fundamental "three
Suppositions":

> First, That all Cœlestial Bodies Whatsoever, have an attraction or gravitating
> power towards their own Centers, whereby they attract not only their own
> parts . . . but . . . also . . . all the other Cœlestial Bodies that are within the
> sphere of their activity; and consequently that not only the Sun and the Moon
> have an influence upon the body and motion of the Earth, and the Earth upon
> them, but that [all the planets], by their attractive powers, have a considerable
> influence upon its motion as in the same manner the corresponding attrac-
> tive power of the Earth hath a considerable influence upon every one of their
> motions also. The Second Supposition is this, That all bodies whatsoever that
> are put into a direct and simple motion, will so continue to move forward in a
> streight line, till they are by some other effectual powers deflected and bent into
> a Motion, describing a Circle, Ellipsis, or some other more compound Curve
> Line. The third supposition is, That these attractive powers are so much the
> more powerful in operating, by how much the nearer the body wrought upon
> is to their own Centers.[15]

Unperturbed by the metaphysical and epistemological implications that Newton would later explicate in the Copernican Scholium, Hooke's "system of the world" offers remarkably similar celestial scenery: the motion of heavenly bodies is ruled by independent forces and motions. No neat orbits are assumed or promised; the heavenly trajectories may be "Circle, Ellipsis, or some other more compound Curve Line." Uniformity belongs to matter: "*all* Cœlestial Bodies *Whatsoever*," Hooke stresses, "have an attraction or gravitating power," towards "other Cœlestial Bodies" and towards "their own parts." The mathematical properties of this attraction may be assumed universal— the same for all material bodies—but this universality reflects the oneness of matter and not an underlying simple mathematical structure. The particular force law is a contingent fact, to be determined empirically, and Hooke adds, "what these several degrees I have not yet experimentally verified."[16]

### The Address to the Royal Society

However, Hooke, we saw, *has* already determined what these "several degrees" are. Eight years earlier he had no doubt that gravity declines by the square of the distance. Why should he avoid using the ISL in his "System of the World" whereas in the *Micrographia* he took it for granted? It is true that in the *Micrographia* he is referring only to terrestrial gravity, while in the "System" he is more concerned with the attractions affecting celestial motions. Yet in the later text he clearly declared that it is the same "power" that operates between and within bodies, and titled it "gravitating power." The plain and effortless way in which he writes to Newton in January 1680 that "my supposition is that the Attraction always is in a duplicate proportion to the Distance from the Center Reciprocal" demonstrates that he neither forgot the ISL nor found it difficult to apply to celestial mechanics. Once the question of a force law is introduced into the correspondence by Newton as a theoretical concern, Hooke is immediate with putting the ISL forward as his "supposition." Moreover, in the merger of celestial mechanics and matter theory that the "System" offers, the force law has a very clear function. The measure of the decline of "these attractive powers" with distance should account for the shape of the "compound Curve Line" that has replaced the orderly planetary orbit. What is more, this is not the first opportunity that Hooke gives himself to apply the ISL in this very way.

A law for the decline of the attraction had this import—of determining the shape of planetary trajectories—in Hooke's "programme,"[17] "of compounding the celestiall motions of the planetts of a direct motion by the tangent & an attractive motion towards a central body," from its very first

presentation. This took place in an address to the Royal Society on May 23, 1666, when Hooke wondered

> why the planets should move about the sun according to Copernicus's suppo-
> sition, being not included in any solid orbs ... nor tied to it, as their center, by
> any visible strings; and neither depart from it by such a degree, nor yet move
> in a straight line, as all bodies, that have but one single impulse, ought to do.[18]

This early presentation already contains the main ideas that Hooke would later submit to Newton and reveals that Hooke had thoroughly absorbed the implications of a *physica coelestis* that complies with the creed of the new mechanics. The planets, just like "all bodies," should obey all mechanical laws, and their orbits are purely physical phenomena; effects requiring a cause. Hooke is not in awe at the magnificence of the celestial cycles and he is not worried by the need to "save the phenomena"—to subject apparent irregularities to mathematical rule. He asks his audience to be surprised by the very fact that there is cyclical order, because, as they are all supposed to know, "all bodies, that have but one single impulse, ought [to] move in a straight line." Given Descartes' second law of nature—later to be called the law of inertia—the very fact that the planets move in closed curved trajectories becomes a "wonder." As the very exposition of the planetary orbits as a physical riddle is so innovative, Hooke allows himself to quickly suggest two causal accounts:

> All the celestial bodies, being regular solid bodies, and moved in a fluid, and
> yet moved in circular or elliptical lines, and not straight, must have some other
> cause, besides the first impressed impulse, that must bend their motion into
> that curve. And for the performance of this effect I cannot imagine any other
> likely cause besides these two: The first may be from an unequal density of
> the medium, thro' which the planetary body is to be moved ... But the second
> cause of inflecting a direct motion into a curve may be from an attractive prop-
> erty of the body placed in the center; whereby it continually endeavours to at-
> tract or draw it to itself.[19]

Yet in spite of the lip service to the "unequal density of the medium, thro' which the planetary body is to be moved," Hooke has only one possible cause in mind: planetary motion

> is compounded of an endeavour by a direct motion by the tangent, and of an-
> other endeavour tending to the center.[20]

Loyal to his role as curator of experiments, Hooke now moves to elucidate and expound his novel ideas with a series of demonstrations with

conic pendulums—pendulums that circulate horizontally, rather than oscillating vertically. The conic pendulum serves to demonstrate the mechanical feasibility of "the inflection of a direct motion into a curve by a supervening attractive principle," but Hooke adds a caveat clarifying that he takes for granted that the "attractive property of the body placed in the center" declines with distance at some lawful rate:

> Not that I suppose that the attraction of the sun to be exactly according to the same degrees, as they are in the pendulum: for in a circular pendulum the degrees of conatus at several distances from the perpendicular are in the same proportion with the sines of the arches of distance . . . which seems otherwise in the attraction of the sun, as I may afterwards farther explain.[21]

When the pendulum is pushed around, it becomes evident that Hooke also has a very clear idea what the physical meaning of the "degrees" are—the force law governing the attraction to the center determines the shape of the orbit:

> And it was found, that if the impetus of the endeavour by the tangent at the first setting out was stronger than the endeavour to the center, there was then generated an elliptical motion, whose longest diameter was parallel to the direct endeavour of the body in the first point of impulse. But if that impetus was weaker than the endeavour to the center, there was generated such an elliptical motion, whose shorter diameter was parallel to the direct endeavour of the body in the first point of impulse.[22]

### Terrestrial Gravity vs. Celestial Attraction

Already in 1666, then, and definitely by 1674, Hooke had a clear idea of the physical elements of the celestial mechanics he was seeking and the way it should be formulated as a mathematical-physical question: the celestial bodies are being constantly attracted to each other, and the attraction towards the center—presumably the sun—"inflects" their rectilinear-uniform motion into a curved trajectory. The shape of the resultant orbit is a product of the mathematical contingencies of tangential velocity, distance between the bodies, and the law that governs the decline of the attraction by distance. By then he also had a very good candidate for this force law: the ISL of terrestrial gravity. The fact that he refrained from applying the ISL is interesting not for considerations of priority or delayed progress, but because it reveals the long and winding road that led to the complete flexibility that Newton institutes in the relations between mathematical order,

mathematical practices, and mathematical constants of nature. Hooke's re-
luctance to export the ISL from the context of terrestrial gravity in which
he first established it to that of celestial attraction in which he required it is
particularly telling, as it reflects distinctions and boundaries that he—flex-
ible and pragmatic thinker that he was—was still making between the vari-
ous modes of mathematical-physical inquiry—measuring, calculating, con-
structing a geometrical model—and the ways in which a force law could be
established and utilized in one of those modes.

The boundaries are reflected in the different terminology Hooke uses
in his first presentation of the ISL and in his submission to Newton. In the
1665 *Micrographia* it is "the power of *Gravity*" that declines with the square
of the distance; in the January 6, 1680, letter it is "*Attraction*" that is "always
in a Duplicate proportion to the Distances from the Center Reciprocal."
Hooke is very careful and consistent in employing "gravity" and "attraction"
separately. "Attractive motion" is the phrase he uses when he first submits
his hypothesis of "compounding the celestiall motions of the planets" to
Newton, in the letter commencing the correspondence (November 24, 1679).
In the final letter (January 17, 1680) he again applies the "Duplicate propor-
tion to the Distances Reciprocally taken" to "a centrall attractive power." It
is Newton who introduces "gravity" into the discussion in his November 28
reply to Hooke's first letter. It is very appropriate for Newton to mention
gravity in that particular context, since he is discussing free fall "towards ye
center of ye earth," and in answering him Hooke concedes the terminology
and refers to "*gravitation* to the . . . center." Once he succeeded in diverting
the discussion back from free fall to orbiting by taking advantage of New-
ton's mistake, however, Hooke immediately reverts to his favorite term, al-
luding to his "Theory of Circular motions compounded by a Direct motion
and an *attractive* one to a Center."[23] Newton answers again in terms of grav-
ity, with his remark about "*gravity* be supposed uniform," which entices
Hooke into divulging his ISL, again as a law of "*Attraction*." And indeed, al-
ready in his first presentation of his ideas in the 1666 address to the Royal
Society, one year after the *Micrographia* and the ISL for gravity, Hooke refers
to "an attractive property of the body placed in the center" and "attraction
of the sun" (see above). The 1674 *System of the World* represents a digression:
there Hooke tries several terms: "attraction or gravitating power," as well as
"sphere of . . . activity" and "influence," but even there, when he comes to
wonder about the "several degrees" by which these forces decline with dis-
tance and which he had not yet "experimentally verified," he is careful to
ascribe it to "attractive powers."

*Static and Dynamic Causation*

As Newton will explain in the Copernican Scholium, the concept of precarious celestial order that he inherited from Hooke required mathematical practices that transgressed the boundaries that gave mathematics its traditional legitimation. The strict differentiation that Hooke maintains between gravitation and attraction attests that Hooke, for all his innovativeness, was still instinctively beholden to some of those boundaries. The barrier between gravity and attraction that Hooke does not presume to cross is not set up by a metaphysical conviction but by a distinction between static and dynamic modes of mathematical-physical explanation.

This distinction may appear in hindsight of little consequence, but it is embedded in the pendulum experiments that Hooke used to illustrate his ideas to the Royal Society in 1666. When the demonstrations of "the inflection of a direct motion into a curve by a supervening attractive principle" succeed, Hooke adds "another experiment by fastening another pendulous body to a shorter string on the lower part of the wire." The purpose of this double pendulum experiment is to illustrate a hypothesis "concerning the ebbing and flowing of the sea" presented to the society a week earlier by John Wallis[24] and published in the *Philosophical Transactions* as "An Essay, of Dr. John Wallis, exhibiting his Hypothesis about the Flux and Reflux of the Sea."[25] This hypothesis, and the way in which Hooke incorporates it into his experimental demonstrations, reveals how deeply entrenched the distinction between the static and the dynamic is for both Wallis and Hooke, and how it enforces on Hooke the strict separation between gravity and attraction.

Wallis' idea is to explain the tides by the motion around the sun of the common center of gravity of the earth and the moon. Prima facie, Wallis may appear to be suggesting an idea very similar to Hooke's celestial hypothesis—a mechanical account of a complex motion around the sun—and Wallis does begin his essay with a tribute to "*Galileo* and (after him) *Torricellio*, and others," who demonstrated beyond doubt that

> the World, and the great Bodies therein, are manag'd according to the *Laws of Motion*, and *Static Principles*[26]

Yet a closer look reveals that gravity, in Wallis' hypothesis, does not feature in "the *Laws of Motion*," but rather in the "*Static Principles*":

> The *Seas Ebbing and Flowing*, hath so great a connexion with the *Moons* motion that in a manner all Philosophers ... have attributed much of its cause to the

*Moon*; which either by some *occult quality*, or *particular influence*, which it hath
on moyst Bodies, or by some *Magnetic virtue*, drawing the water towards it,
(which should make the Water there *highest*, where the Moon is *vertical*) or by
its gravity and pressure downwards upon the Terraqueous Globe (which should
make it *lowest*, where the Moon is *vertical*) or by whatever other means.[27]

For Wallis, gravity and attraction are not only different but diametrically
opposed. The moon, he says, has *either* "occult quality . . . magnetic virtue . . .
influence," *or* gravity. The former "draw," the latter is "pressure downwards."
Neither of the alternatives functions like Hooke's "supervening attractive
principle," which causes "the inflection of a direct motion into a curve";
both are strictly rectilinear in their effect. A "draw" will cause the water to
be *"highest* where the moon is vertical," and gravity to be lowest under the
vertical moon. Furthermore, even this symmetry is only apparent. Much like
Galileo, whose "inertial," force-free account of the tides he explicitly fol-
lows,[28] Wallis uses "gravity" to account for balance and stability rather than
motion. In Galileo, the "proper gravity" (propria gravità) of water causes it
to "attempt to reach equilibrium."[29] In Wallis, the gravity of the earth and
the moon creates *"one common center of Gravity* . . . (according to the known
Laws of *Saticks*)."[30] To account for the motion they are trying to explain—the
tides—both refer to another motion—that of the "vessel" that is the sea basin.

Clearly, neither Wallis nor Galileo should have had any difficulty imagin-
ing gravity causing motion. What they were careful not to conflate are static
and dynamic causes: once gravity is assigned a balancing function, it is
handled according to the "known Laws of *Saticks*," and it is only a "second-
ary cause"[31] in the explanation of motion. For Hooke and Wallis' contem-
poraries this is a clear and strict distinction. Mathew Hale, e.g., in his *Essay,
Touching the Gravitation and non-Gravitation of Fluid Bodies* of 1673, applies
it in the opposite direction: once he uses "gravity" dynamically, he refrains
from giving it any static functions. Since "Gravitation is either Motion itself
or the *conatus* or *nisus ad motum*," he explains, then

> though Solid Bodies do actually Gravitate, yet if they be continued, the parts
> thereof do not Gravitate one upon another, because mutually or mechanically
> susteined one by another, and in a state of Continuity.

The distinction forces Hale to explain the contiguity of the earth by the
"mutual Compression [of its parts] one to another, and partly by the Inter-
vention of the cement of Water, they are *quasi unum continuun*."[32] In the ver-
sion of Wallis' paper presented to the Royal Society a week before Hooke's
momentous *Address*, gravity is a "bond or tie," a kind of a rigid connection

FIGURE 6.4 Hooke's conic pendulum experiments from Birch, *History of the Royal Society*. Reproduced with permission of the Rare Books and Special Collections Library, The University of Sydney.

that creates a common center of gravity. It is, to be sure, a connection over distance, as the gentlemen of the society noted, inquiring, "how two bodies, that have no tie, can have one common center of gravity."[33] Still, as their complaint reveals they too perceived Wallis as suggesting that, reaching across space, gravity "ties" bodies, rather than affecting motion.

Hooke assimilated Wallis' "Hypothesis about the Flux and Reflux of the Sea" into his experiments smoothly and without any reservations. He clearly shared the strict demarcation between dynamic and static causes on which Wallis' "Hypothesis" was predicated, and carefully embedded it in the experimental apparatus. The attraction of the sun is represented by the abstract "conatus of the body [the pendulum] to descend," captured by the imaginary horizontal lines FG and CD (fig. 6.4).[34] It is a limited analogy, Hooke points out, since the pendulum's "conatus" increases with distance,

whereas the sun's attraction declines—by what "degrees" he does not reveal. The gravity between the earth and the moon, on the other hand, is represented by the very real "short string" connecting them. It is this demarcation that he expresses in the correspondence with Newton by insisting on distinguishing attraction and gravity.

### From Light to Gravity

It is crucial to stress that Hooke's distinction was not some old epistemological or metaphysical superstition that stood in the way of his discovering the full significance of the ISL. In fact, the imagery of static force, distributed evenly and continuously around a center, as a solid rather than a line, was essential to Hooke's initial application of the law to gravity.

Hooke's first, parenthetical reference to the decline of gravity with the square of distance comes, as mentioned, as a justification for applying the results of a "late improvement of the *Torricellian* Experiment" to calculating the height of the atmosphere. In the first experiment he describes, Hooke uses a four-foot pipe (*ED* of *Fig. 3* in fig. 6.1, above), sealed at the bottom and attached with "a small wooden box" (*C*) at the top. He fills the box with mercury and dips into it a thinner pipe (*AB*). He then seals the pipe at the top and pulls it out, finding that the mercury column breaks (on that particular day) "neer thirty inches." Now that he knows the atmospheric pressure for the day, Hooke opens the top of *AB*, pulls it one inch above the mercury and seals it again, trapping 1″ of air above the mercury. Next he pulls *AB* up so that the mercury in it rises 2″ above the level of the mercury in the box and measures the trapped air, finding that it expanded to 1⅙″. Hooke continues these measurements, raising *AB* in increments of 2″ of mercury and observing the expansion of the air, as the rising mercury column counters and gradually balances the atmospheric pressure which forced the air into its original dimensions, and collects the (extremely nonlinear) results in a table. Deducting the height of the mercury column in *AB* from the 30″ of mercury that represents the pressure of the atmosphere gives Hooke a measure of the declining "Elater"—expanding force—of the trapped air.

"The other experiment . . . to find what degrees of force were required to compress . . . the air,"[35] consists of the "five foot long" siphon *AB* (*Fig. 4* in fig. 6.1). Hooke fills the left, longer side of his siphon with increasing quantities of mercury, adds the height of the mercury column to the atmospheric pressure (equivalent this time to 29″ of mercury), and measures the corresponding compression of the air on the right. "*Mr. Townly's*

*hypothesis*" (Boyle's law) prescribes that the height of the mercury column plus 29 (representing the pressure of the mercury and the atmosphere combined) will be inversely proportional to the height of the compressed air column, and the experiment appears to confirm it. As Hooke expects, if a combined height of 29″ of mercury results in 24″ of air, then doubling the pressure to 58″ of mercury compresses the air to half its volume—12″. Similarly, increasing the pressure of the mercury to 43.5″, or 1.5 times that of the original, results in 16 of air, or 2/3 of the original volume, and so on. "By these Experiments" Hooke has now "somewhat confirm'd the hypothesis of the reciprocal proportion of the Elaters to the Extensions," and also acquired a measure of the constant of the air's 'Elater' in terms of mercury. Since "because by the accurate tryals of the most illustrious and incomparable Mr. *Boyle*" he also knows the proportional "weight of mercury to that of Air here bellow" (which "is found neer about as fourteen thousand to one"), he can go on to analyze the changing densities of the layers "the cylinder of the *Atmosphere*," provided of course that he can "say *Cylinder*, not a piece of a *cone*."[36]

This is the calculation that presents Hooke with the occasion and motivation to introduce his assumption that the "power of gravity" declines with the square distance. Some thirty years later, in his *Lectures of light* (delivered between 1680 and 1681 but published only posthumously), Hooke credited Kepler with originating this assumption:

> This is the proportion that the ingenious *Kepler* allows to the Decrease of Light, supposing it to be only in Duplicate Proportion of the Distance reciprocal; and according to this, he found the Proportion of the Power of the Sun in moving the Planetary Bodies at several Distances.[37]

Hooke was reading his own thoughts into Kepler's (whose astronomical work he might have known only through the works of Ismaël Boulliau and his English commentators—Ward, Streete, and Wing):[38] the great astronomer, as we will discuss below, never applied the ISL that he concluded for "the Decrease of Light" to "the Power of the Sun." However, the overly generous credit that Hooke bestows on Kepler reveals his own line of thought: the ISL was true of light, "and according to this," it was also true for gravity.

The reference to Kepler's theory of light clarifies why the *Micrographia* was the proper context for the considerations, experiments, and calculations that gave the occasion for Hooke's submission of the ISL. It also gives some reason why Hooke thought that his application of the ISL to gravity was a trivial move, deserving only a brief parenthesized mention.

## Spheres of Light

The brevity is not dictated by the format: the *Micrographia* is a book-length monograph (Hooke's first and last one) in which Hooke was free to expand on his ideas as he saw fit. So it is obvious that Hooke did not regard himself as pronouncing a great new truth about nature, and that he expected his readers to be acquainted with the hypothesis of an ISL and familiar enough with the line of thought leading to it to regard both as legitimate, at least until some future "Explication of Gravity." It is also obvious he was wrong. Almost a decade later a competent reader like Mathew Hale could still complain about

> the mistake of their supposition that think the impendent Column of the Atmosphere, which they think to be seven Miles high, is a bare Column commensurate in its top and bottom, for it cannot be so, but at the most is an inverted Cone or *pyramis*, considerably wider at seven Miles distance then it is at the Earth, which if considered, would trouble their Explication of the *Toricellian* Experiment, upon an account of the actual Gravitation of a Column of Air.[39]

Hooke's offhand and abbreviated argument did not get through to Hale, but the image of "an inverted Cone or *pyramis*," which the two gentlemen shared, is the key to the line of reasoning that Hooke follows in his *Micrographia* from Kepler's *Optics*, with which both were familiar, to gravity.

True to its name, the *Micrographia* is primarily a collection of microscopic observations. Prepared by Hooke to be presented to the king, it is indeed a "handsome book"[40] that won much acclaim for its fantastic illustrations, all in Hooke's own hand. Yet it was not only that. The preface to the book presented Hooke's technological credo, which he summarized very humbly:

> As for my part, I have obtained my end, if these my small Labours shall be thought fit to take up some place in the large stock of natural Observations, which so many hands are busie in providing. If I have contributed the meanest foundations whereon others may raise nobler Superstructures, I am abundantly satisfied; and all my ambition is, that I may serve to the great Philosophers of this Age, as the makers and grinders of my Glasses did to me; that I may prepare and furnish them with some Materials, which they may afterwards order and manage with better skill, and to far greater advantage.[41]

This careful homage to the epistemic hierarchy of the Royal Society, however, does not genuinely represent the aspirations of the *Micrographia*. The book is not a sporadic collection of observations; it is also a step-by-step account of the minute elements of reality—from the (needle) point, through the (razor

edge) line and the (fabric) surface and up to the most sophisticated structures of the animal kingdom (like the fly's eye)—and an account of the manipulation of light by instruments to reveal these elements. As we discussed in chapter 3, the book introduces Hooke's version of radical instrumentalism, and the atmospheric experiments that induced his reference to an ISL of gravity are an integral part of his work to establish the legitimacy and accuracy not only of microscopy but of instrumental observation in general.

In the long "Observation LVIII"[42] Hooke turns his expertise in microscopy to deal with telescopy. *"Magno Astronomiæ damno in investigatione motûs solis & Æquinoctioroun factum est, ut Refractiones à Veteribus fuerint neglectæ"*:[43] he must have read the quote from Kepler's *Optics* in Vincent Wing's 1665 *Examen astronomiae Carolinae.* To be sure, with the exponential growth in the accuracy of astronomical observations since the end of the previous century, and especially with the advent of telescopic observations, optical phenomena relating to the behavior of light in the atmosphere became increasingly worrisome, and Hooke proposes to deal with these through a new theoretical optical concept—*"Inflection."*[44]

Inflection is "nothing else," Hooke explains, "but a *multiplicate refraction,* caused by the unequal *density* of the constituent parts of the *medium,* whereby the motion, action or progress of the Ray of light is hindered from proceeding in a streight line, and *inflected* or *deflected* by a *curve."*[45] It is a new and surprising concept, and Hooke, following the rules of *vera causa,* sets out to establish its efficacy as well as its reality. He begins by demonstrating through a series of simulations that his hypothetical cause *is* capable of producing the investigated effects; "that a *medium,* whose parts are unequally *dense* . . . will produce all these visible effects upon the Rays of light." That being accomplished, he goes on to confirm that the hypothesis is applicable to reality; "that there is in the Air or *Atmosphere,* such a variety in the constituent parts of it, both as to their *density* and *rarity,* and to their diverse mutations and positions one to another."[46] It is for this purpose Hooke employs the "Torricellian experiment[s]" occasioning the ISL.

However, whereas the *Micrographia* represents Hooke's first use of the ISL (and also his last for fifteen years), it is neither the first nor the last occasion on which he performs these experiments. "I had several other Tables of my Observations, and Calculations," he reports in the *Micrographia,* "but it being above twelve month since I made them . . . I was resolved to make them over once again, which I did *August* the second 1661."[47] About a year and a half after this earliest date and two and a half years before the publication of the *Micrographia*—on December 10, 1662—Hooke reports them again.[48] With his

curatorship still two years in the future, Hooke demonstrated to the Royal Society his experimental savvy with an "account of the rarefaction of air," in which he returns to the first of the experiments (the pulling of one tube out of the other). He collects the results a little differently than in the August 1661 session reported in the *Micrographia*: in December 1662 the independent variable is "the air's expansion," and the dependent variable "the [mercury's] height," and his tubes are apparently of lesser quality, but otherwise this is the very same experiment. As in the *Micrographia*, Hooke allows himself to replace the real "inverted Cone or *pyramis*" of the atmosphere with an "atmospherical cylinder,"[49] but he does not treat his Royal Society audience to any justification of the simplification, let alone the ISL he would introduce in the printed version. Not that this simplification is less important in the early version: Hooke uses in the *Account* the very same analysis of the "cylinder," in which he divides the atmosphere into 1000 imaginary segments of equal quantity of air, the volume of each determined by the pressure of the segments it supports, according to the "reciprocal proportion of the Elaters to the Extensions" established by the experiment.

Light is the reason the ISL presents itself to Hooke in the *Micrographia* rather than a few years earlier in the report to the Royal Society. The primary concern of the *Micrographia* is instrumental observation, and understanding the behavior of light, as we discussed in chapter 3, is crucial to establishing the legitimacy of the new mediated senses. Hooke's investigations of the air and the atmosphere in the *Micrographia* are only auxiliary to this main task. With these interests at the center of his attention, Hooke, consciously following Kepler's lead, turns to light to give sense to embedding mathematics into physical explanations through its essential geometrical structure. Gravity declines by the square of distance because, like light, it expands like the "shels of a Sphere."

In his *Lectures of Light*, we saw, Hooke explicitly states that the origin of the ISL is in optics. The "Decrease of the Power of Light," he tells his readers, is "in Duplicate Proportion, that is, as the square of the several Distances." He then credits "the ingenious *Kepler*" for both discovering the ISL and applying it to "the Power of the Sun in moving the Planetary Bodies at several Distances."[50] Where light is concerned, spherical expansion seems self-evident. Once Hooke accepts Kepler's assumption that the same amount of light falls on an ever-increasing envelope, then an ISL—a decline by the square of the distance from the source—also appears as a trivial consequence of common optical lore, and Hooke provides the Keplerian argument unaltered:

for according to the Increase of the imaginary Bases of the parts of the Cones, and according to the Decrease of the Thickness of the several Parts; so is the Decrease of the Power of Light at those Distances[51]

Since gravity, like the atmosphere whose gravitational pressure is the subject matter of the "*Torricellian* Experiment," expands in the same way, Hooke takes himself to be following a path beaten by Kepler, whom he knows in his popularizer Boulliau's rendition. The cone, like Hale's "inverted Cone or *pyramis*," alludes to the complementary geometrical image of this optical context, that of the optical cone, and provides, of course, the same mathematical ratios.

Importantly, Hooke's conception of light and force is neither Kepler's nor Boulliau's, and he carefully distances himself from the reification of geometry fundamental to Keplerian optics. Light, Hooke stresses, "is not therefore what the Learned and Ingenious *Bulialdus* have it to be; namely, a certain Substance which is a Geometrical *Medium*, between a body and a spirit." Rather, it is thoroughly corporeal and mechanical, a vibration passed from the source to the medium:

> Light then is nothing else but a peculiar Motion of the parts of the Luminous Body, which does affect a fluid Body that incompasses the Luminous Body, which is perfectly fluid, and perfectly Dense, so as not to admit of any farther condensation; but that the Parts next the Luminous body being moved, the whole Expansum of that fluid is moved likewise.[52]

Rejecting its neo-Platonist underpinning, however, Hooke remains completely loyal to Kepler's geometrical reasoning. In a manuscript inscribed "Sept. 1, 1685,"[53] perhaps an attempt at that "Explication of Gravity" promised in the *Micrographia*, he produces his own combination of optical imagery to explain gravity. This comprises the old image of spherical expansion with the implied geometry of the cone, together with a concept of "pulses of strokes of light" that Hooke develops from his theory of matter in *Lectures of Light*,[54] which is founded on the assumption of vibrating particles. The outcome is a speculation about "continuall impulse expanded from the center of the earth indefinitely by a conicall Expansion,"[55] which allows a clear, dynamically based expression of the ISL for gravity, exactly twenty years after its first enunciation:

> The power of gravitation [at] several distances from its apex the center of the earth is in Reciprocal proportion to the areas of the bases of the said Cone cut at those several Distances that is Reciprocal to the Squares of the Distances.[56]

Despite his boldness in drawing from and merging physical ideas from all practical and theoretical contexts, Hooke never strays from the geometrical image of spherical expansion, which he inherited from Kepler, as a foundation for the mathematical law of force. His combination of mathematical orthodoxy and metaphysical innovation has a curious consequence. While adopting the ISL for "the Power of the Sun," Hooke is finally led to the conclusion that "the Force or Power of *Light* must decrease in *quadruplicate* Proportion to the distances reciprocally taken," since for the traveling pulse that light is, the "Decrease of the Thickness of the several parts" has also to be taken into account.[57]

More crucially, it is this essentially static geometry of spherical and conical expansion in which, for Hooke, the ISL was and remained rooted, that first impelled him to apply the force law from light to gravity, and then prevented him from employing it as a dynamic element in his celestial mechanics until coaxed by Newton. Hooke's work with the ISL marks the capacities and the limits of search for "Nature's Drawing"; for mathematical structures expressing themselves directly in nature. This epistemology, which legitimized and directed the application of mathematics to *physica* from Kepler and Galileo to Hooke, also set its boundaries. The ISL could not serve as the celestial force law responsible for bending planetary motions into curved trajectories as long as it was conceived as essentially a corollary of mathematical representation, which made it applicable to gravity and light alike.

## KEPLER

### *Light and Virtus Motrix*

As he generously acknowledges, Hooke inherited this geometrical reasoning, with its potentialities and limitations, together with the ISL, from "the ingenious Kepler." Like Hooke, Kepler perceived the ISL as a trivial implication of spherical expansion; like him, he was tempted to expand the applicability of the ISL to other forces, sharing the same geometrical structure; and like him he convinced himself by this very line of reasoning that the application cannot hold. His first presentation of this law of the mathematical distribution of light was proposition 9 of the first book of his 1604 optical opus magnum, the *Ad Vitellionem paralipomena, quibus Astronomiæ Pars Optica Traditur*:

> just as [the ratio of] spherical surfaces, for which the source of light is the center, [is] from the wider to the narrower, so is the density or fortitude of the

rays of light in the narrower [space], towards the more spacious spherical sur-
faces, that is, inversely. For according to 6 & 7, there is as much light in the nar-
rower spherical surface, as in the wider, thus it is as much more compressed
and dense here than there. If, however, there was a difference in the density of
the ray or a difference in distribution according to position relative to the center
(which is negated by Proposition 7) it would be a different issue.[58]

Kepler's claim is clear: light expands spherically, with its source as the
center. The surface of a sphere is proportional to the square of its radius,
and the amount of light is constant. Thus the "fortitudo seu densitas" of
light—its impact on each point of the surface it illuminates—is inversely
proportional to the distance of this surface from the source.

With *"fortitudo"* Kepler points at the motivation driving his optics—not a
mere mathematical *scientia media*, but, as discussed in chapter 1, *Astronomiæ
Pars Optica*: a physical enquiry into vision that will provide epistemologi-
cal foundation for astronomy as a mathematical *physica coelestis*. Five years
after the publication of the *Ad Vitellionem*, in the *Astronomia Nova* of 1609,
he declared the venture a success: "Physicists, prick up your ears! For here
is raised a deliberation involving an inroad to be made into your province."
The inroad into physics included a very clear physical role for the law of the
decline of light. The *New Astronomy* was a *physica coelestis* because it was not
satisfied with calculating the positions of the planets but aspired to explain,
"with the help of a few generally accepted and purely *physical* axioms,"[59] how
the planets, material and hence inert (that is—resisting motion), are moved.

Kepler's answer is that "the power that moves the planets resides in the
body of the sun."[60] To this he adds that "the power that moves the planet
in a circle diminishes with the removal from its source"[61] and proceeds to
argue that "in all respects and in all its attributes, the motive power from
the sun coincides with light." The application of the ISL to "the motive
power from the sun" should have therefore been all but automatic, but after
seemingly convincing himself and his readers that this is the proper move
to take, Kepler decides instead that "the light of the sun *cannot be* the mov-
ing power itself."[62] He later concludes a long discussion titled "by what mea-
sure the motive power from the sun is attenuated as it spread through the
world"[63] with the disclaimer that the sun's "power is not considered orbicu-
larly in a sphere as light is, but in the circle in which the planet proceeds."[64]

### Boulliau

With the benefit of a generation of dynamical thought, this wavering in
the application of the ISL stains Boulliau's otherwise unmitigated admira-

tion for Kepler's astronomy. "On the rocks of these hesitations," he exclaims in 1645, Kepler "crushes his very astronomy into shipwreck,"[65] and suggests both geometrical and physical arguments to save the forsaken analogy between light and *virtus motrix*. He finds it almost hard to distinguish between them, using "species" to denote light—as Kepler did in the *Ad Vittelionem* (see chapter 1) but carefully avoided in the *Astronomia Nova*, reserving "species" to denote the solar moving force alone—and assaults each and every one of Kepler's diffident distinctions between the two. It cannot be, Boulliau argues for example, that the moon is moved by a force emanating from earth. If the earth is passive and inert like other planets, it cannot possess the force to move the moon. It is much more likely that it is the sunlight rebounding from earth that hurls it around, and indeed, the velocity of the moon is highest when it is new (which means that the earth, seen from the moon, is full) and slowest when it is full (namely, when the earth, from the moon, is new). Boulliau is also completely unimpressed by Kepler's point that light extends in all directions while the solar force emanates "only in longitude, in which the parts of the solar body themselves are moving."[66] Whether the force *is* light, carried by the rays of light or only flows from the sun with light, it has to get in contact with the planets "surface to surface," as light does, and thus has to follow the same law. He appreciates even less Kepler's attempts to account for the discrepancies of the observed proportions between planetary cycles from those calculated according to the simple law of decline by fiddling with the assumed resisting bulk of the planets. Also, the magnet analogy that Kepler ends up offering instead of light to account for the changing planetary distances seems to Boulliau beside the point altogether: the sun does not have two opposing poles—it only attracts.

So when Newton turned Hooke's generosity on it head, writing acrimoniously to Halley on June 20, 1686, that Hooke got the ISL from a "general proposition in Bullialdus,"[67] he was correct in one sense. Hooke thought the application of the ISL from light to gravity was self-evident, already carried out by the "the ingenious *Kepler*," because he received Kepler's celestial mechanics in the feisty version of "the Learned and Ingenious *Bulialdus*." Yet Newton's ingratitude was misdirected: Hooke never presumed to have discovered the ISL and was happy to defer to Kepler and Boulliau on that matter. Hooke's real innovation was the celestial mechanics he was discussing with Newton, which were markedly different from theirs: instead of seeking the forces moving inert bodies, he sought the forces bending inertial motion. Hooke could find nothing of this application of Cartesian mechanics

to the heavens in Boulliau's *Astronomia philolaica* and the *Philolai* and even less in the writings of Boulliau's commentators, the British astronomers of the 1650s and '60s—Ward, Streete, and Wing—who had little interest in Kepler's speculations concerning celestial causes.

However, Hooke's crucial indebtedness to Kepler was not for the acquaintance with the ISL. For both, we saw, the proportion seemed trivially true. What Hooke learned from Kepler, via Boulliau, was the geometrical reasoning that founded the ISL on the one hand and prevented its further application on the other: the particular way of physical-mathematical thought that distinguished them from both Kepler's predecessors and Hooke's and constituted a pivotal stage in the development of Baroque mathematical philosophy of nature.

### Kepler's Recoil

Boulliau's disappointment aside, Kepler's recoil from the ISL was neither negligence nor mere hesitation. Fully aware of the novelty of his mathematical-physical speculations, he carefully works his readers through every turn of his argument, beginning with the claim that "the power that moves the planet in a circle diminishes with the removal from its source"; a law of decline, just like the ISL for light, is necessary. The angular velocity of the planets, he demonstrates geometrically and from observations in chapter 32, is inversely proportional to their distance from the center of their orbit (which at this stage he still assumes is circular). "The elapsed times of a planet on equal parts of the eccentric circle . . . are in the same ratio as the distances of those parts from the point whence the eccentricity is reckoned," he summarizes in the following chapter. "Put more simply," he concludes, obviously unworried about the possible complexities in the relations between power, motion, and angular velocity, "to the extent that a planet is farther from the point that is taken for the center of the world, it is less strongly urged to move about that point."[68]

Careful to leave no gaps, however, Kepler does not hurry to conclude from the above that there is a force originating from *the sun* and declining with distance. The constant ratio between velocity and distance, he continues cautiously, signifies that the two are related causally—"either one is the cause of the other or both are the effects of the same cause." It cannot be, however, that the decline in motion or "urge to move" is the cause of the distance, because distance is necessary for motion, and not vice versa. "And since distance is a kind of relation whose essence resides in end points . . .

it therefore follows ... that the cause of the variation of intensity of motion inheres in one or the other end points." Yet the celestial body itself cannot change merely by approaching or receding from the center of the universe, nor does it seem reasonable "that an animal force, which the motion of the heavens suggests is seated in the mobile body of the planet, undergoes intension and remission so many times without ever becoming tired or growing old." Indeed, the very notion of "animal force ... seated in the ... planet" that was once part and parcel of his cosmology now seems to Kepler highly suspect, and he is as happy to get rid of it as he would be of its counterpart—the planets' rationality (see below). He thus offers his provisional conclusion "that the source of motive power is at the supposed centre of the world," and goes on to consider "which body it is which is at the centre?"[69]

Now fully secure, Kepler delivers his final argument and the conclusion he was striving for. Not only does it make more physical sense to calculate the planets' velocities and their changes from a real body than from an unoccupied point in space, it is also the case that "phenomena at either end of the night follow beautifully if the oppositions of Mars are reckoned according to the sun's apparent positions." It is *the sun*, then, which is "in the centre of the planetary system," and it is in the sun, from which the power "urging" the planets originates, a "motive power" that increases and decreases as the planet draws closer or further from the sun. Everything seems ready for the application of the law of the decline of light—the hardearned ISL of emanation from the sun—to the emanation of this motive force, when Kepler takes what seems to be only one more cautious detour, designed to drive in the final conclusion with additional power, and asks explicitly "whether light is the vehicle of the motive power." However, to the great disappointment of Boulliau, he concludes rather that "the light of the sun *cannot be* the moving power itself."[70]

Kepler is entirely aware of what he is giving up on. Only a sentence earlier he referred his readers to proposition 9 of the *Ad Vittelionem*, in which the ISL was presented as the law of distribution of light, and adding "that the power is weaker to the extent that it is more spread out, and more stronger to the extent that it is more concentrated," concluding that "in all respects and in all its attributes, the motive power from the sun coincides with light." Of course, as the next sentence demonstrates, this declaration was overzealous; the only "respect" of similarity he considers is the decline with distance. Already in importing the image of "thinning" in space from light to the motive power Kepler reverts from the spherical propagation of light back to the circular, ecliptic propagation of power. Indeed, all he is willing

to consider from this point on is the possibility that light is "a kind of instrument or vehicle, of which the moving power makes use."[71]

Thus, rather than its main benefit, Kepler finds in the ISL the limit of the analogy between light and power. Light was useful in explicating the obscure notion of immaterial emanation from the sun, but at this stage, when he is comfortable with the physical underpinning of his hypotheses, Kepler finds the mathematical implications of the light analogy cumbersome. *Physica coelestis* implied for Kepler that *motion* should disseminate from the sun to the planets. He hypothesized the *virtus motrix* in order to explain this motion, and clearly expected the relation between the motion and the motive force to be straightforward: if the planets' velocity declines as the distance, he cannot allow that the motive power declines as the square of the distance. In other words, Kepler finds an impasse exactly where his project comes to culmination; in deriving physical properties from mathematical structures. He brings in light to provide an explication of physical properties. Its *mathematical* properties—the ISL of its emanation—however, follow from its geometrical attributes—its spherical "commuted proportion"— and Kepler cannot find a way to reapply these attributes to his model of planetary motion.

A decade later, in a newly annotated edition of the *Mysterium Cosmographicum* published in 1621, Kepler stressed that the mathematical causation of the *Astronomia Nova* was physical, and that he did not suppose any reasoning on the part of the of the planets (see below); the planets were not required to direct themselves according to the mathematical relations embedded in their trajectories. Yet his version of mathematical *physica coelestis* did suppose that these mathematical relations be drawn directly into and by nature; that the physical world reflects them simply and immediately. Hence the ratio of the decline of force should be the ratio of the decline of motion and the rule for the spherically distributed light could not be applied to the circularly emanating *virtus motrix*; an inverse-square proportion could not explain linearly declining motion.

### The Origin of the ISL for Light

As it would be with Hooke, the spherical imagery on which the ISL was founded blocked its farther application, but like it would be with Hooke, this way of using mathematics was not an antiquated obstacle. In fact, while the ISL seemed neither to Hooke nor to Kepler a discovery worth bragging about, relying on the geometrical structure of reality to endow mathematics

with physical efficacy *was* radically new, and the ISL owed its very existence as a physical law to this imagery.

Like Hooke and his "decrease of the power of Gravity," which is supposed to compensate for the *"triplicate* proportion of the shels of a Sphere to their respective diameters," Kepler does not bother to trumpet as a great discovery the idea that the decrease of light is as the ratio of "spherical surfaces … from the wider to the narrower." To be exact, Kepler's considerations are strictly geometrical: it is the ratio of distance to the power of light that he asserts, not the *"decrease* of the power" that Hooke assigns to gravity. Yet Kepler's idea was far from commonplace. Even if the decline of light with distance is, by itself, a common, self-evident experience, there is nothing self-evident about the notion that this decline can be captured geometrically, or that this geometry itself can account for the rate of this decline. Kepler is fully aware of these difficulties, and the metaphysical justification he offers in support of his mingling of the geometrical and the physical is rather spectacular: "the spherical," he tells his readers, "is the archetype of light (and likewise of the world)":[72]

> The point of the center is in a way the origin of the spherical solid, the surface the image of the inmost point, and the road to discovering. The surface is understood as coming to be through an infinite outward movement of the point out of its own self, until it arrives at a certain equality of all outward movements. The point communicates itself into this extension, in such a way that the point and the surface, in a commuted proportion of density and extension, are equal.[73]

Light, in Kepler's presentation, does not simply propagate spherically—it is sphericity itself, as manifested in the "corporeal world"; the embodiment of "infinite outward movement," of "commuted proportion" between center and periphery. This is how it can fulfill the mediating role we discussed in chapter 4: between mathematics and motion; between the sun and the planets; as "the chain linking the corporeal and the spiritual world"; between the ideal and the material. Kepler grounds this Neo-Platonic speculation in an explicitly theological claim: light is "the most excellent thing in the whole corporeal world,"[74] it is the "instrument of the Creator, for giving form and growth to everything … the matrix of the animate faculties, and the chain linking the corporeal and spiritual world by which He introduced laws into them."[75] This dual existence of light embeds Kepler's mathematical structures in the corporeal world and allows him to infer its physical properties directly from the geometry of spherical propagation and

to deduce the relation between its "density of fortitude" and its distance from the source, viz., the ISL.

### Early Attempts

Even in his most enthusiastic proclamations of the power of mathematics in the *Mysterium Cosmographicum* of 1596, Kepler did not venture to explain physical properties so directly and immediately by the mathematical structures underlying them. It was in his juvenile work that he set himself "the task of constructing the universe with order and pattern,"[76] which will occupy him for the rest of his career, and also adopted the pivotal assumption that "God allotted motion to the spheres to correspond with their distances."[77] Calculating these proportions between heavenly distances and motions on the basis of a mathematical law governing "a single moving soul at the center of all the spheres, that is, in the sun, [which] impels each body more strongly in proportion to how near it is"[78] would have been a glorious culmination of the project. He also has a good inkling as to what this mathematical law may be: "it is highly probable, that motion is dispensed by the Sun in the same proportion as light."[79] However, when he sets up this first try at merging the geometry of vision with speculations concerning the agency of light he makes a curious mistake:

> The amount of light in a small *circle* is the same as the amount of light or of the solar rays in the great one. Hence, as it is more concentrated in the small circle, and more thinly spread in the great one, the measure of this thinning out must be sought in the actual ratio of the *circles*, both for light and for the moving power. Therefore in proportion as Venus is wider than Mercury, so Mercury's motion is stronger . . .[80]

Instead of the spherical emanation of light that would seem so obvious eight years later, when he endeavored to amend and expand optics in the *Ad Vitellionem*, Kepler assumes a planar, circular distribution. This smoothes the analogy between light and "the moving power," which stirs the planets on the ecliptic, but is obviously counter to all experience. Kepler's reasoning here is the same that he will codify in the *Ad Vitellionem*: light, with its divine constitution, cannot be lost—it is "equally diffused on any point" as Witelo, his optical reference, had put it[81]—so the decline of illumination has to be ascribed to its distribution through space; the same amount of light in larger space means less illumination at each point. Once he assumes that light emanates circularly, as if on plane surrounding a point source of light,

it follows that the larger the circumference of that circle, the less illumination received by each point on it, or in other words, that light declines in simple ratio to the distance from the source of light.

The strange assumption of circular emanation attests to Kepler's reasoning in the *Mysterium*. Light diffuses *spherically*, in all three dimensions—this is one thing that the tradition upon which Kepler builds never had any qualms about.[82] Moreover, plane circles are rarely mentioned in the *Mysterium*, whose subject matter is the proportions between celestial *spheres*; Kepler's thought here is clearly directed by some other considerations. Indeed, the *Mysterium Cosmographicum*, unlike the *Ad Vitellionem* (the *Optics*), is not primarily an investigation of light.

Similarly to the way in which Hooke moves from investigating light to inquiring about the atmosphere, Kepler in the *Mysterium* is using light to investigate the structure of the planetary heavens, and it is the sun that occupies Kepler's attention in this early tract—not primarily as a source of light, but of *virtus motrix*," the hypothetical power by which it moves the planets. Light is still of great interest to Kepler, except not in and of itself. It is rather a convenient analogy for this "moving power," an analogy he bases on the assumption, "as is highly probable, that motion is dispensed by the Sun in the same proportion as light." This is the origin of the notion of circular emanation: "motion is dispensed by the Sun" in the plane of the ecliptic, shared by all planets.

The difference between the spheres of the *Ad Vitellionem* and the circles of the *Mysterium* stems from the different foundations on which Kepler bases his mathematical reasoning. In the *Ad Vitellionem*, we saw, mathematics is endowed with physical efficacy by being embedded directly in nature: light *is* a sphere. In the earlier *Mysterium*, Kepler is still looking for mathematics, as we saw Tartaglia and Oresme do, and as we see his optical predecessor does, in the abstract, ideal representations. Circles are the common denominator of the two traditions he is trying to merge—astronomy and optics. They stand for both celestial spheres and light spheres, and Kepler, assuming that "the ratio in which light spreading out from the center is weakened" according to the "actual ratio of the *circles*, both for light and for the moving power"—that is in simple ratio—thinks that he is only repeating what was already "stated by the opticians."[83]

The project of mathematical natural philosophy, the riddle to be solved, was to find a medium in which to combine the mathematical and the physical. As pointed out in the previous chapter, in the *Mysterium* Kepler had to explain the planets' compliance with the mathematical archetypes he assigned them by direct reference to God or by assuming that

it is by some divine power, the understanding of the geometrical proportions governing their courses, that the stars are transported through the ethereal fields and air free of the restraints of the spheres.[84]

In the years after physicalizing optics (in the *Ad Vitellionem*) and astronomy (in the *Astronomia Nova*), he found this early way of explaining the capacity of abstract mathematical proportions to account for material facts somewhat embarrassing. "So indeed I supposed," he remarked concerning the ascription of rationality to the planets, when he returned to annotate the *Mysterium* for the second edition of 1621,

> but later in my *Commentaries on Mars* [the *Astronomia Nova*] I showed that not even this understanding is needed in the mover. For although definite proportions have been prescribed for all the motions, and that by the supreme and unique Understanding himself, in other words, by God the Creator, yet those proportions between the motions have been preserved unchanged from the Creation right up to the present not by some understanding created jointly with the Mover, but by two other things. The first is the completely uniform perennial rotation of the sun, along with its immaterial emanation, which is diffused to the whole universe, an emanation which takes the place of a mover. The other cause is the weights and magnetic directing of the forces of the moving bodies themselves, which are immutable and perennial properties. Thus there is no more need for these created things to have understanding to observe the proportions of their motions than there is for the scales and weights of a balance to have intellect to declare the proportions of weights.[85]

It is this intellectual progress that Kepler celebrates at the beginning of his 1609 *Astronomia Nova* with his "Physicists, prick up your ears!" The new way of combining careful mathematical analysis of astronomical data (primarily the outcome of Tycho's observations of Mars) with bold mathematical speculations on the structure of the planetary heavens was predicated on embedding mathematics directly in nature. It ended up disallowing the use of ISL for *virtus motrix*, but beforehand it allowed its application to light.

### BEFORE KEPLER

#### *John Dee*

Hooke thought that Kepler "found the Proportion of the Power of the Sun" to be the ISL. Kepler thought the ISL for light was "stated by the opticians." Both were wrong. This does not mean, however, that in applying a geomet-

rical law to the decline of light Kepler is completely original and unique. To begin with, Kepler was not the only one of his contemporaries attempting to integrate the Neo-Platonic geometrization of light with the rigorous geometry of the tradition of mathematical optics. One such attempt was presented by John Dee (1527–1609).

In his *Monas Hieroglifica*, Dee, who left Rudolfine Prague less than a decade before Kepler's arrival, makes use of the same terminology of "the point of the center is in a way the origin of the spherical solid" that Kepler will use thirty years later, in the *Mysterium*, to make sense of the claim that "the spherical is the archetype of light." Adding magical practices to the contemplative aspiration of mediaeval Neo-Platonism,[86] he aimed to transform simultaneously the observer and the physical world. From a point and lines as the primary elements of the world, Dee proposes to construct a model of the universe and the powers that govern it that, if assembled according to certain proportions, would also result in an icon—the *Monas Hieroglifica*—and an amulet to concentrate celestial influences. The magical force of the image is anchored in that relation between center and periphery that would also enchant Kepler. Directing his thoughts towards light and its spherical propagation, Dee, like Nicholas of Cusa, embeds his emblem in a material-visual substratum (fig. 6.5):

> Yet the circle cannot be artificially produced without the straight line, or the straight line without the point. Hence, things first began to be by way of a point, and a monad. And things related to the periphery (however big they may be) can in no way exist without the aid of the central point. Thus the central point to be seen in the centre of the hieroglyphic monad represents the earth, around which the Sun as well as the Moon and the other planets complete their

FIGURE 6.5  Dee's emblem from *Monas Hieroglyphica*.

courses. And since in that function the Sun occupies the highest dignity, we represent it (on account of its superiority) by a full circle, with a visible centre.[87]

However, focusing on the optional visualizations he detects in the spherical model, Dee ends up neglecting its more abstract and strictly geometrical aspects. He still attempts to apply mathematical optical principles rigorously, in order to ensure his control over the propagation of celestial light and its influences, and turns his Monad into a concrete physical object, devoid of the geometrical speculation that fascinated him in his youth. Wandering in later years through central Europe he appropriately transforms his two-dimensional image into a true material object—a crystal sphere—as an artificial means to concentrate illumination and to converse with angles.

### The Philosophers of Light

Dee, then, fell short of fully integrating the two geometrical approaches to light to produce a mathematical law of decline, nor could he or Kepler find such a law in the writings of the mediaeval Neo-Platonists both read. The complex of notions that Dee and Kepler share—the mathematical infrastructure of the cosmos, light as the divine agent of its propagation and the sphericity of the cosmos it affects—are the major themes of the *perspectiva* tradition to which Kepler refers to by titling his book *Ad Vitellionem paralipomena* after Witelo. It is most beautifully articulated by Robert Grosseteste (c. 1168–1253), the founding father of this tradition in the Medieval West, in the opening paragraphs of his *De Luce*:

> The first corporeal form, which some call corporeity, is in my opinion light. For light of its very nature will produce instantaneously a sphere of light of any size whatsoever, unless some opaque object stands in the way. Now extension of matter in three dimensions is a necessary concomitant of corporeity, and this despite the fact that both corporeity and matter are in themselves simple substances lacking all dimensions.[88]

Light is the embodiment of agency at a distance, asserts Grosseteste, and as such it is the major instrument of dissemination of matter and motion throughout the universe, and enforces spherical geometry on both:

> Light through the infinite multiplication of itself extends matter into finite dimensions that are smaller and larger according to certain proportions that they have to one another, namely, numerical and non-numerical.[89]

The incorporeal power ... which moves the first and highest sphere in diurnal motion, moves all the lower heavenly spheres with this same diurnal motion. But in proportion as these spheres are lower they receive this motion in more weakened state, because in proportion as a sphere is lower the purity and strength of the first corporeal light is lessened in it.[90]

It is tempting to read into these lines the source of Kepler's inference of the rate of the decrease of light from the geometry of the sphere,[91] but Grosseteste's metaphysics and motivations are different from Kepler's. What Grosseteste provides here is not a justification of a mathematical procedure, but a visual image, or to use Grosseteste's own vocabulary, a corporeal form for the reader's mind to meditate upon. One can trace this meditative practice of using a visual scheme for contemplation throughout the history of Christian Neo-Platonism. Light in this tradition provides the primary vehicle of human knowledge, as it is also the primary expression of Divine essence and creative power and in its spherical expansion from a central point a model of His perfection. A special emphasis on visibility followed the commentaries on pseudo-Dionisius Areopagitius and reached a climax in twelfth-century theologies with Suger of St. Denis and Hugh of St. Victor. Grosseteste's unique achievement was the integration of Arab abstract optical theorems into a concrete and detailed mental picture. This move necessitated a three-dimensional model for the expansion and attenuation of light through the universe.

Yet such a pictorial representation could not serve as the harbinger of further physico-mathematical elaborations for a number of reasons. To begin with, Grosseteste did not conceive light as a force emanating from the center of the universe. Light, for him, did not originate from a material center but from the border between the realm of Divine forms and the realm of primal matter. Kepler also viewed light as the conduit of Divine archetypes into the material realm, but the congruence between the metaphysical place of origin and the material one—the sun—was the principle underlying his case for the geometricity of creation. Furthermore, the result of light's action, according to Grosseteste, was not the motions of the planets but a system of static spheres where only light emanates; as discussed in chapter 4, it was a difficult and counterintuitive undertaking by Galileo and Kepler to reconcile mathematics and motion. Although Grosseteste seemed to have suggested a mathematically coherent structure for the universe, in its final conclusion his world-picture is qualitative and hierarchic, where each sphere is the perfection of the one below. Within the inner sphere

around the material center of the universe light is so weak and corrupted that motion is no longer circular but linear, up and down. Thus, Grosseteste's unified explanation of the emanation of the world preserves the Aristotelian differentiation between the perfected world above the moon and the corrupt materiality in the sublunar region.

Finally, one should consider *On Light* as a scholastic exercise in meditation, intended to transform the reader and allow him to speculate on the perfect numbers and harmonic, Pythagorean ratios that underlie it. The structure of this short text exemplifies the Neo-Platonic diastole-systole: the procession and reversion that "constitute together a single movement, which is the life of the universe."[92] Whilst the creation of the cosmos descends from the primal sphere of light towards the mundane earth, the human mind, by its visual and intellectual powers, can use light and the species it generates to ascend towards an understanding of God's creation. *On Light* outlines the limits of human reason in its search for Divine illumination, and its textual structure mimics the pulsating motion it depicts. The text begins with a physico-theological account of creation of the corporeal universe and culminates with the entire picture of the world in front of the reader. It then reverses, abstracting from this world-picture the numerical ratios that lead the mind to the extremities of the intellectual speculation. From the final point of the text with its celebration of the number ten, the road is open to a new kind of understanding of superrational nature, beyond scholastic dialectic.[93]

There is nothing of either these far-reaching metaphysical speculations or epistemological humility in Kepler, even though the mathematical consequence implied by Grosseteste's image is, undeniably, remarkably similar to Kepler's:

> Light through the infinite multiplication of itself equally and in all directions extends matter on all sides equally into the form of a sphere and, as a necessary consequence of this extension, the outset parts of matter are more extended and more rarefied than those within, which are close to the center.[94]

In any case, Kepler never cites Grosseteste. It is therefore much more likely that his adoption of the image of spherical expansion is from Nicholas of Cusa (1401–64), whom he does cite on various occasions (e.g. in his *Mysterium Cosmographicum*, C. II), and who does, in his *The Game of the Spheres*, inject material import into Grosseteste's speculations. Nicholas of Cusa's game consists of a semispherical ball, "somewhat concave in the middle," that is hurled from the outside into nine concentric circles drawn on the

ground. It embodies a "philosophical speculation that we propose to hunt" and aims, like Grosseteste's text, at theological insight about the human soul and its motion towards God:

> The likeness of the ball to the body and of its motion to the soul is very pleas-ing. Man makes the ball and its motion which he imprints upon it by impetus and it is invisible, indivisible, not occupying a place, just like our soul.[95]

Like Grosseteste, Nicholas of Cusa is engaged with pure Pythagorean and Neo-Platonic abstractions. In the second book of the dialogue, e.g., he discusses the mystification of the circles (*circularum mysterium*). The formal characteristics of the circle are turned into an analogy of motion and light; and the medieval hierarchy, so lucid in Grosseteste, is turned inside out. The center is not the lower, inert, and passive place in the universe, but the ori-gin of motion and in itself possesses the most rapid circular motion:

> The motion which is the life of the living is therefore circular and central. The closer the circle is to the center the more rapidly it can orbit around the center. Therefore the circle that is also the center can orbit instantaneously. Therefore it would be infinite motion. It will therefore be the greatest or infinite motion, and likewise the smallest, where the center and circumference are the same. And we call it life of the living which enfolds all possible motion of life in its fixed eternity.[96]

This system of circles does not represent only grades of motion, but also grades of vision: "Therefore circles are grades of vision. A center common to all is seen in every circle, closer in one that is closer to it and more remote in one that is farther from it."[97] Nicholas of Cusa proceeds to explicate these circles as intellectual light, which he contrasts to sentient light: "this light does not diffuse itself through corporeal places in such a way that it illumi-nates the places closer to it more strongly as does corporeal light."[98]

This contrast implies that the defining property of sentient light is its decline with distance, as if to invite a physical and optical consideration. Unlike Grosseteste, Nicholas of Cusa invests his theological Neo-Platonism with strictly physical considerations. For example, the spheroid's motion is not straight but helical, "that is spiral or inwardly curving motion" and the result is that it

> sometimes suddenly ceases when the ball falls on the flat part of its surface. The motion is hindered because of the irregularities in the hemispherical ball and in what it encounters, and it [the ball] stops naturally when the motion suc-cessively lessens in itself above the pole or the middle of the curved surface.[99]

Such detailed dealing with mundane motion clearly distinguishes Nicholas of Cusa from Grosseteste, and he indeed commits himself to relating his speculations to earthly nature:

> I believe that these and many other things must be subtly noted on account of the likeness of art and nature. For since art imitates nature we approach the powers of nature from these things which we find subtly in art.[100]

Nonetheless, at the end Nicholas of Cusa turns his gaze to higher and more subtle speculations. He never bothers to develop the mathematical relations to offer a physical force law and instead builds up his mystical excitement towards a paradoxical climax with the assertion that "God is a circle whose center is everywhere."[101]

## The Perspectivists

So it was from Grosseteste, via the writing of Nicholas of Cusa, that Kepler obtained the image of an expanding sphere of luminosity, from which he then infers the ISL. This image comprises the complex of ideas one finds in the *Optics*: the agency of mathematical form, carried into nature by light, creating a sphere that expands from center to periphery. However, this is also where Kepler's indebtedness to this line of reasoning comes to its end: Grosseteste and Nicholas of Cusa (and later Dee) were engaged only with the iconic aspect of the spherical geometricity of light. They found in the expanding sphere of light an emblem for visualizing and contemplating the contained infinity of creation and creator, but added no clue as to the details of the geometry of this expansion. These details awaited Kepler in the commentaries of the medieval perspectivist tradition.

This is not to say that Kepler could find, or even straightforwardly deduce his ISL from the tradition represented for him by Witelo, the honorary referent of his optics. It *is* true that the geometry of the cone, to which Hooke refers when he reassigns the ISL from optics to gravity, was more than suggested by this tradition. Geometrical optics, since its inception with Euclid and Ptolemy, had the "visual cone" as a fundamental working assumption: rays are scattered in a cone, with their source at its apex.[102] For the Greek mathematical opticians the source of visual rays was the eye, and the physical embodiment of the rays obscure. The cone (or pyramid) with the eye-vertex remained a common tool for mediaeval opticians and renaissance perspectivists, but the synthesis between the geometrical and physical approaches affected by the Arab thinkers between the ninth and eleventh cen-

turies allowed Alhacen (Ibn al-Haytham, c. 965–1039) to reverse the Greek geometrical reasoning and apply it to light:

> The eye does not perceive the light and color in the visible object unless something come to the eye from the light and color in the object.[103]

With considerations like this Alhacen established the tradition of perspective that Grosseteste imported to the Mediaeval Latin West some 200 years later. By naming his astronomical studies *Ad Vitellionem paralipomena* Kepler relates himself to the definitive formulation of this tradition, produced by Witelo (c. 1230–c. 1280) with his massive *Perspectiva*. In this tradition the decline of light with distance was an obvious phenomenon that could be made use of in theoretical considerations. For example, Alhacen himself claims that "reflected light and color are weaker than primary light and color, but they are stronger than secondary [light and color] which are in equal distance from their source,"[104] and goes on to explain and argue why it is not *only* "their elongation from their origin"[105] that causes reflected rays to be weaker than primary rays. The same self-evidence is expressed by Witelo's contemporary Roger Bacon (c. 1214–c. 1292), who inherited from Grosseteste the heavily Neo-Platonized Aristotelianism in which light is the paradigm of *species*—an Aristotelized version of al-Kindi's conception of causation-as-radiation:

> It must be said that a species is continuously weakened in the mundane bodies in which it is multiplied, as far as the nature of multiplication passing through is concerned, and this falls under the law of species.[106]

Bacon also follows Grosseteste in contemplating some mathematical structure to this weakening:

> the species generated in the prior part [of space] is equal or in some ratio to the species in the posterior part [of that space], according to some kind [of ratio] of greater inequality.[107]

Yet there is a strict limit to the similarity. Bacon discusses *species*, and light is but an instance of these, although a paradigmatic one (heat, color, and magnetism are others). Grosseteste and Kepler's attention is concentrated on the notion that "Light will produce instantaneously a sphere of light of any size whatsoever."[108] It is the image of "outflowing or projection from its origin towards a distant place ... moving forward into infinity ... motion ... not in time, but in a moment," as Kepler defines light in the first proposition of his *Ad Vitellionem*,[109] that supports the unmediated inference of the properties of light, and the ISL in particular, from spherical geometry. How-

ever, this image of spherical expansion, of instantaneous propagation of an agency throughout the universe, from center to periphery (and, for Grosseteste, back again), is of much less importance for Bacon. His discussion of *species* remains within the boundaries of metaphysics of causation, and his arguments concerning *species*' weakening are founded on the traditional edict that an effect can never transcend its cause. He shows none of Grosseteste and Kepler's excitement for the geometry and formal properties of this expansion and concludes that "distance as such is not a cause of weakening."[110]

The tension between the Aristotelian and Neo-Platonic elements of Grosseteste's legacy is resolved by Bacon here, one might say, if somewhat crudely, in favor of Aristotle, and once Bacon moves on to the geometrical sections of his tract, he offers no new insights into the properties of light and its propagation. Yet it would be wrong to conclude that Neo-Platonism was a necessary condition for any attempt to argue for the decline of light with distance from straightforward geometrical reasons. It is rather loyalty to Alhacen and his geometrical legacy that moves Bacon's contemporary and arch-rival in all matters metaphysical, John Pecham (c. 1235–92), to assert that "the light of a single body is stronger at a nearer point than at a more remote point."[111] A similar line of reasoning directs Witelo in proposition 22 of book II of his *Perspectiva*: "Any opaque body [which is] closer to the luminous point is illuminated more strongly than a body more distant from that point."[112]

Witelo, whose argument is more complete than Pecham's, reasons from a given source of light—perceived as a luminous body—and an illuminated body, and assumes, somewhat problematically,[113] that the illumination is uniformly distributed along the illuminating body. The degree of illumination, he claims in his proposition 21,[114] is dependent on the sector of the luminous body from which light falls on the illuminated one: the larger the part of the illuminating body exposed, the more incident light. Distance thus causes illumination to decline indirectly, by narrowing the angle by which the illuminated body is perceived from the point of view of the illuminating one, limiting the sector from which the radiated light can fall on it perpendicularly.

This argument does not originate with Witelo. A very similar one is to be found in Alhacen:

> The light radiating on one place from the whole of the luminous body is stronger than that radiating from a part of that body upon that place and from that distance [and] the light radiating from a larger part is stronger than that radiating from a smaller part[115]

Witelo's indebtedness to Alhacen, the grand master and final authority of the Muslim optical tradition, should of course come as no surprise, nor should Pecham's, for that matter, but in fact the very same argument is to be found already in al-Kindi (c. 800-c. 870), Alhacen's predecessor:

> It has been made clear that the center is illuminated more strongly, and that which is closer to it is more [strongly] illuminated than that which is further from it; for more light falls on it because it is illuminated by more luminous parts[116]

It was al-Kindi, to be sure, who established for the medieval opticians the relation between the visual cone and light. He did so by way of analogy, involving considerations of strength and change with distance. Trying to understand why objects appear clearer the closer they are to the axis of the visual cone, al-Kindi rejected the Euclidean explanation, which ascribes the difference in visibility to differences in distance. Instead, he argued that clarity of vision follows from the strength of the visual ray, elaborating this notion of "strength of ray" by reference to strength of light. It is in this very context that he offers the argument whose conclusion is cited above: visibility, like illumination, depends on the amount of radiation reaching the object from the radiating body—the eye or the light source, respectively. Hence, as Witelo learned via Alhacen, the larger the sector of that radiating body that is exposed to the object, the better the visibility or the illumination. For al-Kindi's theoretical purposes the important conclusion is that this sector is largest at the axis of the visual cone, but it also follows, as Witelo points out, that illumination declines with distance, since the angle of vision between light source and object decreases with distance as well.[117] Indeed, one can still find in Leonardo the notion that "where there is a smaller luminous angle there is less light, because the pyramid of this angle has a smaller base, and therefore from this smaller base a lesser number of luminous rays converge at its point."[118] The decline of light with distance could still be explained as a result of the decrease of the angle of illumination well into the Renaissance.

Yet there is a significant difference between any optical-geometrical argument originating in al-Kindi and the one with which Kepler inferred the ISL and whose structure he apparently borrowed from Grosseteste. Al-Kindi offers an epistemology of perception, not a theory of light. When he does come, in this particular context, to discuss light, it is *illumination* rather than *propagation* that his interest is directed towards. This is further highlighted by recalling that al-Kindi, unlike Alhacen, remains loyal to the extra-

mission approach to vision (giving it a Galenic flavor by stressing, together with his contemporary Hunain Ibn ʾIsḥāq, the role of the eye and its relation to the medium).[119] The spherical explosion-like image that Grosseteste develops and Kepler is guided by, is not his. Without it the attempt to "quantify" light, to geometrically infer its "density or fortitude," makes little sense.

Yet even the narrative of the mathematical tradition that can provide geometrical laws but not their physical instantiation is too simplistic. Despite the impression of Euclidean continuity of proof that Witelo's cross-references creates in his *Perspectiva*, the demonstration of the decline of light with distance in proposition 22 of book 2 does not follow from the previous propositions. Instead of the circle that represented a luminous body in the earlier propositions, and especially in numbers 20 and 21 that lead to this proof, Witelo posits in proposition 22 point *a* as the luminous body (fig. 6.6). Taking *bg* to represent the illuminated body in closer distance and *vz* the same body at a larger distance, Witelo does not argue simply that *bg* is better illuminated than *vz* because the angle of illumination *vaz* is smaller than angle *bag*, as his proposition 21 would allow him. His claim, rather, is that *bg* receives more light because "triangle *abg* is greater than triangle *aht*."[120] This is hardly a coherent argument; if "light is equally diffused on any point of these triangles," as Witelo claims next, then its "power" should rather be *inversely* proportional to the area of the triangle illumination. The only way the "proof" can stand is if the source of light is considered as a luminous *body*, not a point, and the amount of light determined by the sector, namely angle *a*, rather than the area.

Far from diminishing the importance of Witelo's attempt, his confusion actually highlights the novelty of the approach he adopts here: taking a rare exception to his venerable predecessors, Witelo is trying to find a place in his theory for the intuitive notion that distance has a *direct* impact on illumination; that the phenomenon of the decline of light with distance should be explained through the qualities of light proper, independently of the lu-

FIGURE 6.6 Witelo's explanation for the decline of illumination with distance. *Perspectiva* II, proposition 22.

minous body. Light, Witelo is trying to claim, indeed *declines, after* it has left its source, and this decline can be captured by the same plane geometry deployed in optics since its inception. What his convoluted argument demonstrates is how difficult Witelo's seemingly straightforward expansion of the mathematical treatment of light turns out to be; how nonintuitive is the seemingly modest concept he is looking for.

The difficulty encountered in trying to develop a coherent geometrical concept of diffusion of light through space may appear less surprising when one considers what it is that Witelo is trying to mathematize, what kind of restrictions he is taking upon himself, and what his limits are in applying the tools developed in the *perspectiva* tradition. Light is a nonmaterial entity—*"primum omnium formarum senisibilium"*[121]—and its diffusion through space instantaneous. So even though its propagation can be represented geometrically, there is nothing in it that suggests itself, on first consideration, to be quantified or measured. It is obviously the agent of illumination, but as we discussed in chapter 1, the Aristotelian account of this causal agency does not lend itself to mathematical analysis—Aristotelian accounts rarely do. Alhacen's version of this account, in spite of the great mathematical credentials of its formulator, is not much different in that regard. Light, in this version, the *lux* inherent in the luminous body, does not "emanate" or "diffuse" per se, but rather replicates itself as *lumen*, so it can scarcely be perceived as a subject of decline with distance. Nor is *lumen*, as a replication, an "intentional physical representation" of *lux*,[122] carrying *visibilia* from the luminous object to the eye, a better candidate. Optics, which provides Witelo with context and motivation, naturally provides a mathematical model as well, but the application of this plane geometry to the notion of spherical diffusion proves to be anything but transparent. In order for physical properties of light, like its decline with distance, to be inferred from its geometry, this geometry has to be perceived as capturing its true propagation, and this is exactly what al-Kindi and Alhacen vehemently denied.[123] For Alhacen, Witelo's primary source, this denial had a central theoretical import—it anchored his rejection of the extramission theory of vision. This does not mean that Witelo could not bypass this metaphysical injunction, as was indeed customary in the optical tradition, by simply proceeding with the geometrical considerations, only that he had to do so at his own peril, without much instruction from his great predecessor, and the task proved confusing.

Especially confusing, it appears, was the fact that although envisioned as three-dimensional, the visual cone was always represented by its two-

dimensional triangular projection—the same confusion that Kepler experienced in the *Mysterium*. Unproblematic for the investigation of refraction and reflection, with regards to diffusion this convention thwarted not only Witelo's attempt, but also those of much more sophisticated mathematicians.

As a paradigmatic case of "difformed quality," the decline of light with distance was of particular interest to the fourteenth-century Oxford *calculatores*, who were of course well acquainted with the teachings of Grosseteste, the great chancellor of the previous century.[124] Trying out the new technique of latitudes on the changing intensity of illumination, Richard Dumbleton provides a particularly revealing example of this attempt at a mathematical treatment of light:

> The whole latitude of intensity corresponds to the point that is immediate to the agent, as in a pyramidal body the base corresponds to its whole depth, and as in a pyramidal body, according as the points terminate lines which are like the diameters of the bases of proportional parts and according as they are smaller proportionately, so are the points in an illuminated medium.[125]

There is hardly a doubt, as Edith Sylla points out, that Dumbleton works his argument here through the image of the cone (or pyramid) of light, and on first consideration one might think that this argument is very much like Kepler's proposition 9 of the *Ad Vitellionem*, namely that illumination diminishes as the surface on which light falls grows. Since the base of a cone is proportional to the square of its height, this should have led him, like Kepler, to the ISL, but in fact his conclusion is that the luminous body "acts difformly and more weakly at remote points than at near points, because of the distance,"[126] and in particular, that "light weakens (*debilitatur*) as it departs (*distans*) from the sun,"[127] seemingly positing a simple ratio of decline. A second look reveals that Dumbleton's use of the optical cone is completely different from Kepler's and that he shares with Witelo only the confusion of two- and three-dimensional representation. Unlike Grosseteste and Kepler with their spheres, Dumbleton does not use the cone as a reflection of the actual propagation of light through space, but only as a proto-graphic representation of the decline of its intensity. In other words, Dumbleton does not infer the decline of light *from* the cone, but represents the decline *by* the cone. This is why, in exact opposition to Witelo, it is the base of the cone that Dumbleton uses to represent the luminous body, or the maximum degree of illumination, reserving the apex for the terminating point—the illuminated body. This way, the diminishing diameter of the base of the cone can represent the diminishing "latitude" of intensity.

Now, representing the luminous body by a point, rather than the traditional circle (itself a projection of a sphere), was a daring innovation on Witelo's part, daring enough to apparently confuse Witelo himself. Dumbleton's use of the base of a cone for this purpose, however, is not a return to Alhacen or al-Kindi. For them, the circle, whether representing the luminous body or the eye, had a definite significance; it allowed them to consider angles of radiation and incidence and speculate about the effects of those. For Dumbleton, the circle is meaningless. If Witelo is confused by the change of representation from two-dimensional circle to a point, Dumbleton ignores the three-dimensionality of the cone, and treats it as if it were a plane triangle. For Dumbleton, remarks Sylla, "the volume of the figure has no significance."[128] The area of the base, from which Kepler drew his inverse square ratio, is just as meaningless.

## CONCLUSION

These, then, are the metaphysical images and epistemological convictions that the inverse square law reflected until it became the law of universal gravitation.

One important lesson from the history of the coming to being of ISL as the fundamental law of celestial dynamics is that it cannot be told as the process of the universalization of gravity. This narrative, commonly used to capture Newton's great unification of heaven and earth under one system of physical laws, suggests an act of *generalization* in which a well-understood and close-at-hand phenomenon—that of terrestrial gravity—was extended to save the mysterious and far-away—planetary motion. This was the way it was perceived by the French positivists,[129] who bequeathed it to posterity as the epitome of scientific achievement, together with Newton as its personification. The archaeology of the ISL, however, reveals a much more strenuous route, if one can be construed, which often leads in the opposite direction, namely from the heavens to earth.

For both Kepler and Hooke, the notion of force acting at a distance to affect motion was much easier to conceive on the grand scale of the celestial realm than down on earth. For Kepler, a mathematical force law was befitting of light exactly because of light's unique ontological status as a heavenly agent, essentially formal yet causally efficacious. His hesitation to apply it from light to the sun's motive power did not come from the inability to generalize by way of mathematics, but, quite the contrary, from considering the implication of universal geometrical structure. The schism that Hooke

needed to ignore—but could not—in order to use the force law established for gravity in a hypothesis about heavenly attraction was also not, as in the story of "universalization," that between the terrestrial and the celestial. Hooke had no problem, we saw, in assuming the same matter and the same laws in heaven and on earth. It was, rather, a division entrenched in the developing practices of physical-mathematical explanations: the ISL was predicated on static gravity, while "the hypothesis of compounding the celestial motions of the planets" required dynamic attraction. He did suspect that the two were related, as his pondering about "attraction or gravitating power" in the *System of the World* suggests. But this relation appeared to him as anything but trivial, and not enough to assume that the mathematical analysis of the one is applicable to the other.

Unwittingly on his part and unnoticed by Hooke, by stubbornly conflating Hooke's careful distinction between gravity and attraction in their correspondence, Newton was actually providing Hooke with the physico-mathematical assistance he was requesting. "Compounding the celestiall motions of the planetts of a direct motion by the tangent & an attractive motion towards a central body" could be achieved only if, pace Wallis, the "central body"—the sun—defines *both* the center of gravitation, that is, of attraction, *and* the center of gravity. This is the primary innovation of the celestial dynamics that Newton offers in the Copernican Scholium:

> The whole space of the planetary heavens either rests (as is commonly believed), or moves uniformly in a straight line, and hence the communal center of gravity of the planets . . . either rests or moves along with it. In both cases . . . the relative motions of the planets are the same, and their common centre of gravity rests in relation to the whole of space, and so can certainly be taken for the still centre of the whole planetary system. Hence truly the Copernican system is proved a priori. For if the common centre of gravity is calculated for any position of the planets it either falls in the body of the Sun or will always be very close to it.[130]

This is the insight that allowed Newton to put the ISL to use in solving the challenge Hooke submitted to him in the many and diverse ways we explored in the previous chapter.

From the point of view of universal dynamics, therefore, Newton's achievement was not so much a grand union of heaven and earth under one force law as it was the suppression of in-built hindrances to the perception of earthly gravitation as a particular embodiment of such cosmic power. From a more general perspective, the search for a force law, the vicissitudes

of its use, and the boundaries set and unset on its application encapsulate the striving for a causal-mathematical philosophy of nature and the changing concepts of natural order and human knowledge. Merging the rigorous mathematics of perspectivist optics, the ideas of the agency of light, and its quasi-corporeal nature from mediaeval neo-Platonism to develop the concept of mathematical causation with light as its carrier and emblem, Kepler determined that light declines by the square of the distance from its source. From this hard-won perspective, the ISL seemed like an obvious consequence of the spherical emanation of light assumed by medieval and Renaissance opticians and neo-Platonists, but in fact such a force law would have made sense for neither. Adopting Kepler's way of endowing mathematics with causal efficacy and employing his geometrical analysis of light to gravity, Hooke determined that gravity declines by the square of distance. From his vantage point, the application of the ISL from light to gravity was an obvious route that Kepler had surely traveled, but in fact Kepler had reasoned himself away from such a move by the very concepts of mathematical causality that led him to the ISL.

None of these considerations impressed Newton. For him the inverse square law was nothing but a tool in the hands of human mathematical practitioners: a contingent constant of nature with no aspiration or promise to reflect some underlying simplicity or perfection. It could have been somewhat different and it could be used flexibly and approximately. The final success of Baroque mathematical natural philosophy was predicated on shedding the very metaphysical assumptions that legitimized giving mathematics a causal, explanatory role in the first place.

# *PART III*

*Passions*

———— ✳ ————

# Passions, Imagination, and the Persona of the New Savant

## INTRODUCTION: THE PRINCESS AND THE SAGE

ON MAY 6, 1643, RENÉ DESCARTES, at the height of his career and the most famous savant in Europe, received a letter from Elisabeth, princess of Bohemia. Directly and with only a minimal gesture to courtesy, the young woman was nominating him "the best doctor of [her] soul," binding him by "the Hippocratic oath," and asking for "remedies."[1]

It was not the first time that Descartes was compelled to reflect on his work in a concrete way, not merely as a New Science but as moral teaching and a way to lead a life. His methodological writings of those years—the *Discourse on Method* of 1637 and especially the *Meditations* of 1641—and their personal, autobiographical tenor, so different from the declamations of the youthful *Regulae*, testify that he was acutely aware that such reflection was necessary. The delicate seams that tied together knowledge, belief, and behavior were undone by the bold aspirations, spectacular success, and steep price of the new mathematical, experimental, instrument-based natural philosophy. The traditional intellectual alternatives of balancing nonenthusiast certainty in His Word, modest skepticism in human knowledge, and respectful adherence to the "laws and customs"[2] of one's land could no longer be counted on. Within a generation, the radical implications of the New, Baroque Science would become matter of fact; the mediating role of the senses, the irreducible variety of the phenomena, the human origin of mathematical order: all will be carefully wrapped in the rhetoric of the divine laws of nature. But for Descartes and his immediate disciples they were

still extremely unsettling, and the controversy was not merely intellectual: not only did the Galileo affair make Descartes suppress the publication of his *Le Monde*; his own philosophy was becoming a focus of fierce contention in the universities of the Netherlands, his adopted homeland.[3]

Yet Elisabeth's challenge, being practical, immediate, and personal, was particularly powerful, all the more so because Elisabeth personified the real cultural and political context of the New Science in an almost emblematic way. A daughter of the deposed and exiled Palatinate elector, she was a knowledgeable and involved witness to the tumultuous later years of the Thirty Years War. A victim of a botched cross-confessional engagement to the Polish heir (and an angry observer of her brother's conversion for similar political-marital reasons), she had personal experience of the pain and politics of religious strife. Learned and impressively intelligent, she was a formidable interlocutor, but as a woman she was ipso facto an outsider: barred from the budding new institutions and communities of knowledge—real or imaginary—as much as from the old ones, she could not be distracted by the jargons of either the schools or the republic of letters. Indeed, Elisabeth, respectful but persistent, was anything but overwhelmed by the arguments of the *Meditations* or by Descartes' replies to his critics, which she carefully read. Like most readers since, she understood Descartes to be defending religion and morality from the tyranny of matter-in-motion by instituting a strict dichotomy between body and soul, and she was quick to notice that this is a self-defeating strategy, especially for one who would like to take Descartes' teaching seriously, as a method to gain knowledge, avoid error and lead a life of reason. With this dichotomy in place, Descartes leaves it a complete mystery "how the soul of a human being (it being only a thinking substance) can determine the bodily spirits, in order to bring about voluntary actions"[4]

Quite astonishingly, Descartes denies the problem altogether. True, he grants in his May 21 answer, "The question your Highness proposes seems to me that which, in view of my published writing, one can most rightly ask me,"[5] but this is just an artifact of the rhetoric he was compelled to use in the *Meditations* because his "principal aim was to prove the distinction between the soul and the body."[6] He never intended, he insists, to dig the ontological dip that philosophers have been trying to climb out of ever since. His point was epistemological and anti-reductionist, and he posited three rather than two fundamental categories: body, soul, and "body and soul together."[7] He was considering, he explains, "the whole of human knowledge [*science*]"—not the making of His Creation—and his attempt was to prevent confusion between "primitive notions." To the body applies "only

the notion of extension . . . to the soul alone we have only that of thought." This is what Elisabeth and tradition have found in the *Meditations—res extensia* and *res cogitans*—but this is not all there is:

> Finally, for the soul and body *together*, we have only that of their union, on which depends that of the power the soul has to move the body and the body to act on the soul, in causing sensations and passions.[8]

The union of body and soul is as "primitive" a notion as any of the two alone.

Descartes' presentation of his own previous work is so different from what has been taught to generations of students that it is hard to avoid the question of whether one can or should grant him a privileged authority over the interpretation of the philosophy he authored. As Cook stresses,[9] the Sixth Mediation does contain statements such as "there is nothing that my own nature teaches me more vividly than that I have a body" and "I and my body form a unit,"[10] but Elisabeth had every right to be more impressed with assertions like: "I am clearly distinct from my body, and can exist without it,"[11] just two pages earlier.

Yet the methodological issue of the author's authority and even the question of Descartes' coherence are somewhat beside the point here. What is crucial is the mode of explanation that Descartes commits to, and that will define his work for the last few years of his life: the attempt to legitimize the New Science philosophically will itself take a hypothetical and quasi-empirical shape. As Kepler first acknowledged, even if he failed to fully accept it, the causal and natural mediation of the senses meant that human knowledge is always constructed. Descartes, we have seen,[12] found these ramifications of the project of mathematical natural philosophy deeply disturbing. The doubt in our direct acquaintance with the world could have devolved into the full-blown skepticism explored in the early *Meditations*, the skepticism that gives rise to the strict dichotomy troubling Elisabeth. But it did not, and he takes pains to make the princess see that. Instead, the implication of this absurd skepticism convinced Descartes to forgo any attempt to make claims to such direct knowledge: ontology, the study of what there is, is the purview of "science." A priori considerations, like the distinction between body and soul, are limited to the analysis of "notions."

The relations between body and soul, Descartes explains, are not a matter for metaphysical speculation. They should be approached either as a methodological task of clarifying the concepts we use in natural philosophy or as a practical-ethical question of proper *dietetics*. His original reasons for the very distinction were of the former sort: to prevent the mistaken rei-

fication of the presumed "qualities of bodies, such as heaviness, heat, and others" and the false sense of understating it gives rise to: "for example, in supposing that heaviness is a real quality, of which we have no other knowledge but that it has the power to move a body in which it is toward the center of the earth, we have no difficulty in conceiving how it moves the body or how it is joined with it." This baseless confidence is damaging, as it prevents us from inquiring how "this happens through a real contact of one surface against another," but Descartes "cannot find a reason to observe the Hippocratic oath" in all these considerations, and since Elisabeth did not divulge any concerns of the latter, ethical sort, he feels comfortable concluding with a few lines of poetic compliments.[13]

Elisabeth was neither convinced by the explanations nor impressed by the compliments, and her June 10 reply is unrelenting. The shift of the discussion to practical terms did not console her, but made her weary of the "false praise" Descartes was lavishing on her, whose "upbringing in a place where the ordinary way of conversing has accustomed to understand that people are incapable of giving one true praise." The hypocrisy of court manners was not only "annoyance and boredom," but a true personal and moral dilemma, because "the interest of [her] house, which [she] must not neglect," prevented her from taking philosophy as "a habit of meditation." She was particularly unimpressed with the analogy to gravity as a quality of the body, a "power to carry the body toward the center of the earth," which Descartes himself had promised to reduce to a corpuscles-in-motion account. In general, the surprising "trialism" of Descartes' letter leaves her cold: either one has "to concede matter and extension to the soul [or] to concede the capacity to move a body or be moved by it to an immaterial thing." The former is obviously difficult, because the soul "can subsist without the body." But the latter, which Elisabeth understands as Descartes' position, seems to her even more difficult to accept: how can the intelligent mind lose its capacity "of reasoning well" to "some vapors" and be "governed" by a mindless body? This is the ethical core of Elisabeth's worry about "how the soul (nonextended and immaterial) can move the body,"[14] and she was unimpressed by Descartes' attempt to handle the fundamental philosophical question with tentative, natural philosophy considerations.

Descartes answers, on June 28, along the lines drawn by Elisabeth, but he relents neither the tripartite division that baffled the princess nor the epistemological-conceptual reasons supporting it, reasons that he now labors to elucidate. "These three sorts of notions" differ in the ways of acquiring knowledge associated with them:

the soul is conceived by pure understanding; the body, that is to say, extension, shapes and motions, can also be known by understanding alone, but is much better known by the understanding aided by the imagination; and finally, those things which pertain to the union of the soul and the body are known only obscurely by understanding alone, or even by the understanding aided by the imagination; but they are known clearly by the senses.[15]

This is a pivotal paragraph. Whether or not Descartes ever held the firm belief in the power of "pure understanding" to lead us to knowledge of the world—the belief that tradition (and, he seems to assume, Elisabeth) ascribed to him—he most definitely no longer holds it. At this stage of his intellectual career, with his main contributions to the New Science already in place and his opus magnum, the *Principia Philosophiae*, only a year from publication, he allows the soul direct, a priori access only to itself. The previous letter was an attempt to explain to Elisabeth that what she is seeking is not a philosophical understanding of a mysterious relation between two independent entities, but practical knowledge of "the union of the soul and the body," a union that has to be taken as a primitive notion. This knowledge, Descartes now adds, is to be had "clearly by the senses." There is no point in searching for "a doctor for the soul"; for every one of us—"a single person who has together a body and a thought"—the experiential, sensual knowledge of the regular physician has to suffice. Indeed, it is from "life and ordinary conversations . . . that we learn to conceive the union of the soul and the body." Moreover, "the meditations which are required in order to know well the *distinction* between the soul and the body" are arduous and should not be dwelt on too strenuously, or they will damage one's health, and Descartes himself makes a point to "never spend more that few hours a day in thoughts that occupy the imagination, and very few hours a year in those which occupy the understanding alone."[16]

Descartes is completely aware how surprising this epistemologically motivated trialism should be to readers of his earlier work: "I almost fear that your Highness will think that I do not speak seriously here," he writes. The Hippocratic oath by which he is bound to Elisabeth obliges him to spend most of his explanations on the ethical-medical sides of this analysis: our knowledge of ourselves as an abstract soul and our knowledge of ourselves as an embodied whole. But the real novelty, the radical epistemological insight that Descartes is presenting, is in the third part of the analysis: the knowledge of the world. Nothing has changed in Descartes' assumption of what the world consists of: "body, that is to say, extension, shapes, and mo-

tions." The epistemological decree stemming from this ontology is also well-known: this knowledge should be thoroughly mathematical.

Where and how Descartes thinks such mathematical knowledge can be had, however, is deeply surprising: "by the understanding aided by the imagination." Mathematics requires the work of imagination.[17]

## IMAGINATION

The notion that the acquisition of knowledge must take recourse through the imagination is a symptomatically *Baroque* idea; a corollary of the realization that *all* knowledge is mediated—including the most fundamental sensual perception. Thus, unexpected as it is coming from Descartes and in relation to mathematics, it was not completely unprecedented, as we will show below; versions of it were being developed by his contemporaries and immediate predecessors. It was, however, a radically new development: even though one can hear the Aristotelian *imago* and *phantasia* resonating in Descartes' terminology, his use of it is completely foreign to the Aristotelian tradition he was familiar with.

It is true that in Aristotle's psychology, imagination and fantasy were corporeal faculties producing images from the disparate data provided by the senses, and Aristotle himself found no fundamental difficulty in assuming that this mediation is necessary for the production of knowledge.[18] His Stoic and Scholastic interpreters, however, changed this dramatically, putting a strong emphasis on the unreality of "phantasm" and "phantastic." Scholastic Aristotelianism invested much intellectual effort into preserving and buttressing the distinction between "imagination" as part of a reliable cognitive process and "fantasy" as the faculty of delusions and mental fictions, but by the fourteenth century this attempt was recognized as a failure. Oresme himself, in stark contradistinction to his recognition of the necessity to *mathematice fingere* the objects of geometry (see chapter 4), pointed to the imagination as the weakest link in the weak human sensual cognition. The mind, he stressed, is unable to distinguish between species that enter the eye from outside and species that the imagination retrieves from memory; illusions are formed "by species retained [in memory] and judged internally."[19] In Renaissance medical thought the demarcation between the two faculties was completely blurred and human inability to form clear borderlines between image and fantasy became a *topos* in all philosophical schools.[20] Making reliable knowledge, let alone mathematics, dependent on fantasy, would have been an anathema for Renaissance thinkers: knowledge was

what reason succeeded in rescuing from and guarding against the frivolity of imagination.

### Empiricism—Bacon

Francis Bacon, for example, belaboring the new modes of learning and their appropriate methodological underpinning, still regularly pointed at the imagination as both a sign for and a cause of the corruption of the old ways. In the *Advancement of Learning* he enumerates "vain imaginations, vain altercations, and vain affectations" as the major "vanities in studies, whereby learning hath been most traduced." This is the reason Bacon condemns "astrology, natural magic, and alchemy": they are "sciences . . . which have had better intelligence and confederacy with the imagination of man than with his reason." The imagination *is* the problem of these "degenerate" sciences, he reiterates later on in the treatise:

> whosoever shall entertain high and vaporous imaginations, instead of a laborious and sober inquiry of truth, shall beget hopes and beliefs of strange and impossible shapes. And, therefore, we may note in these sciences which hold so much of imagination and belief, as this degenerate natural magic, alchemy, astrology, and the like, that in their propositions the description of the means is ever more monstrous than the pretence or end.

Of "the three parts of man's understanding," Bacon assigns "history to his memory, poesy to his imagination, and philosophy to his reason," he can explain very clearly why "poesy" is not a source of true knowledge. This is because the "imagination,"

> being not tied to the laws of matter, may at pleasure join that which nature hath severed, and sever that which nature hath joined, and so make unlawful matches and divorces of things.[21]

This is, in essence, the traditional complaint about imagination, which Bacon crystallizes in the *Novum organum*: "names are formed by fanciful imaginations which are without an object."[22] Imagination leads reason astray by introducing false richness, false multitude and variety, which reason tries in vain to rein in:

> let no one be alarmed at the multitude of particulars, but rather inclined to hope on that very account. For the particular phenomena of the arts and nature are in reality but as a handful, when compared with the fictions of the imagination, removed and separated from the evidence of facts.[23]

The imagination deceives, and this deception is damaging in many ways—not only to reason, but to the body as well:

> As for the ... the operation of the conceits and passions of the mind upon the body, we see all wise physicians, in the prescriptions of their regiments to their patients, do ever consider *accidentia animi*, as of great force to further or hinder remedies or recoveries: and more specially it is an inquiry of great depth and worth concerning imagination, how and how far it altereth the body proper of the imaginant; for although it hath a manifest power to hurt, it followeth not it hath the same degree of power to help.[24]

The belief of "*Paracelsus,* and some darksome *Authors* of Magick," that "ascribe to Imagination exalted Power of Miracle-working Faith" is "vast and bottomless Follies," he adds in the *Sylva Sylvarum.*[25]

The struggle against the "false assertion that the sense of man is the measure of things"[26] is at the core of Bacon's project, and the effort to prevent "vaporous imaginations" from getting in the way "of a laborious and sober inquiry of truth" is an integral part of it. But that is not to say that Bacon was a naïve believer in the power of the senses to circumvent the imagination and furnish reason with undistorted "evidence of facts." The unsettling variety with which reason has to come to terms is not merely a deception introduced by the imagination—it is the basic truth of our sensual encounter with the world:

> The universe to the eye of the human understanding is framed like a labyrinth; presenting as it does on every side so many ambiguities of way, such deceitful resemblances of objects and signs, natures so irregular in their lines, and so knotted and entangled. And then the way is still to be made by the uncertain light of the sense, sometimes shining out, sometimes clouded over, through the woods of experience and particulars.[27]

Moreover, the senses cannot provide reason with a reliable guide out of the labyrinth of nature because they are an integral part of it. The organs of sense, writes Bacon, are but natural instruments, and, he stresses, it is not only analogy that he offers:

> Are not the organs of the senses of one kind with the organs of reflection, the eye with a glass, the ear with a cave or strait, determined and bounded? Neither are these only similitudes, as men of narrow observation may conceive them to be, but the same footsteps of nature, treading or printing upon several subjects or matters.[28]

These words, in the *Advancement of Learning* of 1605, a mere year after Kepler's revolutionary *Optics* and four years before Galileo's telescope, dem-

onstrate that like his two contemporaries, and even without the optical and instrumental arguments they could furnish, Bacon was keenly attuned to "the mediated character of observation"[29] as a fundamental epistemological fact. "To the immediate and proper perception of the sense therefore I do not give much weight"[30] he writes, and incorporates even reason into the mediating process; an instrument, and a faulty one at that:

> the mind of man is far from the nature of a clear and equal glass, wherein the beams of things should reflect according to their true incidence; nay, it is rather like an enchanted glass, full of superstition and imposture, if it be not delivered and reduced.[31]

Like Kepler and Galileo, Bacon in his conclusion turns to artificial means in order to acquire knowledge, "to provide helps to the sense—substitutes to supply its failures, rectification to correct its errors that the office of sense shall be only to judge of the experiment, and that experiment itself will judge the thing."[32] The attempt to gain knowledge, to find a way within and out of the "labyrinth" by the naked senses, is as limited as sailing "only by observation of the stars." Such strict sensual procedures could allow one to

> coast along the shores of the old continent or cross a few small and mediterranean seas; but before the ocean could be traversed and the new world discovered, the use of the mariner's needle, as a more faithful and certain guide, had to be found out.[33]

Without a "mariner's needle," using only "practice, meditation, observation, argumentation," knowledge is limited to "discoveries . . . near the senses and immediately beneath common notions." Bacon takes great care that his analogy not be missed: "in like manner," he explains, contemporary "arts and sciences" need artificial means if they are to "reach the remoter and more hidden parts of nature."[34]

These means do not have to be material—Bacon's is primarily promoting his method—but method and "experiment" present the same epistemological dilemma as the compass, the camera obscura, and the telescope: they all introduce reason with artificial "substitutes" to the real objects of nature. This is a necessary evil; natural objects and their motions are invisible to the senses:

> The Knowledge of man (hitherto) hath beene determined by the View, or Sight; So that whatsoeuer is Invisible, either in respect of the Finenesse of the Body it self; Or the Smallnesse of the Parts; Or of the Subtility of the Motion is little inquired. And yet these are the Things that Gouerne Nature principally . . . And therefore the Tumult in the Parts of Solide Bodies . . . which is the Cause of all

Flight of Bodies thorow the Aire, and of other Mechanicall Motions . . . is not seene at all. But neuerthelesse, if you know it not, or enquire it not attentiuely and diligently, you shal neuer be able to discerne, and much lesse to produce, a Number of Mechanicall Motions.[35]

"To discerne" the "Things that Gouerne Nature principally" is closely related to "to produce" them, and this imitation of nature, essential to "The Knowledge of man," necessarily involves an active participation of the imagination: "In all persuasions that are wrought by eloquence and other impressions of nature, which do paint and disguise the true appearance of things, the chief recommendation unto Reason is from the Imagination."[36]

It is not only the need to deal with the hidden and disguised, whether by "eloquence" or by "nature," that makes imagination, in spite of the danger it represents, an essential element in Bacon's epistemology. Imagination is also the indispensable mediator between reason and will, and in this role it takes a similar responsibility for shaping the objects of knowledge:

> The knowledge which respecteth the faculties of the mind of man is of two kinds—the one respecting his understanding and reason, and the other his will, appetite, and affection; whereof the former produceth position or decree, the latter action or execution. It is true that the imagination is an agent or *nuncius* in both provinces, both the judicial and the ministerial. For sense sendeth over to imagination before reason have judged, and reason sendeth over to imagination before the decree can be acted. For imagination ever precedeth voluntary motion. Saving that this Janus of imagination hath differing faces: for the face towards reason hath the print of truth, but the face towards action hath the print of good; which nevertheless are faces, "Quales decet esse sororum." Neither is the imagination simply and only a messenger; but is invested with, or at least wise usurpeth no small authority in itself, besides the duty of the message.

Thus, beyond the oratory of sobriety and responsibility, Bacon is fully committed to giving imagination its complete due, and he proceeds to quote what

> was well said by Aristotle, 'That the mind hath over the body that commandment, which the lord hath over a bondman; but that reason hath over the imagination that commandment which a magistrate hath over a free citizen, who may come also to rule in his turn.[37]

Imagination has to be properly ruled, has to be reined in by reason so as not to become "frivolous" or "usurp" its mission as a messenger, but by no means can or should it be suppressed. Rather, it needs to be studied, and there is a proper science ready to be devoted for the task: "rhetoric, or art of eloquence, a science excellent, and excellently well laboured." "The duty and office of rhetoric is to apply reason to imagination," and poetical

devices such as ancient fables and myths should be used in order to "fill the imagination to second reason, and not to oppress it."[38] The imagination has to be studied, understood, and controlled, and finally, in the *Sylva Sylvarum* Bacon moves to do just that in the most commendable way—by applying his own method. "There is no doubt but that Imagination and vehement Affection work greatly upon the Body of the Imaginant," he declares, and proceeds to analyze "the *Force of Imagination* upon other *Bodies*, and the means to exalt and strengthen it" and even suggests "Experiments of Imagination."[39]

### Morals—Shakespeare

It is a similar transitory, hesitant attitude towards the imagination that one finds in William Shakespeare, Bacon's contemporary and compatriot. "Such tricks hath strong imagination,"[40] he writes; like Bacon, he is keenly aware of, even worried by, the way imagination challenges rationality and sets the limits to its aspiration for knowledge. But being the master of "Poesy," he is even more intrigued by the essential ambivalence of the relations between reason and imagination. He explores this theme, critically and ironically, in *A Midsummer Night's Dream*, with Athens and its surrounding woods taking their obvious respective symbolic roles.

In the midst of preparations for his own wedding ceremony, Theseus, Duke of Athens, is faced with a challenge to both the moral convictions and the epistemological grounds on which he makes his ethical-political decisions. Egeus demands that Theseus force his (Egeus') daughter Hermia to marry the man he (Egeus) chose for her rather than the one she loves. Theseus cannot base his judgment on his senses: the two men look too much alike. The daughter, Hermia, beseeches him to adopt, instead, a change of perspective: "I would my father looked but with my eyes," she implores. This recourse to imagination is not a viable option for Theseus. It carries dangerous political ramifications of instability that Theseus chooses to quash with an appeal to the legal power of tradition supporting the arbitrariness of her father's judgment: "Rather your eyes must with his judgment look," he decrees.[41]

Yet the alternative of the rule of imagination does not disappear: it is transported to the wood and to the night, where fantasy in its struggle against "cool reason"[42] is embodied by creatures of dream and fable, contesting in their whims the participants' convictions and common sense, ridiculing their naïve belief in "What thou seest when thou dost wake."[43]

Unlike the woods of stoic contemplation we will consider below, the

wood in *A Midsummer Night* is "not a paradise, a heaven of romance and bliss; it is a place of queasy shifts and disturbing fantasies, capricious and tyrannical in its own way . . . of total absurdity."[44] The wood sets real limits to Theseus' beliefs in the rational flow of time and in the power of reason to turn, by its decree, melancholy into mirth and violence into love.[45] In effect, it confirms his worry that Hermia is not merely presenting the ancient dilemma between reason and passions, but a bold novel attempt to reform the relations between them:[46]

> Reason and love keep little company together nowadays.
> The more the pity that some honest neighbors will
> not make them friends.[47]

It is Hippolyta, his beloved, who implores Theseus to reevaluate his beliefs in the clear separation between reason and imagination; between the rational realm of the orderly and the unruly realm of fantasy and desire; between the rigidity of a uniform and consistent law and the playful variety of nature. "'Tis strange, my Theseus, that these lovers speak of,"[48] she says upon hearing the four confused lovers' report of their adventures.

Theseus' immediate answer is contemptuous dismissal of the lovers' poetic madness. It is a vision that is "more strange than true," a confused amalgam of "antique fables" and "fairy toys." Their story, he claims, is the result of a "seething brains," which, drawn in by excess and variety, "apprehend More than cool reason ever comprehends":

> The lunatic, the lover and the poet
> Are of imagination all compact:
> One sees more devils than vast hell can hold.

This is not just prudish intransigence. Imagination and the passions—fear, desire—pose a real threat to reason and knowledge, because they couple to fill our mind with fictitious entities:

> . . . as imagination bodies forth
> The forms of things unknown, the poet's pen
> Turns them to shapes and gives to airy nothing
> A local habitation and a name.
> Such tricks hath strong imagination,
> That if it would but apprehend some joy,
> It comprehends some bringer of that joy;
> Or in the night, imagining some fear,
> How easy is a bush supposed a bear![49]

This dismissal, however, is too easy and too self-serving, and Shakespeare sets Hippolyta to point that out. As Descartes will recount in the *Meditations*, some fifty years later, dreams and hallucinations often appear as coherent as real sensations, and no less vivid and convincing:

> But all the story of the night told over,
> And all their minds transfigured so together,
> More witnesseth than fancy's images
> And grows to something of *great constancy*,
> But, howsoever, strange and admirable.[50]

Imagination cannot be simply dismissed. It needs to be accounted for, considered, controlled. Neither can the senses tell us the difference between "things plain" and the products of "fine frenzy," nor can reason allude to "constancy" to make the distinction. As it will be for Elisabeth, the epistemological problem of knowledge, motivated from the start by an ethical question of choice, returns to become a moral and practical question of who to believe, especially in the rhetorical, hypocritical world of the court. Theseus' solution is to listen to silence:

> Out of this silence yet I picked a welcome, and in the modesty of a fearful duty, I
> Read as much as from the rattling tongue
> Of saucy and audacious eloquence.
> Love, therefore, and tongue-tied simplicity
> In least speak most, to my capacity.[51]

The answer to the question of knowledge can only come from the passions—love, tenderness, simplicity of mind:

> For never anything can be amiss,
> When simpleness and duty tender it.[52]

And if passions and trust have to guide reason, the imagination no longer poses such a threat; indeed, it may provide some assistance:

> The best in this kind are but shadows, and the worst
> are no worse, if imagination amend them.[53]

### Mathematics—Galileo and Kepler

Galileo and Kepler bring the same double-edged sword of imagination to where Descartes would find it—in mathematics and mathematical natural philosophy. In his polemics with the Jesuits over the nature of the comets,

which we discussed in chapter 3, Galileo condemns his adversaries for following "the strength of their passions,"[54] trapped in "the bounty of nature in producing her effects."[55] In the *Two New Sciences*, we saw, he scoffs at those working on "imagined helices and conchoids."[56] Kepler was as wary of the "speculations of abstract Geometry,"[57] and as proficient in the anti-imagination rhetoric: when he finds the speculative work of John Dee uncomfortably resembling his own, he dissociates himself from the English *magus* by accusing him "of indulging in 'enigmatics [*aenigmata*],' of writing in an 'occult and shadowy [*occultum et tenebrosa*] manner,' of engaging in 'dreams [*somnia*],' of creating 'dense mysteries [*mesteriae proundissimae*],' ... and finally of delighting in 'pictures [*picturae*]' and 'pure symbolism [*meri symbolism*].'"[58]

Yet even more than Bacon, Galileo and Kepler rely on the ability to dwell on subject matter that is "invisible, either in respect of the Finenesse of the Body itself; Or the Smallnesse of the Parts; Or of the Subtility of the Motion." For them, it is not only "the Cause of all Flight of Bodies thorow the Aire" which needs to be "determined" without recourse to "View, or Sight." Their commitment to Copernicanism, for which vision, even assisted by their instruments, can provide only indirect support, compels them to find ways to put before the mind the motions themselves—before even aspiring to contemplate their causes. And in spite of their avowal to follow only "the traces of the Creator" and "consider the phenomena" only "as actually occurs in nature" and "observed," they do not shy away from the obligation. Sagredo's imagined journey to Alexandretta, with the pen leaving an imaginary trail in the sky, exemplifies this necessary recourse: reason has to resort to imagination to capture motions that cannot be perceived by the senses. Galileo makes sure that his readers will understand the dilemma and its solution. He lets Simplicio complain about the "bald denial of manifest sense" involved in assuming that the earth moves, and stress: "If the senses ought not to be believed, by what other Portal shall we enter into philosophizing?" Sagredo then introduces his fable exactly as it is: "a certain fantasy which passed through my imagination."[59]

It needs to be emphasized that this deployment of the imagination is not merely for rhetorical or educational purposes: imagination *is* the way by which reason approaches its objects of knowledge when those lie beyond the reach of the senses. Kepler demonstrates this necessary resort to imagination in his *Somnium*. Like Galileo, he seeks to capture the hidden motion of the earth, and does so by fantasizing a voyage to the moon. He tells of a dream, in which he finds a book, in which a man from Iceland re-

counts an account of the view from the moon conveyed to him by a dae-
mon introduced to him by his witch mother. The imaginary view from the
moon provides very real knowledge, full of details that are by no means
trivial. For example, since the moon does not rotate on its poles (it always
presents us with the same face) its dwellers conceive time completely dif-
ferently from us. First of all, the moon changes the face it reveals to the sun
only when it completes a revolution around the earth, which means that
its day is what we would count as a lunar month. Secondly, the inhabitants
of one hemisphere of the moon always see the earth, "fixed in place . . . as
though it were attached to the heavens with a nail,"[60] whereas those of the
other hemisphere never see it at all. We are used to the steady motion of
the sun through the day sky and the stars through the night, and our as-
tronomers know to trust those and not the capricious motion of the moon.
For the lunar dwellers, in contrast, the sun and stars move very irregularly,
and it is the steady rotation of earth, marked by the "wonderful variety of
spots"[61] that provides a good measure of time, just as its steady position in
the heaven provides a stable frame of reference for space.

Kepler uses the introductory fable to the *Somnium*—a fanciful rendi-
tion of his own journey into the heart of astronomy and his tutelage under
Tycho Brahe—to stress the role of fantasy. Moreover, once he teaches his
readers how to move from one perspective to another, he takes pains to
show them that it is far from obvious *which* of these perspectives is fantas-
tic; after all, those motions we seem to observe by the senses "exist only in
the imagination of the earth-dwellers. Hence, if we transfer the imagination
to another sphere, everything must be understood in a different form."[62] As
if following Hermia's call, Kepler provides in the *Somnium* a change of per-
spective, possible for us only by means of the imagination.

The daemon's account of the celestial motions is imaginary, but there is
nothing fanciful about it. As pointed out above, it is a sober and substantial
gain of knowledge, punctuated by carefully worked calculations such as:

> For us in one year there are 365 revolutions of the sun, and 366 of the sphere
> of the fixed stars, or more accurately, in four years, 1461 revolutions of the sun
> but 146 of the sphere of the fixed stars. Similarly, for them the sun revolves 99
> times and the sphere of the fixed stars 107 times. But they are more familiar
> with the nineteen-year cycle, for in that interval the sun rises 235 times, but the
> fixed stars 254 times.[63]

This mathematical account, buttressed by an extended apparatus of notes
and explanations, saves the work of the imagination from deteriorating into

the melancholic delusion of Shakespeare's woods. Similarly, Sagredo's fantastic pen, drawing the path of the ship on the rolling waves, is meaningful only due to the mathematical explanation that follows. The relations that Kepler and Galileo are drawing between imagination and mathematics are reciprocal: imagination, pace their avowals to "geometry of real bodies" (see chapter 4), provides mathematics with its objects; mathematics keeps imagination in check.

The demands that Galileo and Kepler were putting on their mathematics were nigh on contradictory: to relate directly to the real objects, so they could produce causal accounts of the phenomena, and to legitimate the new mode of instrumental perception, with its implication that there is no direct relation to the objects, and all perception is essentially mediated. The imagination—the seat of images—was the locus of these paradoxical demands: the realm where the impressions from the objects, mediated by the senses, could be given significance, being turned by the creative powers of the mind into objects of knowledge. Mathematics was to rely on and govern this process.

## Epistemology—Descartes Again

Entrusting reliable knowledge to the imagination was a Baroque line of thought that Kepler and Galileo would not complete. Descartes, with his concept of mathematical "understanding aided by the imagination" (see above), makes it a centerpiece of his epistemology already in the early *Rules for the Direction of the Mind*.[64]

Unlike Galileo and Kepler, Descartes never pretended to read his mathematics directly from nature. But assigning it to pure intellection would have meant, for Descartes, detaching it from the objects in a way that would have rendered it worthless. His philosophical analysis of Keplerian optics, as we saw in chapter 1, led to the conclusion that the objects considered by the mind—objects that Descartes reluctantly agrees to call "images" for the sake of simplicity and tradition—"in no way resemble the things they signify."[65] As discussed in chapter 4, for the practitioners of the mathematical *scientiae mediae* this discrepancy did not represent anything more than the obvious: "of course, the line of intensity of which we have just spoken is not actually extended,"[66] Oresme had remarked. The power of mathematics came from its abstract simplicity and perfection; the world was concrete and complex. "Indivisible points, or lines," could be "feign[ed] mathematically for the measures of things and for the understanding of their ratios," but that was all that could be achieved with them; mathematics could not provide

causal accounts and did not aspire for truth. This was a compromise that Descartes would no longer accept. On the one hand, he was fully committed to the project of mathematical natural philosophy: mathematical analysis, as he demonstrated in his analysis of the rainbow, could and should be expected to provide causes. On the other hand, like Galileo before him and Newton later, he was completely secure in the power of mathematics to capture all complexity.

The imagination provided Descartes with an arena of mediation, where the mathematical products of the mind and the perceptual products of the senses can meet and be matched. To stress again: despite the Aristotelian terminology and resources, this was not his Jesuit education that Descartes was reverting to; the Aristotelianism that his mentors and his intellectual milieu recognized strictly denied that the imagination could lead to truth and was indeed preoccupied with its dangers.[67]

Descartes, instead, turns the medieval distinctions and limitations obsolete by presenting the very distinction between the various parts of cognition as practical and flexible:

the power through which we know things in the strict sense is purely spiritual, and is no less distinct from the whole body than blood is distinct from bone or the hand from the eye. It is one single power whether it receives figures [*figuras*] from the 'common' sense [*sensus communis*] at the same time as the corporeal imagination [*phantasia*], or applies itself to those which are preserved in memory or forms new ones which so occupy the imagination that it is often in no position to receive ideas from the 'common' sense at the same time, or to transmit them to the power responsible for motion in accordance with a purely corporeal mode of operation. In all these functions the cognitive power is sometimes passive, sometimes active; sometimes resembling the seal, sometimes the wax. But this should be understood merely as an analogy, for nothing like this power is to be found in corporeal things. It is one and the same power: when applying itself along with imagination to the 'common' sense it is said to see, touch etc.; when addressing itself to the imagination alone, in so far as the latter is invested with various figures, it is said to remember; when applying itself to the imagination in order to form new figures, it is said to imagine or conceive; and lastly, when it acts on its own, it is said to understand ... According to its different functions, then, the same power is called either pure intellect, or imagination, or memory, or sense perception. But when it forms new ideas in the corporeal imagination [*phantasia*], or concentrates on those already formed, the proper term of it is 'native intellect' [*proprie ingenium*].[68]

In this epistemological scheme, mathematical cognition becomes a straightforward if creative process that can be directed by practical instructions:

Rule Thirteen: If we [are to] perfectly understand a problem, we must abstract it from every superfluous conception, reduce it to its simplest terms and, by means of enumeration, divide it up into the smallest possible parts.

Rule Fourteen: The problem should be re-expressed in terms of the real extension of bodies, and should be pictured in our imagination entirely by means of bare figures. Thus it will be perceived much more distinctly by our intellect.

Rule Fifteen: It is generally helpful if we draw these figures and display them before our external senses. In this way it will be easier for us to keep our mind alert.[69]

Both constitutive elements of cognition are symbolically represented in the imagination: the abstract, indeterminate, general quantities of pure intellection are "re-expressed" there as determinate lines and angels; the fuzzy objects of the senses are represented as distinct figures in discernible motions, ready to be captured mathematically. With both components now conceived as results of complex interrelated processes, Descartes no longer needs to worry about the supposed discrepancy between them.

As Stephen Gaukroger argues, this scheme constitutes "a radical departure from the standard Thomist account, where the role of the imagination . . . is to present sensory information to the . . . intellect. . . . The process Descartes envisages is one where the end point . . . is the imagination rather than the intellect."[70] For medieval mathematicians like Oresme and Witelo, as we saw in chapter 4, the claim that the "mathematical line is to be assumed imaginarily"[71] served to detach mathematics from the objects of the world. It thus allowed "understanding of their ratios"[72] at the accepted price: that this was the only understanding mathematics could aspire to provide. For Descartes the imagination serves to *connect* mathematics with objects to create causal, substantive knowledge—even if it be, as the savants of the Baroque were coming to terms with, mediated knowledge.

It is very telling to note how little Descartes is concerned with the imagination as the source of variety, illusion, and finally delusion; the concept of imagination that troubled Bacon, enchanted Shakespeare, and was chastised by Galileo. Imagination for him is, almost literally, the cognitive faculty in charge of images. Kepler's naturalization of vision made Descartes lose his belief that images "resemble the objects they represent,"[73] but he gained, instead, a confidence in them as the effects of a natural causal process. The image cannot be trusted to tell us what the object it signifies *is*, because of the "difference between the sensation that we have of it, that is, the idea that we form of it in our imagination through the intermediary of our eyes, and what it is in the objects that produces the sensation in us."[74] But exactly be-

cause it relates to the object in a causal, natural way, the very presence of the image in the imagination ensures that such an object *exists*. This line of thought, developing from the early *Regulae* through the *Meteorology* and the *Dioptrics* of his mature years, serves Descartes in the arguments of the *Meditations* that Elisabeth could not quite follow:

> Suppose then that we are dreaming, and that all these particulars ... are not true ... Nonetheless it must surely be admitted that the things seen (*visa*) in sleep are just like painted images (*pictas imagines*), which could not have been formed unless in the likeness of real objects (*ad similitudinem rerum verarum*); and, therefore, that at least those general objects ... are not imaginary things (*res quasdam non imaginarias*), but really existent.... although these general objects, viz. [a body], eyes, a head, hands, and the like, be imaginary, it is still necessary to admit at least that some other objects still more simple and universal than these are real, those from which ... are formed all those images of things (*rerum imagines*), whether true or false, that are found in our thought.[75]

To the degree that we *do* get confused, it is by ill-functioning faculties, as in sleep or madness, or when "our imagination is impaired, as occurs in melancholia, and we judge that its disordered images [*phantasmata*] represent real things."[76] The famous malign demon of the *Meditations* is not a product of the imagination: it is a supposition, a postulate of the intellect.

With all the anxiety it induced, the growing conviction in the mediated nature of all knowledge, and of perceptual knowledge in particular, and in the consequent detachment of the mind from nature had a great liberating effect on Descartes' epistemology. It allowed for the creativity of controlled fantasy, of which he makes exemplary use in introducing his hypotheses for *The World*:[77]

> I want to wrap up part of [this discourse] in the guise of a fable, in the course of which I hope the truth will not fail to manifest itself sufficiently clearly. For a while, then, allow your thought to wander beyond this world to view another, wholly new, world, which I call forth in imaginary spaces before it. The philosophers tell us that these spaces are infinite, and they should be believed, since it is they themselves who invented them.[78]

Space itself, the proper subject matter of geometry, is "invented"; the invention "should be believed" because it is geometrically controlled. These are the reciprocal relations between mathematics and the creative powers of the mind envisioned by Galileo and Kepler: fantasy introduces mathematics with its objects, and it can be a trusted as a legitimate contributor

to knowledge as long as it is kept at bay by mathematics. It therefore needs
to be "confined" to the prime object of Baroque mathematics, discussed in
chapter 4—pure motion:[79]

> Someone else may if he wishes imagine the 'form' of fire, the quality of 'heat',
> and the action of burning to be very different things in wood. For my part, I am
> afraid of going astray if I suppose there to be in the wood anything more than
> what I see must necessarily be there, so I am satisfied to confine myself to con-
> ceiving the motion of its parts.[80]

The fantastic products of the imagination can be as infinitely varied as the
objects in the world, and the mind has no guarantee that the two corre-
spond. Only pure motion, in its complete simplicity, is one and the same for
objects on both sides of the sensory divide, and its mathematical study in
the imagination provides trustworthy knowledge of the world:

> The nature of the motion that I mean to speak of here is so easily known that
> even geometers, who among all men are the most concerned to conceive the
> things they study most distinctly, have judged it simpler and more intelligible
> than the nature of surfaces and lines, as is shown by the fact that they explain
> 'line' as the motion of a point and 'surface' as the motion of a line.[81]

It is in the imagination, this most Baroque of faculties, that Descartes
tries to fit together the competing motivations, ambitions, and criteria of his
knowledge: causal yet mathematical; fantastic yet well-measured; mediated
yet reliable. And so it is, through the imagination, that the philosopher of
nature may venture to decipher God's creation:

> Since everything I propose here can be imagined distinctly, it is certain that
> even if there were nothing of this sort in the old world, God can neverthe-
> less create it in a new one; for it is certain that He can create everything we
> imagine.[82]

## RULE OF REASON

### *The Correspondence Again: Exercising the Mind*

It is in this context and with this in mind that Descartes recommends
mathematics to Princess Elisabeth, as a means to exercise the imagination
and achieve the anxiously sought balance between body and soul, desire
and reason. He sets her to solve an ancient problem: to construct a circle
whose circumference touches the circumferences of three given circles. It is

the famous Apollonius Problem; not a "simple and easy question" at all, but one that nicely exemplifies the advantages of his new algebraic methods.[83] To Descartes' surprise and delight, Elisabeth solved the problem, and in a way different and perhaps preferable to his. He was so impressed that he dedicated his *Principles* to her, using almost verbatim the words he wrote to her personally in commending not only "the outstanding and incomparable sharpness of [her] intelligence" but also on the rarity of the combination of talents she possesses—in both geometry and metaphysics.[84]

The juxtaposition of "reasoning of metaphysics" and "understand[ing] of algebra"[85] makes particular sense at this stage of the correspondence and of Descartes' thought: as we have argued in chapter 4, he has come to view mathematics as a practical means of putting order into varied nature and disturbed mind, as he will reiterate in the preface to the *Principles*, immediately following the excited dedication to Elisabeth:

> [one] must study that logic which teaches how to use one's reason correctly in order to discover the truth of which one is ignorant; and because this depends greatly upon practice, [one] should drill [one]self for a long time by using the rules of logic in relation to simple and easy questions, like those of Mathematics.[86]

Descartes' instructions to Elisabeth are very much in this vain: practical and unpresuming. He writes nothing about rigor, epistemological standards, or metaphysical assumptions, and offers instead down-to-earth directions for efficient problem solving: to work with parallel or perpendicular lines; to limit oneself to similar triangles and to Pythagoras' theorem; and if it is necessary to multiply unknowns for these purposes—so be it.[87] He shows how to solve the problem in principle, and when it becomes "planar or of the second degree," he declares that "it is no longer necessary to go on, for the rest does not serve to cultivate or entertain the mind, but only to exercise one's patience for laborious calculation."[88] After receiving Elisabeth's own solution, from which he is "filled with joy, and . . . taken with a bit of vanity," he adds some more helpful tips, fitting the more advanced mathematical mind that she demonstrated herself to be: "to retain the same letters" and "to make sure that the quantities one denotes by letters have similar relations to each other, as much as is possible." All this allows not just "to arrive at a theorem which can serve as a general rule for solving other [problems]," but also "to render the theorem more elegant and shorter."[89]

These are clearly the brightest moments of the correspondence. Elisabeth

was understandably delighted with the "public testimony . . . of [Descartes']
friendship and . . . approval." She was proud of the "new morality" that he
allegedly constructed "in order to render [her] worthy," and declared:

> I take this morality as the rule of my life, feeling myself to be only at the first
> stage which you approve there, the will to inform my understanding and to fol-
> low the good it knows.[90]

This was a moment of contentment. Descartes seemed to rise up to his des-
ignation as "doctor of the soul" and his "new method"[91] for knowing ap-
peared to provide Elisabeth with her desperately sought relief from "annoy-
ance and boredom"[92] and a useful, practical understanding of her mind in
its relation to her body. But the contentment was short-lived. In the spring
of 1645, after a lull in their communication, Descartes heard that the prin-
cess' physical and mental health was deteriorating again. The mathematical
exercises, successful as the princess was, proved to be very transient as
"remedies," and Descartes turns to discharge his "Hippocratic oath" in a
much more traditional way—by recommending Stoic resignation.

Descartes does not shy away from considering very directly the bodily
symptoms the princess is suffering from (about which he was informed only
indirectly, through their common friend Pollot): "low grade fever, accompa-
nied by dry cough." He also does not shy away from a diagnosis:

> The most common cause of low-grade fever is sadness, and the stubbornness of
> fortune in persecuting your house continually gives you matters for annoyance
> which are so public and so terrible that it is necessary neither to conjecture
> very much nor to be particularly experienced in social matters to judge that the
> principal cause of your indisposition consists in these.[93]

Descartes' diagnosis remains loyal to the tight relations between body and
soul that he was arguing for through the correspondence with Elisabeth,
but his medical advice strays. Rather than the "union" he was presenting
to her, he is now advocating a clear hierarchy: in order "to recover from it
all," the princess should employ "the force of [her] virtue" to make her "soul
content despite the disfavor of fortune."[94]

This is a clear about-face from the novel and bold "trialism" of the early
letters. The remedy that Descartes is suggesting now demands not only a
clear separation, but a strong detachment between body and soul:

> The difference between the greatest souls and the base and vulgar souls consists
> principally in that the vulgar souls give themselves over to their passions and
> are happy or sad only according to whether those things that happen to them

are agreeable or unpleasant; whereas [the great souls] have reason so strong and so powerful that, even though they do have passions, and often even more strong and violent . . . their reason nevertheless remains mistress.[95]

Virtue is reason's power to exert control over the bodily passions. In this return to the traditional relations between mind and body, the imagination retains something of its exciting new role as a mediator. Great souls "esteem this life so little with respect to eternity that they give events no more esteem than we do event in comedies." Detaching themselves from their bodily surrounding, virtuous souls survey life as if on stage, so that "even afflictions" may "serve them and contribute to the perfect felicity which they can enjoy already in this life":

> Just as those sad and lamentable stories which we see represented on a stage often entertain us as much as the happy ones, even though they bring tears to our eyes, in this way the greatest souls of which I speak draw a satisfaction in themselves from all the things that happen to them, even the most annoying and insupportable.[96]

The imagination, the realm of controlled fantasy, turns out to be as essential to morals as it was to mathematical reasoning. But some of the bold enthusiasm of Descartes' early letters has been lost: in this newly found stoicism, the mediating role of the imagination is no longer to connect mind and body but to detach them, creating "a stage," on which Elisabeth's reason can calmly observe that "which is right under her," and assess those goods she possesses "which can never be taken away from her . . . and see all the reasons she has to be content with them."[97]

### Neo-Stoicism: Lipsius

Descartes underscores that it is Stoicism that provides the inspiration and terminology for this phase of the discussion by choosing to continue "with considerations . . . of Seneca's *De vita beata*."[98] Given the intellectual aboutface it required, this was not an unproblematic choice, and Elisabeth was harsh in her criticism of Seneca's ideas and his relevance, as we will discuss later. But it was not a surprising choice either. Facing the same "tempest of ciuill warres"[99] and religious strife that caused Elisabeth's pain, scholars in the Netherlands were considering the resignation advocated by ancient Stoicism as an attractive practical and intellectual option for almost a century. According to young Justus Lipsius (1547–1606), he was introduced to this option by his senior friend Langius (Charles de Langhe, or Lang), when seeking

refuge in Langius' house outside Liège on his way to Vienna, around 1572. Over a decade later Lipsius described this meeting in his *De constantia*, one of the best-sellers of the period, published in forty-four Latin editions and fifteen French translations, and further translated with great success into almost all European languages; all in all over eighty editions were published between the end of the sixteenth century and the eighteenth century.[100]

Lipsius was taking his trip in particularly bad times, especially for scholars. The religious tensions in the Netherlands erupted in 1565 in an iconoclastic fervor, as bands of Calvinists assaulted decorated churches, chapels, and cathedrals in all the major cities of the country.[101] These riots were countered by strict measures of the Hapsburg Spanish king, who sent over the duke of Alba to crush the rebellious population. The duke reestablished the Inquisition, and under the brutal control of "the Council of Troubles" attempted to suppress the dissenting religious sects. The result was a long and bloody civil war that lasted well into the seventeenth century.

Langius, the wise conversant of *De constantia*, was a real person. He served as a canon of the cathedral at Liège, and was twenty-five years older than Lipsius. He studied in Leuven and led a calm life devoted to religion, scholarship, and horticulture—conscious of but unaffected by the surrounding turmoil, much like the life Descartes attempted to fashion for himself in Egmond and was now suggesting to Elisabeth. In their long discussion, Lipsius writes, Langius taught him the merit of constancy and urged him not to flee his homeland and not to seek consolation and refuge in the external world but solely within the realm of his own reason. Endurance, not flight, is the need of the moment and the principle that should guide one's whole life; *constancia, patientia, firmitas* would protect one against the ills of the external world.

The extended and nuanced conversations described in *De constantia*, however, could not have taken place in reality. Lipsius, threatened by the Inquisition and the Council of Troubles, fled Louvain to the imperial court in Vienna to try to make his way in the humanist circle of Maximilian II, and had no time for lengthy sojourns with scholarly friends. Nor did he stay long in Vienna. Shortly after arrival he applied for a position at the Lutheran University of Jena, where he publicly accepted the new confession. Only a couple of years later he tried to return to Catholic Louvain, but was prevented by recent political and military upheavals. In 1578 Don Juan of Austria won the battle in Gembloux; Lipsius escaped to Antwerp barely in time as the soldiers sacked his deserted house. Fortunately, Martin Del Rio, his Jesuit friend and a confidante of the Spanish prince, was able to res-

cue his books and manuscripts. In 1579 he was offered a chair at the newly founded Calvinist university of Leiden, and it was there, in 1584, that he published *De Constantia*, describing his fictional encounter and conversation with Langius.

Composing a work of fiction, Lipsius clarifies that his primary concern is not whether one should flee troubles. Like Elisabeth's, the main challenge he faces is how he, as a scholar and a moral person, can preserve constancy and integrity in the face of a chaotic and corrupt political world.[102] Lipsius discerned that the light irony available to Erasmus and Thomas More, or the critical cynicism of Machiavelli earlier in the sixteenth century, were no longer viable attitudes. One could be ironic or cynical towards a war declared for the greater glory of a prince, but not so when the pretense of war is securing the presence of Divine Word in this world. A new mode of operation was needed for the scholar in this new political world, where strict and violent religious convictions overcame logical subtlety and rhetorical eloquence. Even in relation to the ancient sources this new world required a change: the concise, terse, and almost military style of Tacitus and Seneca became preferable over the flowery style of Cicero.[103] Like Elisabeth, Lipsius is torn between his knowledge and his belief, between his morality and his loyalties, and the treatise is an attempt to mold for himself, as a scholar, a new persona to withstand the tensions; a firm, patient, and constant persona, able to keep its composure while serving the king and the state even in their most atrocious acts. After all, he convinces himself, this political organization with all its vices is a necessary evil—the only vouchsafe of stability.[104]

The treatise begins as the young Lipsius, desolated by "the troubles of the Low-countries" and especially by the "insolencie of the gouernours and soldiers" and the atrocities that engulfed his homeland and his fellow countrymen, arrives at Langius' house seeking counsel. Standing on the porch, they discuss the young friend's questions of moral philosophy in an attempt to decide the right course of life suitable to him. "How should I not bee touched and tormented with the calamities of my countrey for my countreymens sake, who are tossed in this sea of aduersities, and doe perish by sundry misfortunes?" Lipsius desperately asks his friend; "who is of so hard and flinty a heart that he can anie longer endure these euils?" The distress, he tells Langius, drove him to take the road to the imperial court in Vienna, seeking peace of mind there. Langius replies to these complaints with a discussion of the virtue of constancy as the essential human aptitude to face the chaotic world and its incomprehensible disasters: "Our mindes must be

so confirmed and conformed, that we may bee at rest in troubles, and haue peace euen in the midst of warre."[105]

Langius' arguments then veer into the combination of epistemology and moral philosophy that made Neo-Stoicism such a relevant option for Descartes and Elisabeth sixty years later: it is futile to wander the world seeking refuge from strife, he claims. Lipsius' emotions and distress are due to his unclear mind ruled by mere opinions that are the result of human passions and affections and not of true reason:

> For these mystes and cloudes that thus compasse thee, doe proceede from the smoake of OPINIONS. Wherefore, I say with *Diogenes*, Thou hast more neede of reason, .... That bright beame of reason (I meane) which may illuminate the obscuritie of thy braine, ... wee, who being sicke in our mindes doe without any fruite, wander from one countrey to another ... Otherwise it is of olde festered affections, which holde their seat, yea & scepter in the castle of the mind.[106]

Running away and changing sceneries is of no avail, because the bitterness and fears are the result of a sick mind that will continue to haunt one's soul, leaving it restless and oppressed. Langius anticipates Lipsius' retort: "Doth not the sight of faire fields, riuers and mountains put a man out of his paines?" and answers:

> It maybe they withdraw vs from them, but yet for a very short time, and so to no good end. Euen as a picture be it neuer so exquisite, delighteth the eyes a little while: So all this varietie of persons and places pleaseth vs with the noueltie. What doth it boot (*iuuat*) me to beholde the Sunne for a season,[107] and immediatlie to bee shut vp in a close prison? So it commeth to passé that these externall pleasures do beguile the mind, & vnder pretence of helping, doe greatly hurt vs ... For thou shalt still finde an enemie about thee, yea euen in that closet of thine ... Thou cariest warre with thee.[108]

The remedies offered by calmed senses are transitory; the only real cure is virtue, guided by reason:

> Vertue keepeth the meane, not suffering any excesse or defect in her actions, because it weigheth all things in the balance of Reason ... Right Reason to be, *A true sense and iudgement of thinges humane and diuine.*[109]

The body and the soul, reason and the senses, are in "communion and societie," but this interdependence is detrimental to the soul, which has to free itself from "opinion" to preserve its "dignity":

> The bodie be sencelesse and immooueable of it selfe, yet it taketh life and motion from the soule: And on the other side, it representeth to the soule the

shapes and formes of thinges thorough the windowes of the senses. Thus there
groweth a communion and societie betwixt the soule and the bodie, but a so-
cietie ... not good for the soule. For she is therby by litle and little depriued
of her dignity, addicted and coupled vnto the senses, and of this impure com-
mixtion OPINION is ingendred in vs, *Which is nought els but a vaine image and
shadow of reason*: whose seat is the Sences.[110]

Thus, to regain its dignity and achieve the desired tranquility, the soul has
to renounce its dependence on the body, reject the senses and their *"vaine
image and shadow,"* and find knowledge within itself: "If we beare an ear-
nest desire to haue a good mind, we must cast downe euen by the founda-
tion this castle of opinions."[111] Subduing the castle of opinion enables the
true sage to withstand all worldly afflictions and preserve his fortitude and
integrity: "Let showers, thunders, lighteninges, and tempestes fall round
about thee, thou shalt crie boldlie with a loude voyce *I lie at rest amid the
waues.*" Self-reliant and "constant," the soul of the sage can "passe thorough
the confused tumultes of this world, and not be infected with any brynish
saltnes of this Sea of sorrowes." "I must touch the sore with my hande,"
Langius says to Lipsius, "the causes of your sorrowe [are] *thinges as are not
in vs, but about vs: And which properlie doe not helpe nor hurte the inner man,
that is, the minde.*"[112]

If one can easily see how these ideas could charm Elisabeth and Des-
cartes, the further development of Langius' argument is much more prob-
lematic. In its intentional oblivion to the external "causes of ... sorrowe,"
the soul has to harden itself also to the sight of human misery such as sigh-
ing, sobbing, and weeping.[113] It is, again, a matter of knowledge: under-
standing the nature of historical events as the result of divine providence.
"Publike euilles are imposed vppon vs by God ... they be necessarie and by
destinie";[114] they seem to be with no end or purpose, but in truth they are—
they cannot but be—ruled by divine order:

For you knowe well that there is an eternall Spirite, whome wee call GOD,
which ruleth, guideth and gouerneth the rolling Spheares of heauen, the mani-
folde courses of the Stars and Planets, the successiu alterations of the Elements,
finally, al things whatsoeuer in heauen and earth. Thinkest thou that CHANCE
or FORTUNE beareth any sway in this excellent frame of the world?[115]

Whatever inspiration Descartes found in Neo-Stoicism, it could not have
been in what Langius has to offer next. The moral-epistemological consider-
ations that Lipsius lets him develop now become completely foreign to the
motivations and hopes of the New Science. It is still knowledge, and *"A true
sense and iudgement of thinges humane and diuine"* that Langius is seeking

as a guide for sagely life, but he does not expect this search for *"thinges . . . diuine"* to be conducted through, or lead to, the investigation of this world. The laws that govern nature are beyond the ken of human ability, not because the reasons behind them are divine, but because the world is a place of constant change and shifting images. Even the heavens are not stable; they elude human efforts to know their motions and shape:

> And howsoeuer the wit of man cloaketh and excuseth these matters, yet there haue happened and daily do in that celestiall bodie such things as confound both the rules and wittes of the Mathematicians . . . But beholde our Astrologers were fore troubled of late with strange (*noui*) motions, and new stares. This very yeare there arose a star whose encreasing and decreasing was plainly marked, and we saw (a matter hardly to be credited—*difficulter creditum*) euen in the heauen itself, a thing to haue beginning and end againe.[116]

Lipsius knows the science he is alluding to: he correctly refers in the margins to *"Anno Dom.* 1572," the date of Tycho's discovery of the new stars, and adds a well-informed and pointed remark: *"all the best Mathematicians agreed that it vvas aboue the elementarie regions."* But instead of admiration for the capacities of the new astronomy, the discovery fills him with skepticism and disdain to all human aspiration to forge knowledge out of "OPINION." Destiny and providence rule the world but their reasons and laws are not available to human knowledge. "Euen so I thinke of destiny, which must be looked vnto; not into: and be credited, not perfectly known." And Langius concludes by admonishing young Lipsius: "What appertaineth it vnto thee to enquire curiouslie of the libertie or thraldome (*servitute*) of our will?"[117]

Disappointing for the savant, this skepticism still had something to offer to the scholarly courtier, because it does not lead Langius to resignation from the world of action. On the contrary, he is resolute to translate constancy and detachment into an active involvement in worldly affairs. Young Lipsius admits his confusion:

> one tempestuous waue of a troubled imagination that tosseth me . . . if all publike euils come by Destenie, which cannot be constrayned nor controlled, why then shall wee take anie care at all for our countrrie? . . . Why doo wee not . . . sit still our selues with our handes in our bossomes?[118]

But Langius will have none of this. Such an attitude will bring "desolation by humaine meanes," he warns, and instructs: "Yeeld to God, and giue place to the time."[119]

## The Sage and His Garden

How can one maintain these tensions between resignation and activity, skepticism and *"true sense and iudgement of things?"* Langius' answer is a traditional Renaissance trope—he invites Lipsius to calm his troubled soul in the garden: "the way is not farre, you shall exercise your bodie, and see the towne; Finallie, the aire is there pleasant and fresh."[120]

The garden was the humanist's favorite place of knowledge. Replacing the scholastic scriptorium, with its arid contemplation of essences and substantial forms, it offered a site *within* the real world, where the particulars of nature could be attentively studied, with proper detachment from daily tedium but without compromising the commitment to *vita activa*—the commitment Langius strives to maintain. Other humanists pressed this trope further; Conrad Celtis retorted to an imagined scholastic opponent that even divine inspiration is better sought *outside*, in His temple of nature:

> You wonder why I greedily seek bright fields and the hot sun? Here the great image of omnipotent Jove comes to meet me, and the highest temples of god. The woods please the muses, while the city is hostile to poets and full of the unhealthy crowd.[121]

The garden offered more than relaxing and inspiring environment. It presented a "most beautiful, varied, and rare botanical species, punctiliously listed," as Francesco Colonna had it in his fantastic allegory *Hypnerotomachia Poliphilii*;[122] a variety of forms and colors, as enlightening and informative as it was splendid. The garden's mixture of art and nature was as philosophically loaded as it was aesthetically spectacular; Renaissance fascination with gardens gave rise to technical virtuosity side by side with poetic celebration and to careful natural history alongside aesthetic extravagance.[123]

The garden encouraged the study of particulars in all their magnificent variety. Rabelais has Gargantua advise his son Pantagruel to devote himself to the study of the natural world and its entire variety, and Erasmus commended the study of natural particulars as a conduit to a more comprehensive contemplation of the Creator.[124] Sensual pleasure and intellectual delight expanded spiritual wisdom. Beyond the general religiosity of "bright fields and the hot sun," the garden's amalgam of nature and artifice provided tropes by which to contemplate the divine that were crucial for humanist students of nature like Conrad Gessner:

Let him be a student and admirer of nature, so that from the contemplation and admiration of so many works of the Great Artificer . . . a pleasure of the mind is conjoined with the harmonious pleasure of all the senses. Then, I ask you, what delight will you find in the bounds of nature that could be more honest, greater, and more perfect in every respect?[125]

*Variety* was the foundation of the epistemological and devotional powers of the garden, and variety provided its medicinal benefits. When Ficino recommends the garden as a cure for a sorrowful heart, melancholy, and black bile, he advocates "frequent viewing of shining water and of green or red color, the haunting of gardens and groves and pleasant walks along rivers and through lovely meadows . . . but above all, of variety."[126] And it seems, at first, that Lipsius lets Langius direct him through his garden with similar curiosity for variety and sensual pleasure leading the way: "In the very entrance as I cast my eyes about with a wandering curiositie, wondering with myself at the elegancie and beautie of the place." Lipsius is moved to poetic hyperbole and exclaims that, in comparison, other famous gardens are "no better than pictures of flies (*imagines muscarum*)," and continues that when "I . . . applied some of the flowers to my nose and eyes . . . This delight so tickleth and feedeth both my sences at once."[127] The epistemological function of sensual delight—driving Man to seek empirical knowledge—goes back to Aristotle, but Lipsius envelops this idea in his stoic version of Christianity:

> As it is not possible for any man to contemplate heauen and those immortal spirits there, without feare & reuerence: so can we not behold the earth & her sacred treasures, nor the excellent beautie of this inferior world, without an inward tickling and delight of the sense. Aske thy mind and vnderstanding, it wil confesse it self to be led, yea & fed with this aspect and sight.[128]

This is a strong empiricist plea, but it is a very different empiricism from the one argued for a generation later. Hinged on sensual pleasure, Lipsius' epistemology (itself only tentative, awaiting Langius' gentle condemnation, as we shall see below) creates a strict distinction between immediate, earthly experience and the remote observation of the heavens: exactly the distinction that Kepler and Galileo would militate against in the name of their instruments and astronomical observations. The garden is not a place for excited innovation; rather, the knowledge gained from marvel at its variety and "multitude" leads the "mind and vnderstanding" to peaceful "cogitation":

> Pause I pray thee a litle while and behold the multitude of flowers with their daylie increasings, one in the stalke, one in the bud, another in the blossome.

Marke how one fadeth suddenly, and another springeth. Finallie, obserue in one kind of flower the beautie, the forme, the shape or fashion either agreeing or disagreeing among themselues a thousand wayes. What minde is so sterne that amid all these will not bend it selfe with some mild cogitation, and be mollified thereby?[129]

Still, sensual delight is fundamental to the acquisition of knowledge from a "thousand ways" of "the beautie, the forme, the shape or fashion" of nature, and Lipsius stresses that with a reference to the goddess of love and beauty: "O the true fountaine of ioy and sweete delight! O the seate of *Venus* and the Graces."[130] It is again a commonplace that he is using: "[Venus] through her pleasure lures to external things, while [Saturn] through his, recalls us to the internal" was Ficino's version of the same traditional trope.[131] But here Lipsius' attitude takes a turn. Even though, wandering through the garden, his "minde being beguiled with a kind of wandering retchlesnes, [he] may cast off the remembrance of all cares and troubles,"[132] the moral-epistemological challenges that the garden presents cast it also as a locus of anxiety, and its lively variety becomes a source of melancholic dread of vanity.[133] Langius, who has led Lipsius to and through the garden, suddenly becomes weary of his young friend's enthusiasm: "I see you loue this flourishing purple Nymph," he says paternally, "but I feare mee you doate vpon her."[134] Lipsius has missed the point, he explains:

You commend gardens, but so as you seeme only to admire vain and outward things therin, neglecting the true & lawful delights therof. You poare only vpon collours, and borders, and are greedy of strange Flowers brought from all partes of the world. And to what end is all this? Except it be that I might account thee one of that sect which is risen vp in our dayes, of curious & idle persons, who haue made a thing that was in it self good and without al offence, to be the instrument of two foule vices, *Vanity* and *Slouthfulnes.*[135]

"Doting" over every detail is idle curiosity. "True gardens . . . were ordained for modest recreation, not for vanitie: for solace, not for slouth," and the vain admiration of "outward things" leads instead to "heauier heart" and "merrie madnesse."[136]

The Neo-Stoicism of *De Constantia* is not, therefore, a commendation of the new modes of knowledge, with their stress on the senses, the empirical engagement, the spectacular instrument, the particular, and the new. Quite the opposite: Lipsius (the real one, represented by the character of wise Langius), aware of this intellectual option, considers and rejects it on moral grounds:

I will esteeme al things according to their worth, and setting aside the intice-
ment of rarenes and noueltie, I knowe they are but hearbes or flowers; that is,
things fading and of smal continuance.[137]

It is enough to know about the plants in the garden that they are "hearbes
or flowers." These "outward things" do not merit closer attention—the em-
pirical attention of the new savant—they are "things fading and of smal con-
tinuance," and concentrating on them leads the mind away from its pursuit
of "true & lawful delights."

This is not mere conservatism, a vote for the "the wise men of olde time"
against the "moderns." Langius expresses great admiration for "the studious
and learned wits of our age":

They delight in gardens; and in them (for the most part) are compiled those
diuine writings of theirs which we woonder at, and which no posteritie or con-
tinuance of time shall be able to abolish. So many sharp and subtil disputations
of naturall philosophy, proceed from those greene bowers.

But those great achievements are the outcome of contemplation, not of ac-
tive empirical inquiry, and the "fruitfull ouerflowings" of the garden should
not provide a display of "external things" to study through the senses, but
"a wholsome withdrawing place from the cares and troubles of this world";
a safe and relaxing haven, for the mind to turn inward:

out of the walkes and pleasant allies of gardens, spring those sweet abounding
riuers which with their fruitfull ouerflowings haue watered the whole world.
For why? the mind lifteth vp and advanceth it self more to these high cogita-
tions, when it is at libertie to beholde his owne home, heauen.[138]

### Other Gardens: Clusius and de Gheyn

"I doe not contemne the beautie and elegancie of them," says Langius about
gardens whose contents come from "*Thracia, Greece,* and *India,*" and proceeds
to expose the rival Lipsius has in mind: "But I dissent from the opinion of
these great Garden-masters, in that I get them without much trauell, keepe
them without care, and lose them without grief."[139] The "Garden-master"
alluded to is Carolus Clusius (the Latinized name of Charles de l'Escluse,
1526-1609), the great botanist, Lipsius' colleague at the University of Leiden.

Clusius did engage in "much trauell" and in the "hunt after strange
hearbs & flowers," as attested by the titles of his books—*Rariorum plan-
tarum historia* and *Exoticorum libri decem*; and the knowledge he boasted

in them was exactly the type Lipsius denigrated: meticulous differentiation between as many kinds of a single plant as possible. By 1583 he had identified four kinds of mountain garlic, "most of which ... [had] not yet been observed," and in the funeral oration that Edward Vorst composed in his honor he was commended for "direct acquaintance with the particulars of regions, peoples, topography, and local languages."[140] The frontispiece of Clusius' opus magnum, the *Rariorum plantarum historia* of 1601 (fig. 7.1), reflects pride and confidence in his project: the title, with its dedication to the brother emperors Maximilian and Rudolph, is flanked by Adam, who "gave names to all the animals"; Solomon, the wisest amongst men; and the two ancient naturalists, Theophrastus and Dioscorides (in Renaissance garb). Tulips and other rare flowers adorn the spaces between them, and the name of the Jewish God, in Hebrew, graces them all from above—the only clear Neo-Platonist reference of the drawing. The motto is brusque and uncompromising: *"Virtute et genio"* (with virtue and skill). With his painstaking empiricism, his firm rejection of dogmatism, and his celebration of the variety of Nature and Her infinite capacity to generate novelties, Clusius epitomized the Hippocratic creed that the newly established University of Leiden—and its faculty of medicine in particular—had chosen to adopt.[141]

It was a political and religious creed as well as epistemological. The university was established after Leiden, which supported William of Orange against the Hapsburgs, had withstood the traumatic sieges laid by Hapsburgs' troops first at the end of 1573 and then from April to October 1574. The university was both a reward to the citizens of Leiden for their endurance and loyalty and a political maneuver by William to strengthen his hand in the Breda peace negotiations, and as such was at the heart of a religious debate from its inception.[142] The radical Calvinists aspired to shape the curriculum so the university could serve for the religious instruction of future clergy; the university curators (appointed for life by the States of Holland and Zeeland), and the Leiden burgomasters were struggling to protect its religious tolerance and aspired for a wider academic appeal and recognition. The recruitment of famous scholars (such as Lipsius) and the establishment of an innovative faculty of medicine were part of this struggle, as well as the Hippocratic principles by which it was framed, with a strong stress on keen observation, accurate descriptions, and practical facility. The future physicians were expected to be engaged in "examining, dissecting, dissolving and transmuting the bodies of animals, vegetables, and minerals,"[143] assisted by two ambitious new facilities: the anatomy theater and the botanical garden.

Lipsius' tranquil garden, as metaphor and reality, was thus a position

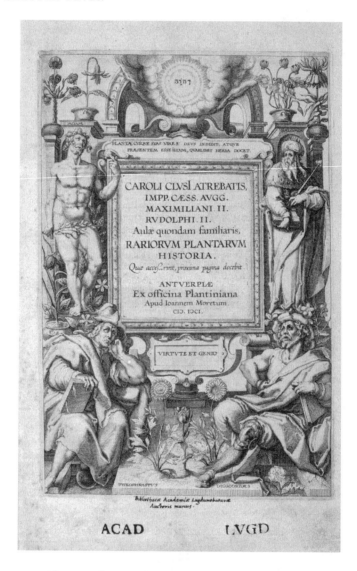

FIGURE 7.1 Title page of Clusius' *Rariorum Plantarum Historia* (1601). Reproduced with permission of Leiden University Library, 661 A 3.

defended in a highly contested moral, political, and epistemological field, especially as he, an avid gardener himself, was involved with the faculty's endeavors from their early stages.[144] Clusius, with his clear interests in turning the garden into a locus of intensive observational activity, was not an intellectual ally.

Clusius was already at the height of his fame in 1573, when he arrived in Vienna to become Maximilian II's herbalist and plant collector. He held this capacity for the next fifteen years, becoming a major node in a network of astronomers, alchemists, and humanist scholars in and around the Hapsburg court.[145] In this mannerist context, resembling the one in which Kepler dwelt in Prague a quarter century later, Clusius enthusiastically pursued exotica and curiosities as the pinnacle of an active exploration of nature. Finally moving to Leiden in 1594, Clusius was exempt from teaching and was too old to actively tend the botanical gardens. He dedicated his time to collecting reports of travelers from around the globe (e.g. Thomas Harriot's accounts of his travels to Virginia) and translating many of them into Latin; to acclimatizing exotic plants for European gardens; and to introducing new species of flowers and plants.

Clusius did not do much to assuage Lipsius' anxieties of "the inticement of rarenes and noueltie." In fact, the product of his Leiden collaboration with the painter Jacob (Jacques) de Gheyn II[146]—a series of meticulous and precise pictorial depictions of flowers in watercolors—could have served the wizened Langius as excellent evidence that his worries were justified; that such fussy attention to detail was vain and self-indulgent, bound to lead to "heauier heart" and melancholy. The playful array of the *Insects and Flowers*, with its whimsical composition, guided by considerations of colors and shapes rather than substance, full of allusions to sexuality and femininity, to metamorphosis and immortality, suggest that Lipsius' distrust had good reasons. De Gheyn's *Study of Hermit Crab* (fig. 7.2) demonstrates that the nexus of themes was no accident; that fantasy and detailed observation of *naturalia* were indeed closely intertwined in De Gheyn's own mind. The crab is meticulously depicted, every detail portrayed faithfully and realistically, but in clear allusion to the crab's role as a symbol of witchcraft waywardness, de Gheyn surrounds it with fantastical figures of the netherworld.[147]

This reference to witchcraft was not only a mischievous extravagance in a private drawing: in his engraved portrait of Clusius (fig. 7.3), probably prepared for inclusion in gift copies of the *Rariorum plantarum historia*, de Gheyn makes the close relations between observation and fantasy an explicit theme. Under the oval frame with the portrait of the elderly Clusius are a variety of exotic seeds and pods such as peanuts and pine cones, as well as corals. These *naturalia* were the pride of Clusius' Leiden *Wunderkammer* and, like the flowers of the official frontispiece, represented a lifetime of avid collection of curiosities and natural wonders. Yet the emblems flanking the old botanist put his life project and its achievements in curious light: two winged Naiads, rising from intertwined cornucopias; "on their heads

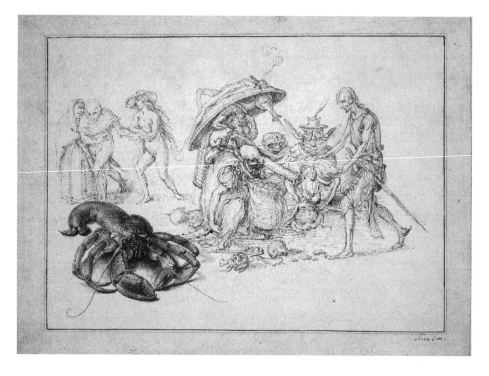

FIGURE 7.2 Jacques de Gheyn II, *Study of Hermit Crab and Witchcraft*. Städel Museum, Frankfurt am Main (1602–3).

is a crown of piled up sea urchins (echinoderms), topped by a vase with tulips (a flower Clusius was one of its chief promoters in the Netherlands) and Turk's cap lilies and fritillaries."[148] There is an obvious correspondence between these two nymphs, their expression luring and mocking, and Langius' reprimand of Lipsius for doting over the "flourishing purple Nymph." The carefully maintained "constancie" of mind, this semi-private version of the *Historia*'s frontispiece clearly declares, could not be served by the adoration of the beauty of botanical plethora in all its particulars, which so easily metamorphose into inveigling mythological creature. The attached motto amplifies the mystery: it reverses the meaning of the original *Virtute et genio* motto: *"Virtute et genio non nitimur: at mage* CHRISTO *Qui nobis istaec donat, et Ingenium"* (We do not rely on Virtue and Talent, but rather on the Christ who gives us these as well as Intelligence).

What is being mocked? Did Clusius instruct de Gheyn to produce a satirical quip at the Neo-Stoicism of his colleagues for the consumption of his

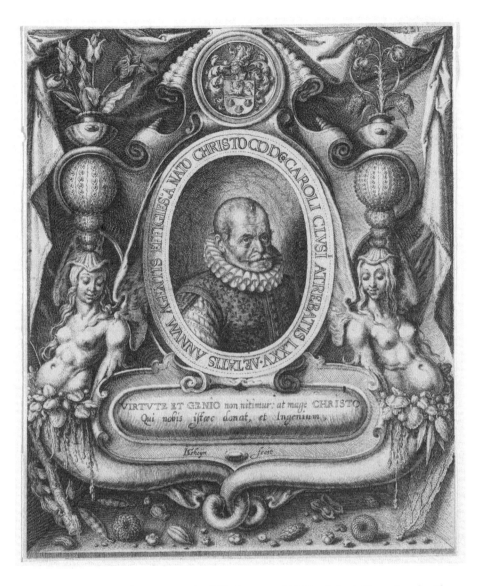

FIGURE 7.3 De Gheyn's *Portrait of Clusius as an Old Man* (1600). Reproduced with permission of Leiden University Library, Leiden University Library, BN 331.

closest friends and allies? Or was he, at his advancing age, coming around to look at his life work the same way that old Langius treats young Lipsius' enthusiasm? The portrait itself seems to suggest that much: it depicts Clusius as a tormented and weary seventy-five-year-old, apparently reviewing his achievements with little approval. But, again, perhaps it is an ironic gesture.

Whatever was Clusius' genuine view of himself, de Gheyn's 1603 *Vanitas* (fig. 7.4) demonstrates that he, the painter, was fully conversant in the visual language with which the *"Vanity* and *Slouthfulnes"* of detailed empiricism was denounced. The composition of the *Vanitas* is similar to both frontispieces, but the place of Adam and Solomon gracing the original *Historia* is taken here by Heraclitus and Democritus: one weeping at human folly; the other laughing. The motto, inscribed in the capstone of the arch, reads *"Humana Vana"*: human emptiness. The presiding skull is the common emblem of human transience, and the two coins at the bottom left and right stress that even mighty kings are not exempt: they show the obverse and reverse sides of a Spanish coin, minted to commemorate the Hapsburg Emperor Charles V and his mother, Joanna of Aragon and Castile (Queen Joanna the Mad). Above the skull a concave spherical mirror reflects vague images, emphasizing that human experience of the world, and especially visual experience, is nothing but phantasms and vain imaginations.[149] On the two sides of the skull appear two objects that usually symbolize ephemeral existence—vapors rising from a small phial and a flower in a vase. The flower, however, is not any old plant: it is a tulip; the flower emphatically associated with Clusius, who was instrumental in introducing it to the Netherlands, setting in motion the famous cultural and economic trend culminating in the famous "tulip mania" of 1637.[150] The tulip in the *Vanitas* is thus not only a symbol of frailty and insignificance, but of the human search for knowledge of "hearbes or flowers; that is, things fading and of smal continuance," the knowledge de Gheyn collaborated with Clusius to produce, a knowledge of empty aspirations, constrained to shifting appearances and momentary images.

## PASSIONS

### *The Passion of the Sage*

What were the real positions of these late Renaissance humanists? Did de Gheyn's anxiety about the melancholy and madness symbolized by Queen Joanna override his sensual joy of the copious colors and shapes of the world

FIGURE 7.4 De Gheyn's *Vanitas* (1603). Image copyright © The Metropolitan Museum of Art/Art Resource, NY.

of insects and flowers? Was Lipsius using his own name to present a real en-
thusiasm for empirical knowledge of the material world, or was his real atti-
tude the exasperation of its inanity that he puts into Langius' mouth? Was
Clusius confident of his *Virtus et genius* and convinced of the epistemic im-
port of *planta rara*, or was he indeed putting his trust in *Christus* to provide
knowledge and wisdom?

Intriguing as they may sound, these are moot questions. Any and all of
the men could have held one position at one time of their life and the other
at another time, or changed their views with intellectual or emotional mood,
or even as required within a particular debate or in a given political con-
text.[151] What is crucial is that all of them recognized that the positions are
incompatible. The alert resignation of Langius is a denouncement of Lipsius'
empiricist enthusiasm; the folly of naiads subverts the confidence of Adam
and Solomon; the attention to visual details lamented by de Gheyn's skull as
vanity is the same one producing the marvelous locusts, orchids, and dragon-
flies; Clusius' long motto strictly contradicts his short one. One has to choose
between the vigorous inquisitiveness of the savant and the tranquil wisdom
of the scholar; Neo-Stoicism was not a viable moral option to complement
the New Science—it was a competing, alternative intellectual program.

Descartes should have been aware that for anyone dedicated to the New
Science, the Neo-Stoic stroll through the garden leads to a dead end. He had
taken this route just a few years earlier, in his *La Recherche de la Vérité par la
Lumière Naturelle*,[152] which he indeed left unfinished. The treatise is an at-
tempt at the very same direction he would follow in the correspondence: to
install his own terminology and intellectual motivations into Neo-Stoic con-
ventions, thereby producing a balance between "book-learning" and "per-
forming good actions." Descartes' protagonist Eudoxus, for example, is a
version of the disengaged sage, whose "garden"—his realm of physical and
moral comfort—sets the bounds of his intellectual curiosity. "I assure you
that I no longer feel any passion to learn anything at all," he tells the "two
friends" who visit him "in his country home";

> I am as happy with what little knowledge I have . . . And my mind, having at
> its disposal all the truths it comes across, does not dream there are others to
> discover. Instead it enjoys the same tranquillity as would a king if his country
> were so isolated . . . that he imagined there was nothing beyond his frontiers
> but infertile deserts and uninhabitable mountains.[153]

Unlike Lipsius' hero Langius, however, Eudoxus is "a man of moderate in-
tellect, but possessing," instead, the intellectual makeup hailed by the new
epistemological rhetoric: "a judgment which is not corrupted by any false

beliefs and reason which retains all the purity of its nature." The ideas are presented in a Lipsius-like dialogue, but the Stoic moral instruction is replaced with an open "conversation in which several friends, frankly and without ceremony, disclose the best of the thoughts to each other." As it was in *De constantia*, the ethical discussion quickly and naturally turns into an epistemological one, since the moral challenge lies in *knowing* the actions that "reason would have to teach," and everyone "came into the world in ignorance."[154]

Within these craftily modified Neo-Stoic conventions Descartes attempts to develop an ethical doctrine to fit the new savant. He lets Eudoxus lead his friends—"Polyander [who] has never studied at all [and] Epistemon [who] has a detailed knowledge of everything that can be learned in the schools"— through the paradoxical maneuver of positing the most radical doubt to achieve certainty. This "method . . . which casts doubt on everything"[155] was made famous in the *Meditations*,[156] where it led to comfortable epistemological security in "my senses, my memory, and my understanding."[157] The *Recherche*, however, is more ambitious: Eudoxus promises his friends that this "method which enables someone of average intelligence to discover for himself everything that the most subtle minds can devise" would also solve their moral dilemmas:

> Having thus prepared our understanding to make perfect judgments about the truth, we must also learn to control our will by distinguishing good things from bad and observing true difference between virtues and vices.[158]

On this promise he cannot make good.

Descartes reveals what he perceived as the promise of this combination of the Neo-Stoic ethics and New Science "methodology" by letting Eudoxus guide Polyander, his open-minded ignoramus, until Polyander comes to recognize the "first principle" of morality and truth: understanding oneself as a "thinking thing."[159] But much more has to be said for this marvelous insight to serve as a true moral guide, a positive instruction for "distinguishing good things from bad." Descartes learns this lesson in a difficult way: "so many things are contained in the idea of a thinking thing," Polyander exclaims, as he prepares to elaborate: "By a 'thinking thing' I mean . . ." he begins, and the treatise comes to an abrupt end.[160]

## Essential Passions

Still, it is not difficult to understand the hold that Neo-Stoicism kept on Descartes even with this failure. The attraction was emotional, more than intel-

lectual, as the sensitive Elisabeth recognized. "I see the charms of solitary life have not destroyed in you in the least the virtues requisite for society,"[161] she teases Descartes gently, and he concurs: in Egmond, "in solitude . . . so removed from the world that I do not learn anything at all about what happens,"[162] he has fashioned himself in the persona of a Neo-Stoic sage. Yet this is all it is—a self-fashioned lifestyle, enabled by personal privilege: "the curse of my sex keeps me from the contentment of a voyage to Egmond, where I might learn the truths you draw from your garden,"[163] Elisabeth laments. The sage's garden is not open to her, a woman absorbed by the political fate of her family, and as one disaster follows another her fragile aptitude fails to stand up to the constant trials and "injurious accidents that befall" her house. The intellectual frustration of the *Recherche* aside, the Neo-Stoic option turns out to provide none of the practical "medicine for the soul" that Elisabeth was seeking; a person like her cannot in real life undertake political responsibilities and yet keep calmly detached, finding the space and time to attend to the betterment of her soul:

> If my life were entirely known to you, I think the fact that a sensitive mind, such as my own, has conserved itself for so long amidst so many difficulties, in a body so weak, with no counsel but that of her own reason and with no consolation but that of her own conscience, would seem more strange to you than the causes of this present malady.[164]

Descartes does not immediately relent, and during the spring and summer of 1645 the correspondence is steeped in Stoic tropes and commonplaces. Yet he does gradually come to a realization that an altogether different approach is needed; that proselytizing about those whose "conscience tells . . . that they fulfilled their duty and that this is what makes an action praiseworthy and virtuous"[165] or how "virtue alone is sufficient to render us content in life"[166] provides little solace and less understanding, and he concedes:

> When I chose Seneca's *de vita beata* as the book to propose to your Highness as an agreeable topic of discussion, I did so only on the basis of the reputation of the author and the dignity of the subject matter, without thinking of the manner in which he treats it. Having since considered this manner, I do not find it sufficiently exact to merit following it through.[167]

Elisabeth's practical demand from Descartes—to "cure my body with my soul"[168]—forces him to recognize that the Neo-Stoic approach enforces on him a dichotomy between "understanding, on the one hand, and imagination or sensation on the other."[169] But the dichotomy between a know-

ing reason and a sensing, passionate body is, in essence, the same as that between soul and body that he refused to grant Elisabeth at the beginning of their correspondence. As much as it would come to be associated with his name, it is a dichotomy Descartes can no longer adhere to: the naturalization of the senses that followed from the adoption of Keplerian optics and the mediated concept of empirical knowledge that this entailed, turned the imagination, as we saw above, into the main arena of knowledge. Reason could not ignore the imagination, as Neo-Stoicism demanded; it had to consider its contents and construct clear and useful representations. Descartes never completely loses sight of these requirements of his new epistemology: it is not a rejection of the passions and the imagination that he suggests, but a careful control of them. Even if she had "all sorts of reasons to be content," Elisabeth should avoid "tragedies full of dreadful events" because "even though these events are feigned and fabulous . . . [they will] move her imagination without touching her understanding [and] suffice to accustom her heart to close itself up and emit sighs." On the other hand, even if she "has an infinite number of true sources of displeasure," she can "turn her imagination from them . . . so that she considers only those objects that bring her contentment and joy." Thus, unlike Langius, Descartes warmly recommends to Elisabeth to "think of nothing in looking at the greenery of a wood, the colors of a flower, the flight of a bird."[170]

Elisabeth was unimpressed:

> I confess that I find it difficult to separate from the senses and the imagination those things that are continuously represented to them . . . I know well that in removing everything upsetting to me (which I believe to be represented only by my imagination) from the idea of an affair, I would judge it healthily and would find in it the remedies as well as the affection which I bring to it. But I have never known how to put this into practice until the passion has already played its role.[171]

The general "ancient precepts" are useless. Of course, if one could control the passions by controlling the imagination, one could "judge healthily," but since the imagination mediates all objects of knowledge, whether coming from the senses or reason or produced "only by [the] imagination" itself, one can hardly tell in advance which should be avoided. Moreover, how can one decide which of the "things that are continuously represented to . . . the senses and the imagination" are harmful, "until the passion has already played its role?"

It takes Descartes ten more weeks of discussion, some of it face to face,[172]

and more of Elisabeth's harsh criticism of the ancient philosophers, who "write with the idea of accumulating admirers by surprising the imagination, rather than disciples by shaping the faculty of judgment," to fully acknowledge that the challenge she had presented to him cannot be met by ancient platitudes. If the New Science is to provide "the means of strengthening the understanding, so as to judge the best in all the actions of life,"[173] it will need to do it directly, by providing its own theory of the relations between true knowledge and good life. What is required is a natural philosophy of the passions—the mediators of knowledge and action—and in the fall of 1645 Descartes sets out to write what will become his last major work, *Les Passions de l'âme*.

### Passions and Knowledge

*The Passions of the Soul* is thus an answer to Elisabeth's challenge.[174] It is Descartes' genuine attempt to become, as she had asked, a "doctor of [her] soul," by providing a thorough hypothesis of "how the soul of a human being (it being only a thinking substance) can determine the bodily spirits, in order to bring about voluntary actions." It is also his final epistemological word: a theory of human knowledge-in-practice, based on New Science assumptions and insights and delivered with New Science intellectual tools. And the most fundamental insight in this regard is a concession to Elisabeth and a clear break with the Neo-Stoicism she was unwilling to accept. She was correct, Descartes comes to admit; it is a meaningless demand—a "category mistake" in a much later parlance—to expect the soul to distinguish "things upsetting" from "remedies . . . until the passion has already played its role." It is exactly the role of the passions to make this distinction.[175] The passions, he realizes, fulfill an indispensible role in assessing knowledge and directing behavior, and for this reason we need *not*

> despise them entirely, nor even that we ought to free ourselves from having the passions. It suffices that we render them subject to reason, and when we have thus tamed them they are sometimes the more useful the more they tend to excess.[176]

This insight guides the *Passions*. The separation between *pathos* and *pathology* is a divorce from all Stoicism, ancient and new, and it is triggered by Elisabeth's insistence on transposing the moral discussion from Descartes' enclosed country estate to her populated court, from the garden of the secluded sage to the worldly life of the genuine scholar. But it is also a

logical consequence of Descartes' evolving natural philosophy and a partial resolution of, a way of coming to terms with, its epistemological paradoxes. If the senses are conduits of opaque images, of mediated and meaningless natural effects; if mathematics is a human art, enforcing artificial order on recalcitrant phenomena, then knowledge can no longer be considered reason's strive for certainty; it is no longer in place to ask whether reason sees "through a glass, darkly" or "face to face" (see chapter 2). Human knowledge has to be considered as the product of an active pursuit of the "the soul and body *together* . . . of their union, on which depends . . . the power the soul has to move the body and the body to act on the soul, in causing sensations and passions."[177]

Committed to the moral-practical context in which the treatise was conceived and to an empirical, natural philosophy mode of discourse, Descartes in the *Passions* has little patience for Lipsius-style eulogies to the "bright beame of reason." For the "union of body and soul," which is the real, active moral agent, in need of "understanding, so as to judge the best in all the actions of life," knowledge and "understanding" are measured by their contribution to its own well-being, and in that the passions play an essential role. As the senses are but "screens," blind stations in natural, causal processes, physically "moved" by all objects, it is the passions that determine which of their infinite variety will touch our consciousness:

> the objects which move the senses do not excite different passions in us in proportion to all of their diversities, but only in proportion to the different ways they can harm or profit us or, generally, be important to us.[178]

Our knowledge pertains only to those objects that affect our well-being, and only insofar as they do so, and the passions are the gauge of this relevance.[179]

Descartes concludes here the process of reshaping his concept of knowledge—a process he commenced in adopting Kepler's optics and deciding to directly engage with its philosophical ramifications (see chapter 1). Kepler's analysis of image formation meant that there was no reason to expect that "images . . . should resemble the objects they represent"—the optical process by which they were *"formed* by the objects" had no intrinsic cognitive value.[180] Dwelling on the status of images—and by extension, on that of the sensations in general—led to the hyperbolic doubt of the *First Meditation,* but already in the *Optics* Descartes was clear that the soul is not engaged in such activity: "the soul [does not] contemplate certain images transmitted by the objects to the brain."[181] Rorty famously ascribed to Descartes the image of "The Inner Eye survey[ing] these representations hoping to find

some mark which will testify to their fidelity."[182] In fact, this is exactly the concept of knowledge Descartes already rejected in the later *Meditations*: the extreme doubt does not pose any real threat, argues Descartes, because it is founded on that uninformed concept of knowledge. The worry that "it is not reliable judgment . . . that there exist things distinct from myself which transmit to me ideas or images of themselves through the sense organs"[183] is an anxiety arising from the expectation that these "ideas or images" should resemble the objects that "transmit" them. But we can be assured that "corporeal things exist" even if "they may not all exist in a way that exactly corresponds with my sensory grasp of them," because the impressions on the senses are *"produced* by corporeal things."[184] The relation between the objects and our knowledge of them is natural and causal, and the uncertain credibility of this knowledge is thus based on the fact that it is a part of a functioning natural, causal system:

> There is no doubt that everything that I am taught by nature contains some truth. For if nature is considered in its general aspect, then I understand by the term nothing other than God himself, or the ordered system created by God.[185]

Descartes, treading dangerous ground, still wants to make sure that the naturalistic substance of his argument will not be lost in its theological garb: assuming that "God is not a deceiver," he is not trying to rely on the benevolence of God, but on the basic assumption that nature, in general, is an "ordered system." The epistemological warranty turns out to be ontological common sense: for us to be completely wrong, the order of nature itself would need to be denied. The "malicious demon" argument follows the complementary line of thought: for our knowledge to always be in error; for there to "be any falsity in my opinions which cannot be corrected by some other faculty supplied by God,"[186] one needs to assume the counter-order personified by the cunning God-like entity.

The epistemology of images had a clear criterion for their value: their resemblance to the objects they purported to represent. In the new, naturalized epistemology, it is the passions that evaluate knowledge, actively, practically and pragmatically:

> The use of all the passions consists in this alone: they dispose the soul to will the things nature tells us useful.[187]

Crucially, it is "nature" which "tells us" what is "useful"; naturalizing epistemology requires a thorough naturalization of the knowing subject, and Descartes dedicates part I of the *Passions*—the first fifty articles—to delineat-

ing the project of accounting for "the Entire Nature of Man,"[188] in which body and soul are not two independent *rei*, but interdependent aspects of a "union," distinguished by their "functions."[189] He discusses in brief the idea of the body as self-governing automaton, its various parts and functions, and in particular the movement of the heart and the muscles, all on the way to explaining "How objects outside us act upon the sense organs."[190] It is a mechanical extension of the Keplerian explanation he adopted in the *Optics*: the nerves, like vibrating strings, relate the motions of the "membranes" at the sense organs to the brain. In every one of its stages, the acquisition of knowledge is causal and mediated:

> [perceptions] we refer to things outside us, namely to the objects of the senses, are caused (at least when our opinion is not false) by these objects, which, exciting movements in the organs of the external senses, excite some in the brain too by the mediation of the nerves. So, when we see the light of a torch and hear the sound of a bell, the sound and the light are two different actions, which, solely by exciting two different movements in some of our nerves and thereby in the brain, impart to the soul two different sensations, which we refer to the subjects we suppose to be their causes in such a way that we think that we see the torch itself and hear the bell, and not that we only feel the movements proceeding from them.[191]

There is no "veil of ideas"[192] here; no representations, only mechanical causes and their effects. The mediated nature of human knowledge has turned from a troubling epistemological insight into a working hypothesis.

Within this hypothesis, which belongs to natural philosophy and epistemology in equal measures, ethics befitting the New Science can be developed; ethics that will celebrate and marshal the curiosity, attention, and excitement of the new savant. Neo-Stoicism preached the suppression of these passions for knowledge, along with all other passions; the positive, essential role that Descartes now assigns them allows him to tie together these three strings of his new scheme. The passions provide Descartes not only with a pragmatic criterion of knowledge to replace the discarded resemblance, but also with the primary drive for knowledge, replacing the discarded vision of "the soul contemplat[ing] certain images." Since "the strength of the soul does not suffice without knowledge of the truth,"[193] the first thing that the passions need to "dispose the soul to will"; the primary "thing nature tells us useful" is to acquire knowledge. "Wonder," therefore, "is the first of all passions."[194]

This is Descartes' final divorce from his Neo-Stoic pretenses. In the

aborted *Recherche de la Vérité* he was following the same line that Lipsius had Langius declaiming: the main aspiration of the soul was tranquility; curiosity and the passion for knowledge stood in its path—they were embodiments of human insatiability and thus the chief causes for human discontent. These limitations on human desire for knowledge were made sense of by rendering the soul a detached "thinking thing"; an idealization of the detached sage. In the *Passions*, however, the soul is no longer this abstracted entity. From its "principal seat" at the pineal gland in the middle of the brain, it "exercises its functions": directing the complex economy of bodily perceptions, emotions, volitions, and ratiocinations "by the mediation of the spirits filling the brain's cavities."[195] Kepler "left to the natural philosophers to argue about" how images are being mediated by "the spirits into the caverns of the cerebrum to the tribunal of the soul."[196] Descartes answers the challenge by letting the passions endow meaning into the physical process of mediation, which he extended from perception all the way through reason and back to action.[197] It is the passions aroused by external objects that are remembered and recalled, promising that the proper actions will be taken, "according to whether one has previously secured oneself by defense or by flight against the harmful things to which the present impression bears a resemblance."[198] Esteem and scorn; veneration and disdain; love and hatred; desire; anger; regret etc.[199]—all can be counted on to repeat themselves, "according to the differing temperament of the body or the strength of the soul,"[200] in an orderly manner, orderly enough for their causes and functions to be empirically investigated; orderly enough for their facial expressions to be carefully recorded; and most important, orderly enough to ensure that "the same agitation of spirit that usually causes them disposes the body to the movements conducive to the execution of those things [nature tells us are useful]."[201]

### Passionate Ethics

Here is the final, and perhaps most dramatic of the Baroque paradoxical reversals. It is a paradox that touches at the very heart of the order of knowledge; a reversal of the hierarchy between reason and the passions. Dependent on the imagination and on the causal mediation of the senses, reason is always in danger of leading us astray. The orderly function of the passions assures that it does not do so: directing body and soul together through the vicissitudes of nature, the passions are sanctioned by the well-being of their "union."[202]

Just as the properties of matter came to assure Newton of the precarious orderliness of celestial motions that mathematics could study (see chapter 5), so the causal constancy of the passions comes to found, for Descartes, the precarious orderliness of "the connection between our 'soul and our body."[203] It is this constancy that allows "habituation"—the "principle" behind all memory and learning:

> There is such a connection between our body and our soul that when we have once joined some bodily action with some thought, one of the two is never present to us afterwards without the other also being present to us [even though] the same actions are not always joined by the same thoughts.[204]

Following his new epistemology, Descartes' ethics for the New Science is a passionate one. Like Shakespeare's Hippolyta and Theseus, he would thus conclude the *Passions* with a clear and powerful vindication of their responsibility for the well-being of body and soul:

> The soul may have pleasures by itself. But as for those which are common to it and the body, they depend entirely on the Passions, so that the men they can move the most are capable of tasting the most sweetness in this life.[205]

But Descartes' passions are not only inward-directed; they are also responsible for moral behavior. Just as knowledge is driven by wonder, morality is driven by generosity (Générosité): both object-seeking passions. Generosity itself is rewarded by another passion: it "makes a man to esteem himself as highly as he legitimately can,"[206] and it is, in its turn, the gauge of all other passions; "Generosity . . . serves as a remedy for all the disorders of the Passions."[207] As if a last homage to the discarded Neo-Stoicism, Descartes explains this role of generosity with a version on the themes of humility, self-control, and autarky, but one that replaces detachment with benevolence:

> Those who are generous in this way are naturally inclined to do great things, and yet to undertake nothing they do not feel themselves capable of. And because they esteem nothing more highly than doing good to other men and for this reason scorning their own interest, they are always perfectly courteous, affable and of service to everyone. And along with this, they are entirely masters of their Passions—particularly Desires, Jealousy, and Envy, because there is nothing whose acquisition does not depend on them which they think is worth enough to deserve being greatly wished for.[208]

Descartes' savant is a generous person. Like Elisabeth, he, or she, is necessarily embedded in the world, cannot escape its vicissitudes, and must embrace them in order to produce meaningful knowledge. Lipsius' sage was

a "citizen of the world—For a high and loftie mind will not suffer itselfe to be penned by OPINION within such narrow bounds but conceiveth and knoweth the whole world to be his owne."[209] For Descartes' passionate savant this is no longer a viable or even desirable option. Like her, Descartes consoles the troubled princess, the practitioner of the New Science is an involved, attentive, and compassionate citizen of nature and society:

> One does not know how to subsist alone . . . one is one part of the universe and, more particularly even, one part of this earth, one part of this state, and of this society, and this family, to which one is joined by his home, by his oath, by his birth . . . in considering oneself as part of the public one takes pleasure in acting well toward everyone.[210]

# *Abbreviations*

| | |
|---|---|
| Birch | Thomas Birch, *The History of the Royal Society* in 4 volumes (1756–57). Facsimile reprint in *The Sources of Science*, vol. 44. New York: Johnson Reprint Corporation, 1968. |
| *The Controversy* | Stillman Drake and C. D. O'Malley (eds. and trans.), *The Controversy on the Comets of 1618: Galileo Galilei, Horatio Grassi, Mario Guiducci, Johann Kepler*. Philadelphia: University of Pennsylvania Press, 1960. |
| CSM | René Descartes, *The Philosophical Writings of Descartes*, John Cottingham, Robert Stoothof, and Dugald Murdoch (trans.). Cambridge: Cambridge University Press, 1985 (3 vols.) |
| *CW* | Aristotle, *The Complete Works of Aristotle*, Jonathan Barnes (ed.). Princeton: Princeton University Press, 1984. |
| *GW* | Johannes Kepler, *Gesammelte Werke* 1571–1630, Walther von Dyck and Max Caspar (eds.). Munich: C. H. Beck, 1937 -. |
| *Opere* | *Le opere di Galileo Galilei*, edizione nazionale, Antonio Favaro (ed.). Florence: Barbera, 1899–1909. |
| *The World* | René Descartes, *The World and Other Writings*, Stephen Gaukroger (ed. and trans.). Cambridge: Cambridge University Press, 1998. |

# Notes

## INTRODUCTION

1. On the location of Vermeer's paintings and whether this is indeed the same room see Steadman, *Vermeer's Camera*, esp. chapters 4 and 5, 59–100.

2. Both globes, apparently, represent a Jodocus Hondius piece from 1600.

3. For further interpretations of this painting see Bean, *A Vision of Peace*, and Woollett and van Suchtelen, *Rubens & Brueghel*, esp. 96–97. For the novel representation of the telescope in this painting see Molaro and Selvelli, "The Mystery of the Telescopes in Jan Brueghel the Elder's Painting," and Selvelli and Molaro, "On the Telescopes in the Paintings of J. Brueghel the Elder."

4. Alpers, *The Art of Describing*; Reeves, *Painting the Heavens*; and Jones, *The Good Life in the Scientific Revolution* are important deviations from the rule.

5. White et al. (eds.), *Seventeenth-Century Verse and Prose*, 1:391.

6. Hall, *The Scientific Revolution*, xi.

7. Sabra, "The Appropriation," 225.

8. Galileo, "The Assayer," in Drake and O'Malley, *The Controversy on the Comets of 1618* (henceforth *The Controversy*), 183–84.

9. For classical treatments of Baroque in literature and plastic arts see: Wölfflin, *Principles of Art History*; Benjamin, *The Origin of German Tragic Drama*; Panofsky, "What Is Baroque?"; and Maravall, *The Culture of the Baroque*. See also Levine, *Between the Ancients and the Moderns*; Wellek, "The Concept of Baroque in Literary Scholarship"; and Croce, *Benedetto Croce's Essays on Literature and Literary Criticism*. In music history and theory the term "Baroque" came to refer to a later period—the question of whether the music of the seventeenth century can be understood along the same lines offered here will have to be answered in another place.

10. This section owes much to discussions with the participants of the Baroque Science workshop in Sydney in 2008 and the contributors to the consequent volume on *Science in Baroque Culture* forthcoming in *Archives for the History of Ideas*. We thank Nick Dew for the following quotation from Collinwood.

11. "Die Geschichte dieser Zeit und dieses Geschmacks liegt noch sehr im Dunkeln." Herder, *Zerstreute Blätter*, V, 58, cited in Benjamin, "Ursprung des deutschen Trauerspiels," *Gesammelte Schriften* 1.I. 344.

12. "Für [Harvey] gilt genau, was Wölfflin vom Künstler sagt, der nicht das Auge, sondern den Blick des Menschen sieht. Nicht der Körper in seiner Begrenztheit, sondern die unbegrenzte Bewegung des Körpers und seiner Teile fesselt ihn. Er sieht nicht den Muskel, sondern die Kontraktion des Muskels und ihre Wirkung. . . . So ist Harvey derjenige Mediziner, in dem sich die Weltan-

schauung des Barock zuerst verkorpert hat." Sigerist, "William Harveys Stellung," 166. We thank Warwick Anderson for this reference.

## CHAPTER ONE

1. Johannes Kepler, *Ad Vitellionem*. We will use *Ad Vitellionem* to refer to the original Latin and *Optics* to refer to Donahue's translation.

2. Kepler, *Optics*, 259.

3. The relation between the camera obscura and the eye is at the heart of the historiographic debate concerning Kepler's optics. For Stephen Straker (*Kepler's Optics*, and cf. Crombie's *Robert Grosseteste*) the instrument represents Kepler's novel commitment to the mechanization of the eye and his indebtedness to the artisanal tradition. Kepler's claim that the locus of images is the retina rather than the crystalline humor, Straker argues, is an immediate consequence of comparing the eye to a camera obscura. David Lindberg, in contrast, arguing for Kepler's reliance on the perspectivist tradition, stresses that "only on one occasion did [Kepler] explicitly compare the eye to a camera obscura" (*Theories of Vision*, 206). As we claimed above and will argue below, this debate is somewhat misdirected: Kepler's main motivation in equating the eye and the camera obscura is legitimating the instrument rather than understanding the eye.

4. Kepler, *Optics*, 56.

5. Aristotle, *Problems*, bk. 15, ch. 6, 911b1, in *CW*, 2:1417. See also Lindberg, "The Theory of Pinhole Images"; Thro, "Leonardo's Early Work."

6. Pecham, *John Pecham and the Science of Optics*, 67.

7. Lindberg, "The Theory of Pinhole Images in the Fourteenth Century," 303ff.

8. For Maurolyco on pinhole images see Zik and Hon, "Geometry of Light and Shadow."

9. "Sciendum igitur figuram sphericam esse luci cognatam et omnibus mundi corporis esse consonam ut pote nature maxime salvatiamque omnes partes suo intimo perfectissime coniungit, unde et stilla in rotunditatem indicit. Ad hanc igitur naturaliter lux movetur et eam protelata distintia paulatim acquirit." Pecham, *John Pecham and the Science of Optics*, 70–71. See also Lindberg, "Laying the Foundations," esp. 26–29.

10. Lindberg, "Laying the Foundations," esp. 37–40; and "Optics in 16th Century Italy," esp. 134–35; see also Zik and Hon, "Geometry of Light and Shadow," esp. 561.

11. Kepler, *Optics*, 59, 61, 62.

12. Kepler, *Ad Vitellionem*, 8; see also Jardine, *The Birth of History and Philosophy of Science*.

13. Nicodemus Frischlin, *De astronomicae artis*, 41, quoted in Jardine, "Epistemology of the Sciences," 700. See also Barker and Goldstein, "Realism and Instrumentalism."

14. Aristotle, *Parts of Animals*, bk 1.5, 644b, in *CW*, 1:1003.

15. Maestlin, *De Astronomiae hypothesibus*, A2r; cited in Barker and Goldstein, "Realism and Instrumentalism," 249.

16. Tycho Brahe, *Epistolarum astronomicarum*, 111.

17. Kepler, *New Astronomy*, 89.

18. Kepler, *Optics*, 336, 335, 338, 336. For the inherent tension between astronomical calculations and physical speculations in the context of Renaissance astrology, see for instance Grafton, *Cardano's Cosmos*, and "Chronology, Controversy, and Community," in *Worlds Made by Words*, 114–36.

19. "Amplectamur ergo veram sententiam . . . et irrefutabilibus experimentis stabilitam, a Sole scilicet, et a coloribus Sole illustratis, defluere species consimiles, ipsoque fluxu attenuari, donec in medium quacunque ratione opacum incidant, ibique suum fontem depingant: Fierique visionem . . . , cum opacus oculi paries hoc modo pingitur, confusum, cum confunduntur ibi picturae variorum colorum, distinctam, cum non confunduntur." Kepler, *Ad Vitellionem*, 41–42.

20. "Nam luminis seu radiorum ab illustribus descendentium sunt certae passiones, quaetenus

lumen, non quaetenus in pellucido aere inhaeret, cuiusmodi sunt emissio et extenuatio, iisque con-
trariae, repercussio et refractio seu condensatio. Ergo nihil prohibet eiusdem etiam actiones quas-
dam esse, . . . illustrationem et alterationem parietum, quibus non tantum affunduntur colores seu
lux, sed etiam imprimuntur et contrarii destruuntur." Ibid.

21. This is the central argument of David Lindberg's *Theories of Vision from al-Kindi to Kepler*.

22. Cf. A. Mark Smith, "What Is the History of Medieval Optics Really About?"

23. Cf. Smith, "Getting the Big Picture." For the role of these visual impressions in medieval
spirituality see Park, "Impressed Images"; Hamburger, "Seeing and Believing."

24. Pecham, *John Pecham and the Science of Optics*, 161.

25. Kepler, *Optics*, 45.

26. Alberti, *On Painting*, 41.

27. Alpers, *The Art of Describing*, 41.

28. "Agens naturale multiplicat virtutem suam a se usque in patiens, sive agat in sensum, sive
in materiam. Quae virtus aliquando vocatur species, aliquando similitudo, et idem est, quocunque
modo vocetur." Grosseteste, "De lineis angulis et figuris," 60.

29. "Species sit similes agenti et genranti eam in essentia et diffinitione." Bacon, *Roger Bacon's
Philosophy of Nature*, 7. For an extensive treatment of species in medieval optical theory see espe-
cially Smith, "Getting the Big Picture"; Spruit, *Species Intelligibilis*. Tachau provides an authorita-
tive treatment of the issues involved in medieval theory of species in "The Problem of the *Species*";
see also her *Vision and Certitude*. See also Denery, *Seeing and Being Seen*, esp. 82–96.

30. Smith, "Getting the Big Picture," 569.

31. Pecham, *John Pecham and the Science of Optics*, 121.

32. Cf. Gaukroger comments in Descartes, *The World*, 159–61, arguing for the teleological
nature of Aristotelian theory of perception.

33. Kepler, *Optics*, 78.

34. Kepler, *Optics*, 184. Marine interprets Alpers along these lines: "Le monde est Premier, se
projetant en lumière et en couleurs dans un 'oeil mort'" (Marine, "Éloge de l'apparence," 241).
Marine, however, does not recognize that the "death of the eye" necessitates, rather than elimi-
nates, the "sujet constructeur" (ibid.).

35. Bacon, *Advancement of Learning*, V, 3. See chapter 7.

36. Smith, "What Is the History of Medieval Optics Really About?" 183.

37. Witello, *Perspectiva*, title page: "Habes in hoc opera, Candide Lector, quum magnum nu-
merum Geometricorum elementorum, quae in Euclide nusquam extant, tum vero de proiectione,
infractione, & refractione radiorum visus, luminum, colorum, & formarum, in corporibus trans-
parentibus atque speculis."

38. Cf. Sabra, "Alhazen's Optics in Europe"; Smith, "Saving the Appearances," 73–99. See also
Smith, "Ptolemy's Search for a Law of Refraction."

39. Lindberg, "The Genesis," 10.

40. Bacon, *Roger Bacon's Philosophy of Nature*, 92: "Quia scilicet magis manifesta nobis est mul-
tiplicatio lucis quam aliorum."

41. Boyer, *The Rainbow*.

42. Crombie, *Robert Grosseteste*, 281 (italics added). Eastwood, translating Grosseteste's *De Iride*
in his *The Geometrical Optics of Robert Grosseteste*, is usually very careful to avoid the confusion.

43. Lindberg, "The Genesis," 20.

44. "Kepler departed from the optical tradition of forms and species—though he continued,
sometimes, to use the terms, just as all had continued to speak of 'visual rays.'" Straker, *Kepler's
Optics* 2:504.

45. Malet, "Keplerian Illusions," 2–3.

46. Lindberg, "The Genesis," 34.

47. Smith, "What Is the History of Medieval Optics Really About?," 181, 183.

48. Lindberg, *Theories of Vision*, 63–64; Alhacen (Ibn al-Haytham, Alhazen), *De aspectibus*, bk. 1, chap. 5, sec. 23, p. 14. For a detailed account of Alhacen's teleological analysis of the eye, see Smith, "What Is the History of Medieval Optics Really About?"

49. Kepler, *Optics*, 13 (italics added).

50. Ibid., 205, 236 (italics added).

51. Cf. Hon, "On Kepler's Awareness of the Problem of Experimental Error," and "Putting Error to (Historical) Work"; quotation from "Putting Error," 69.

52. We owe this argument to Antoni Malet and Roy Laird.

53. We use the hyphenated "re-presentation" to stress the literal sense of the term: the real *presence* to the intellect of the object, its own form or a duplicate whose authenticity cannot be coherently doubted; a *spec*.

54. Kepler, *Optics*, 180. In a private communication, Antoni Malet argued that Kepler's reference to the arguments of philosophers is ironic. This may very well be the case, yet it should not obscure Kepler's clear awareness to the epistemological qualm he has given rise to.

55. "Geometria enim . . . Deo coaetrna, inque Mente divina relucens, exempla Deo suppeditavit." Kepler, *Harmonices mundi*, bk. 3, axiom 7, at *GW* 6:104.

56. Kepler, *Harmony*, 303–4: "Ipsa enim quantitatum agnitio, congentia menti, qualis oculus esse debeat, dictat: et ideo talis est factus Oculus, quia talis Mens est, non vicissim." Kepler, *Harmonices mundi*, bk. 4, at *GW* 6:223.

57. Della Porta, *Natural Magick*, 355, 363–64.

58. Kepler refers to and discusses della Porta often in the *Optics* from the Dedication (6) on. On Kepler's indebtedness to della Porta see Dupré, "Kepler's Optics without Hypotheses."

59. Della Porta, *Natural Magick*, 365; *Magia naturalis*, 561.

60. Della Porta, *De refractione*, bk 4, prop. 1, 91: "Forma rei videndae in ipsa re materiale habet naturam, sed lumine susceptam, materiam subito eximere, & spirituali quadam ratione emicare, & quo magis ab obiecto venies appropinquat oculo, eo magis ex latior base accommodare se ipsam ad pupillam, & oculum, sicut & corpora liquida per se locis insinuant. Vnde per radiorum lineas pyramidales ex se ad oculum figuram portnedit, & cono crystallinum verberat. Quod fiat per simulachrorum in oculos illapsum, ita probamus."

61. Ibid., 73: "Diximus de aqueo humore, sequitur de pupilla dicamus, per eam nanq simulachra crystalline intromittuntur, quasi fida ianitrix oculo adsidet, ibique sua munia exercet."

62. Della Porta, *Natural Magick*, 356, 361. Sometimes the distortion is beneficial: "So women pull hairs off the eye-brows, for they will shew as great as fingers. . . . Hostius made such Concave-Glasses, that they might make things shew greater: he was a great provoker to lust; so ordering his Glasses, that when he was abused by Sodomy, he might see all the motions of the Sodomite behind him, and delight himself with a false representation of his privy parts that shewed so great" (ibid., 361). Note that in spite of the "delight," the "representation" is still "false." On Kepler's place in the tradition of virtual images see Malet, "Keplerian Illusions." For a somewhat different approach see Dupré, "Inside the Camera Obscura."

63. Kepler, *Optics*, 171. The uncertainty involved in the different stages of the visual process has already been noted by Nicole Oresme in *De causis mirabilium* (*Nicole Oresme and the Marvels of Nature*), chap. 1. For the general denigration and the radical critique of sight in early modern Europe see Clark, *Vanities of the Eye*.

64. Cf. Summers, *The Judgment of Sense*.

65. Alpers, *The Art of Describing*, 45.

66. Cf. Brusati, *Artifice and Illusion*.

67. Alpers, *The Art of Describing*, 44.

68. On Vermeer application of the camera obscura see Steadman, *Vermeer's Camera*. See also Bird, "Nova Descriptio," esp. 118–19.

69. Hockney, *Secret Knowledge*, 58.

70. Kepler, *Ad Vitellionem*, 181.

71. Kepler, *Ad Vitellionem*, 60: "Dicunt enim imaginem Optici, cum res ipsa quidem cum suis coloribus et figurae partibus cernitur, sed situ ali ... alicubi et alienis induta quantitatibus et partium figurae proportione inepta. Breviter, imago est visio rei alicuius, cum errore facultatum ad visum concurrentium coniuncta. Imago igitur per se pene nihil est, imaginatio potius dicenda. Res est composita ex specie coloribus vel lucis reali, et quantitatibus intentionalibus."

72. Pecham, *John Pecham and the Science of Optics*, 170.

73. Kepler, *Ad Vitellionem*, 74: "Cum hactenus Imago fuerit Ens rationale, iam figurae rerum vere in papyro existentes, seu alio pariete, picturae dicantur." For a technical analysis of the distinction in Kepler and beyond see Shapiro, "Images: Real and Virtual, Projected and Perceived, from Kepler to Dechales," 75–94.

74. See also Smith, "Ptolemy, Alhazen, and Kepler."

75. Scheiner, *Oculus*, 2: "Oculus animali ad videndum à Deo attributus munere suo perfungitur rerum videndarum praesentia potitus. Res oculo paesentes fiunt radiis non ab eo in objecta emissis, sed ab his in eundem admissis."

76. Scheiner's reference is to Aristotle's *Physica* 2, 20.

77. Scheiner has "physical" here, but this is clearly a mis-citation of Aristotle.

78. Scheiner, *Oculus*, Præfatio: "Physici quam Optici circa visibilia, & organum visus versantur; modo tamen diverso. Geometria enim, teste Philosopho, l.2 Phys. t.20 de Physica linea considerat, sed non quatenus est Physici: Perspectiva autem mathematicam quidem lineam, sed non quatenus Physica est. Veritatem ergo ejusdem rei ambo, sed viis diversis, investigant."

79. Cf. Feldhay, *Galileo and the Church*.

80. Scheiner, *Oculus*, 124: "Ex eo quod radius visorius tunicae Retinae transcribitur, ratio faricae oculi reditur."

81. Ibid.: "Confusioni porro rei visae evitandae, picturaeque rerum visibilium in Retina ordinate & distincte experimendae, conduit amplitudo humoris Vitrei, cujus beneficio communis radiorum in Crystallino refractorum concursus ita attemperatur, ut in tunicam Retinae dilucide depingatur."

82. Ibid., 38: "Re igitur intra termini remoti limites collocatâ, quae dextra apparet dextram oculi partem occupat, quae sinistra sinistram, quae supera superam : adeoque locus visus in eandem plagam recidit in quam radius visorius rem in oculum deferens."

83. Cf. Dear, *Discipline & Experience*, esp. chap. 2, and Feldhay, "Mathematical Entities."

84. Scheiner, *Oculus*, 73: "Omnes radii per quos punctum aliquod visibile in organum visûs derivatur, sunt & dicuntur radii visorii, sed aliqui minus principales & secundarii, sive mediate & deferentes, unus autem principalis, primaries & immediatus, seu formalis, est is qui ipsum id organum visûs quod formam coloris sentit ingreditur, &, ut ita dicam, sentitur."

85. Aristotle, *De Anima*, bk. 2, ch. 7, in *CW*, 1:666.

86. Ibid; also Aristotle, *De Sensu et Sensibili*, bk. 1, ch. 3, 439b15–18, in *CW*, 1:698.

87. Aristotle, *Meteorology*, bk. 3, ch. 2, in *CW*, 1:599–600.

88. Boyer, *The Rainbow*, 134, 150.

89. Horatio Grassi, *The Astronomical Balance*, in *The Controversy*, 122.

90. Aristotle, *De Sensu et Sensibili*, bk. 1, ch. 3 (italics added).

91. Aristotle, *Meteorology*, bk. 3, ch. 2, in *CW*, 600 (italics added).

92. Grosseteste, *De Iride*, 176 (italics added).

93. Aristotle, *Meteorology*, bk. 3, ch. 4, in *CW*, 601–2.

94. Aristotle, *De Anima*, Bk. 2, Ch. 7, 1:667.

95. Oresme, *Nicolai Oresme Expositio*, 209.

96. Grosseteste, *De Iride*, 213.

97. Ibid., 214.

98. Eastwood, *The Geometrical Optics of Robert Grosseteste*, 217.

99. Grassi, "Balance," in *The Controversy*, 122 (italics added).

100. Cf. Boyer, *The Rainbow*, 178-92. Boyer, however, misses Kepler's main innovation.

101. Kepler to Maestlin, 19/29 August, 1599, in *GW* 14:Nr. 132:50-51: "Itaque saepe cogitavi, an proportio anguli refractionis constituat terminos in quibus dicatur color Viridis caeruleus etc. Ut si refractio directa, angulus nullus constituat flavum, sive potius id quod est splendidissimum in flavo, lux ipsa. . . .Sic pro ratione divisionis rectj angulj constituuntur colores."

102. Descartes to Mersenne, March 31, 1638, *Oeuvres* 7,161: "ce qui n'empêche pas que je n'avoue que Kepler a été mon premier maître en optique, et qu'il est celui de tous hommes qui en a le plus su par ci-devant."

103. Cf. Schuster and Gaukroger, "The Hydrostatic Paradox and the Foundations of Cartesian Dynamics."

104. For a recent careful analysis and reproduction of Descartes experimental work on the rainbow see Buchwald, "Descartes's Experimental Journey." For the import of the work on the rainbow in Descartes' intellectual project see Tiemersma, "Methodological and Theoretical Aspects of Descartes' Treatise on the Rainbow," and Werrett, "Wonders Never Cease."

105. Descartes, *The World*, 85.

106. Boyer, *The Rainbow*, 150; Eastwood, *The Geometrical Optics of Robert Grosseteste*, 217 (quoted language from Eastwood). Eastwood is usually careful with the distinction between "*lumen*" and "light rays."

107. Descartes, Discourse 8, *Meteors*, in *The World*, 86.

108. Ibid., 87.

109. Ibid., 87-88.

110. Ibid.

111. Ibid., 91.

112. Descartes, "Optics," in CSM, 1:165.

113. Cf. Gaukroger in Arnauld, *On True and False Ideas*, 4-10.

114. Descartes, *Principles of Philosophy*, prop. 67, 30.

115. Descartes, *Rules for the Direction of the Mind*, Rule 12, in CSM, 1:40.

116. Aristotle, *On the Soul* (*De Anima*), bk. 2, ch. 12.

117. Aristotle, *De Sensu et Sensibili*, in *CW*, ch. 3, 1:696, 700-703. Aristotle's attitude to the issue of touch is complex. In *De Anima* he declares that "the primary form of sense is touch," while in *De Sensu et Sensibili* he mocks "Democritus and most of the natural philosophers [who] proceed quite irrationally" in thinking of "all objects of sense as objects of Touch" ( *De Anima*, bk. 2, ch. 2; *De Sensu et Sensibili*, ch. 4).

118. Aristotle, *De Anima*, bk. 2, ch. 12.

119. Ibid., bk. 3, ch. 12.

120. Ibid., bk. 2, ch. 1.

121. Foucault famously claimed that Descartes was the first European thinker to thoroughly do away with resemblances. Foucault, however, did not touch upon the practical and scientific underpinnings of the change. See Foucault, *The Order of Things*, 50-51.

122. Descartes, *Rules for the Direction of the Mind*, Rule 12, in CSM, 1:40-41.

123. Descartes, *The World*, 4; cf. Gaukroger, *Descartes*, 276-90.

124. Aristotle, *De Interpretatione*, ch. 1, 16a, 3-8, in *CW*, 1:25.

125. Descartes, *Optics*, in CSM, 1:165.

126. Cf. Simmons, "Are Cartesian Sensations Representational?"

127. For a comparison and critique of the "traditional" vs. "revisionist" interpretations see Bermúdez, "Scepticism and Science in Descartes."

128. Williams, *Descartes*, esp. 36ff and chap. 7; Edwards, *Encyclopaedia of Philosophy*.

129. Rorty, *Philosophy and the Mirror of Nature*.

130. Popkin, *The History of Scepticism*.

131. The opposing views are represented by Burnyeat, "Can the Skeptic Live His Skepticism," and Fine, "Descartes and Ancient Skepticism: Reheated Cabbage?"

132. Wilson, "Skepticism without Indubitability."

133. Gaukroger, *Descartes*; Gaukroger, *Cartesian Logic*; Gaukroger, "Descartes' Project for a Mathematical Physics"; Garber, *Descartes Embodied*, 221–56; Garber, *Descartes' Metaphysical Physics*, 94–103.

134. Cook, *Matters of Exchange*, 237–40.

135. Smith, "What Is the History of Medieval Optics Really About?," 194.

136. Scheiner, *Rosa Ursina*, bk. 2, chap. 13, 106–8. Cf. Lefèvre, *Inside the Camera Obscura*, 8.

137. *De anima*, bk. 2, 1:412$^b$19–23.

138. Descartes, *Discourse on Method, Optics, Geometry, and Meteorology*, 91–93, 97.

## CHAPTER TWO

1. For an extensive and definite account of the history of spectacles in the Renaissance see Ilardi, *Renaissance Vision from Spectacles to Telescopes*. See also the discussion in Lindberg and Steneck, "The Sense of Vision and the Origins of Modern Science." For recent discussions on the intricate relationship between artificial perspective as the new theory of artistic practice and the new modes of vision see Summers, *Vision, Reflection, and Desire in Western Painting*, and Edgerton, *The Mirror, the Window, and the Telescope*. These recent analyses tend to emphasize painting as a representation, and the mathematical theory of perspective that underlies it, but overlook the practical status of the eye itself and the various instruments of observation that either assist or replace it altogether.

2. See for instance Boffito, "L'occhiale e il cannocchiale del papa Leone X"; Davidson, *Raphael's Bible*, 14; Hamburgh, "Naldini's *Allegory of Dreams*," esp. 697; for the artistic-optical background to Galileo's invention of the telescope see Reeves, *Galileo's Glassworks*.

3. On these reflections see Carter, "Reflections in Armor in the Canon van de Paele Madonna"; Farmer, "Further Reflections on a van Eyck Self-Portrait." See also further discussions of the painting in Seidel, "The Value of Verisimilitude in the Art of Jan van Eyck"; Harbison, *Jan van Eyck: The Play of Realism*.

4. For an extensive discussion and interpretation of this painting see Minnich, "Raphael's Portrait 'Leo X.'"

5. On the import of this epistle to Mediaeval and Renaissance thought see Nolan, *Now through a Glass Darkly*.

6. Alan of Lille, *De Incarnatione Christi* (Rhythmus Alter) (PL 210, col. 579), quoted and translated in Eco, *The Aesthetics of Thomas Aquinas*, 138.

7. Augustine, *Confessions*, bk. 13, ch. 15, translated in Gellrich, *The Idea of the Book in the Middle Ages*, 29. On the allegorical reading of the book of nature see Harrison, *The Bible*, 11–63.

8. Eriugena, *De divisione naturae*, V, 3 (PL 122, cols. 865–66): "Nihil enim visibilium rerum, corporaliumque est . . . quod non incorporale quid et intelligibile significant."

9. Kepler, *Optics*, 19–20—see chapter 4.

10. Pseudo-Dionysius, *The Divine Names*, 94–95.

11. Panofsky, *Abbot Suger*, 63–65.

12. On the separation of High and Low and its moral and political significance see Ginzburg, "High and Low," reprinted in Ginzburg, *Clues, Myths, and the Historical Method*, 60–76.

13. See for instance Hugh of St. Victor, *The Didascalicon of Hugh of St. Victor*.

14. Aristotle, "Metaphysics," bk. I 980$^a$20, in *CW*, 2:1552.

15. Aristotle, *De anima*, bk. II, 7, 418$^b$14–22, in *CW*, 1:666.

16. Thomas, *Scriptum super libros Sententiarum*, 2:329–37.

17. Albertus, "Commentarii in II Sententiarum," in *Opera omnia* (ed. Bergent), 241–42.

18. Albertus, *De anima*, lib. II, tract 3 cap. 15, in *Alberti Magni opera omnia* (ed. Stroick), vol. VII, part I, 122: "De his autem omnibus tractandum est in perspectivis, quia haec et causa eorum sine geometricis sciri non possunt; et ideo quae hic dicta sunt, propter exemplarem explanationem dicta sunt, et non ideo, quia hic sunt intenta. Se ex eis omnibus constat visum medio indigere, quod sit in actu lucidum, per quod tales possunt fieri irradiationes, et quod colores non nisi in tali medio videntur."

19. See the discussion of the mendicant orders' modes of natural philosophy in French and Cunningham, *Before Science*.

20. For a comprehensive intellectual biography of Robert Grosseteste see Southern, *Robert Grosseteste*. On the transmission of Muslim optics to Latin Europe cf. Lindberg, "Alhazen's Theory of Vision."

21. Grosseteste, *Robert Grosseteste: On Light*, 10.

22. Bacon, "De multiplicatione specierum," in *Roger Bacon's Philosophy of Nature*.

23. Bacon, *The Opus Majus of Roger Bacon*, vol. 1, 223-34.

24. Ibid.

25. Pecham, *John Pecham and the Science of Optics*, 159.

26. Ibid.

27. We follow here Phillips, "John Wyclif and the Optics of the Eucharist." For other applications of optical ideas in theological discourse in the later Middle Ages see Denery, *Seeing and Being Seen in the Later Medieval World*; and Chidester, *Word and Light*, esp. 111-28.

28. Oresme, *Nicole Oresme and the Marvels of Nature*.

29. Concerning the change in the intellectual and religious status of supernatural events from the Middle Ages to the Renaissance see Stephens, *Demon Lovers*.

30. Nicholas of Cusa, *De beryllo*, 3: "Beryllus lapis est lucidus, albus et transparens. Cui datur forma concave pariter et convexa, et per ipsum videns attingit prius invisibile. Intellectualibus oculis si intellectualis beryllus, qui formam habeat maximam pariter et minimam, adaptatur, per eius medium attingitur indivisibile omnium principium." For somewhat different translations of the following quotes see *Nicholas of Cusa: Metaphysical Speculations*, 792-93.

31. Nicholas of Cusa, *De beryllo*, 1: "Qui legerit ea, quae in variis scripsi libellis, videbit me in oppositorum coincidentia crebrius versatum quodque nisus sum frequenter iuxta intellectualem visionem, quae excedit rationis vigorem, concludere. Unde ut quam clare legenti conceptum depromam, speculum et aenigma subiciam, quo se infirmus cuiusque intellectus in ultimo scibilium iuvet et dirigat. . . Et quamvis videatur libellus iste brevis, tamen dat sufficientem praxim, quomodo ex aenigmate ad visionem in omni altitudine possit pertingi." See also *Nicholas of Cusa: Metaphysical Speculations*, 792.

32. Nicholas of Cusa, *De beryllo*, 6: "Unde in se homo reperit quasi in ratione mensurante omnia create." See also *Nicholas of Cusa: Metaphysical Speculations*, 794.

33. Nicholas of Cusa, *De beryllo*, 7: "Nam sicut deus est creator entium realium et naturalium formarum, ita homo rationalium entium et formarum artificialium, quae non sunt nisi sui intellectus similitudines sicut creaturae dei divini intellectus similitudines. Ideo homo habet intellectum, qui est similitudo divini intellectus in creando. Hinc creat similitudines similitudinum divini intellectus, sicut sunt extrinsecae artificiales figurae similitudines intrinsecae naturalis formae. Unde mensurat suum intellectum per potentiam operum suorum et ex hoc mensurat divinum intellectum, sicut veritas mensuratur per imaginem. Et haec est aenigmatica scientia." See also *Nicholas of Cusa: Metaphysical Speculations*, 794.

34. See Bono, *The Word of God and the Languages of Man*, esp. ch. 5; quotation is from p. 66: "Sensibilia enim sunt sensuum libri, in quibus est intentio divini intellectus in sensibilibus figuris descripta, et est intentio ipsius dei creatoris manifestatio."

35. Nicholas of Cusa, *De docta ignorantia*, *Werke* 1, 2-3: "Omnes autem investigantes in comparatione certi proportionabiliter incertum iudicant, comparativa igitur est omnis inquisitio medio

proportionis utens . . . Omnis igitur inquisitio in comparativa proportione facili vel deficili existit . . . Proportio vero cum convenientiam in aliquo uno simul et alteritatem dicat absque numero intelligi nequit. Numerus ergo omnia proportionabilia includit." Translation after Hopkins in *Nicholas of Cusa on Learned Ignorance*, 50.

36. Nicholas of Cusa, *De beryllo*, 56: "Et si sic considerassent Pythagorici et quicumque alii, clare vidissent mathematicalia et numeros, qui ex nostra mente procedunt et sunt modo quo nos concipimus, non esse substantias aut principia rerum sensibilium, sed tantum entium rationis, quarum nos sumus conditores."

37. Ibid., 69: "Recte igitur dicebat Protagoras hominem rerum mensuram, qui ex natura suae sensitivae sciens sensibilia esse propter ipsam mensurat sensibilia, ut sensibiliter divini intellectus gloriam possit apprehendere. Sic de intelligibilibus ea ad cognitionem referendo intellectivam, et demum ex eodem contemplatur naturam illam intellectivam immortalem, ut se divinus intellectus in sua immortalitate eidem ostendere possit."

38. Ibid., 45: "Facies tibi scientiam mediante beryllo et aenigmate de principio oppositorum et differentia et omnibus circa illa attingibilibus."

39. Ibid., 19: "figuransmotum, quo deus vocat de non esse ad esse."

40. Ibid., 20: "Unde dum intellectus conditor sic movet cb, exemplaria, quae in se habet, explicat in sua similitudine, sicut mathematicus, dum lineam plicat in triangulum, ipsum triangulum explicat motu complicationis, quem intra se habet in mente."

41. Ibid., 43: "Et quia intellectus noster, qui non potest concipere simplex, cum conceptum faciat in imaginatione, quae ex sensibilibus sumit principium seu subiectum imaginis suae seu figurae, hinc est quod intellectus essentiam rerum concipere nequit. Videt tamen eam supra imaginationem et conceptum suum indivisibilem triniter subsistere."

42. Ibid., 27: "Et si applicas oculare et vides per maximum pariter et minimum modum omnis modi principium, in quo omnes modi complicantur et quem omnes modi explicare nequeunt, tunc facere poteris de divino modo veriorem speculationem."

43. Savanarola, *Predica dell'arte del ben morire* (Florence, 1496), quoted in Summers, *Michelangelo and the Language of Art*, 114–15.

44. See the illuminating discussion in Hamburgh, "Naldini's *Allegory of Dreams*."

## CHAPTER THREE

1. Bacon, *New Organon*, bk. 1, aphorism XLI ("The Idols of the Tribe"): "Falso enim asseritur, sensum humanum esse mensuram rerum; quin contra, omnes perceptiones, tam sensus quam mentis, sunt ex analogia hominis, non ex analogia universi. Estque intellectus humanus instar speculi inaequalis ad radios rerum, qui suam naturam naturae rerum immiscet, eamque distorquet et inficit." Cf. Clark, *Vanities of the Eye*.

2. Van Helden, "The Telescope," 55.

3. Galileo, "The Assayer," in *The Controversy*, 183–84.

4. Grassi, "Disputation," in *The Controversy*, 6–7, 14.

5. Concerning the significance of the superlunary position of comets see van Nouhuys, *The Age of Two-faced Janus*.

6. Grassi, "Disputation," *The Controversy*, 6.

7. Favaro asserts that "the pages of the first part . . . have corrections and additions in Galileo's handwriting. A second part . . . is entirely in Galileo's writing. The third part in Guiducci's hand . . . but there are corrections by [Galileo]" and concludes that "the entire discourse may be said to be essentially his work" (*The Controversy*, xvi–xvii).

8. Grassi, "Balance," in *The Controversy*, 70.

9. Galileo, "Assayer," in *The Controversy*, 169.

10. Grassi, "Disputation," in *The Controversy*, 11.

11. For the persistence of Aristotelian modes of argumentation and basic precepts in face of internal challenges to specific doctrines cf. Grant, "Aristotelianism and the Longevity of the Medieval World View."

12. Grassi, "Disputation," in *The Controversy*, 15, 17.

13. Ibid., 17

14. Guiducci, "Discourse," in *The Controversy*, 50.

15. Ibid., 27.

16. Ibid., 36–37.

17. Ibid., 39–40.

18. Ibid., 39.

19. Ibid.

20. Ibid., 31–32.

21. Drake and O'Malley, *The Controversy*, xxiii.

22. Cassirer, "The Influence," 316.

23. Cf. Koyré, "Galileo and Plato"; De Caro, "Galileo's Mathematical Platonism."

24. Cf. Biagioli, *Galileo's Instruments of Credit*, 220ff. Palmerino, "The Mathematical Characters of Galileo's Book of Nature," offers a synthesis of the two approaches.

25. Galileo, "Assayer," in *The Controversy*, 183–84.

26. Ibid., 311.

27. Shea, *Galileo's Intellectual Revolution*, 86–87.

28. Cassirer, "The Influence," 316.

29. This was not always the case: in his *De Motu* of the 1590s he rejects Copernicanism. See Gal, "Tropes and Topics."

30. Grassi, "Balance," in *The Controversy*, 71.

31. Finocchiaro, *The Galileo Affair*, 87–99.

32. Galileo, "Assayer," in *The Controversy*, 180.

33. Kepler, *Kepler's Conversation with Galileo's Sidereal Messenger*, 22.

34. Ibid.

35. Guiducci's manuscript carries corrections and additions in Galileo's hand (Drake and O'Malley, *The Controversy*, xvi–xvii.)

36. Guiducci, "Discourse," in *The Controversy*, 40.

37. Drake, *The Controversy*, xiii–xiv, and especially Shea, *Galileo's Intellectual Revolution*, 88.

38. Shea, *Galileo's Intellectual Revolution*, 86–87.

39. Ibid., 88.

40. Ramponi, cited ibid., 86.

41. Ibid, 85.

42. Galileo, *Opere*, 2:277–84. Cf. Dupré, "Galileo's Telescope," 373.

43. Grassi, "Disputation," in *The Controversy*, 14 (italics added).

44. Ibid., 5

45. Malet, "Early Conceptualizations of the Telescope."

46. Sarsi, "Balance," in *The Controversy*, 80–81.

47. Ibid., 79.

48. Ibid., 82.

49. Galileo, "Assayer," in *The Controversy*, 209.

50. Ibid., 220.

51. Ibid., 221.

52. Ibid., 321.

53. Ibid., 324. On traditional views about irradiation and Galileo's in particular Cf. Dupré, "Galileo's Telescope and Celestial Light."

54. Grassi, "Disputation," in *The Controversy*, 17.

55. Galileo, "Assayer," in *The Controversy*, 326.

56. Ibid., 319-20.

57. Ibid., 322-23.

58. Scheiner, *Oculus*, 2. See chapter 1.

59. Galileo, "Assayer," in *The Controversy*, 209. Malet writes: "In our understanding of them, telescopes always work by próducing geometrical optical images, real or virtual, regardless of whether or not any observer is peering through them. From our theoretical point of view, it does not matter whether an eye, or a screen, or just empty space gets the light rays coming out of the ocular lens, because the telescope *always* produces one geometrical image. However, in Kepler's time, and up to the last decades of the seventeenth century, when somebody looked through a telescope, it was not understood to work by producing images similar to the pictures projected upon screens" (Malet, "Early Conceptualizations of the Telescope," 239). We differ from Malet in arguing that in spite of the absence of theoretical grounding, the independence of the geometrical image from the observer is exactly the position Galileo formulates and defends.

60. Galileo, "Assayer," in *The Controversy*, 225.

61. Dupré, "Ausonio's Mirors and Galileo's Lenses." See also Zik and van Helden, "Between Discovery and Disclosure."

62. Faber, "Dedication to Galileo," in *The Controversy*, 154.

63. Kepler, *Harmony of the World*, 304.

64. Galileo, "Assayer," in *The Controversy*, 212-13.

65. Ibid., 183-84.

66. Cf. Bono, *The Word of God and the Languages of Man*, esp. ch. 6.

67. Galileo, "Assayer," in *The Controversy*, 311.

68. Ibid., 311-12.

69. For the Jesuits project of New Science in the service of faith cf. Feldhay, *Galileo and the Church*, and Dear, "Jesuit Mathematical Science."

70. Van Helden, "The Telescope," 53.

71. Kepler, *New Astronomy*, 89. (See chapter 1.)

72. Galileo, "Assayer," *The Controversy*, 184.

73. Cf. Dear, *Discipline & Experience*.

74. Riccioli, *Almagestum Novum*, 56.

75. Ibid., 55, right column.

76. Cited by Malet, "Early Conceptualizations of the Telescope," 247.

77. Riccioli, *Almagestum Novum*, 56 left column (italics added).

78. Hooke, *Lectiones Cutlerianae*.

79. Hooke, *Animadversions*, 4 (italics in original).

80. Cf. Van Helden, "Telescopes and Authority from Galileo to Cassini."

81. Van Helden, "The Telescope," 47.

82. Hooke, *Animadversions*, 11.

83. Ibid., 5 (italics original, underline added).

84. Ibid., 8.

85. Ibid., 9.

86. Buchwald, "Discrepant Measurements," 592 n 84, 613-15.

87. Hevelius, *Johannis Hevelii annus climactericus*.

88. Buchwald, "Discrepant Measurements," 614.

89. Hevelius, "An Extract of Monsieur Hevelius's Letter," 27: "in isto Dioptrarum negotio."

90. Ibid., 29.

91. Ibid., 28.

92. Hooke, *Micrographia*, xvii. The preface to the *Micrographia* was not originally paginated. We used the pagination provided in Google Books. It is printed in italics, with stressed words unitalicized. We reversed the italicization for the sake of readability.

93. Hevelius, "An Extract," 27-28.

94. Hooke, *Micrographia*, xi. "oculos novos mihi arte paravi," wrote Reneri to Mersenne in 1688, cited by Lüthy, "Atomism," 1.

95. Scheiner, *Rosa Ursina*, cited by Malet, "Early Conceptualizations of the Telescope," 247.

96. Ibid.

97. Sprat, *History of the Royal Society*, 2.

98. Hooke, *Micrographia*, xvii.

99. Ibid.

100. Ibid.

101. Ibid., xvii–xviii.

102. Ibid., xviii.

103. Winkler and van Helden," Johannes Hevelius and the Visual Language of Astronomy," 111.

104. Hooke, *Animadversions*, 32.

105. Galileo, "Assayer," in *The Controversy*, 183-84.

106. Hooke, *Micrographia*, 1.

107. Ibid.

108. Ibid.

109. Ibid., 1-2.

110. Ibid., 8, 4, 8.

111. Ibid., 2.

112. Ibid., 8.

113. Ibid.

114. Ibid., 2.

115. Malebranche, *The Search after the Truth*, 25, 732, 733, 25.

116. Grassi, "Disputation," in *The Controversy*, 5.

117. Hooke, *Micrographia*, xxxii.

118. Galileo, "Assayer," in *The Controversy*, 324.

CHAPTER FOUR

1. Kepler, *Ad Vitellionem*, Dedication to the Emperor, 10: "Neque animum explevi speculationibus Geometriae abstractae, picturis scilicet Και των οντων και μη οντων, in quibus pene solis hodie celeberrimi Geometrarum aetatem transigunt: sed Geometriam per ipsa expressa Mundi corpora, Creatoris vestigia cum sudore et anhelitu secutus, indagaui."

2. Galileo, *Dialogues Concerning the Two New Sciences*, Third Day [197], 160.

3. Concerning Kepler, see Stephenson, *Kepler's Physical Astronomy*; Stephenson, *The Music of the Heavens*. Concerning Galileo, see Gouk, *Music, Science and Natural Magic*; Coelho (ed.), *Music and Science in the Age of Galileo*.

4. On traces in general and in the seventeenth century in particular see Sutton, *Philosophy and Memory Traces*.

5. See also Field, *Kepler's Geometrical Cosmology*; Stephenson, *Kepler's Physical Astronomy*; Stephenson, *The Music of the Heavens*.

6. Kepler, *Harmony*, 146-47: "Geometria enim . . . Deo coaeterna, inque Mente divina relucens, exempla Deo suppeditavit, . . . exornandi Mundi, ut in fieret Optimus et Pulcherimus, denique Creatoris similimus. Dei vero Creatoris imagines sunt, quotquot Spiritus, Animae, Mentes. . . . Cum igitur typum quendam Creatoris sint complexae suis munijs: leges etiam cum Creatore easdem observant operis, ex geometria desumptas." Kepler, *Harmonices mundi*, bk. 3, axiom 7, at *GW* 6:104-5.

7. Kepler, letter to Maestlin, no. 23, at *GW* 13:38: "Motrix anima ut dixi, in Sole. . . . Sed accidit alia causa quae tardiores efficit remotiores. Capiamus a luce experimentum. Nam lux et motus utique ut origine sic etiam actibus conjunctj, et forsan ipsa lux vehiculum motus est. Igitur in parvo orbe, et sic etiam in parvo circulo prope Solem tantum est lucis, quantum in magno et remo-

tiore. Tenuior igitur lux in magno, in angusto confertior et fortior. At haec fortitudo rursum est in circulorum proportione, sive in distantiarum."

8. Kepler, *Mysterium Cosmographicum*, 60/169.

9. *Harmonices mundi*, bk. 4, chap. 3, at *GW* 6:232: "Generaliter autem in omnibus rebus, in quibus quantitas, et secundum eam Harmoniae, quaeri possunt, insunt illae multo evidentiores per motum, quam sine motu. Nam et si in est in unaqualibet linea recta, ejus dimidium, tertia, quarta, quinta, sexta, earumque multiplices: latent tamen eae, inter partes alias, toti incomensurabiles, in una et eadem confusione cum tota." Aiton et al. suggest a somewhat different translation for the first sentence in Kepler, *Harmony*, 315.

10. "Adeoque ne mens ipsa quidem in data quantitate, proportiones harmonicas, sine quadam motus imagine, discernit ab inconcinnis infinitis, ante et post stantibus." Kepler, *Harmonices mundi*, bk. 4, chap. 3, at *GW* 6:233 (italics added).

11. Kepler, *Harmonices mundi*, bk. 3, chap. 1, at *GW* 6:102 : "Chorda hic sumitur non pro subtensa arcui circuli, ut in Geometria, sed pro omni longitudine, quae apta est ad sonum edendum; et quia sonus per motum elicitur; in abstracto chorda inteligenda est de longitudine motus cuiuscunque, vel de quacunque alia longitudine, etiam mente concepta"

12. Kepler, *Optics*, 20–22.

13. Ibid., 19–20.

14. Ibid., 22 (italics original, underline added).

15. Kepler, *Harmonices mundi*, bk. 4, chap. 1, at *GW* 2:40: "Radius in perspicuo (quatenus perspicuum) non est, sed fuit, vel quasi fuit." For discussion of Kepler's concept of ray cf. Chen-Morris, "Optics, Imagination, and the Construction of Scientific Observation in Kepler's New Science."

16. Kepler, *Dioptrice*, 61: "Quemadmodum omnis sensus externus perficitur receptione et impressione, passione scilicet; cum imprimitur ei quod sentit, species rei externae: et haec passio sensio dicitur. Sic etiam intus in cerebro est aliquid, quicquid sit, quod communis sensus dicitur, cui imprimitur species instrumenti visorij affecti, hoc est picti a luce rei visibilis." At *GW* 4:372.

17. Kepler, *Ad Vitellionem*, 15: "Vbi consideratur rerum species, seu lux et umbra."

18. Cf. Alpers, *The Art of Describing*, chap. 2.

19. Kepler, *Dioptrice* 45, at *GW* 4:372.

20. Kepler, *The Harmony*, 316, 233.

21. Galileo, *Dialogue Concerning the Two Chief World Systems*, 171–72.

22. Oresme, *Nicole Oresme and the Medieval Geometry*, 165–69; Witelo, *Perspectiva*, 46/240 (bk. 2 prop. 3): "Omnis linea qua pervenit lux . . . est linea naturalis sensibilis . . . in qua est linea mathematica ymaginabiliter assumenda."

23. Regiomontanus, *De triangulis*, 37: "Nam idem est principium generationis omnibus lineis commune, scilicet punctus, cuius fluxu sive motu imaginario lineas nasci praedicans mathematici."

24. Alberti, *On Painting*, 98: "Fugienda est consuetudo non nullorum qui suoppte ingenio ad picturae laudem contendunt, nullam naturalem faciem eius rei oculis aut mente coram sequentes."

25. Galileo, *Sidereus Nuncius*, quoted by Reeves, *Painting the Heavens*, 11.

26. Cf. Edgerton, "Galileo, Florentine 'Disegno,' and the 'Strange Spottedness' of the Moon."

27. Galileo, "Assayer," in *The Controversy*, 311.

28. Cf. Feldhay, *Galileo and the Church*; Dear, *Discipline & Experience*.

29. Cf. Renn et al. "Hunting the White Elephant," Lefèvre (ed.), *Picturing Machines*.

30. Cf. Laird, "Galileo and the Mixed Sciences"; Lennox, "Aristotle, Galileo and the Mixed Sciences."

31. Cf. Bertoloni Meli, "Guidobaldo dal Monte and the Archimedean Revival"; Machamer, "Galileo's Machines, His Mathematics, and His Experiments." in: Machamer, *Cambridge Companion to Galileo*.

32. Shea, "The Galilean Geometrization of Motion," 51–60; Naylor, "Galileo, Copernicanism, and the Origins of the New Science of Motion"; Renn et al., "Hunting the White Elephant."

33. Koyré, *Galileo Studies*, 67.

34. Renn et al., "Hunting the White Elephant."

35. Galileo, *Dialogues Concerning the Two New Sciences*, Second Day [185–86], 148–49.

36. For the material embodiment of geometry in general and in Galileo in particular, cf. Büttner, "The Challenging Images of Artillery."

37. Galileo, *Dialogues Concerning the Two New Sciences*, First Day [96], 52.

38. Ibid.

39. The literature about Galileo's treatment of the *Rota Aristotelis* has stressed the atomism motivating his discussion, which he hopes to support by the successful solution of the paradox. Cf. Drabkin, "Aristotle's Wheel." Our interest is not in Galileo's theory of matter but in the relations between mathematics, motion, and order reflected in his argumentation and the setting of the dialogue. A somewhat similar perspective is offered by Carla-Rita Palmerino: "the *Rota Aristotelis* functions in the *Two New Sciences* . . . to transform continuist theory of motion into an atomist theory of space, time and matter, and back again." Palmerino, "Galileo and Gassendi," 384.

40. Although it is no longer perceived as a paradox, modern textbooks still reflect the tension at this boundary by offering either a mathematical or a physical solution to the ancient wonder, but never both. The mathematical solution is that the points on the different sized circumferences can still map one to one because the cardinality of the infinities is the same. The physical is that one wheel does slip along (against the ancient assumption), as can be verified empirically.

41. Galileo, *Dialogues Concerning the Two New Sciences*, First Day, [60–65], 12–18.

42. Ibid., [66], 18.

43. Ibid., [67], 20.

44. Ibid., [95], 51.

45. Ibid., [60], 12–13.

46. Galileo, *Dialogue Concerning the Two Chief World Systems*, 207. See discussion in Palmerino, "Galileo and Gassendi," 400–402.

47. Palmerino, "Galileo and Gassendi," 382.

48. For the context of Alberti's theory of painting cf. Grafton, *Leon Battista Alberti*, esp. 111–49.

49. Alberti, *On Painting*, 98. "At ex partibus omnibus non modo similitudinem rerum, verum etiam in primis ipsam pulcheritudinem diligat."

50. Ibid., 73. Translation slightly amended.

51. Ibid., 37.

52. Ibid., 98: "Ergo a pulcherrimis corporibus omnes laudatae partes eliggendae sunt. Itaque non in postremis ad pulchhritudinem percipiendam, habendam atque experimendam studio et idustria contenndendumm est . . . quod non uno loco omnes pulchritudinis laudes comperiantur sed rarae illae quidem ac dispersae sint."

53. Ibid., 68.

54. This is Dürer's interpretation of Alberti—it is obviously problematic in application, as it will produce a very distorted figure of the reclining woman, with a small head and large knee.

55. Alberti, *On Painting*, 33.

56. Quoted in Kemp, *Leonardo da Vinci*, 302.

57. Leonardo, *The Notebooks*, 2:65.

58. Cf. Galluzzi, "Art and Artifice in the Depiction of Renaissance Machines," 66–68.

59. Leonardo, *The Notebooks*, 2:273.

60. Ibid., 2:477.

61. Quoted in Kemp, *Leonardo da Vinci*, 298.

62. The refraction of light at the eye's surface creates a wider visual angle than that assumed by Albertian perspective, with the effect that "the eye judges the size of an object as being larger than that which is shown in the painter's perspective." Quoted in Kemp, *Leonardo da Vinci*, 331.

63. Ibid., 332–34.

64. Quoted in Drake and Drabkin, *Mechanics in Sixteenth-Century Italy*, 65.

65. Ibid., 84.

66. Ibid.

67. Cf. Renn et al. "Hunting the White Elephant"; Büttner et al., "The Challenging Images of Artillery."

68. Maestlin, *De Astronomiae Principalibus*, folio A2ᵛ (italics added).

69. Freedberg, *The Eye of the Lynx*, 349.

70. Pliny, *Natural History*, bk. XXV iv.8, 7:140–41, translation amended.

71. Freedberg, *The Eye of the Lynx*, 349.

72. Jones, *The Good Life in the Scientific Revolution*, 39. The following analysis of Descartes' concept of mathematical certainty owes much to Jones (especially chap. 1, 15–53). Our purposes and conclusions, however, are different from his. As his title suggests, Jones stresses the moral value of mathematics as a practice. Our main interest is in the epistemological ramifications of Descartes' turn to habits and artificial means of tracing to produce mathematical certainty. For Descartes' iconography of motion, cf. Lüthy, "Where Logical Necessity Becomes Visual Persuasion"; Lüthy, "The Invention of Atomist Iconography." For Descartes' indebtedness to Kepler in his analysis of motion, see Mahoney, "The Mathematical Realm of Nature," esp. 714; Gaukroger, *Descartes*, esp. 129, 297.

73. Descartes, *Regulae*, Regula xiv, 440: "Praecipuam partem humanae industriae non in alio collocari, quam in proportionibus istis eo reducendis, ut aequalitas inter quaesitum, & aliquid qoud sit cognitum, clare videtur." Cf. Jones, *The Good Life*, 33.

74. Leibniz in particular. Cf. Dascal, "Leibniz and Epistemological Diversity."

75. Descartes, *Regulae* xiv, 440: "quando enim [comparatio] aperta est & simplex, nullo artis adjumento, sed solius naturae lumine est opus ad veritatem, quae per illam habetur, intuendam." Cf. Jones, *The Good Life*, 33.

76. Rule vii explains how "the weakness of our memory" prevents long deductions from being genuine intuitions.

77. Cf. Van Maanen, "Seventeenth Century Instruments for Drawing Conic Sections"; Taimina, "Exploring Linkages."

78. Descartes, "Geometry," in *Discourse On Method*, 190.

79. Ibid., 191.

80. Jones, *The Good Life*, 30–31.

81. Descartes, *Rules for the Direction of the Mind*, Rule 10, in CSM 1:35. *Regulae*, Regula x: "levissima quasque artes & simplissimas prius esse dicutiendas, illasque maxime, in quibus ordo magis regant, ut sunt artificum qui telas et tapestria texunt, aut mulierum quae acu pingunt." Cf. Jones, *The Good Life*, 31; James, *Passion and Action*, 219.

82. On Descartes' epistemological requirements of mathematics see Mahoney, "Infinitesimals and Transcendent Relations"; Mahoney, "The Beginnings of Algebraic Thought."

83. Cf. Mancosu, *Philosophy of Mathematics and Mathematical Practice in the Seventeenth Century*.

84. The segments *NR* and *LO*, which are the path *MS* viewed as receding from the point *B*, are equal to the arcs *NB* and *LB*, respectively. The curve *BRS* will be called the "involute" of the circle when investigated in the *Horologium Oscillatorium*. Cf. De Gandt, *Force and Geometry*, 134–37; Gal, *Meanest Foundations*, 184–88.

85. Huygens, *Oeuvers* 16, 197.

86. A thorough analysis of the excruciating details of Huygens' process of discovery was offered by Michael S. Mahoney in a series of incomparable papers: "Huygens and the Pendulum"; "Christiaan Huygens: The Measurement of Time and of Longitude at Sea"; and "Drawing Mechanics."

87. Mahoney, "Huygens and the Pendulum."

88. Huygens, cited by Mahoney, "The Measurement of Time and of Longitude at Sea."

89. Cf. Landes, *Revolution in Time*; Yoder, *Unrolling Time*; Gal, *Meanest Foundations*.

90. Cf. Mahoney, "The Mathematical Realm of Nature."

91. For a close analysis of Hooke's spring law and the consequent isochrony of springs see Gal, *Meanest Foundations*, chap. 2.

92. Hooke, *Lectures De Potentia Restitutiva*, 19.

93. Ibid., 1.

94. For a comprehensive analysis of the theory of matter that Hooke develops in the *Micrographia* and *Lectures De Potentia Restitutiva* see Gal, *Meanest Foundations*.

95. Hooke, *Micrographia*, 15.

96. Ibid., 16.

97. Ibid., 12.

98. Hooke, *Lectures De Potentia Restitutiva*, 9.

99. Ibid., 17.

100. Galileo, *Dialogue (Dialogo)*, Second Day, fig. 15, 228.

101. Galileo, *Dialogues (Discorsi)*, Third Day, Theorem I, Propositions I and II and Corollary I; figs. 47–49, 173, 176.

102. Cf. Galluzzi, *Momento*.

103. Hooke, *Lectures De Potentia Restitutiva*, 19–20.

104. Ibid., 16.

105. Ibid., 20.

106. Mahoney, "Huygens and the Pendulum."

107. Newton, *Principia*, 382. Given the momentous importance of this short text—one page of philosophical musings prefacing the *Principia* (the other couple of paragraphs are a short introduction of the topics of the three books and an acknowledgment of Halley and the Royal Society)—it is almost bizarre how little attention it has drawn. The only part of the preface that historians and philosophers of science seem to have noticed is the little cliché concerning philosophy's goal "to discover the forces of nature from the phenomena of motions and then to demonstrate the other phenomena from these forces" (ibid.).

108. Newton, *Principia*, 381.

109. Descartes, "Geometry," in *Discourse on Method*, 190 (italics added).

CHAPTER FIVE

1. Halley's *Ode to Newton*, in Newton, *Principia*, xiii. We preferred the translation of the ode in the old Motte edition to the one in the otherwise more accurate and updated Cohen that we used everywhere else.

2. Voltaire, *The Works*, 7:80.

3. Halley, *Ode to Newton*, *Principia*, xiv.

4. For the emergence of the concept of natural law in the seventeenth century see Steinle, "The Amalgamation of a Concept: Laws of Nature in the New Sciences." The literature on the religious aspects of the New Science and its laws of nature is too extensive to be accounted here; for a recent analysis and bibliography see Gaukroger, *The Emergence of a Scientific Culture*, esp. chaps. 2 and 4. An interesting aspect of this religiosity is brought to light by Brockey's account of the Jesuits' use of these ideas in their attempts to convert the high cultures of East Asia in his *Journey to the East*.

5. Cf. Fara, *Newton: The Making of a Genius*.

6. Kepler, *Harmony*, 146–47; *Harmonices mundi*, bk. 3, axiom 7, at *GW* 6:104–5.

7. Hooke, "Robert Hooke to Isaac Newton, November 24, 1679," in *The Correspondence of Isaac Newton* 2:297. For a detailed study of the correspondence between Hooke and Newton see Gal, *Meanest Foundations*, esp. the introduction.

8. Hooke, *The Correspondence of Isaac Newton* 2:297.

9. Newton, "Isaac Newton to Robert Hooke, December 13, 1679," in *The Correspondence of Isaac Newton* 2:308.

10. Cf. Gal, "Hooke's Programme: Final Thoughts." Michael Nauenberg claims that Newton is basing his claim on a calculation ("Robert Hooke's Seminal Contribution"). There is no evidence to support this claim. Cf. De Gandt, *Force and Geometry in Newton's "Principia."*

11. Kepler, *New Astronomy*, 119.

12. To be exact, to the level of "theoria": in traditional astronomy this is status of the plotted orbit.

13. Cf. Field, *Kepler's Geometrical Cosmology*; Stephenson, *Kepler's Physical Astronomy* and *The Music of the Heavens.*

14. Kepler, *Mysterium Cosmographicum* [2nd ed.], 96–97.

15. Ibid., 167.

16. Ibid., 53–55.

17. Ibid., 122.

18. Kepler, *New Astronomy*, 89.

19. For the persistence of the metaphysics of the *Mysterium* in Kepler's later work see Voelkel, *The Composition of Kepler's "Astronomia Nova."*

20. Kepler, *Mysterium Cosmographicum*, 168–69.

21. Ibid., 96–97.

22. Ibid., 122.

23. Ibid.

24. Newton, *Principia*, 534–45.

25. Ibid., 544.

26. Newton to Hooke, in *The Correspondence of Isaac Newton* 2:297.

27. Newton, *Principia*, 534.

28. Ibid., proposition 1, theorem 1, 444–46.

29. On the import of the proof of Kepler's area law in the *Principia* and its drafts see De Gandt, *Force and Geometry.*

30. Newton, *Principia*, proposition 2, theorem 2, 446–48.

31. Ibid., proposition 43, 534.

32. Ibid., proposition 44, 535.

33. Ibid., 545.

34. Ibid., 943.

35. Ibid., 537

36. Newton, *Principia*, 943.

37. Newton, quoted in Herivel, *The Background to Newton's Principia*, 297.

38. Whiteside, "Newton's Lunar Theory," 319.

39. Ibid., 324.

40. Newton, *Principia*, 840.

41. Newton, *Principia* (1st ed.), 462: "vitio Tabularum tibuendum esse." Cf. Whiteside, "Newton's Lunar Theory," 321.

42. Halley's *Ode to Newton*, Newton *Principia*, xiv.

43. Chandler's "The *Principia*'s Theory of the Motion of the Lunar Apse" and Westfall's "Newton and the Fudge Factor" make a similar point.

44. Newton, *Principia*, 570 (translation slightly modified).

45. Ibid., 793, 794, 795, 943 (italics added).

46. Cf. Gal, *Meanest Foundations.*

47. Ibid., 194–213.

48. Ibid., 197–206, 174.

49. Newton, *Principia*, 452.

50. Ibid., proposition 4, 450.

51. Ibid., 448–49.

52. Ibid., 444, 462, 459, 462–63. In this discussion we are much indebted to George Smith's excellent analysis of these theorems in "From the phenomenon of the Ellipse to an Inverse-Square Force: Why Not?"

53. Smith, "From the Phenomenon of the Ellipse," 40.

54. Westfall, "Newton and the Fudge Factor," 755, 752.

55. Ibid., 752. Kollerstrom ("Newton's Two 'Moon-Tests,'" 371) notes that Newton did not in fact think or calculate in terms on accelerative gravity: "Historians have preferred to treat the Moon-test as though it had been formulated in terms of the acceleration due to gravity, rather than deal with the now arcane geometrical methods used to deal with the motion of falling objects, before algebraic methods of treatment had been devised." For our purposes here Westfall's anachronism can be excused.

56. Westfall, "Newton and the Fudge Factor," 754.

57. Newton, *Principia*, 943.

58. Westfall, "Newton and the Fudge Factor," 757, 755, 752.

59. Newton, *Principia*, book three, General Scholium, 943 (italics added).

60. Newton, *System of the World*, 24.

## CHAPTER SIX

1. On the priority disputes concerning the "discovery" of the ISL cf. Lohne, "Hooke versus Newton"; and Gal, *Meanest Foundations*, 168–88.

2. Herivel, *Background*, 192–98.

3. Quoted ibid., 195: "Denique in Planetis primarijs cum cubi distantiarum a sole reciproce sunt ut quadrati numeri periodorum in dato tempore: conatus a sole recedendi reciproce erunt ut quadrata distantiarum a sole."

4. Hooke, *Micrographia*, 227 (square parenthesis in the original).

5. Ibid.

6. Newton, *The Correspondence of Isaac Newton* 2:309.

7. Ibid., 297.

8. Ibid., 301.

9. *Op. cit.*, 305.

10. Cf. Gal, "Hooke, Newton, and the Trials of Historical Examination."

11. Newton, *The Correspondence of Isaac Newton* 2:308.

12. Ibid., 309.

13. Ibid., 313.

14. Ibid.

15. Hooke, *An Attempt to Prove the Motion of the Earth from Observations*, 27–28.

16. On Hooke's use of experiments as a means of conceptualization see Bennett, "Robert Hooke as Mechanic and Natural Philosopher."

17. Cf. Gal, "Hooke's *Programme*."

18. Birch, May 23, 1666, 2:91.

19. Ibid.

20. Ibid., 92.

21. Ibid., 91–92.

22. Ibid., 92.

23. Newton, *The Correspondence of Isaac Newton* January 17, 1680, 2:313, 306 (italics added).

24. Birch, 1666, 2:92, 89.

25. *Philosophical Transactions*, Monday, August 6, 1666, 16:263–88.

26. Ibid., 264.

27. Ibid., 265.

28. Ibid. Galileo first presented his "Discorso sul flusso e il reflusso delmare" in 1616 as a letter to Cardinal Orsini (*Opere* 5:377–95; English version in Finocchiaro, *The Galileo Affair*, 119–33). Wallis' reference is to the version of the theory of the tides published in the Fourth Day of Galileo's *Dialogue Concerning the Two Chief World Systems* (trans. Drake), 416–65.

29. *Opere,* 5:388, 391.

30. *Philosophical Transactions* 1666, 16:272.

31. *Opere,* 5:388.

32. Hale, *An Essay,* 10, 14, 15.

33. Birch, 1666, 2:89.

34. Ibid., 91.

35. Hooke, *Micrographia,* 225.

36. Ibid., 227.

37. Hooke, *Posthumous Works,* 114.

38. Ward, *Ismaelis Bullialdi astronomiae philolaicae fundamenta*; Streete, *Astronomia Carolina;* Wing, *Astronomia Britanica.*

39. Hale, *An Essay,* 18.

40. Birch, July 6, 1663, 2:272.

41. Hooke, *Micrographia,* xix.

42. Ibid., 217–40.

43. Wing, *Examen astronomiae Carolinae,* 5.

44. Gal, *Meanest Foundations,* 34–57.

45. Hooke, *Micrographia,* 220.

46. Ibid., 219. For a discussion of Hooke's development of "inflection" see Gal, *Meanest Foundations,* chap. 1.

47. Hooke, *Micrographia,* 225.

48. *Birch,* December 10, 1662, 1:141–44.

49. Ibid., 142.

50. Hooke, *Lectures of Light,* in *Posthumous Works,* 114.

51. Ibid.

52. Ibid., 113 (italics in original).

53. Trinity College MS O.11.a.1[16c].

54. Hooke, *Lectures of Light,* in *Posthumous Works,* 114. For Hooke's vibration theory of matter see Gal, *Meanest Foundations,* 86–92, 127–31.

55. Trinity College MS O.11.a.1[16c].

56. Ibid.

57. Hooke, *Lectures of Light,* in *Posthumous Works,* 114 (italics added).

58. Kepler, *Ad Vitellionem,* 10: "Sicut se habent sphaericae superficies, quibus origo lucis pro centro est, amplior ad angustiorem: ita se habet fortitudo seu densitas lucis radiorum in angustiori, ad illam in laxiori sphaerica superficie, hoc est, conuersim. Nam per 6. 7 tantumdem lucis est in angustiori sphaerica superficie, quantum in fusiore, tanto ergo illic stipatior & densior quam hic. Si autem radii linearis alia atque alia esset densitas, pro situ ad centrum (quod Proposition 7 negatum est) res aliter se haberet." We use *Ad Vittelionem* for the original and *Optics* for William Donahue's translation.

59. Kepler, *New Astronomy,* 89 (italics added).

60. Ibid., 376 (title of chapter 33).

61. Ibid., 372 (title of chapter 32).

62. Ibid., 380.

63. Ibid., 394 (title of chapter 36).

64. Ibid., 397.

65. Boulliau, *Astronomia philolaica*, liber I, caput X, 24: "In hunc imminutionis scopulum al-lidens ipsius Astronomia fibrata naufragium facit."

66. Ibid., 23.

67. Newton, *The Correspondence of Isaac Newton* 2:438.

68. Kepler, *New Astronomy*, 372, 376.

69. Ibid., chapter 33, 376-78.

70. Ibid., 378-80 (italics added).

71. Ibid.

72. "Sphaericum Lucis (adeoque mundi) archetypus." Kepler, *Ad Vitellionem*, 7.

73. Kepler, *Optics*, 19. "Hinc Centri punctum, est spahaerici quaedam quasi origo, superficies puncti intimi imago, & via ad id inueniendum, quaeque infinito puncti egressu ex se ipso, vsque ad quondam omnium egressum aequalitatem, gigni intelligetur, puncto se in hanc amplitudinem communicante, sicvt punctum & superficies, densitatis cum amplitudine commutata proportione, sint aequalia. Hinc est vndique punctum inter & superficiem absolutissim vnio, pulcherrima con-spiratio, connexus, relatio, proportio, commensus." Kepler, *Ad Vitellionem*, 6.

74. Ibid.

75. Kepler, slightly modified from Donahue's translation in *Optics*, 19-20. ". . . instrumentum Creatoris, ad figuranda & vegetanda omnia . . . matrix animalium facultatum, viniculumque corpo-rei & spiritualis mundi, in leges easdem transfiuerit." Kepler, *Ad Vitellionem*, 7.

76. Kepler, *Mysterium Cosmographicum*, 53-55 (Latin original)/155-59 (English translation).

77. Ibid., 63/175.

78. Ibid., 75/199: "vnam esse motricem animam in orbium omnium centro, scilice in Sole; quae, vt quodlibet corpus est vicinitus, ita vehementius incitet."

79. Ibid., 76/201.

80. Ibid (italics added).

81. Witelo, *Perspectiva II*, 62.

82. Cf. Lindberg, in Lindberg and Cantor, *The Discourse of Light*, 51.

83. Kepler, *Mysterium Cosmographicum*, 76/201.

84. Ibid., 59/167.

85. Ibid., 60/169 (footnote to the second edition).

86. Dee read both Grosseteste and Nicholas of Cusa. Clulee, *John Dee's Natural Philosophy*, 55, 153.

87. Dee, in Josten, "A Translation of John Dee," 155 (Theorems 2 and 3).

88. Grosseteste, *Robert Grosseteste: On Light*, 10.

89. Ibid., 12.

90. Ibid., 16.

91. Kepler's indebtedness to Grosseteste is frequently suggested (e.g. Aiton et al. in their an-notations to Kepler's *Harmony of the Heavens*, xli and 292 n. 12), but Lindberg's remark that "it is generally impossible to identify the specific sources of Kepler's thought on light, since . . . he does not cite them" (Lindberg, "The Genesis of Kepler's Theory of Light," 29) is especially pertinent in the case of Grosseteste, who is never (to our knowledge) mentioned by him. It is somewhat of a mystery, since Kepler was usually generous with his sources, and the similarity between him and Grosseteste is too obvious to deny. Concerning Grosseteste's theory of light see Lindberg, *Theories of Vision*, 94-102, and introduction in *Roger Bacon's Philosophy of Nature*, xlix-lv.

92. Scholem, *Major Trends in Jewish Mysticism*, 20.

93. Cf. Marrone, *William of Auvergne and Robert Grosseteste*, 167-88.

94. Grosseteste, *Robert Grosseteste: On Light*, 13.

95. Nicholas de Cusa, *De Ludo Globi*, 67, fol. CLV.

96. Ibid., 93, fol. CLXI.

97. Ibid., 95, fol. CLXII.

98. Ibid.

99. Ibid., 57, fol. CLII.

100. Ibid.

101. Ibid, 101, fol. CLXIII.

102. Smith, introduction to Witelo, *Perspectiva* V; 20ff.

103. Cited in Lindberg, *Theories of Vision*, 63.

104. "Lux & color reflexi sunt debiliores luce & colore primis: fortiores autem secundis, cum quibus ab eodem aequabliter distant." Alhacen, *De aspectibus*, p. iv c. 5, 103.

105. "Poterit aliquis dicere, non esse debilitatem formarum in reflexione, nisi ex elongatione earum a sua origine. Sed explanabitur, quod licet ab ortu aequaliter elongatur lux directa & lux reflexa: tamen debilior erit reflexa." Ibid.

106. Bacon, *Bacon's Philosophy of Nature*, 207.

107. Ibid., 217.

108. Grosseteste, *Robert Grosseteste: On Light*, 10.

109. Kepler, *Optics*, 19–20.

110. Bacon, *Bacon's Philosophy of Nature*, 208, 209: "Quadpropter distantia in quantum huiusmodi no videtur esse causa cum tali expositione."

111. Pecham, *John Pecham and the Science of Optics*, 94, 95: "In puncto proprionquiori fortior est lux unius corporis quam in remotiori."

112. Witelo, *Perspectiva* II, 61.

113. Strenuously argued in proposition 6; see Unguru's commentary, 190.

114. Ibid., 60.

115. Alhazen, *The Optics of Ibn al-Haytham*, 20.

116. Cited in Lindberg, *Theories of Vision*, 28.

117. Ibid., 26–30.

118. Cited ibid., 159

119. Ibid., 18–32.

120. Witelo, *Perspectiva* II, 62

121. Cited by Unguru in Witelo, *Perspectiva* II, 15 n 10, from the dedicatory epistle to Wiliam of Moerbeke.

122. Smith in Witelo, *Perspectiva* V, 39.

123. Ibid., 23–24; Lindberg, *Theories of Vision*, 66.

124. Sylla, *The Oxford Calculators*, 142–44, 247–52; Crombie, *Robert Grosseteste*, 184–85.

125. Quoted in Crombie, *Robert Grosseteste*, 184.

126. "A aget difformiter et remissus ad puncta remota quam ad propinqua propter distantiam." Quoted ibid., 185 n 5.

127. "Debilitatur lux distans a sole." Quoted ibid., 185 n 3.

128. Sylla, *The Oxford Calculators*, 251.

129. The locus classicus for this view is Duhem's *Aim and Structure of Physical Theory*.

130. "Cæterum totum cœli Planetarij Spatium vel quiescit (ut vulgo creditur) vel uniformiter movetur in directum et perinde Planetarum commune centrum gravitatis . . . vel quiescit vel una movetur. Utroque in casu motus gravitatis inter se . . . eodem modo se habent, et eorum commune centrum gravitatis respectu spatij totius quiescit, atque adeo pro centro immobili Systematis totius Planetarij haberi debet. Inde vero systema Copernicæum probatur a priori. Nam si in quovis Planetarum situ computetur commune centrum gravitatis hoc vel incidet in corpus Solis vel ei semper proximum erit." Newton, *The Preliminary Manuscripts*, 20. Translation edited from Herivel, *The Background to Newton's Principia*, 301.

CHAPTER SEVEN

1. Elisabeth and Descartes, *The Correspondence*, 63.

2. Descartes, *Discourse on Method*, 20.

3. Cf. Verbeek, *Descartes and the Dutch*; Cook, "Body and Passions"; Israel, *Radical Enlightenment*, 23ff.

4. Elisabeth and Descartes, *The Correspondence*, 62. For the social implications of Descartes' notion of a mechanistic body and its relationship with an immaterial soul see Dear, "A Mechanical Microcosm." For the Dutch and medical-anatomical context of Descartes' speculations on the passions see Cook, *Matters of Exchange*, 226–59.

5. Elisabeth and Descartes, *The Correspondence*, 63.

6. Ibid., 65.

7. In his insightful "Cartesian Trialism," John Cottingham referred to this doctrine as "Trialism," pointed out that it can be found in the *Meditations* side by side with "his official dualistic doctrines," and analyzed it in terms similar to the following. Cottingham notes Descartes' move from ontological to epistemological analysis, but does not suggest a reason for it or an account of its further development into the *Passions*. See also his *Descartes*, esp. 127–34, as well as Brown and de Sousa, "Descartes on the Unity of the Self and the Passions." For a thorough analysis of this apparent turn in Descartes' thought see Gaukroger, *Descartes*, esp. 388–94. For the passions as transgressing Descartes' alleged mind-body dichotomy see James, *Passion and Action*, esp. 15 and 106.

8. Elisabeth and Descartes, *The Correspondence*, 65 (italics added).

9. Cook, *Matters of Exchange*, 238–39; see also chapter 1 and discussion below.

10. Descartes, *Meditations*, in CSM 2:56.

11. Ibid., 54.

12. See chapter 1.

13. Elisabeth and Descartes, *The Correspondence*, 66.

14. Ibid., 67, 68.

15. Ibid., 69.

16. Ibid., 70.

17. Cf. Gaukroger, *Descartes' System of Natural Philosophy*, esp. 100, 217–20. We will return to Gaukroger's analysis below.

18. See Frede, "The Cognitive Role of *Phantasia* in Aristotle"; Schonfield, "Aristotle on the Imagination."

19. "propter species reservatas et quod virtus interior iudicativa." Oresme, *Nicole Oresme and the Marvels of Nature*, 156.

20. For further discussion see for instance Park's seminal work, "The Imagination in Renaissance Psychology"; Summers, *Michelangelo and the Language of Art*, 103–43; Clark, *Vanities of the Eye*, esp. 39–122; Reiss, *Knowledge, Discovery, and Imagination in Early Modern Europe*, esp. 45–69.

21. Bacon, *Advancement of Learning*, 1st bk., IV, 2; 1st bk., IV, 11; 2nd bk., VIII, 3; 2nd bk., I, 1; 2nd bk., IV, 1.

22. Bacon, *Novum organum*, 60.

23. Ibid., 112.

24. Bacon, *Advancement of Learning*, 2nd, bk., IX, 3.

25. Bacon, *Sylva Sylvarum*, 197.

26. Bacon, *Novum organum*, 1st bk 1, XLI: "Falso enim asseritur, Sensum humanum esse Mensuram rerum."

27. Bacon, *Instauratio magna*, 18.

28. Bacon, *Advancement of Learning*, V, 3. See chapter 1.

29. Levao, "Francis Bacon and the Mobility of Science," 13. See also Barnaby and Schnell, *Literate Experience*, exp. 6; Paradis, "Montaigne, Boyle, and the Essay of Experience," esp. 70.

30. Bacon, *Instauratio magna*, 26.

31. Bacon, *Advancement of Learning*, 1st bk., XIV (9).

32. Bacon, *Instauratio magna*, 26.

33. Ibid., 18.

34. Ibid.

35. Bacon, *Sylva Sylvarum*, 31–32.

36. Bacon, *Advancement of Learning*, 2nd bk., XII (1), 382.

37. Ibid, 2nd bk., XII (1).

38. Ibid., 2nd bk., XVIII (1), 2nd bk., XVIII (2), 387.

39. Bacon, *Sylva Sylvarum*, 198, 203, 205.

40. Shakespeare, *A Midsummer Night's Dream*, V. i. 18.

41. Ibid., I. i. 56.

42. Ibid., V. i. 6.

43. Ibid., II. ii. 27.

44. McGinn, *Shakespeare's Philosophy*, 21.

45. This is the way Theseus presents himself in the opening of dialogue with Hippolyta (I. i. 1–19). For a further interpretation of this dialogue see Marshall, "Exchanging Visions," esp. 548–50.

46. See also the discussion of the play in Garber, *Dream in Shakespeare*, 59–87. For the passions in some of Shakespeare's other plays see James, *Passion and Action*, 13–14.

47. Shakespeare, *A Midsummer Night's Dream*, III. i. 144–47.

48. Ibid., V. i. 1–2.

49. Ibid., 3–23.

50. Ibid., 24–28.

51. Ibid., 100–5.

52. Ibid., 83–84.

53. Ibid., 212–13. Most interpretations of Shakespearean philosophy stress Shakespeare's indebtedness to the Stoic and Skeptical schools and pay little attention to his struggle to meet their challenge. Cf. McAlindon, *Shakespeare's Tragic Cosmos*; Bell, *Shakespeare's Tragic Skepticism*; Bevington, *Shakespeare's Ideas*.

54. Galilei, "The Assayer," in *The Controversy*, 164.

55. Ibid., 252.

56. Galileo, *Dialogues Concerning the Two New Sciences*, Third Day [197], 160.

57. Kepler, *Ad Vitellionem*, "Dedication to the Emperor," 10.

58. Westman, "Nature, Art and Psyche," 180.

59. Galileo, *Dialogue Concerning the Two Chief World Systems*, 171.

60. Kepler, *Kepler's Somnium*, 22.

61. Ibid., 21.

62. Ibid., 85. See also Chen-Morris, "Shadows of Instruction."

63. Kepler, *Kepler's Somnium*, 17–18.

64. The following discussion owes much to Gaukroger's analysis, especially in his *Descartes' System of Natural Philosophy*.

65. Descartes, *Optics*, in CSM 1:165.

66. Oresme, *Nicole Oresme and the Medieval Geometry*, 165–69.

67. For Descartes' ideas concerning the imagination and the passions and his complex indebtedness to and departure from the Aristotelian tradition, especially as taught in La Fleche, see James, *Passion and Action*, esp. 90ff.

68. Descartes, *Rules for the Direction of the Mind*, Rule 12, in CSM 1:42.

69. Ibid., Rules 13–15, in CSM 1:51, 56, 65.

70. Gaukroger, *Descartes' System of Natural Philosophy*, 218.

71. Witelo, *Perspectiva*, 46/240.

72. Oresme, *Nicole Oresme and the Medieval Geometry*, 165-69.

73. Descartes, *Optics*, in CSM 1:165; see chapter 1.

74. Descartes, *The World*, 3; see chapter 1.

75. Descartes, *Meditationes*, Meditatio 1: "Age ergo somniemus, nec particularia ista vera sint . . . ; tamen profecto fatendum est visa per quietem esse veluti quasdam pictas imagines, quae non nisi ad similitudinem rerum verarum fingi potuerunt; ideoque saltem generalia haec, . . . res quasdam non imaginarias, sed veras existere. . . . quamvis etiam generalia haec, oculi, caput, manus, & similia, imaginaria esse possent, necessario tamen saltem alia quaedam adhuc magis simplicia & universalia vera esse fatendum est, . . . seu verae, seu falsae, quae in cogitatione nostrâ sunt, rerum imagines effinguntur."

76. Descartes, *Rules for the Direction of the Mind*, Rule 12, in CSM 1:47. Translation slightly modified.

77. For an extensive treatment of the role of the imagination in Descartes' philosophy see Sepper, *Descartes's Imagination*. See also Galison, "Descartes's Comparisons."

78. Descartes, *The World*, 21.

79. As Gaukroger demonstrated, the adoption of matter-in-motion metaphysics was Descartes' way of laying the ground for his main epistemological project, by creating objects of knowledge that can be captured mathematically. See Gaukroger, "Descartes' Project for a Mathematical Physics."

80. Descartes, *The World*, 6.

81. Ibid., 26.

82. Ibid., 24.

83. Some letters of this period of the correspondence—around November 1643—are missing, among them Elisabeth's solution, of which we know only indirectly.

84. Ibid., 19, 78.

85. Ibid., 78.

86. Descartes, *Principles*, xxiv. Cf. Jones, *The Good Life*, esp. 41-43.

87. Elisabeth and Descartes, *The Correspondence*, 73.

88. Ibid., 77.

89. Ibid., 78-79.

90. Ibid., 83.

91. Ibid.

92. Ibid., 67-68.

93. Ibid., 86.

94. Ibid., 87.

95. Ibid.

96. Ibid.

97. Ibid., 88.

98. Ibid., 96.

99. Lipsius, *Two Bookes of Constancie*, 2. This is a contemporary English translation of Lipsius Latin original.

100. Oestreich, *Neostoicism and the Early Modern State*, 13. This book gives an excellent account of *De constantia* (pp. 13-27) and its place in Lipsius' political philosophy. For a portrayal of Lipsius' philology see Grafton, "Portrait of Justus Lipsius," in his *Bring Out Your Dead*, 227-43.

101. For an excellent assessment of the Dutch wars see Rowen, "The Dutch Revolt."

102. Cf. Sellars, "Justus Lipsius's *De Constantia*."

103. See the discussion in McCrea, *Constant Minds*.

104. See also the discussion of stoic constancy in Lagrée, *Juste Lipse et la restauration du stoïcisme*.

105. Lipsius, *Two Bookes of Constancie*, 29, 2-3.

106. Ibid., 5.

107. In the Latin "only light": "*si lucem paullisper video.*"

108. Ibid., 6.

109. Ibid., 9.

110. Ibid., 12.

111. Ibid., 13. Twenty years later, one may recall, Kepler set out in his *Optics* "to preserve astronomy's dignity and to subdue the hostile fortress of doubt."

112. Ibid., 14, 15.

113. Descartes would find this line of Neo-Stoicism repulsive: "I am not one of those cruel philosophers who want their sage to be insensible," he writes to Elisabeth. Elisabeth and Descartes, *The Correspondence*, 87.

114. Lipsius, *Two Bookes of Constancie*, 31.

115. Ibid., 32.

116. Ibid., 37–38.

117. Ibid., 54.

118. Ibid., 53.

119. Ibid., 56–57.

120. Ibid., 59.

121. "Miraris campos liquidos Phoebumque calentem/ me cupidum expetere./ Hic mihi magna Iovis subit omnipotentis imago,/ templaque summa dei./ Silva placet musis, urbs est inimica poetis/ et male sana cohors." Conrad Celtis, "Ad Sepulum disdaemonem," in Schnur, *Lateinische Gedichte*, 42, quoted and translated in Ogilvie, *The Science of Describing*, 106–7.

122. Azzi Visentini, *L'Orto botanico*, 81–83, quoted in Ogilvie, *The Science of Describing*, 108.

123. On the Renaissance garden in general and its mixture of nature and art in particular, see Lazzaro, *The Italian Renaissance Garden*; Shepherd and Jellicoe, *Italian Gardens of the Renaissance*; Miller, "Domain of illusion: the grotto in France," in MacDougall and Miller, *Fons Sapientiae*, 175–205; Szafranska, "The philosophy of nature and the grotto in the Renaissance; Werrett, "Wonders Never Cease." On the humanist garden and the development natural history see Ogilvie, *The Science of Describing*, and Findlen, *Possessing Nature*, esp. 97–150.

124. Rabelais, *Gargantua and Pantagruel*, 58, 158, quoted in Ogilvie, *The Science of Describing*, 110. One should note the irony of this passage and Rabelais' allusion to the study of natural variety as the study of "nothing."

125. Gessner, *De raris*, 48, 50, quoted in Ogilvie, *The Science of Describing*, 113.

126. Ficino, *Three Books on Life*, 135–37.

127. Lipsius, *Two Bookes of Constancie*, 59, 60.

128. Ibid., 62.

129. Ibid.

130. Ibid., 62–63.

131. Ficino, *Three Books on Life*, 215.

132. Lipsius, *Two Bookes of Constancie*, 63.

133. See also Stoichita, *The Self-Aware Image*, esp. 144–47. For a different interpretation see Swan, *Art, Science, and Witchcraft*, 115–20. Swan concentrates, however, only on the opening chapter of the second book of *De constantia* and thus reads this garden scene as a celebration of empirical investigation and as an embodiment of the new science, ignoring the complications of the later chapters.

134. Lipsius, *Two Bookes of Constancie*, 63.

135. Ibid.

136. Ibid., 64.

137. Ibid.

138. Ibid., 65.

139. Ibid., 64.

140. Siraisi, "Oratory and Rhetoric in Renaissance Medicine," 200.

141. See discussion of Clusius' work in the context of the University of Leiden in Cook, *Matters of Exchange*, 93–132. See also Ubrizsy Savoia, *Papers Dealing with Carolus Clusius*; Tjon Sie Fat, "Clusius's Garden: A Reconstruction."

142. For a detailed account of the founding of the university in Leiden see Jurriaanse, *The Founding of Leyden University*. For the story of the siege see Fruin, *The Siege and Relief of Leyden*. See also the discussions of the intellectual and religious ambience in Leiden in Cook, *Matters of Exchange*, 104–20; and Grafton, *Bring Out Your Dead*, 118–37.

143. J. E. Kroon, quoted and translated in Cook, *Matters of Exchange*, 110.

144. The political import of these debates stretched well beyond the Netherlands. For the impact of Lipsian ideas on the political life in England of the late sixteenth and early seventeenth centuries see Evans, *Jonson, Lipsius and the Politics of Renaissance Stoicism*; Bromham, "Have You Read Lipsius"; and McCrea, *Constant Minds*. For the general vogue of Stoicism in early modern English culture see Monsarrat, *Light from the Porch*; and Salmon, "Stoicism and Roman Example."

145. See Evans, *Rudolf II and His World*, 119–24; and Smith, "Alchemy as a Language of Mediation at the Habsburg Court."

146. On de Gheyn's botanical sketches and drawings see Swan, *Art, Science, and Witchcraft*, esp. 66–94; see also Egmond, "Clusius, Cluyt, Saint Omer."

147. In her *Art, Science, and Witchcraft* Swan interprets this sketch differently. We take, however, after Francesca Fiorani's comment that Swan separates "what de Gheyn ostensibly saw related." Fiorani, "Claudia Swan," 217.

148. Ommen, *The Exotic World of Carolus Clusius*, 16.

149. For late sixteenth-century apprehensions concerning vision and its epistemic role see Clark, *Vanities of the Eye*. For de Gheyn's *Vanitas* and his use of allegory see Grootenboer, *The Rhetoric of Perspective*, 137–44.

150. For the cultural significance of tulips see Goldgar, "Nature as Art: The Case of the Tulip."

151. For an excellent analysis of incoherence as a methodological and philosophical challenge to the writing of history of science and ideas see Iliffe, "Abstract Considerations."

152. There is a debate concerning the date of the composition of this work, but the summer of 1641 seems like the best hypothesis. Cf. Descartes, *The Search for Truth*, in CSM 2:399.

153. Ibid., 402.

154. Ibid., 400–401.

155. Cf. Broughton, *Descartes's Method of Doubt*, esp. 108–43.

156. Descartes follows the *Meditations* argument very closely in the *Recherche*, sometimes repeating phrases verbatim.

157. Descartes, *Meditations*, in CSM 2:62.

158. Descartes, *The Search for Truth*, in CSM 2:405.

159. Ibid., 415, 420.

160. Ibid., 420.

161. Elisabeth and Descartes, *The Correspondence*, 88.

162. Ibid., 85.

163. Ibid., 94.

164. Ibid., 89.

165. Ibid., 88.

166. Ibid., 99.

167. Ibid., 96.

168. Ibid., 89.

169. Ibid., 91.

170. Ibid., 91–92.

171. Ibid., 93.

172. His letter from July 21, 1645, starts: "Since I had the honor of seeing your Highness, the air has been so inconstant . . ." Ibid., 95.

173. Ibid., 105, 106.

174. See also Rodis-Lewis' introduction to Descartes, *Passions*, esp. xv–xvi. For general discussions of *The Passions of the Soul* see Shapiro, "The Structure of the *Passions of the Soul*"; Brown, *Descartes and the Passionate Mind*; Greenberg, "Descartes on the Passions." See also James, *Passion and Action*, for an interpretation of Descartes' theory of passions that stresses "the very divide Descartes has created" between body and soul (106) but also the passions' role in "negotiating the divide" (84ff.).

175. Cook summarizes a similar position in discussing "a view consonant with Cartesianism, in which the body and its passions for the most part dominate reason, instead of the prevailing idea that reason could and should dominate the passions and through them the body." Cook, "Body and Passions," 25.

176. Elisabeth and Descartes, *The Correspondence*, 109.

177. Ibid., 65 (see above).

178. Descartes, *Passions*, article 52, 51.

179. On the analogy—or perhaps true continuity—between the passions and sensory perceptions of secondary qualities in the sense of capturing the world-for-us, see James, *Passion and Action*, 102–4.

180. Descartes, *Optics*, in CSM 1:165.

181. Ibid., 1:165.

182. Rorty, *Philosophy and the Mirror of Nature*, 45.

183. Descartes, *Meditations*, in CSM 2:27.

184. Ibid., 55 (italics added).

185. Ibid., 56.

186. Ibid., 55–56.

187. Descartes, *Passions*, article 52, 51.

188. Ibid., 18.

189. Ibid., article 1, 19. Cf. Brown and de Sousa, "Descartes on the Unity of the Self and the Passions."

190. Ibid., article 12, 25.

191. Ibid., article 23, 31.

192. Rorty, *Philosophy and the Mirror of Nature* (see chapter 1).

193. Descartes, *Passions*, article 49, 47.

194. Ibid., article 53, 52.

195. Ibid., articles 31–32, 36–37.

196. Kepler, *Optics*, 18; see chapter 1.

197. On the passions as causes see Radner, "The Function of the Passions," in Williston and Gombay (eds.), *Passion and Virtue in Descartes*, 175–87.

198. Descartes, *Passions*, article 36, 39.

199. Ibid., second part, 50ff.

200. Ibid., article 36, 39.

201. Ibid., article 52, 51–52. For an analysis of what she terms "the principle of nature and habituation" and the role of the passions in it, see Shapiro, "The Structure of the *Passions of the Soul*."

202. For the fundamental import of the traditional dichotomy and hierarchy between reason and the passions that Descartes is discarding see Gaukroger's introduction to his (ed.) *The Soft Underbelly of Reason*, esp. 5–6.

203. Descartes, *Passions*, article 107, 76.

204. Ibid., article 137, 91. Cf. Shapiro, "The Structure of the *Passions of the Soul*," 40–41.

205. Descartes, *Passions*, article 212, 135.
206. Ibid., article 153, 104.
207. Ibid., article 156, 105.
208. Ibid.
209. Lipsius, *Two Bookes of Constancie*, 20.
210. Elisabeth and Descartes, *The Correspondence*, 112.

# Bibliography

Alberti, Leon Battista, *On Painting and On Sculpture: The Latin Texts of De pictura and De statua*, C. Grayson (trans. and ed.). London: Phaidon, 1972.

Albertus Magnus, *Alberti Magni opera omnia*, Clemens Stroick (ed.). Cologne, 1968.

———, *Opera omnia*. Stephen C. A. Bergent (ed.). Paris, 1894.

Alhacen (Alhazen, Ibn al-Haytham), *De aspectibus*. In *Opticae thesaurus Alhazeni Arabis libri septem*, Friedrich Risner (ed.). Basel, 1572.

Alhazen (Alhacen), *The Optics of Ibn al-Haytham*, A. I. Sabra (trans. and comm.), London: Warburg Institute, 1989.

Alpers, Svetlana, *The Art of Describing: Dutch Art in the Seventeenth Century*. Chicago: University of Chicago Press, 1984.

Aristotle, *The Complete Works of Aristotle*, Jonathan Barnes (ed.). Princeton: Princeton University Press, 1984.

———, *On the Soul (De anima)*, J. A. Smith (trans.). http://classics.mit.edu/Aristotle/soul.html

Arnauld, Antoine, *On True and False Ideas*, Stephen Gaukroger (trans. and ed.). Manchester: Manchester University, 1990.

Azzi Visentini, Margherita, *L'Orto botanico di Padova e il giardino del Rinascimento*. Milan: Edizioni il Polifilio, 1984.

Bacon, Francis, *The Advancement of Learning*, David Price (ed.). London: Cassell & Company, 1893.

———, *Instauratio magna*. In *The Works of Francis Bacon, Baron of Verulam, Viscount St Albans and Lord High Chancellor of England*, vol. IV, James Spedding, Robert Leslie Ellis, and Douglas Denon Heath (eds.). London, 1857-74.

———, *The New Organon, or True Directions Concerning the Interpretation of Nature*. James Spedding (trans. and ed.), in Francis Bacon, *The Works*, vol. VIII. Boston: Taggard and Thompson, 1863.

———, *Novum organum*. In *Franciscy de Verulamio, summi Angliae cancellarij instauratio magna*. London: Apud [Bonham Norton and] Ioannem Billium typographum regium, 1620.

———, *Sylva Sylvarvm: or A Naturall Historie*. London: J.H. for William Lee at the Turks Heard in Fleet Street, next to the Miter, 1626.

Bacon, Roger, *The Opus Majus of Roger Bacon*, Robert B. Burke (trans. and ed.). New York: Russel and Russel, 1962.

———, *Roger Bacon and the Origin of Perspectiva in the Middle Ages*, David Lindberg (trans. and ed.). Oxford: Clarendon Press, 1996.

———, *Roger Bacon's Philosophy of Nature: A Critical Edition, with English Translation, Introduction and Notes of "De multiplicatione speciorum" and "De speculis comburentibus,"* David C. Lindberg (trans. and ed.). Oxford: Oxford University Press, 1983.

Barker, Peter, and Bernard Goldstein, "Realism and Instrumentalism in Sixteenth Century Astronomy: A Reappraisal." *Perspectives on Science* 6.3, 1998: 232–58.

Barnaby, Andrew, and Lisa J. Schnell, *Literate Experience: The Work of Knowing in Seventeenth-Century English Writing.* New York: Palgrave Macmillan, 2002.

Bean, Sarah Elizabeth, *A Vision of Peace: Issues of Diplomacy and Humanism in Brueghel's and Rubens' The Allegory of Sight.* Williamsburg, VA: College of William and Mary, 2004.

Bell, Millicent, *Shakespeare's Tragic Skepticism.* New Haven: Yale University Press, 2002.

Benjamin, Walter. *Gesammelte Schriften,* Rolf Tiedemann and Hermann Schweppenhäuser (eds.). Frankfurt: Suhrkamp, 1977.

———, *The Origin of German Tragic Drama,* John Osborne (trans.). London: Verso, 2003.

Bennett, J. A., "Hooke and Wren and the System of the World: Some Points towards an Historical Account." *British Journal for the History of Science* 8, 1975: 32–61.

———, "Robert Hooke as Mechanic and Natural Philosopher." *Notes and Records of the Royal Society* 35, 1980: 33–48.

Bermúdez, José Luis, "Scepticism and Science in Descartes." *Philosophy and Phenomenological Research* 57.4, 1997: 743–72.

Bertoloni Meli, Domenico, "Guidobaldo dal Monte and the Archimedean Revival." *Nuncius* 7, 1992: 3–34.

———, *Thinking with Objects: The Transformation of Mechanics in the Seventeenth Century.* Baltimore: Johns Hopkins University Press, 2006.

Bettini, Mario, *Apiaria universae philosophiae mathematicae.* Bologna: Battista Ferronij, 1642.

Bevington, David, *Shakespeare's Ideas: More Things in Heaven and Earth.* Chichester: Wiley-Blackwell, 2008.

Biagioli, Mario, *Galileo, Courtier: The Practice of Science in the Culture of Absolutism.* Chicago: University of Chicago Press, 1994.

———, *Galileo's Instruments of Credit: Telescopes, Images, Secrecy.* Chicago: University of Chicago Press, 2006.

Birch, Thomas, *The History of the Royal Society.* 4 vols. (1756–57). Facsimile reprint in *The Sources of Science,* vol. 44. New York: Johnson Reprint Corporation, 1968.

Bird, Jon, "Nova Descriptio . . . On Jan Vermeer's The Geographer (1668–69)." *Parallax* 5.4, 1999: 117–22.

Boffito, Giuseppe, "L'occhiale e il cannocchiale del papa Leone X." *Atti della Reale Academia delle Scienze di Torino* 62, 1926–27: 559–60.

Bono, James J., *The Word of God and the Languages of Man: Interpreting Nature in Early Modern Science and Medicine.* Madison: University of Wisconsin Press, 1995.

Bos, H. J. M., *Redefining Geometrical Exactness: Descartes' Transformation of the Early Modern Concept of Construction.* New York: Springer, 2001.

Boulliau, Ismaël, *Astronomia philoloaica.* Paris: Simeon Piget, 1645.

———, *De natura lucis.* Paris: Ludovick de Heuqueville, 1638.

———, *Philolai, sive dissertationis de vero systemate mundi, libri IV.* Amsterdam: Gvil & Johannes Blaev, 1639.

Boyer, Carl B., *The Rainbow: From Myth to Mathematics.* Princeton: Princeton University Press, 1987 [1959].

Brahe, Tycho, *Epistolarum astronomicarum libri.* Uraniborg, 1596. Reprinted in Tycho Brahe, *Opera omnia,* J. L. E. Dreyer (ed.), Copenhagen: Gyldendal, 1913–29; reprinted Amsterdam: Swets & Zeitlinger, 1972.

Brockey, Liam Mathew, *Journey to the East: The Jesuit Mission to China 1579–1724.* Cambridge, MA: Harvard University Press, 2007.

Bromham, A. A., "'Have You Read Lipsius?': Thomas Middleton and Stoicism." *English Studies* 77.5, 1996: 401–21.

Broughton, Janet, *Descartes's Method of Doubt*. Princeton: Princeton University Press, 2002.

Brown, Deborah J., *Descartes and the Passionate Mind*. Cambridge: Cambridge University Press, 2006.

Brown, D. J., and R. de Sousa, "Descartes on the Unity of the Self and the Passions." In Byron Williston and André Gombay (eds.), *Passion and Virtue in Descartes*. New York: Humanity Books, 2003, 153–73.

Brusati, Celeste, *Artifice and Illusion: The Art and Writing of Samuel van Hoogstraten*. Chicago: University of Chicago Press, 1995.

Buchwald, Jed Z. "Descartes's Experimental Journey Past the Prism and Through the Invisible World to the Rainbow." *Annals of Science* 65.1, 2007: 1–46.

———, "Discrepant Measurements and Experimental Knowledge in the Early Modern Era." *Archives for History of Exact Sciences* 60, 2006: 565–649.

Burke, Peter, "The Crisis in the Arts of the Seventeenth Century: A Crisis of Representation?" *Journal of Interdisciplinary History*, 40.2, 2009: 239–61.

Burnyeat, M. F., "Can the Skeptic Live His Skepticism?" In M. Schofield et al. (eds.), *Doubts and Dogmatism*. Oxford: Oxford University Press, 1980: 20–53.

Büttner, Jochen, Peter Damerow, Jürgen Renn, and Matthias Schemmel, "The Challenging Images of Artillery." In Lefèvre et al. (eds.), *The Power of Images in Early Modern Sciences*, 3–27.

Carter, D. G., "Reflections in Armor in the Canon van de Paele Madonna." *Art Bulletin* 36, 1954: 60–62.

Cassirer, Ernst, "The Influence of Language upon the Development of Scientific Thought." *Journal of Philosophy* 39.12, 1942: 309–27.

Celtis, Conrad, "Ad sepulum disdaemonem." In Harry C. Schnur (ed.), *Lateinische Gedichte Deutscher Humanisten*. Stuttgart: Philip Reclam Jun., 1978.

Chandler, Philip P., "The *Principia*'s Theory of the Motion of the Lunar Apse." *Historia Mathematica* 4, 1977: 405–10.

Chen-Morris, Raz, "Kepler's Optics: The Mistaken Identity of a Baroque Spectator." *Zeitsprünge: Forschungen zur Frühen Neuzeit* 4, 2000: 50–71.

———, "Optics, Imagination, and the Construction of Scientific Observation in Kepler's New Science." *Monist* 84.4, 2001: 453–86.

———, "Shadows of Instruction: Optics and Classical Authorities in Kepler's *Somnium*." *Journal of the History of Ideas* 66.2, 2005: 223–43.

Chidester, David, *Word and Light: Seeing, Hearing, and Religious Discourse*. Urbana: University of Illinois Press, 1992.

Clark, Stuart, *Vanities of the Eye: Vision in Early Modern European Culture*. Oxford: Oxford University Press, 2007.

Clulee, Nicholas H., *John Dee's Natural Philosophy: Between Science and Religion*. London and New York: Routledge, 1988.

Clusius, Carolus, *Exoticorum libri decem: quibus animalium, plantarum, aromatum, aliorumque peregrinorum Fructuum historiae describuntur*. Leiden: ex officina Plantiniana Raphelengii, 1605.

———, *Rariorum plantarum historia*. Antwerp: ex officina Plantiniana itania apud Joannem Moretum, 1601.

Coelho, Victor (ed.), *Music and Science in the Age of Galileo*. Dordrecht: Kluwer Academic Publishers, 1992.

Cohen, I. Bernard, "Newton's Third Law and Universal Gravity." *Journal of the History of Ideas* 48.4, 1987: 571–93.

Collingwood, R. G., *The Idea of Nature*. Oxford: Clarendon Press, 1945.

Cook, A., *Edmond Halley: Charting the Heavens and the Seas*. Oxford: Clarendon Press, 1998.

Cook, Harold John, "Body and Passions: Materialism and the Early Modern State." *Osiris*, 2nd s., 17, 2002: 25–48.

———, *Matters of Exchange: Commerce, Medicine, and Science in the Dutch Golden Age*. New Haven: Yale University Press, 2007.

Cottingham, John, "Cartesian Trialism." *Mind* 94, 1985: 218–30.

———, *Descartes*. Oxford: Basil Blackwell, 1986.

Croce, Benedetto, *Benedetto Croce: Essays on Literature and Literary Criticism*, M. E. Moss (trans. and ann.). Albany: State University of New York Press, 1990.

Crombie, A. C., *Robert Grosseteste and the Origins of Experimental Science 1100–1700*. Oxford: Clarendon Press, 1953.

Dascal, Marcelo, "Leibniz and Epistemological Diversity." In A. Lamarra and R. Palaia (eds.), *Unita e Molteplicita nel Pensiero Filosofico e Scientifico di Leibniz*. Rome: Leo S. Olschki Editore, 2000: 15–37.

Daston, Lorraine, and Katharine Park, *Wonders and the Order of Nature, 1150–1750*. New York: Zone Books, 1998.

Davidson, Bernice E., *Raphael's Bible: A Study the Vatican Logge*. London: Pennsylvania State University Press, 1985.

Dear, Peter, *Discipline & Experience: The Mathematical Way in the Scientific Revolution*. Chicago: University of Chicago Press, 1995.

———, "Jesuit Mathematical Science and the Reconstitution of Experience in the Early Seventeenth Century." *Studies in History and Philosophy of Science* 18, 1987: 133–75.

———, "A Mechanical Microcosm." In Christopher Lawrence and Steven Shapin (eds.), *Science Incarnate: Historical Embodiments of Natural Knowledge*. Chicago: University of Chicago Press, 1998: 51–82.

De Caro, Mario, "Galileo's Mathematical Platonism." In Johannes Czermak (ed.) *Philosophy of Mathematics*. Vienna: Verlag Holder-Pichler-Tempsky, 1993: 13–22.

De Gandt, François, *Force and Geometry in Newton's Principia*. Princeton: Princeton University Press, 1995.

della Porta, Giambattista, *De refractione optices parte libri novem*. Naples: Io. Iacobum Carlinum & Antonio Pacem, 1593.

———, *Jo. Baptistæ Portæ . . . magiæ naturalis libri viginti*. Rouen: Joannis Berthelin, 1650 [1558].

———, *Natural Magick*. London: Thomas Young and Samuel Speed . . ., 1658.

Denery, Dallas G., II, *Seeing and Being Seen in the Later Medieval World: Optics, Theology, and Religious Life*. Cambridge: Cambridge University Press, 2005.

Descartes, René, *Descartes' Conversations with Burman*, John Cottingham (trans. and ed.). Oxford: Clarendon Press, 1976.

———, *Discourse on Method, Optics, Geometry, and Meteorology*, Paul Oslcamp (trans.). Indianapolis: Hacket, 2001 (rev. ed.).

———, *Geometria, à Renato Des Cartes anno 1637 gallicè edita. . . .* Amsterdam: Apud Ludovicum & Danielem Elzevirios, 1659–61.

———, *Meditationes de prima philosophia*. Paris, 1641.

———, *Oeuvres*, Victor Cousin (ed.). Paris: F. G. Levrault, 1824–26.

———, *The Passions of the Soul*, Stephen H. Voss (trans.). Indianapolis: Hackett Publishing Co., 1989.

———, *The Philosophical Writings of Descartes*. 3 vols. John Cottingham, Robert Stoothof, and Dugald Murdoch (trans.). Cambridge: Cambridge University Press, 1985.

———, *Principles of Philosophy* (*Principia Philosophiæ*, 1644), Valentine R. Miller and Reese P. Miller (trans.). Dordrecht: Reidel, 1983.

———, *Regulae ad directionem ingenii*. In *Oeuvres de Descartes* X, Charles Adam and Paul Tannery (eds.). Paris: Librairie Philosophique J. Vrin, 1908: 351–488.

———, *The World and Other Writings*, Stephen Gaukroger (ed. and trans.). Cambridge: Cambridge University Press, 1998.

Drabkin, Israel E., "Aristotle's Wheel: Notes on the History of a Paradox." *Osiris* 9, 1950: 162–98.

Drake, Stillman, and I. E. Drabkin, *Mechanics in Sixteenth-Century Italy*. Madison: University of Wisconsin Press, 1969.

Drake, Stillman, and C. D. O'Malley (eds. and trans.), *The Controversy on the Comets of 1618: Galileo Galilei, Horatio Grassi, Mario Guiducci, Johann Kepler*. Philadelphia: University of Pennsylvania Press, 1960.

Duhem, Pierre, *The Aim and Structure of Physical Theory*, Phillip P. Wiener (trans.). New York: Atheneum, 1974.

Dupré, Sven, "Ausonio's Mirors and Galileo's Lenses: The Telescope and Sixteenth-Century Practical Optical Knowledge." *Galileana* 2, 2005: 145–80.

———, "Galileo's Telescope and Celestial Light." *Journal for the History of Astronomy* 34.4, 2003: 369–99.

———, "Inside the Camera Obscura: Kepler's Experiment and Theory of Optical Imagery," *Early Science and Medicine* 13, 2008: 219–44.

———, "Kepler's Optics without Hypotheses." In Gal and Chen-Morris (eds.), *Seeing the Causes*, 501–25.

Eastwood, Bruce S., *The Geometrical Optics of Robert Grosseteste*. Unpublished PhD dissertation, University of Wisconsin, 1964.

Eco, Umberto, *The Aesthetics of Thomas Aquinas*. Hugh Bredin (trans.), Cambridge, Mass.: Harvard University Press, 1988.

Edgerton, Samuel, "Galileo, Florentine 'Disegno,' and the 'Strange Spottedness of the Moon.'" *Art Journal*, Fall 1984: 225–32.

———, *The Mirror, the Window, and the Telescope*. Ithaca, N.Y.: Cornell University Press, 2009.

Edwards, Paul, *Encyclopedia of Philosophy*. London: Mamillan, 1967.

Egmond, Florike, "Clusius, Cluyt, Saint Omer: The origins of the Sixteenth-Century Botanical and Zoological Watercolours in the Libri Picturati A. 16–30." *Nuncius* 20.1, 2005: 11–67.

Elisabeth, Countess Palatine, and René Descartes, *The Correspondence between Princess Elisabeth of Bohemia and René Descartes*. Lisa Shapiro (ed. and trans.), Chicago: University of Chicago Press, 2007.

Eriksson, Gunnar, *The Atlantic Vision: Olaus Rudbeck and Baroque Science*. Canton, Mass.: Science History, 1994.

Eriugena, John Scottus, *De divisione naturae*. In J. P. Migne (ed.), *Patrologiae cursus completus*. Series Latina: Paris, 1844–90.

Evans, R. J. W., *Rudolph II and His World*. Corrected paperback ed. London: Thames and Hudson, 1997.

Evans, Robert C. Jonson, *Lipsius and the Politics of Renaissance Stoicism*. Durango: Longwood Academic, 1992.

Fara, Patricia. *Newton: The Making of Genius*. London: Picador, 2003.

Farmer, David, "Further Reflections on a van Eyck Self-Portrait." *Oud Holland* 83, 1968: 159–60.

Feldhay, Rivka, *Galileo and the Church*. Cambridge: Cambridge University Press, 1995.

———, "Mathematical Entities in Scientific Discourse: Paulus Gulding and His *Dissertatio de motu terrae*." In Lorraine Daston (ed.), *Biographies of Scientific Objects*. Chicago: University of Chicago Press, 2000, 42–66.

Ficino, Marsilio, *Three Books on Life*, Carol V. Kaske and John R. Clark (trans. and ann.). Binghamton: Renaissance Society of America, 1989.

Field, J. V., *Kepler's Geometrical Cosmology*. London: Athlone Press, 1988.

———, "Mathematics and the Craft of Painting: Piero della Francesca and Perspective." In Field and James, *Renaissance and Revolution*, 73–96.

Field, J. V., and Frank A. J. L. James (eds), *Renaissance and Revolution: Humanists, Scholars, Craftsmen and Natural Philosophers in Early Modern Europe*. Cambridge: Cambridge University Press, 1993.

Findlen, Paula, *Athanasius Kircher: The Last Man Who Knew Everything*. New York: Routledge, 2004.

———, "Jokes of Nature and Jokes of Knowledge: The Playfulness of Scientific Discourse in Early Modern Europe." *Renaissance Quarterly* 43.2, 1990: 292-331.

———, *Possessing Nature: Museums, Collecting, and Scientific Culture in Early Modern Italy*. Berkeley: University of California Press, 1994.

———, "Scientific Spectacle in Baroque Rome: Athanasius Kircher and the Roman College Museum." *Roma Moderna e Contemporanea* A. 3, n. 3, 1995: 625-65.

Fine, Gail, "Descartes and Ancient Skepticism: Reheated Cabbage?" *Philosophical Review* 109.2, 2000: 195-234.

Finocchiaro, Maurice A., *The Galileo Affair*. Berkeley: University of California Press, 1989.

Fiorani, Francesca, "Claudia Swan, *Art, Science, and Witchcraft in Early Modern Holland*" (book review). *Renaissance Quarterly* 60.1, 2007: 216-18.

Floris Cohen, H., *The Scientific Revolution: A Historiographical Inquiry*. Chicago: University of Chicago Press, 1994.

Foucault, Michel, *The Order of Things: An Archaeology of the Human Sciences*. New York: Vintage Books, 1973.

Frede, Dorothea, "The Cognitive Role of *Phantasia* in Aristotle." In M. C. Nussbaum and A. O. Rorty (eds.), *Essays on Aristotle's De Anima*. Oxford: Oxford University Press, 1995, 279-96.

Freedberg, David, *The Eye of the Lynx: Galileo, His Friends, and the Beginnings of Modern Natural History*. Chicago: University of Chicago Press, 2002.

French, Roger, and Andrew Cunningham, *Before Science: The Invention of the Friars' Natural Philosophy*. Brookfield, Vt.: Scolar Press, 1996.

Frischlin, Nicodemus, *De astronomicae artis, cum doctrina coelesti, et naturali philosophia, congruentia. . .* Frankfurt: Spies, 1586.

Fruin, R., *The Siege and Relief of Leyden in 1574*. Elisabeth Trevelyn (trans.), The Hague: Martinus Nijhoff, 1927.

Gal, Ofer, "Constructivism for Philosophers." *Perspectives on Science* 10.4, 2003: 523-49.

———, "Hooke, Newton, and the Trials of Historical Examination." *Physics Today*, August 2004: 19-20.

———, "Hooke's Programme: Final Thoughts." In Michael Hunter and Michael Cooper (eds.), *Robert Hooke: Tercentennial Studies*. Aldershot: Ashgate, 2006, 33-48.

———, *Meanest Foundations and Nobler Superstructures: Hooke, Newton and the Compounding of the Celestiall Motions of the Planetts*. Dordrecht: Kluwer Academic Publishers, 2002.

———, "Tropes and Topics in Scientific Discourse: Galileo's *De Motu*." *Science in Context* 7.1, 1994: 25-52.

Gal, Ofer, and Raz Chen-Morris, "The Archaeology of the Inverse Square Law Part I: Metaphysical Images and Mathematical Practices." *History of Science* 43.4, 2005: 391-414.

———, "The Archaeology of the Inverse Square Law Part II: The Use and Non-use of Mathematics." *History of Science* 44.1, 2006: 49-68.

———, "Baroque Optics and the Disappearance of the Observer: From Kepler's Optics to Descartes' Doubt." *Journal of the History of Ideas*, 71.2, 2010: 191-217.

———, "Empiricism without the Senses: How the Instrument Replaced the Eye." In Charles Wolfe and Ofer Gal (eds.), *The Body as Object and Instrument of Knowledge: Embodied Empiricism in Early Modern Science*. Dordrecht: Springer Verlag, 2010, 121-48.

———, "Nature's Drawing: Problems and Resolutions in the Mathematization of Motion. In Gal and Chen-Morris (eds.), *Seeing the Causes*, 429-66.

Gal, Ofer, and Raz Chen-Morris (eds.), *Seeing the Causes: Optics and Epistemology in the Scientific Revolution*, Thematic Section, *Synthese* 185.3, 2012: 429-525.

Galilei, Galileo, *Dialogue Concerning the Two Chief World Systems: Ptolemaic and Copernican*, Stillman Drake (trans.). Berkeley: University of California Press, 1967.

————, *Dialogues Concerning Two New Sciences*, Henry Crew and Alfonso de Silvio (trans.). New York: Dover Publications, 1954 [1638].

————, *Discursus et demonstrationes mathematicæ, circa duas novas scientias pertinentes ad mechanicam & motum localem* . . . Leiden: Apud Fredericum Haaring, et Davidem Severinum, 1699.

————, *Il saggiatore nel quale con bilancia esquisita e giusta si pondera'no le cose contenute nella libra astronomica e filosofica di Lotario Sarsi.* Rome: Giacomo Mascardi, 1623.

————, *Le opere di Galileo Galilei*, edizione nazionale, Antonio Favaro (ed.). Florence: Barbera, 1899–1909.

Galison, Peter, "Descartes's Comparisons: From the Invisible to the Visible." *Isis* 75.2, 1984: 311–26.

Galluzzi, Paolo, "Art and Artifice in the Depiction of Renaissance Machines." In Wolfgang Lefèvre et al. (eds.), *The Power of Images in Early Modern Sciences*. Basel: Birkhäuser Verlag, 2003, 47–68.

————, *Momento: Studi Galileiani.* Rome: Edizioni dell'Ateneo & Bizzarri, 1979.

Garber, Daniel, *Descartes Embodied: Reading Cartesian Philosophy Through Cartesian Science.* Cambridge: Cambridge University Press, 2001.

————, *Descartes' Metaphysical Physics.* Chicago: University of Chicago, 1992.

Garber, Daniel, and Michael Ayers (eds.), *The Cambridge History of Seventeenth Century Philosophy.* Cambridge: Cambridge University Press, 1998.

Garber, Marjorie B., *Dream in Shakespeare: From Metaphor to Metamorphosis.* New Haven: Yale University Press, 1974.

Gaukroger, Stephen, *Cartesian Logic: An Essay on Descartes' Conception of Inference.* Oxford: Clarendon Press, 1986.

————, *Descartes: An Intellectual Biography.* Oxford: Clarendon Press, 1995.

————, "Descartes' Project for a Mathematical Physics." In Gaukroger (ed.), *Descartes: Philosophy, Mathematics, Physics*, 97–140.

————, *Descartes' System of Natural Philosophy.* Cambridge: Cambridge University Press, 2002.

————, *The Emergence of a Scientific Culture: Science and the Shaping of Modernity, 1210–1685.* Oxford: Oxford University Press, 2006.

Gaukroger, Stephen (ed.), *Descartes: Philosophy, Mathematics, Physics.* Sussex: Harvester Press, 1980.

————, *The Soft Underbelly of Reason: The Passions in the Seventeenth Century.* New York: Routledge, 1998.

Gellrich, Jesse M., *The Idea of the Book in the Middle Ages: Language Theory, Mythology, and Fiction.* Ithaca: Cornell University Press, 1985.

Gessner, Conrad, *De raris et admirandis herbis, quae sive quod noctu luceant, sive alia ob causas, Lunariae nominantur, Comshamentariolus.* . . Zürich: Apud Andream Gesnerum F. & Iacobum Gesnerum, fratres, 1556.

Ginzburg, Carlo, *Clues, Myths, and the Historical Method*, John and Anne Tedeschi (trans.). Baltimore: Johns Hopkins University Press, 1989.

————, "High and Low: The Theme of Forbidden Knowledge in the Sixteenth and Seventeenth Centuries." *Past and Present*, 73, 1976: 28–42.

Goldgar, Anne, "Nature as Art: The Case of the Tulip." In Pamela H. Smith and Paula Findlen (eds.), *Merchants and Marvels: Commerce, Science, and Art in Early Modern Europe.* New York and London: Routledge, 2002, 324–46.

Gouk, Penelope, *Music, Science and Natural Magic in Seventeenth-Century England.* New Haven: Yale University Press, 1999.

Gracián y Morales, Baltasar [Lorenzo], *The Critick,* Paul Rycaut (trans.). London: Henry Brome, 1681.

Grafton, Anthony, *Bring Out Your Dead: The Past as Revelation.* Cambridge, Mass.: Harvard University Press, 2001.

————, *Cardano's Cosmos: The Worlds and Works of a Renaissance Astrologer*. Cambridge, Mass.: Harvard University Press, 1999.

————, *Leon Battista Alberti: Master Builder of the Italian Renaissance*. New York: Hill and Wang, 2000.

————, *Worlds Made by Words: Scholarship and Community in the Modern West*. Cambridge, Mass.: Harvard University Press, 2009.

Grant, Edward, "Aristotelianism and the Longevity of the Medieval World View." *History of Science* 16, 1978: 93–106.

Grassi, Orazio, *De tribus cometis anni M.DC.XVIII.: disputatio astronomica publice habita in Collegio Romano Societatis Iesu*. Rome, 1655 [1618].

Greenberg, Sean, "Descartes on the Passions: Function, Representation, and Motivation," *Noûs* 41.4, 2007: 714–34.

Grootenboer, Hanneke, *The Rhetoric of Perspective: Realism and Illusionism in Seventeenth-Century Dutch Still-Life Painting*. Chicago: University of Chicago Press, 2005.

Grosseteste, Robert, *De iride*. In Eastwood, *The Geometrical Optics of Robert Grosseteste*.

————, "De lineis angulis et figuris." In *Die Philosophischen Werke des Robert Grosseteste, Bischofs von Lincoln*, Ludwig Baur (ed.). Münster: I. W. Aschendorff, 1912, 59–65.

————, "De luce." In *Die Philosophischen Werke des Robert Grosseteste, Bischofs von Lincoln*. Münster: I. W. Aschendorff, 1912, 51–59.

————, *Robert Grosseteste: On Light*, Clare C. Riedl (trans.). Milwaukee: Marquette University Press, 1942. Also: http://evans-experientialism.freewebspace.com/grosseteste.htm.

Guiducci, Mario. *Discorso delle comete di Mario Guiducci*. Florence: Pietro Cecconcelli, 1619.

Hale, Mathew, *An Essay, Touching the Gravitation and non-Gravitation of Fluid Bodies, and the Reasons thereof*. London: W. Godbid, 1673.

Hall, A. R., *The Scientific Revolution 1500–1800: The Formation of the Modern Scientific Attitude*. London: Longman (2nd ed.), 1962.

Hamburger, Jeffrey F., "Seeing and Believing: The Suspicion of Sight and the Authentication of Vision in Late Medieval Art." In Alessandro Nova and Klaus Krüger (eds.), *Imagination und Wirklichkeit: Zum Verhältnis von mentalen und realen Bildern in der Kunst der Frühen Neuzeit*. Mainz: Von Zabern, 2000, 47–69.

Hamburgh, Harvey, "Naldini's *Allegory of Dreams* for the Studiolo of Francesco de'Medici." *Sixteenth Century Journal* 27, 1996: 679–704.

Harbison, Craig, *Jan van Eyck: The Play of Realism*. London: Reaktion Books, 1991.

Harrison, Peter, *The Bible, Protestantism, and the Rise of Natural Science*. Cambridge: Cambridge University Press, 1998.

Hazard, Paul, *Crise de la conscience européenne 1680–1720*. 3 vols. Paris: Boivin, 1935.

Herder, Johann Gottfried. *Zerstreute Blätter*. Vols. 5 and 6 of *Vermischte Schriften*. Rev. 2nd ed.. Vienna: Pichler, 1801.

Herivel, J. W., *The Background to Newton's Principia*. Oxford: Clarendon Press, 1965.

Hevelius, Johannes, "An Extract of Monsieur Hevelius's Letter." *Philosophical Transactions* 9, 1674: 27–31.

————, *Johannis Hevelii annus climactericus*. Gedani, sumptibus auctoris: typis D. F. Rhetii, 1685.

————, *Johannis Hevelii machinae coelestis pars prior*. Gdansk, 1673.

————, *Johannis Hevelii Selenographia*. Gdansk, 1647.

————, *Machina coelestis pars posterior*. Gdansk, 1679.

Hockney, David, *Secret Knowledge: Rediscovering the Lost Techniques of the Old Masters*. London: Thames and Hudson, 2001.

Hon, Giora, "On Kepler's Awareness of the Problem of Experimental Error." *Annals of Science* 44, 1987: 545–91.

————, "Putting Error to (Historical) Work: Error as a Tell-tale in the Studies of Kepler and Galileo." *Centaurus* 46.1, 2004: 58–81.

Hooke, Robert, *Animadversions on the . . . Machina Coelestis of . . . Johannes Hevelius*. London: John Martin, 1674.

——, *An Attempt to Prove the Motion of the Earth from Observations*. London: John Martin, 1674.

——, *Lectiones Cutlerianae*. London: John Martin, 1679.

——, *Lectures De Potentia Restitutiva or Of Spring*. London: John Martin, 1678.

——, *Micrographia*. London: Jo. Martin and Jo. Allestry, 1665.

——, *The Posthumous Works*, Richard Waller (ed.). London: Sam Smith and Benjamin Walford, 1705. Facsimile reprint in *The Sources of Science no. 73*. New York: Johnson Reprint Corp., 1969.

——, "Sept. 1, 1685." Trinity College MS o.11.a.1[16c].

——, "Undated Manuscript [probably 1673]." In Hooke's collection at the Trinity Library, reproduced in R. T. Gunther, *Early Science in Oxford*, Vol. X. London: Dawson of Pall Mall, 1930: 57–60.

Hugh of St. Victor, *The Didascalicon of Hugh of St. Victor: Medieval Guide to the Arts*. Jerome Taylor (trans. and ann.). New York: Columbia University Press, 1961.

Huygens, Christiaan, *Horologium oscilatorium*. Paris, 1673. Facsimile reprint by Brussels: Culture et Civilisation, 1966.

——, *Oeuvres Complètes*. La Haye: Société Hollandaise des Sciences, 1888–1950.

——, *The Pendulum Clock or Geometrical Demonstrations Concerning the Motion of Pendula as Applied to Clocks* (Horologium Oscilatorium, 1673), Richard J. Blackwell (trans.). Ames: Iowa State University Press, 1986.

Ibn al-Haytham. *See* Alhacen, Alhazen.

Ilardi, Vincent, *Renaissance Vision from Spectacles to Telescopes*. Philadelphia: American Philosophical Society, 2007.

Iliffe, Rob, "Abstract Considerations: Disciplines and the Incoherence of Newton's Natural Philosophy." *Studies in History and Philosophy of Science* Part A, V 35. 3, 2004: 427–54.

Israel, Jonathan Irvine, *Radical Enlightenment: Philosophy and the Making of Modernity 1650–1750*. Oxford: Oxford University Press, 2002.

James, Jamie, *The Music of the Spheres*. London: Little, Brown and Co., 1993.

James, Susan, *Passion and Action: The Emotions in Seventeenth Century Philosophy*. Oxford: Clarendon Press, 1997.

Jardine, Nicholas, *The Birth of History and Philosophy of Science: Kepler's "A Defence of Tycho against Ursus" with Essays on Its Provenance and Significance*. Cambridge: Cambridge University Press, 1984.

——, "Epistemology of the Sciences." In C. B. Schmitt et al. (eds.), *Cambridge History of Renaissance Philosophy*. Cambridge: Cambridge University Press, 1988.

Jones, Caroline A., and Peter Galison (eds.), *Picturing Science and Producing Art*. New York and London: Routledge, 1998.

Jones, Matthew, *The Good Life in the Scientific Revolution: Descartes, Pascal, Leibniz, and the Cultivation of Virtue*. Chicago: University of Chicago Press, 2006.

Josten, C. H., "A Translation of John Dee's *Monas Hieroglyphica* (Antwerp 1564) with an Introduction and Annotation." *Ambix* 12, 1964: 84–221.

Jurriaanse, M. W., *The Founding of Leyden University*, J. Brotherhood (trans.). Leiden: Brill, 1965.

Kemp, Martin, *Leonardo da Vinci: The Marvellous Works of Nature and Man*. Cambridge, Mass.: Harvard University Press, 1981.

Kepler, Johannes, *Ad Vitellionem paralipomena, quibus astronomiæ pars optica traditur*. In *Gesammelte Werke*, Band II.

——, *Gesammelte Werke 1571–1630*, Walther von Dyck and Max Caspar (eds.). Munich: C. H. Beck, 1937–.

——, *The Harmony of the World*, A. J. Aiton et al. (trans. and ann.). Philadelphia: American Philosophical Society.

——, *Kepler's Conversation with Galileo's Sidereal Messenger*, Edward Rosen (trans., intro., and ann.). New York: Johnson Reprint Corporation, 1965.

——, *Kepler's Somnium: The Dream or Posthumous Work on Lunar Astronomy*, Edward Rosen (trans.). Madison: University of Wisconsin Press, 1967 [1634].

——, *Mysterium Cosmographicum: The Secret of the Universe*, A. M. Duncan (trans.). New York: Abaris Books, 1981 [1596].

——, *New Astronomy (Astronomia Nova)*, William H. Donahue (trans.). Cambridge: Cambridge University Press, 1992 [1609].

——, *A New Year's Gift, or On the Six-Cornered Snowflake*, Colin Hardie (ed. and trans.). Oxford: Clarendon Press, 1966 [1611].

——, *Optics: Paralipomena to Witelo and the Optical Part of Astronomy*, William H. Donahue (trans.). Santa Fe: Green Lion Press, 2000 [1604].

King, H. C., *The History of the Telescope*. New York: Dover Publications, 1979 [1955].

Kollerstrom, N., "Newton's Two 'Moon-Tests.'" *British Journal for the History of Science* 24.3, 1991: 369-72.

Koyré, Alexandre, "Galileo and Plato." *Journal of the History of Ideas* 4.4, 1943: 400-428.

——, *Galileo Studies*, John Mepham (trans.), Atlantic Highlands, N.J.: Humanities Press, 1973.

Kusukawa, Sachiko, and Ian Maclean (eds.), *Transmitting Knowledge: Words, Images, and Instruments in Early Modern Europe*. Oxford: Oxford University Press, 2006.

Lagrée, Jacqueline, *Juste Lipse et la restauration du stoïcisme: Étude et traduction des traités stoïciens De la constance, Manuel de philosophie stoïcienne, Physique des stoïciens*. Paris: Vrin, 1994.

Laird, W. Roy, "Galileo and the Mixed Sciences." In Daniel DiLiscia, Eckhard Kessler, and Charlotte Methuen (eds.), *Method and Order in Renaissance Philosophy of Nature: The Aristotle Commentary Tradition*. Aldershot: Ashgate, 1997, 253-70.

Landes, David S., *Revolution in Time: Clocks and the Making of the Modern World*. Cambridge, Mass.: Belknap Press of Harvard University Press, 1983.

Lawrence, Christopher, and Steven Shapin (eds.), *Science Incarnate: Historical Embodiments of Natural Knowledge*. Chicago: University of Chicago Press, 1998.

Lazzaro, Claudia, *The Italian Renaissance Garden: From the Conventions of Planting, Design, and Ornament to the Grand Gardens of Sixteenth-Century Italy*. New Haven: Yale University Press, 1990.

Lebègue, Raymond, "Le théâtre baroque en France. " *Bibliothèque d'Humanisme et Renaissance* 2, 1941: 161-84.

Lefèvre, Wolfgang (ed.), *Inside the Camera Obscura: Optics and Art under the Spell of the Projected Image*. Berlin: Max-Planck-Institut für Wissenschaftsgeschichte, 2007, Preprint 333.

——, *Picturing Machines 1400-1700*. Cambridge, Mass.: MIT Press, 2004.

Lefèvre, Wolfgang, Jürgen Renn, and Urs Schöpflin (eds.), *The Power of Images in Early Modern Sciences*. Basel: Birkhäuser Verlag, 2003.

Lennox, James, "Aristotle, Galileo, and the Mixed Sciences." In William Wallace (ed.), *Reinterpreting Galileo*, William Wallace. Washington, D.C.: Catholic University of America Press, 1985, 29-51.

Leonardo da Vinci, *The Notebooks of Leonardo da Vinci*, Edward MacCurdy (trans. and ed.). London: Reynal & Hitchcock, 1938.

Levao, Ronald, "Francis Bacon and the Mobility of Science." *Representations* 40, 1992: 1-32.

Levera, Franciscus, *Universae astronomiae restitutae*. Rome, 1663.

Levine, Joseph M., *Between the Ancients and the Moderns: Baroque Culture in Restoration England*. New Haven: Yale University Press, 1999.

Lindberg, David C., "Alhazen's Theory of Vision and its Reception in the West." *Isis* 58.3, 1967: 321-41.

——, "The Genesis of Kepler's Theory of Light: Light Metaphysics from Plotinus to Kepler." *Osiris* 2, 1986: 5-42.

——, "Laying the Foundations of Geometrical Optics: Maurolico, Kepler, and the Medieval Tradition." In David C. Lindberg and Geoffrey Cantor, *The Discourse of Light from the Middle Ages to the Enlightenment*. Los Angeles: William Andrews Clark Memorial Library, UCLA, 1985, 3–65.

——, "Optics in 16th Century Italy." In P. Galluzzi (ed.), *Novità Celsti e Crisi del Sapere*. Florence: Giuti Barbera, 1984, 131–48.

——, *Theories of Vision from al-Kindi to Kepler*. Chicago: University of Chicago Press, 1976.

——, "The Theory of Pinhole Images from Antiquity to the Thirteenth Century." *Archive for the History of Exact Sciences* 5, 1968: 154–76.

——, "The Theory of Pinhole Images in the Fourteenth Century." *Archive for the History of Exact Sciences* 6, 1970: 299–325.

Lindberg, David C., and Geoffrey Cantor, *The Discourse of Light from the Middle Ages to the Enlightenment*. Los Angeles: William Andrews Clark Memorial Library, UCLA, 1985.

Lindberg, David C., and N. H. Steneck, "The Sense of Vision and the Origins of Modern Science." In A. Debus (ed.), *Science, Medicine, and Society in the Renaissance*. 2 vols. New York: Science History Publications, 1972, 1:29–45.

Lindberg, David C., and R. S. Westman (eds.), *Reappraisals of the Scientific Revolution*. Cambridge: Cambridge University Press, 1990.

Lipsius, Justus, *De constantia libri dvo: qui alloquium praecipue continent in Publicis malis*. Quarta editio. Frankfurt: Ioannem Wechelum & Petrum Fischerum, 1591.

——, *Sixe bookes of politickes or ciuil doctrine*, William Iones Gentleman (trans.). London: Printed by Richard Field for William Ponsonby, 1594.

——, *Two Bookes of Constancie: Containing, Principallie, A Comfortable Conference, in Common Calamities*, John Stradling (trans). London: Richard Johnes at the signe of the Rose and Crowne neere S. Andrewes Church in Holborn, 1595.

Lohne, Johaness, "Hooke versus Newton: An Analysis of the Documents in the Case of Free Fall and Planetary Motion." *Centaurus* 7.1, 1960: 6–52.

Lüthy, Christoph H., "Atomism, Lynceus, and the Fate of Seventeenth-Century Microscopy." *Early Science and Medicine* 1.1, 1996: 1–27.

——, "The Invention of Atomist Iconography." In Wolfgang Lefèvre et al. (eds.), *The Power of Images in Early Modern Sciences*. Basel: Birkhäuser Verlag, 2003, 117–38.

——, "Where Logical Necessity Becomes Visual Persuasion." In Sachiko Kusukawa and Ian Maclean (eds.), *Transmitting Knowledge: Words, Images, and Instruments in Early Modern Europe*. Oxford: Oxford University Press, 2006, 97–133.

Lüthy, Christoph H., et al. (eds.), *Late Medieval and Early Modern Corpuscular Matter Theories*. Leiden: Brill, 2001.

MacDougall, E. B., and N. Miller (eds.), *Fons Sapientiae: Renaissance Garden Fountains*. Washington: Dumbarton Oaks, 1978.

Machamer, Peter (ed.), *The Cambridge Companion to Galileo*. Cambridge: Cambridge University Press, 1998.

——, "Galileo's Machines, His Mathematics, and His Experiments." In Peter Machamer (ed.), *Cambridge Companion to Galileo*. Cambridge: Cambridge University Press, 1998, 53–79.

Machamer, Peter, and J. E. McGuire, *Descartes's Changing Mind*. Princeton: Princeton University Press, 2009.

Maestlin, Michael, *De Astronomiae hypothesibus sive de Circulis Sphaericis et Orbibus Theoricis, disputatio ad discutiendum proposita, a' M. Michaele Maestlino Goeppingensis. . . . Respondente Matthia Menero Mulhusano*. Heidelberg: Mylius, 1582.

——, *De Astronomiae principalibus et primis fondamentis disputatio*. Heidelberg: Mylius, 1582.

Mahoney, Michael, "The Beginnings of Algebraic Thought in the Seventeenth Century." In Gaukroger (ed.), *Descartes: Philosophy, Mathematics, Physics*, 141–55.

——, "Changing Canons of Mathematical and Physical Intelligibility in the Later Seventeenth Century." *Historia Mathematica* 11, 1984: 417–23.

———, "Christiaan Huygens: The Measurement of Time and of Longitude at Sea." In H. J. M. Bos et al. (eds.) *Studies on Christiaan Huygens*. Lisse: Swets & Zeitlinger, 1980, 234–70.

———, "Drawing Mechanics," in Wolfgang Lefèvre (ed.) *Picturing Machines, 1400–1700*. Cambridge, Mass.: MIT Press, 2004, 281–308.

———, "Huygens and the Pendulum: From Device to Mathematical Relation." In E. Grosholz and H. Breger (eds.), *The Growth of Mathematical Knowledge*. Dordrecht: Kluwer Academic Publishers, 2000, 17–39.

———, "Infinitesimals and Transcendent Relations: The Mathematics of Motion in the Late Seventeenth Century." In David C. Lindberg and R. S. Westman (eds.), *Reappraisals of the Scientific Revolution*. Cambridge: Cambridge University Press, 1990, 461–92.

———, "The Mathematical Realm of Nature." In Daniel Garber and Michael Ayers (eds.), *The Cambridge History of Seventeenth Century Philosophy*. Cambridge: Cambridge University Press, 1998, 702–55.

Malebranche, Nicolas, *The Search after Truth*, Thomas M. Lennon and Paul J. Olscamp (trans. and eds.). Cambridge: Cambridge University Press, 1997.

Malet, Antoni, "Early Conceptualizations of the Telescope as an Optical Instrument." *Early Science and Medicine* 10.2, 2005: 237–62.

———, "Keplerian Illusions: Geometrical Pictures vs. Optical Images in Kepler's Visual Theory." *Studies in History and Philosophy of Science* 21.1, 1990: 1–40.

Mancosu, Paolo, *Philosophy of Mathematics and Mathematical Practice in the Seventeenth Century*. New York: Oxford University Press, 1996.

Maravall, José Antonio, *The Culture of the Baroque: Analysis of a Historical Structure*, Terry Cochran (trans.). Minneapolis: University of Minnesota Press, 1986.

Marine, Louis. "Éloge de l'apparence." In *De la Représentation*. Paris: Gallimard, 1994.

Marrone, Steven P., *William of Auvergne and Robert Grosseteste: New Ideas of Truth in Early Thirteenth Century*. Princeton: Princeton University Press, 1983.

Marshall, David, "Exchanging Visions: Reading A Midsummer Night's Dream." *ELH* 49.3, 1982: 543–75.

McAlindon, T., *Shakespeare's Tragic Cosmos*. Cambridge: Cambridge University Press, 1991.

McCrea, Adriana, *Constant Minds: Political Virtue and the Lipsian Paradigm in England, 1584–1650*. Buffalo, N.Y.: University of Toronto Press, 1997.

McGinn, Colin, *Shakespeare's Philosophy: Discovering the Meaning behind the Plays*. New York: HarperCollins, 2006.

Miller, Naomi, "Domain of Illusion: The Grotto in France." In E. B. MacDougall and N. Miller (eds.), *Fons Sapientiae: Renaissance Garden Fountains*. Washington: Dumbarton Oaks, 1978, 175–205.

Minnich, Nelson H., "Raphael's Portrait 'Leo X with Cardinals Giulio de' Medici and Luigi de' Rossi': A Religious Interpretation." *Renaissance Quarterly* 56, 2003: 1005–52.

Molaro, Paolo, and Selvelli, Pierluigi, "The Mystery of the Telescopes in Jan Brueghel the Elder's Paintings." *Memorie della Società Astronomica Italiana: Supplementi* 14. 246, 2010: 246–49.

Monsarrat, Gilles D., *Light from the Porch: Stoicism and English Renaissance Literature*. Paris: Didier-Erudition, 1984.

More, Henry, *Remarks upon Two Late Ingenious Discourses* [by M. Hale]. London: Walter Kettilby, 1676.

Morford, Mark, *Stoics and Neostoics: Rubens and the Circle of Lipsius*. Princeton: Princeton University Press, 1991.

Mousnier, Roland, *Les 16e et 17e siècles*. Paris: Presses universitaires de France, 1954.

Nauenberg, Michael, "Hooke, Orbital Motion, and Newton's *Principia*." *American Journal of Physics* 62.4, 1994: 331–50.

———, "Newton's Early Computational Method for Dynamics." *Archive for History of Exact Sciences* 46.3, 1994: 221–52.

——, "Robert Hooke's Seminal Contribution to Orbital Dynamics." In Michael Hunter and Michael Cooper (eds.), *Robert Hooke: Tercentennial Studies*. Aldershot: Ashgate, 2006, 3–32.

Naylor, Ron, "Galileo, Copernicanism, and the Origins of the New Science of Motion." *British Journal for the History of Science* 36, 2003: 151–81.

Newton, Isaac, *The Correspondence of Isaac Newton*, H. W. Turnbull (ed.). Cambridge: Cambridge University Press, 1960.

——, *The Mathematical Papers*, Derek T. Whiteside (ed.). Cambridge: Cambridge University Press, 1974.

——, *Philosophia Naturalis Principia Mathematica*. London: Jussu Societatis Regiae ac Typis Josephi Streater, 1687.

——, *The Preliminary Manuscripts for Isaac Newton's 1687 Principia, 1684–1685*. Facsimile reprint by Derek T. Whiteside (ed.). Cambridge: Cambridge University Press, 1989.

——, *The Principia*, I. B. Cohen and A. Whitman (trans. and ann.). Berkeley: University of California Press, 1999.

——, A Treatise of the System of the World. London: F. Faryam, 1728.

Nicholas of Cusa, *De beryllo*. In *Nicolai de Cusa opera omnia* vol. 11/1. Hamburg: Felicis Meiner, 1988.

——, *De Ludo Globi: The Game of Spheres*, P. M. Watts (trans.). New York: Abaris Books, 1986.

——, *Nicholas of Cusa: Metaphysical Speculations*. Jasper Hopkins (trans.), Minneapolis: Arthur J. Banning Press, 1998.

——, *Nicholas of Cusa on Learned Ignorance: A Translation and Appraisal of De Docta Ignorantia*. 2nd ed. Jasper Hopkins (trans.). Minneapolis: Arthur J. Banning Press, 1996.

——, *Nikolaus von Kues, Werke* (Neuausgegeben des Strassburger Drucks von 1488). Berlin: Paul Wilpert, 1967.

Nolan, Edward Peter, *Now through a Glass Darkly: Specular Images of Being and Knowing from Virgil to Chaucer*. Ann Arbor: University of Michigan Press, 1990.

Nova, Alessandro, and Klaus Krüger (eds.), *Imagination und Wirklichkeit: Zum Verhältnis von mentalen und realen Bildern in der Kunst der Frühen Neuzeit*. Mainz: Von Zabern, 2000.

Oestreich, Gerhard, *Neostoicism and the Early Modern State*, Brigitta Oestreich and H. G. Koenigsberger (eds.), David McLintock (trans.). Cambridge: Cambridge University Press, 1982.

Ogilvie, Brian W., *The Science of Describing: Natural History in Renaissance Europe*. Chicago: University of Chicago Press, 2006.

Ommen, K. van (ed.), *The Exotic World of Carolus Clusius (1526–1609): Catalogue of an Exhibition on the Quatercentenary of Clusius' Death, 4 April 2009*. Leiden: Leiden University Library.

Oresme, Nicole, *Nicole Oresme and the Kinematics of Circular Motion: Tractatus de commensurabilitate vel incommensurabilitate motuum celi*. Edward Grant (ed. and trans.). Madison: University of Wisconsin Press, 1971.

——, *Nicole Oresme and the Marvels of Nature: A Study of His De causis mirabilium*, B. Hansen (ed.). Toronto: Pontifical Institute of Medieval Studies, 1985.

——, *Nicole Oresme and the Medieval Geometry of Qualities and Motions . . . Tractatus de configurationibus qualitatum et motuum*, Marshall Clagett (ed. and trans.). Madison: University of Wisconsin Press, 1968.

——, *Nicolai Oresme Expositio et Quaestiones in Aristotelis De anima*, Benoit Patar (ed.). Paris: Editions de l'Institut superieur de philosophie, 1995.

Palmerino, Carla-Rita, "Galileo and Gassendi's Solutions to the *Rota Aristotelis* Paradox: A Bridge between Matter and Motion Theories." In Christoph Lüthy *et al.* (eds.), *Late Medieval and Early Modern Corpuscular Matter Theories*. Leiden: Brill, 2001, 381–422.

——, "Galileo and the Mathematical Characters of the Book of Nature." In K. van Berkel and A. J. Vanderjagt (eds.), *The Book of Nature in Modern Times*. Leuven: Peeters, 2006, 27–45.

Panofsky, Erwin, *Abbot Suger on the Abbey Church of St. Denis and Its Art Treasures*. Princeton: Princeton University Press, 1946.

——, *Galileo as a Critic of the Arts.* The Hague: Martinus Nijhoff, 1954.

——, "What Is Baroque?" In Irving Lavin (ed.), *Three Essays on Criticism.* Cambridge, Mass.: MIT Press, 1995: 17–90.

Paradis, James, "Montaigne, Boyle, and the Essay of Experience." In George Levine (ed.), *One Culture: Essays in Science and Literature.* Madison: University of Wisconsin Press, 1987, 59–91.

Park, Katherine, "The Imagination in Renaissance Psychology." M.Phil. thesis, University of London, 1974.

——, "Impressed Images: Reproducing Wonders." In Caroline A. Jones and Peter Galison (eds.), *Picturing Science and Producing Art.* New York: Routledge, 1998: 254–71.

Pecham, John, *John Pecham and the Science of Optics: Perspectiva communis,* David Lindberg (trans. and ed.). Madison: University of Wisconsin Press, 1970.

Phillips, Heather, "John Wyclif and the Optics of the Eucharist." In Anne Hudson and Michael Wilks (eds.), *From Ockham to Wyclif.* Oxford and New York: Basil Blackwell, 1987: 245–58.

Pliny, *Natural History,* W. H. S. Johns (trans.). Cambridge, Mass.: Harvard University Press, 1980.

Popkin, Richard H., *The History of Scepticism from Erasmus to Spinoza.* Berkeley: University of California Press, 1979.

Pseudo-Dionysius Aeropigata, *The Divine Names,* C. E. Rolt (trans.). London, 1920.

Rabelais, François, *Gargantua and Pantagruel,* Burton Raffel (trans.). New York: W. W. Norton & Co., 1990.

Radner, Daisie, "The Function of the Passions." In Byron Williston and André Gombay (eds.), *Passion and Virtue in Descartes.* New York: Humanity Books, 2003, 175–87.

Reeves, Eileen, *Galileo's Glassworks: The Telescope and the Mirror.* Cambridge, Mass.: Harvard University Press, 2008.

——, *Painting the Heavens: Art and Science in the Age of Galileo.* Princeton: Princeton University Press, 1997.

Regiomontanus, Johannes, *De triangulis omnimodis libri quinque.* Nuremberg, 1533.

Reiss, Timothy J., *Knowledge, Discovery, and Imagination in Early Modern Europe: The Rise of Aesthetic Rationalism.* Cambridge: Cambridge University Press, 1997

Renn, Jürgen, Peter Damerow, and Simone Rieger, "Hunting the White Elephant: When and How Did Galileo Discover the Law of Fall?" *Science in Context* 13, 2000: 299–423.

Riccioli, Jovani Baptista, *Almagestum novum astronomiam veterem novamque complectens observationibus aliorum et propriis novisque theorematibus, problematibus ac tabulis promotam.* Bologna: Haeredis Victorij Benatij, 1651.

——, *Astronomiae reformatae.* Bologna: H. V. Benatus, 1665.

Rorty, Richard, *Philosophy and the Mirror of Nature.* Princeton: Princeton University Press, 1979.

Rowen, Herbert H., "The Dutch Revolt: What Kind of Revolution?" *Renaissance Quarterly* 43.3, 1990: 570–90.

Sabra, A. I., "Alhazen's Optics in Europe." In Wolfgang Lefèvre (ed.), *Inside the Camera Obscura: Optics and Art under the Spell of the Projected Image.* Berlin: Max-Planck-Institut für Wissenschaftsgeschichte, 2007, Preprint 333.

——"The Appropriation and Subsequent Naturalization of Greek Science in Medieval Islam: A Preliminary Statement." *Journal for History of Science* 25, 1987: 223–45.

Saito, Fumikazu, "Perception and Optics in the 16th Century: Some Features of Della Porta's Theory of Vision." *Circumscribere* 8, 2010: 28–35.

Salmon J. H. M., "Stoicism and Roman Example: Seneca and Tacitus in Jacobean England." *Journal of the History of Ideas* 50.2, 1989: 199–225.

Saridakis, V., *Converging Elements in the Development of Late Seventeenth-Century Disciplinary Astronomy: Instrumentation, Education, Networks, and the Hevelius-Hooke Controversy.* Blacksburg: Virginia Polytechnic Institute, 2001.

Sarsi, Lothario. *Libra astronomica ac philosophica qua Galilaei opiniones de cometis a Mario Guiducio in Florentina Academia expositae, atque in lucem nuper editae, examinantur a Lothario Sarsio Sigensano.* Perugia, 1619.

Scheiner, Christoph, *Oculus, hoc est, fundamentum opticum.* Innsbruck, 1619; reprinted London, 1652.

———, *Rosa Ursina.* Bracciano: Andreas Phaeus, 1626–30.

Schofield, M., et al. (eds.), *Doubts and Dogmatism.* Oxford: Oxford University Press, 1980.

Scholem, Gershom, *Major Trends in Jewish Mysticism.* New York: Schocken, 1941.

Schonfield, Malcolm, "Aristotle on the Imagination." In M. C. Nussbaum and A. O. Rorty (eds.), *Essays on Aristotle's De Anima.* Oxford: Oxford University Press, 1995, 249–78.

Schuster, John A., "Physico-mathematics and the Search for Causes in Descartes' Optics: 1619–1637." In Gal and Chen-Morris (eds.), *Seeing the Causes,* 467–99.

Schuster, John A., and Stephen Gaukroger, "The Hydrostatic Paradox and the Foundations of Cartesian Dynamics." *Studies in History and Philosophy of Science* 33A, 2002: 535–72.

Seidel, Linda, "The Value of Verisimilitude in the Art of Jan Van Eyck." *Yale French Studies* 80, 1991: 25–43.

Sellars, John, "Justus Lipsius's *De Constantia*: A Stoic Spiritual Exercise." *Poetics Today* 28.3, 2007: 339–62.

Selvelli, Pierluigi, and Paulo Molaro, "On the Telescopes in the Paintings of J. Brueghel the Elder." *Proceedings of the International Astronomical Union* 5, 2009: 327–32.

Sepper, Dennis L., *Descartes's Imagination: Proportion, Images, and the Activity of Thinking.* Berkeley: University of California Press, 1996.

Shakespeare, William, *A Midsummer Night's Dream,* Wolfgang Clemen (ed.). New York: Signet Classic (New American Library), 1963.

Shapiro, Alan E., "Images: Real and Virtual, Projected and Perceived, from Kepler to Dechales." In Wolfgang Lefèvre (ed.), *Inside the Camera Obscura: Optics and Art under the Spell of the Projected Image.* Berlin: Max-Planck-Institut für Wissenschaftsgeschichte, 2007, Preprint 333.

Shapiro, Lisa, "The Structure of the *Passions of the Soul.*" In Byron Williston and André Gombay (eds.), *Passion and Virtue in Descartes.* New York: Humanity Books, 2003, 31–79.

Shea, William R., "The Galilean Geometrization of Motion." In William R. Shea (ed.), *Nature Mathematized.* Dordrecht: Reidel, 1983, 51–60.

———, *Galileo's Intellectual Revolution.* London: MacMillan, 1972.

Shea, William R. (ed.), *Nature Mathematized.* Dordrecht: Reidel, 1983.

Shepherd, J. C. and G. A. Jellicoe, *Italian Gardens of the Renaissance.* 5th ed. London: Princeton Architectural Press, 1996.

Sigerist, Henry E., "William Harvey's Stellung in der Europaeischer Geistesgeschichte." *Archives der Kulturgeschichte* 19, 1929: 158–68.

Simmons, Alison, "Are Cartesian Sensations Representational?" *Noûs* 33.3, 1999: 347–69.

Siraisi, Nancy G., "Oratory and Rhetoric in Renaissance Medicine." *Journal of the History of Ideas* 65.2, 2004: 191–211.

Smith, A. Mark, "Getting the Big Picture in Perspectivist Optics." *Isis* 72, 1981: 568–89.

———, "Ptolemy, Alhazen, and Kepler and the Problem of Optical Images," *Arabic Sciences and Philosophy: A Historical Journal* 8, 1998: 9–44.

———, "Ptolemy's Search for a Law of Refraction: A Case-Study in the Classical methodology of "Saving the Appearances" and its Limitations." *Archive for the History of Exact Science,* 26, 1982: 221–40.

———, "Saving the Appearances of the Appearances: The Foundations of Classical Geometrical Optics," *Archive for the History of Exact Science* 24, 1981: 73–99.

———, "What Is the History of Medieval Optics Really About?" *Proceedings of the American Philosophical Society* 148.2, 2004: 180–94.

Smith, George E., "From the Phenomenon of the Ellipse to an Inverse-Square Force: Why Not?"

In David Malament (ed.), *Reading Natural Philosophy: Essays in History and Philosophy of Science and Mathematics*. Chicago: Open Court, 2002, 31–70.

Smith, Pamela H., "Alchemy as a Language of Mediation at the Habsburg Court." *Isis* 85.1, 1994: 1–25.

——, "Art, Science, and Visual Culture in Early Modern Europe." *Isis* 97.1, 2006: 83–100.

——, *The Body of the Artisan: Art and Experience in the Scientific Revolution*. Chicago: University of Chicago Press, 2004.

——, "Science and Taste: Painting, Passions, and the New Philosophy in Seventeenth-Century Leiden." *Isis* 90.3, 1999: 421–61.

Smith, Pamela H., and Paula Findlen (eds.), *Merchants and Marvels: Commerce, Science, and Art in Early Modern Europe*. New York and London: Routledge, 2002.

Southern, R. W., *Robert Grosseteste: The Growth of an English Mind in Medieval Europe*. New York: Clarendon Press, Oxford University Press, 1986.

Sprat, Thomas, *The History of the Royal Society of London for the Improving of Natural Knowledge*. London: J. Martyn and J. Allestry, 1667.

Spruit, Leen, *Species Intelligibilis: From Perception to Knowledge*. 2 vols. Leiden: E. J. Brill, 1994.

Steadman, Philip, *Vermeer's Camera: Uncovering the Truth Behind the Masterpieces*. Oxford: Oxford University Press, 2001.

Steinle, Friedrich "The Amalgamation of a Concept: Laws of Nature in the New Sciences." In Weinert, *Laws of Nature*, 316–68.

Stephens, Walter, *Demon Lovers: Witchcraft, Sex, and the Crisis of Belief*. Chicago: University of Chicago Press, 2002.

Stephenson, Bruce, *Kepler's Physical Astronomy*. Princeton: Princeton University Press, 1994.

——, *The Music of the Heavens: Kepler's Harmonic Astronomy*. Princeton: Princeton University Press, 1994.

Stoichita, Victor, *The Self-Aware Image: An Insight into Early Modern Meta-Painting*, Anne-Marie Glasheen (trans.). Cambridge: Cambridge University Press, 1997.

Straker, Stephen, *Kepler's Optics*. Unpublished Ph.D. dissertation, Indiana University, 1971.

Streete, Thomas, *Astronomia Carolina: A New Theory of the Coelestial Motions*. London: Lodovick Lloyd, 1661.

——, *Examen Examinatum, or, Wing's Examination of Astronomia Carolina Examined*. London: John Darby, 1667.

Summers, David, *The Judgment of Sense: Renaissance Naturalism and the Rise of Aesthetics*. Cambridge: Cambridge University Press, 1987.

——, *Michelangelo and the Language of Art*. Princeton: Princeton University Press, 1981.

——, *Vision, Reflection, and Desire in Western Painting*. Chapel Hill: University of North Carolina Press, 2007.

Sutton, John, *Philosophy and Memory Traces: Descartes to Connectionism*. Cambridge: Cambridge University Press, 1998.

Swan, Claudia, *Art, Science, and Witchcraft in Early Modern Holland: Jacques de Gheyn II (1565–1629)*. Cambridge: Cambridge University Press, 2005.

Sylla, Edith D., *The Oxford Calculators and the Mathematics of Motion, 1320–1350*. New York: Garland Publishing, Inc., 1991.

Szafranska, M., "The Philosophy of Nature and the Grotto in the Renaissance Garden." *Journal of Garden History* 9.2, 1989: 79.

Tachau, Katherine, "The Problem of the *Species in Medio* at Oxford in the Generation after Ockham." *Medieval Studies* 44, 1982: 394–443.

——, *Vision and Certitude in the Age of Ockham: Optics, Epistemology, and the Foundations of Semantics, 1250–1345*. Leiden: Brill, 1988.

Taimina, Daina, "Exploring Linkages." http://kmoddl.library.cornell.edu/linkages/.

Tartaglia, Nicolò, *Nova Scientia*. Venice, 1537.

Thomas Aquinas, *Scriptum super libros Sententiarum* (ed. nova), R. P. Mandonnet (ed.). Paris: Sumptibus P. Lethielleux, 1929.

Thro, E. Broydrick, "Leonardo's Early Work on the Pinhole Camera: The Astronomical Heritage of Levi ben Gerson." *Achademia Leonardi Vinci* 9, 1996: 20–54.

Tiemersma, Douwe, "Methodological and Theoretical Aspects of Descartes' Treatise on the Rainbow." *Studies in History and Philosophy of Science* 19.3, 1988: 347-64.

Tjon Sie Fat, L. A., "Clusius's Garden: A Reconstruction." In L. A. Tjon Sie Fat and E. de Jong (eds.), *The Authentic Garden: A Symposium on Gardens*. Leiden: Clusius Foundation, 1991, 3-12.

Tjon Sie Fat, L. A., and E. de Jong (eds.), *The Authentic Garden: A Symposium on Gardens*. Leiden: Clusius Foundation, 1991.

Ubrizsy Savoia, Andrea, *Papers Dealing with Carolus Clusius*. Rome: Departimento di Biologia Vegetale, 1988.

Van Helden, Albert, "Galileo and the Telescope." In Paolo Galluzzi (ed.), *Novità Celesti e Crisi del Sapere*. Florence: Annali dell'Istituto e Museo di Storia della Scienza di Firenze, 1983, 149-58.

———, "The Telescope and Authority from Galileo to Cassini." In T. L. Hankins and A. Van Helden (eds.), *Scientific Instruments. Osiris* 9, 1994: 9-29.

———, "The Telescope in the Seventeenth Century." *Isis* 65.1, 1974: 38-58.

Van Maanen, Jan, "Seventeenth Century Instruments for Drawing Conic Sections." *Mathematical Gazette*, 76, 1992: 222-30.

Van Nouhuys, Tabitta. *The Age of Two-Faced Janus: The Comets of 1577 and 1618 and the Decline of the Aristotelian World View in the Netherlands*. Leiden: Brill, 1998.

Verbeek, Theo, *Descartes and the Dutch: Early Reactions to Cartesian Philosophy, 1637–1650*. Carbondale: Southern Illinois University Press, 1992.

Voelkel, James R., *The Composition of Kepler's "Astronomia Nova."* Princeton: Princeton University Press, 2001.

Voltaire, *The Works of Voltaire: A Contemporary Version*, William F. Fleming et al. (trans. and ann.). 21 vols. New York: E. R. DuMont, 1901.

Wallis, John, *A Discourse of Gravity and Gravitation, Grounded on Experimental Observations*. "Presented to the Royal Society, the 12th of November, 1674."

Ward, Seth, *Astronomia geometrica, ubi methodus proponitur qua primariorum planetarum astronomia*. London: Jacob Flesher, 1656.

———, *Ismaelis Bullialdi astronomiae philolaicae fundamenta, inquisitio brevis*. Oxford: L. Lichfield, 1653. Published in *Idea trigonometriae demonstrata . . . et inquisitio in Bullialdi astronomiae*. Oxford: L. Lichfield, 1654.

Weinert, Friedel (ed.), *Laws of Nature*. Berlin: Walter de Gruyter, 1995.

Wellek, René, "The Concept of Baroque in Literary Scholarship." In *Concepts of Criticism*, New Haven: Yale University Press, 1963, 69-127.

Welu, James, "Vermeer's Astronomer: Observations on an Open Book," *Art Bulletin* 68.2, 1986: 263-67.

Werrett, Simon, "Wonders Never Cease: Descartes's "Météores" and the Rainbow Fountain." *The British Journal for the History of Science*, 34.2, 2001: 129-47.

Westfall, Richard S., "Newton and the Fudge Factor." *Science* n.s., 179.4075, Feb. 23, 1973: 751-58.

Westman, Robert S., "Nature, Art and Psyche: Jung, Pauli, and the Kepler-Fludd Polemic." In Brian Vickers (ed.), *Occult and Scientific Mentalities in the Renaissance*, Cambridge: Cambridge University Press, 1984, 177-229.

White, Helen C. et al. (eds.), *Seventeenth-Century Verse and Prose*. New York: Macmillan Company, 1971.

Whiteside, D. T., "Newton's Lunar Theory: From High Hope to Disenchantment." *Vistas in Astronomy*, 19, 1976: 317-28.

Willey, Basil, *The Seventeenth-Century Background: Studies in the Thought of the Age in Relation to Poetry and Religion*. London: Chatto & Windus, 1934.

Williams, Bernard. *Descartes: The Project of Pure Inquiry*. London: Pelican, 1978.

Williston, Byron, and André Gombay (eds.), *Passion and Virtue in Descartes*. New York: Humanity Books, 2003.

Wilson, Margaret, "Skepticism Without Indubitability." *Journal of Philosophy*, 81.10, 1984: 538–39.

Wing, Vincent, *Astronomia Britanica: in qua, per novam, concinnioremq; methodum hi quinq; Tractatus tradundur*. London: John Macock, 1669.

———, *Astronomia instaurata*. London: R. & W. Leybourn, 1656.

———, *Examen astronomiae Carlinae:* T. S. London: W. L. Leybourn, 1665.

———, *Harmonicon coeleste*. London: Robert Leybourn, 1651.

———, *Wing's Ephemerides for Thirty Years, Together with His Computatio Catholica*. London: J. C., 1669.

Winkler, Mary G., and Albert van Helden, "Johannes Hevelius and the Visual Language of Astronomy." In J. V. Field and Frank A. J. L. James (eds.), *Renaissance and Revolution: Humanists, Scholars, Craftsmen and Natural Philosophers in Early Modern Europe*. Cambridge: Cambridge University Press, 1993, 97–116.

Witelo, *Witelonis perspectivae liber primus (Book I of Witelo's Perspectiva, Latin and English)*, Sabetai Unguru (trans. and intro.). Wroclaw: Ossolineum; Warsaw: Polish Academy of Sciences Press, *Studia Copernicana* 15, 1977.

———, *Witelonis perspectivae liber Secundus et liber tertius (Books II and III of Witelo's Perspectiva, Latin and English)* Sabetai Unguru (trans. and intro.). Wroclaw: Ossolineum; Warsaw: Polish Academy of Sciences Press, Studia Copernicana 28, 1991.

———, *Witelonis perspectivae liber quintus (Book V of Witelo's Perspectiva, Latin and English)*, Mark Smith (trans. and intro.). Wroclaw: Ossolineum; Warsaw: Polish Academy of Sciences Press, *Studia Copernicana* 23, 1983.

Wölfflin, Heinrich, *Principles of Art History: The Problem of the Development of Style in Later Art*, M. D. Hottinger (trans.). New York: Dover Publications, 1950.

Woollett, Anne T., Ariane van Suchtelen, et al. (eds.), *Rubens & Brueghel: A Working Friendship*. Los Angeles: J. Paul Getty Museum, 2006.

Yoder, Joella G., *Unrolling Time: Christiaan Huygens and the Mathematization of Nature*. Cambridge: Cambridge University Press, 1988.

Zik, Yaakov, and Giora Hon, "Geometry of Light and Shadow: Francesco Maurolyco (1494–1575) and the Pinhole Camera." *Annals of Science* 64.4, 2007: 549–78.

Zik, Yaakov, and Albert Van Helden, "Between Discovery and Disclosure." In Beretta, Marco *et al.* (eds.), *Musa Musaei: Studies on Scientific Instruments and Collections in Honour of Mara Miniati*. Florence: L. S. Olschki, 2003, 173–90.

Zwijnenberg, Robert, *The Writing and Drawings of Leonardo da Vinci: Order and Chaos in Early Modern Thought*, C. A. Van Eck (trans.). Cambridge: Cambridge University Press, 1999.

# Index